Absorption and Theatricality

ABSORPTION AND THEATRICALITY

Painting and Beholder
in the Age of Diderot

MICHAEL FRIED

UNIVERSITY OF CALIFORNIA PRESS

Berkeley · Los Angeles · London

Library of Congress Cataloging in Publication Data
Fried, Michael
 Absorption and theatricality.
 Includes index.
 1. Painting, French. 2. Painting, Modern—
17th-18th centuries—France. I. Title.
ND546.F73 759.4 78-62843
ISBN 0-520-03758-8

University of California Press
Berkeley and Los Angeles, California

University of California Press, Ltd.
London, England

© 1980 by
The Regents of the University of California

Printed in the United States of America

1 2 3 4 5 6 7 8 9

TO RUTH

Contents

Preface

SOME OF THE matters dealt with in this book have been part of my teaching since the spring of 1966, at which time, while still a Junior Fellow in the Society of Fellows of Harvard University, I taught a course on French painting from the mid-eighteenth century through Manet in the Department of Fine Arts. I went on to write my doctoral dissertation on Manet, and at first thought of working backwards toward what I had come to see as the beginnings of the prehistory of modern painting in the 1750s and 1760s. Soon, however, the impracticality of such a way of proceeding became apparent; and I began to work concentratedly on the earlier period with the aim of producing a book that would be at once an interpretation of French painting and criticism between the start of the reaction against the Rococo and the advent of David and the first in a sequence of studies that would culminate in an expanded version of my monograph on Manet.

An invitation to participate in March 1972 in a colloquium organized by Robert Darnton for the Department of History at Princeton University provided a welcome opportunity to present in broad outline my reading of Diderot. In October 1972, at the invitation of Victor Gourevitch, I gave a revised version of the same paper as a public lecture at the Center for the Humanities at Wesleyan University. It was in the course of spending the fall of 1973 as a Visiting Fellow at the Center that I managed to complete a draft of almost all of the present book. And I began to be convinced of the viability of that draft when, thanks to an invitation from Joseph Frank, I made it the basis of three Christian Gauss Seminars in Criticism which I conducted at Princeton University in April 1974. Three other occasions on which I presented material treated in these pages should be mentioned. In August 1975, at

the invitation of Georges May, I delivered a lecture with the same title as this book at a plenary session of the Fourth International Congress on the Enlightenment held at Yale University; in April 1976, having been asked by Ralph Cohen to speak at the annual meeting of the American Society for Eighteenth-Century Studies convened that year at the University of Virginia, I sketched for the first time the Belisarius material that brings the book to a close; and in April 1977, responding to an invitation from Natalie Z. Davis, I read a paper on Vien's *Marchande à la toilette* at the annual meeting of the Society for French Historical Studies at the University of California at Berkeley. On all the occasions just cited I received criticisms and suggestions that I have made use of in the pages that follow; to my hosts, and to those who participated in the discussions that followed my presentations, I wish to express my sincere gratitude.

Among the persons whose encouragement and/or whose advice have been important to me I want especially to thank Svetlana Alpers, Stanley Cavell, Herbert Dieckmann, Robert Darnton, Robert Forster, Sydney J. Freedberg, Charles C. Gillispie, John Harbison, Herbert L. Kessler, Ruth Leys, Steven Orgel, Ronald Paulson, Jules Prown, Mark Ptashne, the late Seymour Shifrin, Seymour Slive, Barry Weller, John Womack, Jr., and Hayden White. Darnton and Harbison in particular gave me strong support at moments when it was most needed, as did my wife, to whom this book is dedicated. The late Frederick C. Deknatel, my adviser during my years as a graduate student and Junior Fellow at Harvard, could not have been more generous with counsel and encouragement at the outset of my career; I deeply regret not being able to place this book in his hands. The introduction was read in manuscript by Stanley Fish and Walter Michaels, both of whom made suggestions for which I am grateful. M. Pierre Rosenberg, Conservateur au Département des Peintures at the Musée du Louvre, more than once enabled me to see paintings in the *réserve* of that great museum; for that kindness and others he has my thanks. I am grateful to the staffs of several libraries—above all the Fogg, Houghton, and Widener at Harvard, the Eisenhower at Johns Hopkins, and the Bibliothèque Nationale—whose assistance over the years facilitated my labors. As I write these lines I am also conscious of how much I have profited from the conventions of intellectual exchange that so remarkably prevail at the Johns Hopkins University. To my colleagues and to the students in many departments who make those conventions work I wish to express my sense of indebtedness. Finally I want to thank William J. McClung, Marilyn Schwartz, and Susan Van der Poel of the University of California Press for their skillful and unflagging efforts on behalf of this book from start to finish.

A word about the place in this study of translations from the French. Because I devote a great deal of attention to what Diderot and his fellow art critics actually wrote, all quotations are given in French and are followed by the English translations. I have not tried to standardize the orthography of the quotations from eighteenth-century writers. Some passages have been modern-

ized by nineteenth- and twentieth-century editors, others are quoted as they originally appeared; I trust that the resulting inconsistency is not confusing. For their assistance in rendering the French into English I am grateful to Martine and David Bell, who did the bulk of the work, and to Elborg Forster, whom I consulted on a number of points. (The final responsibility for all translations is of course mine.) Titles of paintings discussed in the text are for the most part given in French. But some works are cited by their English titles, either for reasons of convenience or because, being in English or American collections, that is how they have come to be known.

Portions of this book have appeared in slightly different form in *New Literary History, Eighteenth-Century Studies, Studies on Voltaire and the Eighteenth Century,* and *The Art Bulletin;* I would like to thank the editors of those journals for permission to reincorporate them here.

The research for and writing of this book were made possible in large measure by fellowships from the American Council of Learned Societies and the John Simon Guggenheim Memorial Foundation. I am profoundly grateful to both for their generous support.

During the time this book has been in press, three exhibitions relevant to its subject have taken place. The first two consisted of drawings and watercolors by Hubert Robert (Washington, D.C., National Gallery of Art, November 1978–January 1979), and drawings by Fragonard in North American collections (Washington, D.C., National Gallery of Art; Cambridge, Mass., Fogg Art Museum; New York, Frick Collection, November 1978– June 1979); the third and largest surveyed the full range of Chardin's art (Paris, Grand Palais; Cleveland, Museum of Art; Boston, Museum of Fine Arts, January 1979–November 1979). All three exhibitions were accompanied by highly informative catalogues, the work of Victor Carlson, Eunice Williams, and Pierre Rosenberg respectively. No reference is made to those catalogues in the present study. But I have followed Rosenberg's suggestions as to the dating of three paintings by Chardin, *The Soap Bubble, The Game of Knucklebones,* and *The Card Castle,* which I treat in some detail; and my proposed dating of Fragonard's drawing, *La Lecture,* is based on Williams's account of his development. Had it been feasible, I would have made further use of Rosenberg's scrupulously argued discussions of chronology and related matters.

One final acknowledgment: to Rosalina de la Carrera for her painstaking reading of galleys.

Illustrations

Introduction

THIS BOOK puts forward an interpretation of the evolution of painting in France between the early and mid-1750s—the moment, roughly, of the advent of Vien and Greuze—and 1781, the year David's *Bélisaire* was exhibited at the Salon.[1] The past two decades have seen an enormous increase of art historical activity in the general area of the second half of the eighteenth century, and I am glad to acknowledge at the outset the very considerable extent to which in the present study I have made use of the findings of my predecessors. But I am also acutely aware that the ideas put forward in the pages that follow differ radically from those to be found in the previous literature on the subject (unless one counts as part of that literature the writings of critics contemporary with the art itself). Some sort of introduction therefore seems advisable, if only to assure the reader that I am conscious of that difference. In addition, I shall take the opportunity to make a few brief observations both about my procedures in this book and about some of the ramifications of the account presented in it. By doing this I do not expect to disarm criticism, an impossible ideal under any circumstances and one particularly out of place in a book that apprehends itself to be saying something new. Rather, I hope to remove grounds for misunderstanding, so that those who are driven to complain about what I have done will at least have an unobstructed view of their target. There are six points in all that I wish to make.

 1. The first point to be underscored is the obvious one that this study is exclusively concerned with developments in France. The point is worth underscoring because the emphasis in much recent scholarship has been on the international scope of developments in the arts in the second half of the eighteenth century. In fact the attainment of a truly international view of those

developments has been one of the triumphs of recent art history.[2] But triumphs have their cost, and the cost in this instance has been a willingness to minimize or ignore differences between national traditions. Specifically, I am convinced that there took place in French painting starting around the middle of the century a unique and very largely autonomous evolution; and it is the task of comprehending that evolution as nearly as possible in its own terms— of laying bare the issues crucially at stake in it—that is undertaken in the pages that follow. It should be noted, too, that the international emphasis to which I have alluded has gone hand in hand with a widespread interest in Neoclassicism, an international style or movement almost by definition,[3] and that one concomitant of the exclusively national emphasis of this study is that except very occasionally the topic of Neoclassicism does not arise. (I speak repeatedly of a reaction against the Rococo on the part of French painters and critics of the period, but I do so without equating that reaction with the advent of Neoclassicism, a far more nebulous event with which I am not concerned.) Finally, I do not mean by my assertion of the uniqueness and relative autonomy of the French developments analyzed in this study either to deny all influence of the painting of other countries on French painting after midcentury[4] or to imply that the developments in question bear no resemblance to any elsewhere.[5] But the particular concerns that are the focus of my investigation appear to have been indigenous to France. And I have chosen to forego comparisons with the art of other nations on the grounds that they would take us far afield and would further complicate an already difficult task of exposition and analysis.

2. It is a commonplace that the middle of the eighteenth century in France saw the invention of art criticism as we know it.[6] But I think it is fair to say that historians of art have made surprisingly little use as evidence of the large amount of writing about painting that has survived from the decades before 1781, even though the general level of the writing is respectable and a few of the critics rank among the finest pictorial intelligences of the age. (By use as evidence I mean something other than use as illustration, i.e., the quotation out of context of a few sentences to clinch a point that has already been made and is usually regarded as wholly obvious.)[7] The present study attempts to make up for that neglect. Thus commentaries by Diderot, La Font de Saint-Yenne, Grimm, Laugier, and perhaps a dozen others are allowed to direct our attention to features of the painting of their contemporaries which until now have simply never been perceived—or if such a statement seems extreme, have never since that period been construed to possess the particular significance which, on the strength of those commentaries, we are led to impute to them. At the same time it must be recognized—this point deserves special emphasis—that not just the painting but the criticism as well stands in need of interpretation. For that reason a large portion of this study is given over to close readings of critical and theoretical texts. (Chapter two, a discussion of the renewal of interest in the doctrines of the hierarchy of genres and

the supremacy of history painting, consists of nothing else.) Moreover, just as the criticism helps light the way to a new and improved understanding of the painting, so the painting is instrumental to our efforts to make improved sense of the criticism. By this I mean that it is only by coming to see the appropriateness to a given painting or group of paintings of certain verbal formulations, stylistic devices, and rhetorical strategies, including many that have never until now been taken seriously, that we are able to attribute to those formulations, devices, and strategies a truly critical significance. The result is a double process of interpretation by virtue of which paintings and critical texts are made to illuminate one another, to establish and refine each other's meanings, and to provide between them compelling evidence for the centrality to the pictorial enterprise in France during those years of a body of concerns whose very existence has not been imagined.

3. As my title implies, the writings of Denis Diderot play a major role in this study—a larger and more essential role than is played by the work of any single painter of the period. The first chapter is largely concerned with pictures exhibited at the Salons of 1753 and 1755, before Diderot turned his hand to art criticism. (His first *Salon* was composed in 1759 for Grimm's *Correspondance littéraire,* where seven of his eight subsequent *Salons* also appeared,[8] if one can speak of anything "appearing" in a private newsletter circulated in manuscript to a few royal houses outside France.)[9] Chapters two and three, however, as well as the last portion of chapter one, are mainly devoted to a sustained effort to see the painting of his age through his eyes. On the basis of that effort I am finally led to conclude, first, that there are in his *Salons* and affiliated texts two distinct but intimately related conceptions of the art of painting, epitomized by the art of Greuze and that of Joseph Vernet among his contemporaries; and second, that each of those conceptions involves a specific, paradoxical relationship between painting and beholder. My title further suggests that I regard the issue of the relationship between painting and beholder as a matter of vital importance. In fact it is the crux of the story I have to tell, and the essentialness of Diderot to my story may be summed up in the acknowledgment that that crux would remain merely speculative but for the evidence provided by his writings. It should also be noted that my reliance on Diderot has imposed certain limitations on the shape and focus of this study. For example, my decision to say very little about specific paintings of the 1770s reflects the fact that Diderot wrote only two comparatively mediocre *Salons* in the course of that decade.[10] But it is part of the claim that I make for the historical significance of Diderot's achievement as a critic that the issues which in his writings of the 1750s and 1760s are held to be central to the pictorial enterprise *actually were* central to the evolution of painting in France, and not just during those years but throughout the decades that followed. (I had better add that I do not pretend to be able to interpret in those terms more than a fraction of the paintings made and exhibited in the *Salons* during that period. My claims are modest as well as large.) And in the analysis of David's *Bélisaire*

that brings chapter three to a close, I examine in detail the workings of the Diderotian problematic of painting and beholder in what is arguably the single most important canvas by a French painter of the early 1780s.

4. The developments analyzed in this study constitute only the opening phase of a larger evolution the full extent of which I hope eventually to chart. Crucial figures in that evolution include David, Géricault, Courbet, and Manet, each of whom may be shown to have come to grips with one primitive condition of the art of painting—that its objects necessarily imply the presence before them of a beholder. Seen in this perspective, the evolution of painting in France between the start of the reaction against the Rococo and Manet's seminal masterpieces of the first half of the 1860s, traditionally discussed in terms of style and subject matter and presented as a sequence of ill-defined and disjunct epochs or movements—Neoclassicism, Romanticism, Realism, etc.—may be grasped as a single, self-renewing, in important respects dialectical undertaking. This is not to say that the traditional art historical categories of style and subject matter are irrelevant to our understanding of the paintings in question. It *is* to suggest that the stylistic and iconographic diversity that we associate with the history of French painting between David and Manet was guided, and in large measure determined, by certain ontological preoccupations which first emerged as crucial to painting in the period treated in this study. Obviously I cannot begin to summarize later developments in a brief introduction. But the centrality to those developments of issues involving the relationship between painting and beholder may perhaps be evoked by asking the reader who is familiar with the following works to reflect, after finishing this study, on the sense in which the choice of moment and other aspects of the composition of Géricault's *Raft of the Medusa* may be seen as motivated by the desire to escape the theatricalizing consequences of the beholder's presence; on the implications of Courbet's repeated attempts in his early self-portraits to transpose himself bodily into the painting; and on the significance of the alienating, distancing character of the chief female figure's frontal gaze in Manet's *Déjeuner sur l'herbe* and *Olympia*.[11]

5. Nowhere in the pages that follow is an effort made to connect the art and criticism under discussion with the social, economic, and political reality of the age. This requires comment. Historians of art have traditionally attempted to explain salient features of French painting in the second half of the eighteenth century in terms of the emergence of a sizable middle-class public to whose vulgar and inartistic tastes, it is alleged, much of that painting sought to appeal. As will become plain, I regard such attempts as misconceived; and my emphasis throughout this study on issues of an altogether different sort is intended at once to repudiate prevailing social interpretations of the subject and to dissolve various confusions to which those interpretations have given rise. It does not follow, however, that I believe that the evolution of French painting between the early 1750s and 1781 took place in a vacuum, isolated from society and uncontaminated by its stresses. Rather, I see the

constitutive importance conferred by my account on the relationship between painting and beholder as laying the groundwork for a new understanding of how the "internal" development of the art of painting and the wider social and cultural reality of France in the last decades of the Ancien Régime were implicated and so to speak intertwined with one another. I should also say that I am skeptical in advance of any attempt to represent that relationship and that development as essentially the products of social, economic, and political forces defined from the outset as fundamental in ways that the exigencies of painting are not. In addition, it must be borne in mind—I am assuming now that the claims put forward in the previous paragraph are correct—that especially starting with the advent of David, the vision of the painting-beholder relationship as I have described it in these pages actually proved amazingly fruitful for the pictorial enterprise in France as regards the artistic level or quality of the works it helped engender. Any thoroughgoing social-historical (e.g., Marxist) interpretation of that material will have to reckon with that fact.[12]

6. The last point I want to make is a somewhat delicate one. In several essays on recent abstract painting and sculpture published in the second half of the 1960s I argued that much seemingly difficult and advanced but actually ingratiating and mediocre work of those years sought to establish what I called a *theatrical* relation to the beholder, whereas the very best recent work—the paintings of Louis, Noland, Olitski, and Stella and the sculptures of Smith and Caro—were in essence *anti*-theatrical, which is to say that they treated the beholder as if he were not there.[13] I do not intend to rehearse those arguments in this introduction. But as my title once again makes clear, the concept of theatricality is crucial to my interpretation of French painting and criticism in the age of Diderot, and in general the reader who is familiar with my essays on abstract art will be struck by certain parallels between ideas developed in those essays and in this book. Here too I want to assure the reader that I am aware of those parallels, which have their justification in the fact that the issue of the relationship between painting (or sculpture) and beholder has remained a matter of vital if often submerged importance to the present day. Read in that spirit, this book may be understood to have something to say about the eighteenth-century beginnings of the tradition of making and seeing out of which has come the most ambitious and exalted art of our time.

CHAPTER ONE

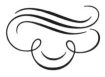

The Primacy of Absorption

MY PURPOSE in the first half of this chapter is to demonstrate the controlling importance, in some of the most significant French paintings of the early and mid-1750s, of a single configuration of concerns. That configuration of concerns, or master configuration as it deserves to be called, found expression in and through a wide but quite specific range of subjects whose connection with one another is often not apparent at first glance. Furthermore, as will be seen, a propensity to engage with those concerns (which involve far more than considerations of subject matter) forms an implicit bond between painters who traditionally have been regarded as disparate or unrelated; and in the case of at least one crucial figure, Greuze, we are enabled to grasp for the first time the integrity of his achievement. In these and other respects the pages that follow assert the coherence and what is more the seriousness of French painting in the first phase of the reaction against the Rococo—a body of work frequently characterized as lacking those qualities.

The method pursued is straightforward. I begin by looking at a well-known picture in the light of a passage of contemporary criticism in which it is described in some detail. I then consider other combinations of paintings-plus-commentaries all of which relate significantly to the first and to each other. The immediate object of this procedure is to bring into focus aspects of those paintings that appear to have been of fundamental importance to the artists and their critics but which modern scholarship has tended either to overlook or to interpret in quite other terms. Another virtue of this approach is that my choice of illustrations has the sanction of contemporary judgment. Without exception the principal works treated in the first half of this chapter are reviewed seriously—we might say they are featured—in one or more *Salons*

of the period, though naturally I do not hesitate to refer to other paintings which seem to me to relate closely to the former and which are mentioned cursorily or not at all by the critics.

In the second half of the chapter I try to place the state of affairs delineated in the first half in somewhat broader historical context. This involves glancing at earlier developments and briefly examining several paintings of the first half of the 1760s. Nevertheless, the main emphasis of this chapter is on works shown in the Salons of 1753 and 1755, exhibitions whose peculiar importance—and in the case of the Salon of 1753, whose relative brilliance—have gone largely unacknowledged by modern writers. I do not mean to imply that most of the paintings cited in these pages are masterpieces in the accepted sense of the term. Of the four painters I begin by discussing, only one, Chardin, is an artist of the first rank. The others are lesser figures. But the issues with which their works engage are central to the evolution of painting in France in the second half of the eighteenth century and beyond, and often the works themselves are more compelling than is usually granted.

One more point by way of preamble. The Salons of 1753 and 1755 antedate the emergence of the greatest critic of painting of the second half of the eighteenth century, Denis Diderot. Although I have occasion to quote his criticism in connection with works of the 1760s, most of the critical quotations that follow are from the writings of his immediate predecessors. But in essential respects, which will become clear as we proceed, the first half of this chapter is intended as a contribution to our understanding of the sources of his vision of painting.

❦

The first painting I want to consider is Jean-Baptiste Greuze's *Un Père de famille qui lit la Bible à ses enfants* (Fig. 1). Greuze (1725–1805) has long been regarded as the most important French painter of his generation, though historians from the Goncourts down to the present have almost unanimously defined his importance in sociological not artistic terms.[1] Born in Tournus, he studied in Lyon before arriving in Paris in the early 1750s. Shortly thereafter he was made *agréé* at the Académie Royale, and in the Salon of 1755 exhibited six canvases, among which was the *Père de famille*.[2] A leading scholar has called Greuze's debut "probably the most brilliant . . . of the century."[3] At all events, it marked the beginning of his fame, which reached prodigious heights in the 1760s, continued more or less unabated through the 1770s, and went into decline only in the 1780s with the maturing of David's generation of history painters. The *Père de famille* in particular caused a sensation, and was discussed at length by several critics. By far the fullest and most informative commentary it received is that of the Abbé de La Porte:

Un père de famille lit la Bible à ses enfans; touché de ce qu'il vient d'y voir, il est lui-même pénétré de la morale qu'il leur fait: ses yeux sont presque mouillés de

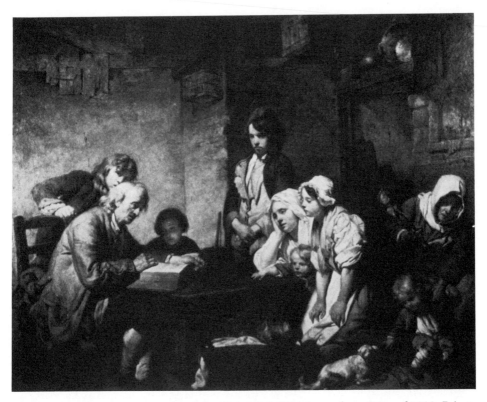

1 Jean-Baptiste Greuze, *Un Père de famille qui lit la Bible à ses enfants,* Salon of 1755. Private Collection.

larmes; son épouse assez belle femme & dont la beauté n'est point idéale, mais telle que nous la pouvons rencontrer chez les gens de sa sorte, l'écoute avec cet air de tranquillité que goûte une honnête femme au milieu d'une famille nombreuse qui fait toute son occupation, ses plaisirs, & sa gloire. Sa fille à côté d'elle est stupéfaite & navrée de ce qu'elle entend; le grand frère a une expression aussi singuliere que vraie. Le petit bonhomme qui fait un effort pour attraper sur la table un bâton, & qui n'a aucune attention pour des choses qu'il ne peut comprendre, est tout-à-fait dans la nature; voyez-vous qu'il ne distrait personne, on est trop sérieusement occupé? Quelle noblesse! & quel sentiment dans cette bonne maman qui, sans sortir de l'attention qu'elle a pour ce qu'elle entend, retient machinalement le petit espiégle qui fait gronder le chien: n'entendez-vous pas comme il l'agace, en lui montrant les cornes? Quel Peintre! Quel Compositeur![4]

A father is reading the Bible to his children. Moved by what he has just read, he is himself imbued with the moral he is imparting to them; his eyes are almost moist with tears. His wife, a rather beautiful woman whose beauty is not ideal but of a kind that can be encountered in people of her condition, is listening to him with that air of tranquility enjoyed by an honest woman surrounded by a large family that constitutes her sole occupation, her pleasures, and her glory. Next to her, her daughter is astounded and grieved by what she hears. The older brother's facial expression is as singular as it is true. The little boy, who is making an effort to grab a stick on the table and who is paying no attention whatsoever to things that he cannot understand, is perfectly true to life. Do you not see how he does not distract anyone, everyone being too seriously occupied? What nobility and what feeling in this grandmother

[9]

who, without turning her attention from what she hears, mechanically restrains the little rogue who is making the dog growl! Can you not hear how he is teasing it by making horns at it? What a painter! What a composer!

This is a fascinating description. Historians who have written about the *Père de famille,* or about Greuze's multifigure genre paintings as a group, have emphasized his preoccupation with subjects of rural piety, familial sentiment, and domestic virtue, and have remarked his presentation of those subjects in a narrative-dramatic mode whose ostensible verism of physiognomy, costume, and milieu is accompanied by a psychological and emotional extremism almost without precedent in French painting. Few of those historians have concealed either their discomfort with the paintings themselves or their disapproval of the audience who went into raptures before them. Greuze's pictures, it has repeatedly been claimed, appealed to the crass and inartistic tastes of a large middle-class public just then emerging as a major force in French cultural life; to that public's preference for "literary" over "pictorial" qualities and values; to its craving for works that told a story, pointed a moral, and assaulted the tenderest emotions of the viewer.[5] On first reading, La Porte's description of the *Père de famille* may seem merely to bear this out.

Certainly there is nothing in his text that suggests that these sorts of considerations did not have their part in the painting's success. But La Porte's commentary makes clear that what he himself found most compelling about the *Père de famille* was what he saw as its persuasive representation of a particular state or condition, which each figure in the painting appeared to exemplify in his or her own way, i.e., the state or condition of rapt attention, of being completely occupied or engrossed or (as I prefer to say) absorbed in what he or she is doing, hearing, thinking, feeling. From this point of view the father's activity of reading the Bible aloud and the family's more nearly passive occupation of listening to him read may be characterized as essentially *absorptive* in nature. And the mastery of expression which the critics of the time found in the *Père de famille* may be seen to have consisted not simply in the "realistic" depiction of individual psychological and emotional responses to the biblical text, which is how contemporary praise of Greuze's expressive powers is invariably understood, but also, and in my judgment more importantly, in the persuasiveness with which the responses made themselves felt as those of persons *wholly absorbed* in the reading itself and the thoughts and feelings it engendered.[6]

Two of La Porte's observations deserve emphasis. First, he calls attention to the implicit contrast between the perfect absorption of the older figures and potentially disruptive activities of the two youngest children. He remarks of the young boy reaching for the stick: "Voyez-vous qu'il ne distrait personne, on est trop sérieusement occupé?" and describes the way in which the child in the right foreground teases the dog. Similarly, another critic, Baillet de Saint-Julien, observes of the older girl and boy: "L'attention de ces deux

figures forme un contraste naturel avec un enfant qui cherche à jouer avec un chien" (the attention of these two figures forms a natural contrast with a child who is trying to play with a dog).[7] For both La Porte and Baillet de Saint-Julien, the actions of the two children, conveying as they do complete indifference to the Bible reading, serve to heighten the beholder's awareness of—to make more perspicuous—the intense absorption of the other figures.

Second, La Porte singles out for special praise the action of the grandmother who "sans sortir de l'attention qu'elle a pour ce qu'elle entend, retient machinalement le petit espiégle qui fait gronder le chien. . . ." That is, he admires what he sees as Greuze's depiction of the old woman restraining the child automatically, as if unconscious of what she is doing. Here too La Porte seems to feel that the almost somnambulistic character of her action underscores the intensity of her absorption in thoughts and feelings stirred by the reading.

It is a commonplace of studies of mid-eighteenth-century art that Greuze's genre paintings are compared and contrasted, much to his disadvantage, with those of the foremost painter of genre subjects of an earlier generation, Jean-Baptiste-Siméon Chardin (1699–1779). The trouble with such comparisons is not that those who make them assert Chardin's superiority—no one doubts that he was the greatest French painter of his time—but that they accept from the outset the pejorative interpretation of Greuze's art summarized above and so fail to understand the true significance of the differences they note. Further discussion of the meaning of those differences must be deferred until later in this chapter. But something of the closeness of the relationship between Chardin's and Greuze's achievements is suggested by another combination of painting and critical commentary, Chardin's *Un Philosophe occupé de sa lecture* (Fig. 2) as seen by the Abbé Laugier. Chardin's canvas was exhibited in the Salon of 1753;[8] Laugier's commentary is taken from his account of that Salon, a small volume that ranks as one of the two or three finest pieces of sustained criticism before Diderot:

Ce caractére [the philosopher] est rendu avec beaucoup de vérité. On voit un homme en habit & en bonnet fourré appuyé sur une table, & lisant très-attentivement un gros volume relié en parchemin. Le Peintre lui a donné un air d'esprit, de rêverie & de négligence qui plaît infiniment. C'est un Lecteur vraiment Philosophe qui ne se contente point de lire, qui médite & approfondit, & qui paroît si bien absorbé dans sa méditation qu'il semble qu'on auroit peine à le distraire.[9]

This character is rendered with much truth. A man wearing a robe and a fur-lined cap is seen leaning on a table and reading very attentively a large volume bound in parchment. The painter has given him an air of intelligence, reverie, and obliviousness that is infinitely pleasing. This is a truly philosophical reader who is not content merely to read, but who meditates and ponders, and who appears so deeply absorbed in his meditation that it seems one would have a hard time distracting him.

Like La Porte's remarks on the *Père de famille*, Laugier's description of Chardin's *Philosophe occupé de sa lecture* praises most of all its persuasive representa-

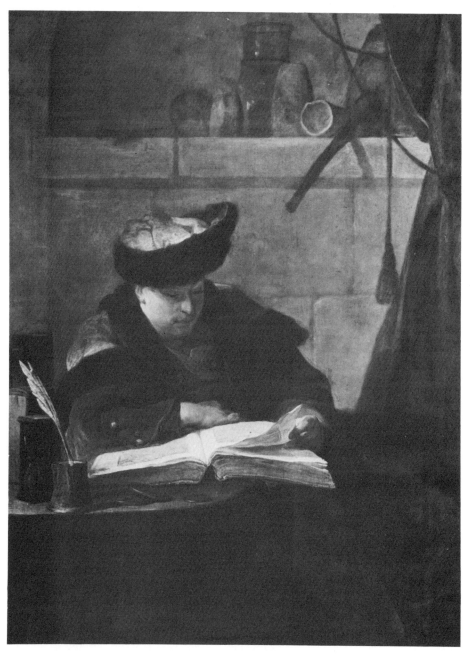

2 Jean-Baptiste-Siméon Chardin, *Un Philosophe occupé de sa lecture*, Salon of 1753. Paris, Louvre.

tion of intense absorption in reading and meditation—in this instance the silent reading and meditation of a single figure alone in his study who evinces no emotion. (In the words of another critic, Huquier: "Il y a dans la tête du philosophe une attention autant bien exprimée qu'il est possible. . . ." [There is in the head of the philosopher a quality of attention expressed as well as possible. . . .])[10] Laugier refers specifically to the philosopher's air of *négligence,* which I understand in the sense of *oubli de soi* or self-forgetting, an obliviousness to his appearance and surroundings consequent upon and expressive of his absorption in his book. And Laugier refers too to the philosopher's air of *rêverie,* a condition that plays an increasingly important role in French painting and criticism in the decades that follow.

Even more striking in the light of La Porte's commentary on the *Père de famille* is Laugier's statement that Chardin's philosopher appears so deeply absorbed in his meditation "qu'il semble qu'on auroit peine à le distraire." For it is precisely this idea that La Porte and Baillet de Saint-Julien find dramatized two years later in Greuze's canvas, in the actions of the youngest children whose failure to distract their elders proves the depth of the latter's absorption. I do not suggest that Greuze was influenced by Laugier's text. We may be sure, however, that he was familiar with Chardin's painting if only from engravings; and Laugier's remarks show beyond a doubt that the persuasive representation of absorption was an issue, or positive desideratum, at least two years before Greuze exhibited the *Père de famille,* and that related themes of attention, obliviousness, and resistance to distraction were in the air as well.

Here it is instructive to consider the Abbé Garrigues de Froment's commentary on another work by Chardin exhibited in the Salon of 1753,[11] *Un Dessinateur d'après le Mercure de M. Pigalle* (Fig. 3). The painting, a repetition of one originally shown in the Salon of 1748, depicts a seated draughtsman drawing from a cast of Pigalle's statue of Mercury while another draughtsman standing immediately behind him watches him work. The relevant passage reads:

Comment peut-on ne pas être vivement affecté de la verité, de la naïveté des tableaux de M. Chardin? Ses figures, dit-on, n'ont jamais d'esprit: à la bonne heure; elles ne sont pas gracieuses: à la bonne heure; mais en revanche n'ont-elles pas toutes leur action? N'y sont-elles pas toutes entières? Prenons par exemple la répétition qu'il a exposée de son dessinateur: on prétend que les têtes en sont louches et peu décidées. A travers cette indécision perce pourtant l'attention de l'une et l'autre figure: on doit, ce me semble, devenir attentif avec elles.[12]

How can one not be strongly moved by the truth, by the naiveté of M. Chardin's paintings? His figures are said not to be clever people—fine. They are not graceful—fine. But on the other hand, do they not all have their own action? Are they not completely caught up in it? Take for example the replica of his draughtsman that he has exhibited: people maintain that the heads are vague and lack precision. And yet, through this lack of precision, the attention of both figures is apparent; one must, it seems to me, become attentive with them.

[13]

The two representations of *Un Dessinateur d'après le Mercure de M. Pigalle* are not the only representations of draughtsmen in Chardin's oeuvre. Several versions of *Le Dessinateur,* in which a single figure seated on the floor is portrayed from the rear, were painted ca. 1738; Chardin twice repeated the composition around 1757–1758; and one of the latter panels was exhibited with success in the Salon of 1759 (Fig. 4).[13] The description of that work by the anonymous critic for the *Journal Encyclopédique* is relevant to the present discussion even if it cannot be used as evidence for the terms in which Chardin's art was seen several years earlier:

[The painting] représente un jeune homme occupé à copier un dessein. . . . On ne voit que le dos du jeune Dessinateur. L'Auteur, malgré cela, a si bien saisi la vérité & la nature de la situation du jeune homme, qu'il est impossible de ne pas sentir à la première inspection du tableau, que ce Dessinateur met à ce qu'il fait la plus grande attention.[14]

[The painting] represents a young man engaged in copying a drawing. . . . One sees only the young draughtsman's back. In spite of this, the author has captured so well the truth and the nature of the young man's situation that it is impossible not to feel, on first viewing the painting, that this draughtsman pays the greatest attention to what he is doing.

3 After Jean-Baptiste-Siméon Chardin, *Un Dessinateur d'après le Mercure de M. Pigalle,* Salon of 1753, engraved by Le Bas. Whereabouts of painting unknown.

Both critics praise Chardin's paintings for being true to nature. But the nature each evokes is that of human beings wholly engaged in quintessentially absorptive activities, and altogether the primacy of considerations of absorption in each passage could not be more explicit.

A third painting exhibited by Chardin in the Salon of 1753[15] that anticipated the *Père de famille* in important respects is *Une Jeune Fille qui récite son Evangile* (Fig. 5), the latest in a series of scenes of domestic instruction going back to the early 1730s. The *Jeune Fille* is described by Laugier as follows:

[O]n voit une jeune Fille les yeux baissés dont la mémoire travaille, & qui récite devant sa mère. Celle-ci est assise, & écoute de cet air un peu pédant que l'on a en faisant répéter une leçon. Ces deux expressions sont d'un naïf charmant.[16]

One sees a young girl with her eyes lowered whose memory is at work, and who is reciting in front of her mother. The latter is seated, and listens with the rather pedantic air that one has when making someone repeat a lesson. These two expressions are charmingly naive.

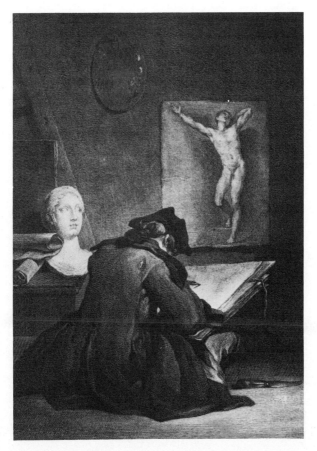

4 After Jean-Baptiste-Siméon Chardin, *Le Dessinateur*, Salon of 1759, engraved by Flipart. Whereabouts of painting unknown.

The Abbé Le Blanc in his account of the Salon of 1753 writes:

[Chardin] a l'art de saisir ce qui échapperoit à tout autre: il y a dans ce Tableau, qui n'est que de deux figures, un feu & une action qui étonnent; il y a tant d'expression dans la tête de la jeune fille, qu'on croit presque l'entendre parler: on lit sur son visage le chagrin intérieur qu'elle éprouve de ce qu'elle ne sçait pas bien sa leçon.[17]

[Chardin] has the art of capturing what would escape anyone else. There is in this painting, which contains only two figures, an ardor and an action that are astonishing. There is so much expression in the young girl's head that one almost believes one hears her speak. On her face can be read the inner distress that she feels at not knowing her lesson well.

No mention is made in these passages of absorption or attention. But both concepts are implicit in Laugier's description of the young girl, eyes lowered, straining to recall her lesson, and of the mother listening to her and as it were comparing her recitation with the original; while the essential inwardness of the girl's condition is further emphasized by Le Blanc's reference to her *chagrin intérieur* at finding that her memory of the lesson is imperfect.

These are just a few of the connections that can be drawn between specific works by Chardin and Greuze. One other example might be cited. The theme of an effort of memory is found in singularly concentrated form in Greuze's fine, restrained *Un Ecolier qui étudie sa leçon* (Fig. 6), a painting exhibited in the

5 After Jean-Baptiste-Siméon Chardin, *Une Jeune Fille qui récite son Evangile,* Salon of 1753, engraved by Le Bas. Whereabouts of painting unknown.

6 Jean-Baptiste Greuze, *Un Ecolier qui étudie sa leçon,* Salon of 1757. Edinburgh, National Gallery of Scotland.

Salon of 1757[18] whose filiation to the *Philosophe occupé de sa lecture* is at once apparent. The student in Greuze's picture has partly covered with his hands the page of his book and seems inwardly to rehearse its contents; his downward gaze conveys an impression of unseeing abstraction; and although the *salonniers* of the year do not discuss the *Ecolier* in detail, we may surmise that its authority as an image of absorption was incontestable.[19]

At this juncture I want to introduce a third figure, not usually seen in relation to Greuze or Chardin—Carle Van Loo (1705–1765). In his lifetime Van Loo was widely regarded as the greatest French painter of his day. In the 1780s and 1790s, however, his reputation plummeted, and only very recently has it begun to recover. As regards the artistic level of much of his oeuvre, this is only somewhat unjust. But it has meant that his work has received little scholarly attention, and that almost no effort has been made to understand what his contemporaries saw in his art.[20] In the next several pages I shall make selective use of the rather large body of criticism of Van Loo's paintings of the early and mid-1750s to demonstrate that he too was admired for the persua-

[17]

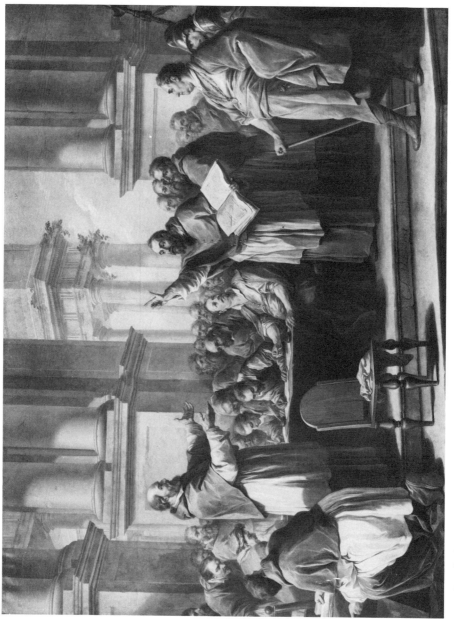

7 Carle Van Loo, *St. Augustin disputant contre les Donatistes*, Salon of 1753. Paris, Notre-Dame-des-Victoires.

siveness of his representations of absorptive states and activities, and that the preoccupation with absorption that I have begun to delineate was not confined to genre paintings but was central as well to works that were then regarded as among the most ambitious of the age.

This becomes clear if we consider Van Loo's *St. Augustin disputant contre les Donatistes* (Fig. 7), the sensation of the Salon of 1753[21] and one of six large-scale history paintings based on events in the life of Augustine executed by the artist between 1748 and 1755.[22] Its subject is the momentous debate of A.D. 411 in which the Catholic party led by Augustine refuted once and for all the claims of the Donatist bishops. The debate took place in Carthage, in the great hall of a Roman bath, before the Tribune Flavius Marcellinus (the official arbiter) and in the presence of hundreds of bishops of both persuasions. Augustine, holding an open book, is depicted speaking, to the apparent consternation of the Donatist champion. In the right foreground, standing apart from the assembled bishops, Marcellinus watches and listens. Toward the middle of the canvas, seated at a table, are several secretaries charged with transcribing the proceedings, one of whom has broken off writing and instead gazes at the saint. Catholic and Donatist bishops bend over the secretaries' shoulders to ensure that what is said is accurately recorded.[23]

For Van Loo's contemporaries the greatness of the painting consisted essentially in what they regarded as its masterful evocation of Augustine's eloquence, his all but irresistible power to compel belief in the souls of those who saw and heard him. In Laugier's words:

Saint Augustin paroît avec cette noble confiance qu'inspire la vérité. Il parle avec force, mais sans emportement. Son visage plein de phisionomie est également spirituel & ingénu. On y remarque des traits d'une modeste gravité et d'une sagesse imposante. On voit que c'est un Sçavant & un Saint. Son attitude, son geste, tous ses mouvemens se ressentent d'un homme qui connoît la bonté de sa cause, qui poursuit son adversaire par la seule voye de la conviction, sans lui opposer ni dureté ni mépris.[24]

St. Augustine appears with the noble confidence that truth inspires. He speaks forcefully but without being carried away. His face, full of character, is at the same time spiritual and ingenuous. One distinguishes in it traits of modest gravity and imposing wisdom. One sees that he is a scholar and a saint. His stance, his gesture, all his movements reveal a man who knows the goodness of his cause, who pursues his adversary by the sole means of conviction, opposing him with neither harshness nor contempt.

Even more crucial than Van Loo's representation of Augustine's facial expression or bodily gestures, however, was his depiction of the effects of the saint's discourse on his audience. Le Blanc observes: "L'attention la plus forte est si heureusement rendue dans les yeux de la plûpart de ceux qui l'écoutent, & spécialement dans ceux du Secrétaire de la Conférence [i.e., the one who has stopped writing], qu'on ne peut s'empêcher de chercher à y deviner les réflexions dont leur esprit paroît occupé" (The strongest attention is so successfully

rendered in the eyes of most of those listening to him, and especially in those of the secretary [i.e., the one who has stopped writing], that one cannot help trying to guess the thoughts with which their minds appear occupied).[25] The secretaries attracted the notice of other critics as well. Laugier for example describes them as follows:

Dans le milieu & sur une estrade élevée, est un grand Bureau couvert d'un tapis. Autour sont assis les Notaires respectifs, la plume à la main & le papier devant eux, paroissant occupés de leur écriture. Celui qui est à leur tête, assis comme eux la plume à la main, & ayant devant lui le papier, se détourne pour écouter. Il semble craindre de ne pas saisir les choses avec assez d'exactitude.[26]

In the middle and on a raised platform, there is a large desk covered with a cloth. Around it are seated the respective secretaries, pen in hand and with paper in front of them, appearing absorbed in their writing. The one at the head of the table, seated like them with pen in hand and paper in front of him, turns from his work in order to listen. He seems to fear that he will not grasp what is said with sufficient accuracy.

Another critic, Lacombe, praises Van Loo's decision "d'avoir fait quitter à un Scribe son ouvrage, pour lui porter son attention du côté où la raison & la vérité sont triomphantes" (to have had a scribe abandon his work in order to direct his attention to where reason and truth are triumphant).[27] While Melchior Grimm, writing in the *Correspondance littéraire,* remarks the contrast between the two secretaries "qui écrivent dans la même attitude, et dont l'un surtout a les oreilles au guet en écrivant avec une grande application," and the third secretary who "au lieu d'écrire, fixe le saint, et le regarde, comme saisi par la force de son éloquence" (who are writing in the same posture, one of whom in particular is keeping his ears open while writing with great application, [and the third secretary who] instead of writing, stares at the saint and gazes at him as if gripped by the force of his eloquence).[28]

Clearly, the group of secretaries was instrumental to the impact Van Loo's painting made on contemporary viewers. As seen by the critics, the first two secretaries are engrossed in their professional responsibilities, a state of mind incompatible with pondering the meaning of specific utterances and certainly with becoming transfixed by the discourse of either speaker. Thus Laugier observes that "les Notaires fortement appliqués à leur travail, ont pour tout le reste l'indifférence convenable à gens qui ne font que prêter leur ministère" (the secretaries, earnestly applying themselves to their work, show toward everything else the indifference characteristic of people who only lend their services).[29] But Augustine's eloquence is such that the third secretary has found it impossible to remain unmoved; his absorption in his professional task has been suspended by his deeper, more intense absorption in Augustine's argument; so that seemingly without being aware of what he is doing, he has stopped writing and has turned toward the saint in admiration. (Another instance of the use of involuntary, automatic, or unconscious action as a sign of intense absorption is noted by Laugier. After describing the Donatist champion and contrasting his physiognomy with Augustine's, Laugier says: "A côté

[20]

de lui, un Evêque de son parti se courbe pour chercher avec précipitation des arguments dans un livre, & se détourne involontairement vers saint Augustin, dont l'éloquence l'étonne" [Next to him, a bishop of the same party bends over a book to search hastily for arguments, and involuntarily turns toward St. Augustine, whose eloquence astonishes him].)[30]

In an obvious sense, *St. Augustin disputant contre les Donatistes* comprises a much wider range of expression than the other paintings so far discussed. Laugier writes that the bishops of Augustine's party "ont en l'écoutant cette douce tranquillité que donne l'assurance de la victoire. Ceux qui examine [*sic*] le travail des Notaires le font sans l'inquiétude" (display, while listening to him, that sweet tranquility given by the certainty of victory. Those who examine the secretaries' work do so without worry).[31] The Donatist bishops on the other hand "ont une sorte de crainte qui présage leur défaite; ceux-mêmes qui examinent le travail des Notaires, le font d'un air un peu déconcerté" (show the kind of fear that presages their defeat; those who examine the secretaries' work do so with a rather disconcerted air).[32] Finally, Marcellinus "regarde saint Augustin d'un oeil assuré. Il donne à son discours l'attention d'un Arbitre Impartial. On croit voir cependant qu'il a du plaisir à trouver dans ses raisonnements, une supériorité qui garantit le triomphe de la bonne cause" (gazes at St. Augustine with a confident expression. He gives to the saint's discourse the attention of an impartial arbiter. One has the impression, however, that he takes pleasure in finding in the saint's arguments a superiority that guarantees the triumph of the good cause).[33] It is striking, however, that the variety of expression Laugier describes involves the participation of individual figures and groups of figures in a few characteristically absorptive activities (e.g., listening, reading, writing, judging), on the persuasiveness of Van Loo's representation of which the painting's persuasiveness as expression ultimately depends. Indeed both for Laugier and, it appears, for Van Loo himself, the multiplicity, variety, and particularity of the individual responses to the central fact of Augustine's eloquence—qualities most English painters of the period would have tended to emphasize[34]—are far less important than the common grounding of those responses in the single fundamental condition I have called absorption. Hence in part the curious *mise-en-scène* of the painting as a whole, which for example confers unusual significance on the activities of the secretaries, and gives disquieting prominence to the attentive but otherwise inexpressive figure of Marcellinus. To quote Laugier once more: "Tout consiste à bien opposer le zele & la supériorité de raison du Défenseur de la vérité, à la mauvaise foi & à l'esprit de chicane de son adversaire, & à faire ensorte que tous ceux présens paroissent attentifs & occupés relativement à l'intérêt que chacun prend à la dispute" (Everything consists in successfully opposing the zeal and superior reasoning of the defender of truth to the insincerity and chicanery of his adversary, and in seeing to it that all those present appear attentive and engaged according to the interest each takes in the dispute).[35]

This is not to say that in Van Loo's picture or Laugier's commentary con-

siderations of absorption simply displace or override considerations of expression. My point is rather that in French painting and criticism of the early and mid-1750s the latter are largely assimilated to the former, so much so that a distinction between them can hardly be said to exist. Thus Chardin is praised repeatedly for his expressive powers, and a painting as hushed, reposeful, and emotionally neutral as *Une Jeune Fille qui récite son Evangile* is characterized by Le Blanc as possessing "un feu & une action qui étonnent." More generally, the demand that painting maximize expression, one of the basic tenets of anti-Rococo criticism and a keynote of Laugier's account of the Salon of 1753,[36] finds satisfaction primarily in and through the representation of absorptive states and activities; and analyses of the variety of expression in particular works, such as Laugier's remarks on *St. Augustin disputant contre les Donatistes* quoted above, characteristically proceed by distinguishing inflections and modulations of absorption more than anything else.

The assimilation of expression to absorption during the period is made all but explicit in Baillet de Saint-Julien's description of Van Loo's *St. Augustin prêchant devant Valère, Evêque d'Hippone* (Fig. 8), one of (the final) two scenes from the life of the saint exhibited in the Salon of 1755:[37]

[L]e Prédicateur qui a l'auditoire le plus brillant & les gestes les plus expressifs ne produit pas un spectacle aussi intéressant que le tableau dont je veux vous parler. Dans ce Tableau l'éclat des figures n'est pas emprunté de la richesse des vêtemens ni de la pompe des dignités; leur beauté intéressante réside principalement dans l'expression des têtes. Les diverses passions que l'éloquence inspire animent les personnages de cette scène évangelique. L'Orateur paroît profondément pénétré de la grandeur des vérités immortelles. Il semble chercher dans les yeux de ses auditeurs ce qui peut accomplir la persuasion. On s'apperçoit qu'ils sont déja ébranlés. Chacun en particulier est affecté selon son caractere. Le Prélat qui écoute laisse voir une admiration réfléchie. Les Prêtres qui sont à ses côtés paroissent attendris en même tems qu'éclairés. Le peuple est seulement ému. Il témoigne la plus grande sensibilité. Il n'y a dans ce grand Tableau qu'un seul enfant qui ne prenne pas un intérêt vif au sujet. Il sourit à quelque objet qui l'occupe. Distraction qui caractérise son age.[38]

The preacher who has the most brilliant audience and the most expressive gestures does not produce a spectacle as interesting as the painting about which I wish to speak. In this painting the distinction of the figures is derived neither from the richness of their dress nor from the pomp of their high rank; their interesting beauty resides principally in their facial expressions. The various passions inspired by eloquence animate the personages of this evangelical scene. The orator appears deeply moved by the greatness of immortal truths. He seems to be seeking in the eyes of his listeners the means fully to persuade them of those truths. One can see that they are already shaken. Each is affected according to his character. The prelate who is listening displays a thoughtful admiration. The priests next to him appear touched as well as enlightened. The crowd is simply moved and shows the greatest sensibility. In this great painting, only one child is not keenly interested in the proceedings. He is smiling at something that occupies him. Distraction characteristic of his age.

Several points are worth noting. Augustine himself is described not only as *profondément pénétré* by the eternal truths of his religion but as engaged in the

[22]

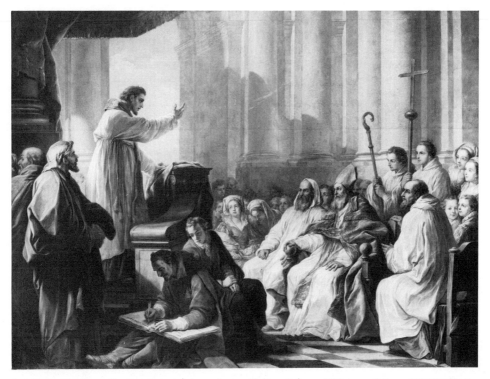

8 Carle Van Loo, *St. Augustin prêchant devant Valère, Evêque d'Hippone,* Salon of 1755. Paris, Notre-Dame-des-Victoires.

absorptive activity of seeking in the eyes of his listeners the means by which to persuade them of those truths. Moreover, although Baillet de Saint-Julien states at the outset that Van Loo's painting represents diverse passions, the actual distinctions he makes between the respective responses of bishop, priests, and ordinary people to Augustine's eloquence typify the manner in which concern with modulations of absorption does the work of the analysis of the passions in French criticism of the time. The reference to the small child who alone in the audience is unconcerned with Augustine's sermon and instead smiles at something that occupies him recalls La Porte's description of the boy reaching for the stick "qui n'a aucune attention pour des choses qu'il ne peut comprendre" in Greuze's *Père de famille.* In Van Loo's painting, too, the behavior of the child—his distraction, to use Baillet de Saint-Julien's word—throws into relief the intense absorption of everyone else. Baillet de Saint-Julien does not mention the secretary who transcribes Augustine's words or the youth who reads over his shoulder. But the evident care lavished upon those figures, and their placement in the extreme foreground, further emphasize the primacy of absorption in the painting as a whole.[39]

Baillet de Saint-Julien's commentary on Van Loo's second Augustine picture of 1755,[40] *St. Augustin baptisé à l'âge de 30 ans, avec son fils & Alipe son ami* (Fig. 9), is also pertinent:

La vérité d'expression est si bien entendue dans Monsieur Vanloo que voulant repré-

[23]

senter S. Augustin qui administre le Sacrement de Baptême à des jeunes gens [*sic*], il a pensé que les Prêtres qui accompagnoient le saint Evêque ne devoient porter aucune attention à cette cérémonie Religieuse. Ils sont sensés en avoir été trop souvent les temoins pour ressentir quelque curiosité à cet égard. Mais les Laïques que la parenté, l'amitié ou le hazard y amenent doivent être profondement occupés du Mystère de Rédemption qui s'opère en leur présence. Aussi l'admiration, le respect & la joye sont les passions qu'ils éprouvent. Il y a encore dans ce Tableau un humble cathecumene qui attend son tour pour être baptisé & qu'on peut comparer à un écolier qui craint de se présenter devant un Précepteur qu'il a offensé.[41]

Truth of expression is so well understood by M. Van Loo that, wishing to represent St. Augustine administering the sacrament of baptism to some young people [*sic*], he thought that the priests accompanying the saintly bishop should not pay any attention to this religious ceremony. They are conceived as having witnessed it too often to feel any curiosity concerning it. But the laymen brought there by kinship, friendship, or chance must be profoundly absorbed in the mystery of redemption being performed in their presence. Thus admiration, respect, and joy are passions that they experience. There is also in this painting a humble catechumen awaiting his turn to be baptized and who might be compared to a schoolboy afraid to appear before a teacher whom he has offended.

The critic cites as primary evidence of Van Loo's mastery of expression the contrast between the inattention of the priests and the absorption of the laymen in the ceremony taking place before them. The depiction of specific passions or emotions is mentioned almost as an afterthought.

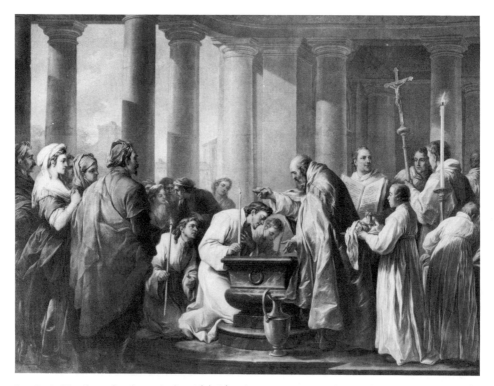

9 Carle Van Loo, *St. Augustin baptisé à l'âge de 30 ans avec son fils & Alipe son ami*, Salon of 1755. Paris, Notre-Dame-des-Victoires.

Another religious painting by Carle Van Loo exhibited in the Salon of 1753,[42] *St. Charles Borromée prêt à porter le Viatique aux malades* (Fig. 10), was widely admired for its persuasive representation of the saint's absorption in prayer.[43] But rather than pursue this point I want to consider another, seemingly quite different work of these years. Around 1754 Van Loo painted for Mme. Geoffrin two pictures of matching dimensions, each of which included among its dramatis personae a male figure in what was considered by the painter and his audience to be Spanish dress, *La Conversation espagnole* and *La Lecture espagnole* (Fig. 11). The first was shown to the public in the Salon of 1755,[44] the second not until that of 1761.[45] Both were famous in their time.

10 Carle Van Loo, *St. Charles Borromée prêt à porter le Viatique aux malades,* Salon of 1753. Formerly Paris, Saint-Merri.

And both exemplify Van Loo's ability to infuse the *sujets galants* that remained popular in the *Encyclopédiste* society in which he moved with a seriousness of purpose appropriate to that society, if nearly invisible to modern taste. For the sake of economy I shall discuss only *La Lecture espagnole*. The commentary that follows is by the anonymous critic for the *Journal Encyclopédique* on the occasion of the painting's exhibition in the Salon of 1761:

[25]

11 Carle Van Loo, *La Lecture espagnole,* Salon of 1761. Leningrad, Hermitage.

Mr Carle Vanloo nous ouvre un jardin ou l'on voit *une famille occupée d'une lecture*. Un jeune homme vêtu à l'Espagnole lit une brochure qu'à sa vive attention & à celle de l'assemblée, on reconnoît pour quelque Roman ou il s'agit d'amour. Deux jeunes personnes l'écoutent avec un plaisir que tout peint en elles. La mère [actually their governess] qui est de l'autre coté du Lecteur, & derrière lui, suspend son ouvrage pour écouter aussi. Mais son attention est toute differente de celle de ses filles; on y lit les reflexions qu'elle fait, et le melange du plaisir que lui donne le livre, & de la crainte qu'elle a peut-etre de la dangereuse impression qu'il peut faire sur de jeunes coeurs. Pendant ce tems, une enfant à qui tout cela est indifferent, joue avec un oiseau qu'elle a attaché par la patte avec un fil, & s'amuse à le voir voler. La beauté du plan, l'elegance du dessein, la varieté & la vivacité de l'expression, et l'espece de magie des couleurs qui regnent dans tout cet ouvrage, le rendent infiniment precieux.[46]

M. Carle Van Loo opens before us a garden in which we see *a family engaged in a reading*. A young man dressed in Spanish costume is reading aloud from a small book, which, on the evidence of his keen attention and that of the company, can be recognized as a novel dealing with love. Two young girls listen to him with a pleasure expressed by everything about them. Their mother [actually their governess], who is on the other side of the reader and behind him, suspends her needlework in order to listen also. But her attention is altogether different from that of the girls; one reads in it the thoughts that she is having, and the mixture of the pleasure given to her by the book and the fear she perhaps entertains of the dangerous impression that that book might make on young hearts. Meanwhile, a young child to whom all this means nothing plays with a bird. She has tied a long string to its leg and is amusing herself watching it fly. The beauty of the arrangement, the elegance of the drawing, the variety and vivacity of expression, and the kind of color-magic that prevail in this work make it infinitely precious.

Even without the sanction of these remarks, the primacy of considerations of absorption in *La Lecture espagnole* would be evident. The young man reading aloud is plainly engrossed in his performance; the young girls seated opposite him are even more intensely absorbed in the narrative, which we are led to feel has reached a crisis; the governess, who has been listening and sewing, studies closely the impression made by the reading on her young charges; and the youngest girl occupies herself with her pet bird. Nor is this all. The governess's suspension of sewing expresses the acuteness of her concern with what is taking place before her; the obliviousness of the girls to being observed dramatizes their raptness in the story; and the indifference of the youngest girl to everything except her bird contrasts naturally but pointedly with the entire participation of the others in the elegant and ingenious structure of absorptive relations that is the painting's action and essence.[47]

It is, I think, unnecessary to spell out the thematic and structural relationships that obtain between *La Lecture espagnole* and paintings like the *Père de famille, Philosophe occupé de sa lecture, Dessinateur d'après le Mercure de M. Pigalle, Jeune Fille qui récite son Evangile, St. Augustin disputant contre les Donatistes*, and *St. Augustin prêchant devant Valère, Evêque d'Hippone*. In any case, specific connections among these and other works are less important than the preoccupation with absorption that underlies the connections and in an important sense determined them.

A further range of absorptive concerns is brought into focus by another picture exhibited in the Salon of 1753,[48] Joseph-Marie Vien's *Ermite endormi* (Fig. 12).[49] Vien (1716–1809) spent the years 1744–1750 in Italy, and exhibited more than a half-dozen works in this, his first Salon. Of these the *Ermite endormi* excited much the warmest interest. It portrays about life-size a bearded hermit sleeping against a tree with a violin and bow in his hands. Around him are various objects—a human skull, a large tome and a quill pen, a few sheets of music, a jug, a wicker basket containing simple vegetables.

Contemporary critics admired the Italianate character, vigorous execution, and coloristic unity of the *Ermite endormi*.[50] But the subject itself—the action of the hermit and the details of the setting—intrigued them as well, and in their commentaries we again find an emphasis on expression we could not have anticipated. Here for example is Laugier:

Le fond du Tableau est l'intérieur d'un pauvre hermitage, ou l'on voit d'un côté une tête de mort, objet sans doute de la méditation du Solitaire, de l'autre des racines & des légumes qui sont sa nourriture. . . . Rien de ce qui peut exprimer le sommeil n'est oublié; la tête est panchée en arrière nonchalamment, les yeux sont fermés, la bouche un peu entre-ouverte, les bras tombans; on voit à un des pieds qui ne touche point à terre la sandale qui se détache, & qui ne tient presque plus. On sent que tous les ressorts sont détendus, & que tous les nerfs sont dans le relâchement. Cependant ce n'est point une mort, c'est un vrai sommeil.[51]

The background of the painting is the interior of a poor hermitage in which we see on one side a skull, no doubt the object of the recluse's meditation, and on the other some roots and vegetables that constitute his food. . . . Nothing that can express sleep has been left out. His head leans back nonchalantly, his eyes are closed, his mouth is slightly open, his arms droop; we see on one of his feet, which is not touching the ground, a sandal that has come loose and is about to fall. One feels that all his sinews are slack and all his nerves relaxed. But this is not death, it is a true sleep.

In the same vein La Font de Saint-Yenne remarks: "Il tient un violon sur ses genoux prêt à lui échapper" (He holds in his lap a violin that is about to slip from his grasp),[52] an observation that parallels Laugier's of the sandal about to fall. A third critic, Huquier, has this to say:

Ce bon Vieux tient un violon dans sa main, & paroît s'être endormi lui-même au son de son instrument; il a bien l'air d'un homme tranquille qui n'a rien à se reprocher: autour de lui sont ses livres de prieres ou d'études, & au bas on voit quelques racines dont il composoit sans doute ses repas frugales.[53]

This good old man holds a violin in his hand and seems to have fallen asleep to the sound of his instrument. His appearance is truly that of a tranquil man who has nothing for which to reproach himself. Around him are his books of prayer or study, and at the bottom one sees a few roots, of which no doubt his frugal meals consisted.

The sentimentalizing tendency evident in these remarks is taken further by Estève, who describes the hermit as an "Anachorète . . . placé dans une sol-

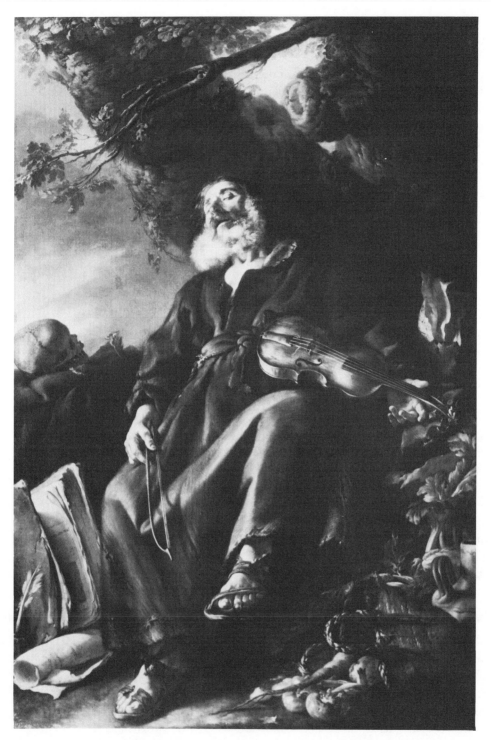

12　Joseph-Marie Vien, *Ermite endormi,* Salon of 1753. Paris, Louvre.

itude affreuse, qui est ornée par des attributs effrayans" (Anchorite . . . placed in a dreadful solitude adorned with frightful attributes), and concludes: "On voit à travers toutes ces horreurs, ce saint Personnage s'abandonner à une douce extase" (Among all these horrors, one sees this saintly person abandoning himself to a sweet ecstasy).[54] His claims, however, are ridiculed by Gautier d'Agoty on the grounds that "personne n'a vu dans le Tableau de M. Vien ces attributs effrayans, ces horreurs" (no one has seen in M. Vien's painting these frightful attributes, these horrors); that "[Estève] donne le nom de saint personnage à un faux Hermite, à un Yvrogne qui court les cabarets" ([Estève] describes as a saintly person a false hermit, a drunkard who frequents taverns); and that "il le croit dans une douce extase, tandis qu'il ne fait que dormir, appesanti par les vapeurs du vin" (he believes him to be in a sweet ecstasy whereas he is merely asleep, dulled by the fumes of wine).[55]

Estève's views notwithstanding, the above quotations make clear that the *Ermite endormi*'s immense appeal to contemporaries was largely a function of the persuasiveness of its representation of sleep. This is explicit in the commentary by Laugier, who treats Vien's painting as a *tour de force* of expression, and is implicit in the statements of Huquier and Gautier d'Agoty, both of whom feel they know even the character of the hermit's repose. Estève, too, it should be noted, enjoys Vien's depiction of a state that involves the extinction of ordinary consciousness; though of course his reading of that state differs from his colleagues' and is certainly mistaken.

Another point that emerges in these accounts is that almost all the objects with which the hermit has been provided are characteristically employed in absorptive activities. Laugier refers to the skull as an object of the hermit's meditation (a *memento mori*); while Huquier describes him as surrounded by books of prayer or study, thereby affirming the absorptive nature of the uses to which in his view the books have been put. My insistence on this point may seem tendentious: both skull and books are conventional attributes of hermithood, which by its nature implies a contemplative and in that sense an absorptive mode of existence. But the same cannot be said of the most prominent objects in the painting, the violin and bow. Thus La Font de Saint-Yenne maintains that Vien ought not to have "placé à côté de cet ermite, une tête de mort, en lui mettant un violon dans les mains. Ces deux objets offrent des idées si opposées qu'il est difficile de les rapprocher sans blesser le spectateur, c'est la seule dissonance que l'on trouve dans ce bel ouvrage" (placed a skull alongside the hermit while putting a violin in his hands. These two objects suggest such opposite ideas that it is difficult to bring them together without offending the beholder. This is the only dissonance to be found in this beautiful work).[56] If however the significance of those objects is construed, not by reference to their conventional associations, but in terms of the activities in which they are used, skull and violin are seen to be functional equivalents of one another—instruments of absorption, objects by means of which the condition of absorption is initiated and sustained.

[30]

This interpretation, implying as it does the primacy of considerations of absorption in the painting as a whole, finds support in the inference that the hermit's present condition has been brought about by his engagement in one of those activities, playing the violin. Huquier infers as much when he remarks that the hermit "paroît s'être endormi lui-même au son de son instrument." If this strikes us as fanciful or absurd, how *are* we to understand Vien's depiction of the hermit as asleep with violin and bow still in his hands?[57] At the very least, we are made to feel that the state of sleep represented in the *Ermite endormi* harmonizes with the absorptive activities of reading, meditation, and playing the violin to which the painting alludes.

I want to go further, however, and propose that the state of sleep, as depicted in the *Ermite endormi* and as described in the criticism I have quoted, is itself to be understood as another manifestation—an extreme instance or limiting case—of the preoccupation with absorption that has been the focus of this chapter from the first.

This requires clarification. The absorptive activities previously considered involve the faculty of attention, and attention naturally involves consciousness. Throughout this chapter, however, we have seen that automatic, involuntary, and unconscious actions were perceived by critics of the early and mid-1750s as signs of intense absorption and for that matter of rapt attention. More generally, we have inferred that for French painters of those years the persuasive representation of absorption characteristically entailed evoking the obliviousness or unconsciousness of the figure or figures in question to everything other than the specific objects of their absorption. I now suggest that precisely that vital sign or index of absorption is epitomized, given independent existence, in the *Ermite endormi*—moreover that the power of Vien's painting to captivate the same audience that stood enthralled before Chardin's *Philosophe occupé de sa lecture* and Van Loo's *St. Augustin disputant contre les Donatistes* is to be understood to a very considerable degree in this light. I do not deny that there are significant differences between the respective states of mind and body of Chardin's philosopher engrossed in his book or Van Loo's secretary transfixed by Augustine's eloquence on the one hand and of Vien's hermit fast asleep against a tree on the other. But I would insist that those differences cannot be understood simply in terms of an opposition between absorption and unconsciousness: in French painting and criticism of the period absorption and unconsciousness are keyed to one another, and implied by one another, to an extent that makes any contrast between them largely empty of meaning. Nor do I overlook the fact that the representation of sleep has innumerable precedents in eighteenth-century art. But there is in the *Ermite endormi* an attempt to evoke, as if from within, the actual experience of sleep in a situation wholly devoid of erotic overtones; and that attempt, although not absolutely without prior example, decidedly strikes a new, nonvoyeuristic, intensely empathic note in eighteenth-century French painting. This is reflected in Laugier's emphasis on the persuasiveness or expressive truth of

Vien's painting, an emphasis which itself signals a new or heightened concern with the internal experience of sleep, with its character as a lived condition or mode of being.[58]

Another brief quotation is illuminating here. Garrigues de Froment, in his account of the Salon of 1753, criticizes Carle Van Loo's *Jupiter et Antiope*[59]—a small, Watteau-inspired painting that depicts Jupiter in the form of a satyr uncovering the sleeping Antiope—for presenting an image of sleep that is "trop dur, trop universel" (too harsh, too universal).[60] The aptness or inaptness of the criticism is beside the point; the remark evinces the same heightened concern with the experience of sleep that we have found in the writings on the *Ermite endormi* cited above. In Laugier's words, Antiope's condition seems to Garrigues de Froment not so much *un vrai sommeil* as *une mort*.

Significantly, the theme of sleep, understood in these terms, plays a major role in Greuze's paintings of the second half of the 1750s. In the Salon of

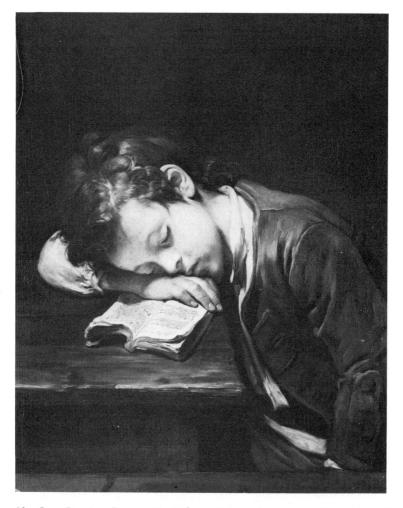

13 Jean-Baptiste Greuze, *Un Enfant qui s'est endormi sur son livre,* Salon of 1755. Montpellier, Musée Fabre.

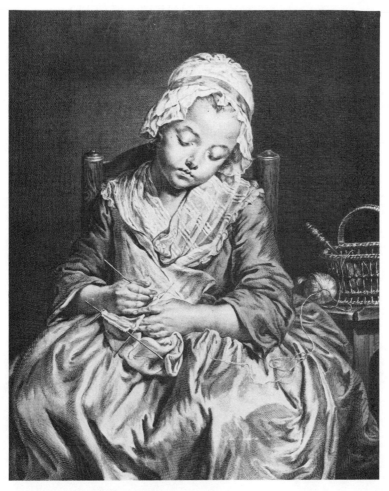

14 After Jean-Baptiste Greuze, *La Tricoteuse endormie,* Salon of 1759, en-
graved by Jardinier. Whereabouts of painting unknown.

1755, where he exhibited the *Père de famille,* he also exhibited *Un Enfant qui
s'est endormi sur son livre* (Fig. 13),[61] a work that impressed contemporary critics
but received no detailed commentary. We see at once, however, that it alludes
to the absorptive activities of reading and study as those are exemplified in
paintings such as the *Philosophe occupé de sa lecture* or the *Père de famille* itself,
and that even more forcefully than Vien's celebrated canvas of the previous
Salon it implies a continuity between those activities and sleep.

 That continuity is also implied in a painting by Greuze shown in the Salon
of 1759,[62] *La Tricoteuse endormie* (Fig. 14). Its subject is a young girl who has
fallen asleep while knitting. According to La Porte it presents "une im-
age . . . naïve de la paresse & de l'ennui de travail . . ." (a naive image of
laziness and boredom with one's work),[63] a statement that recalls Huquier's
remark that Vien's hermit appears to have played himself to sleep. And just as
the hermit's obliviousness and self-abandonment are expressed in his loosened
hold on violin and bow, so in Greuze's picture the condition of the *tricoteuse* is

made almost tangible to the beholder by the way in which the knitting needles and wool are slipping from her fingers. "Elle a laissé échapper son ouvrage de sa main," writes the anonymous critic for the *Journal Encyclopédique,* "& il pourra tomber à terre si la jeune fille ne se reveille" (She has let her work slip from her hand, and it may fall to the ground if the young girl does not wake up).[64] It may well be that both the *Enfant qui s'est endormi sur son livre* and the *Tricoteuse endormie* were influenced by the *Ermite endormi.* That possibility, however, matters less than the conviction that in all three paintings sleep is pres-

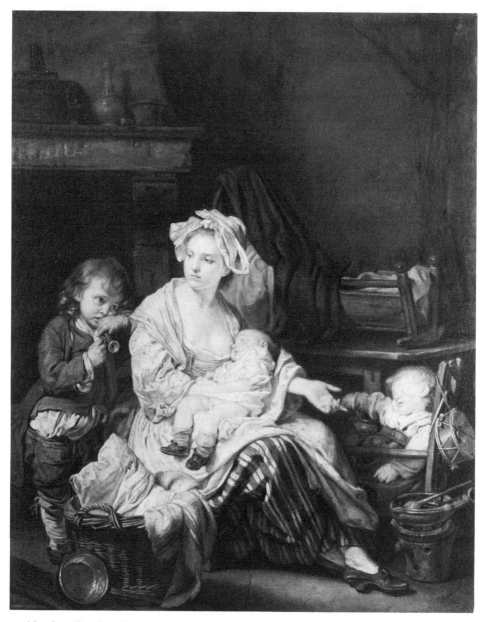

15 Jean-Baptiste Greuze, *Le Repos,* Salon of 1759. Collection of H. M. The Queen.

ented as an absorptive condition, almost an absorptive activity, in its own right.

In Greuze's *Le Repos* (Fig. 15), also shown in the Salon of 1759,[65] themes of sleep and absorption are the basis of a half-emblematic, half-anecdotal structure of some complexity; while other paintings by Greuze of the second half of the 1750s, notably *Les Oeufs cassés* (Fig. 16) and *La Paresseuse italienne* (Fig. 17), both of which appeared in the Salon of 1757,[66] represent not sleep itself but manifestly sleep-related states and activities. Those states and activities are also to be understood as vehicles of absorption. In fact it is only in the context of the primacy of absorption in the painting and criticism of the period that the latter works become expressively, as opposed to merely iconographically, intelligible—that their peculiar, almost unfathomable mood of lassitude, reverie, and psychological absence can be seen as other than aberrant.

In the first half of this chapter I have discussed the work of four painters, Chardin, Carle Van Loo, Vien, and Greuze (in order of birth). They are by no means the only figures of the time in whose art absorptive concerns may be found. But they are among the most important painters of their respective generations; and they differ sufficiently among themselves to make their common preoccupation with absorptive themes, structures, and effects particularly striking. In the second half of this chapter I want to sketch at least the rudiments of a historical context in which that preoccupation is to be understood.

To begin with, the primacy of absorption in French painting and criticism of the early and mid-1750s must be seen in connection with the reaction against the Rococo that began several years before (1747 is the date usually given).[67] The basic features of the reaction are well known: a turning away from the exquisite, sensuous, intimately decorative painting that had held the field for roughly thirty years; and an insistence on the need to return to what were perceived as the high seriousness, elevated morality, and timeless esthetic principles of the great art of the past, by which was meant the sculpture of the ancients and the painting of certain canonical sixteenth- and seventeenth-century masters. In the next chapter I shall examine one of the most conspicuous manifestations of the anti-Rococo reaction, the revival of interest in the sister doctrines of the hierarchy of genres and the supremacy of history painting. For the present, however, two further points are crucial. First, the case against the Rococo was based in part on its apparent neglect of absorptive considerations. Second, a number of the works by previous masters that were regarded as exemplary for ambitious painting were also seen as paradigms of absorption. In other words, both the turning away from the Rococo and the insistence upon the exemplary character of the great art of the past expressed a demand that contemporary painters resume a tradition of absorptive painting that had been allowed to lapse.

[35]

For a succinct illustration of the first point we have only to consider some responses to the work of the then foremost living practitioner of the Rococo style, François Boucher (1703–1770). Boucher achieved prominence in the 1730s, became later on the favorite artist of Mme. de Pompadour, and in 1765 was made *premier peintre du roi* following the death of his friend and contemporary, Carle Van Loo. Starting in 1747, however, his paintings came under attack from art critics for being artificial in color, mannered in drawing, and uncertain in expression.[68] In 1753 his two principal submissions to the Salon were given a mixed reception; and among the criticisms levelled at those paintings by their detractors was the charge that most of the figures did not appear to be paying attention to the actions taking place before them. The paintings in question are *Le Lever du Soleil* (Fig. 18) and *Le Coucher du Soleil* (Fig. 19),[69] large allegorical canvases intended to be executed in tapestry and regarded today as among the masterpieces of Boucher's art. In the first of these, Apollo the sun god rises from the sea to begin his journey across the heavens; in the second, he returns to Thetis and her court at the end of the day. Estève writes of the *Coucher:*

Sur le devant . . . il y a un beau groupe de trois Néréides qu'un Dauphin soutient sur les eaux. L'expression de ces figures n'a pas paru convenable. Abandonnées à leur

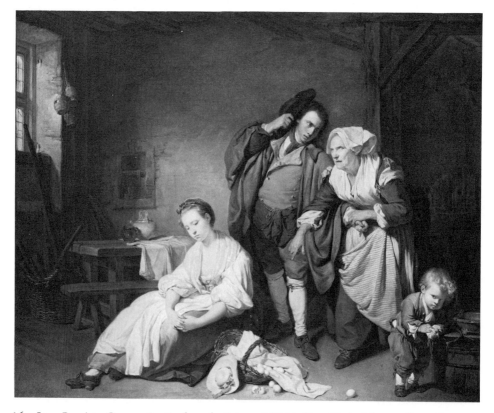

16 Jean-Baptiste Greuze, *Les Oeufs cassés,* Salon of 1757. New York, Metropolitan Museum of Art, Bequest of William K. Vanderbilt, 1920.

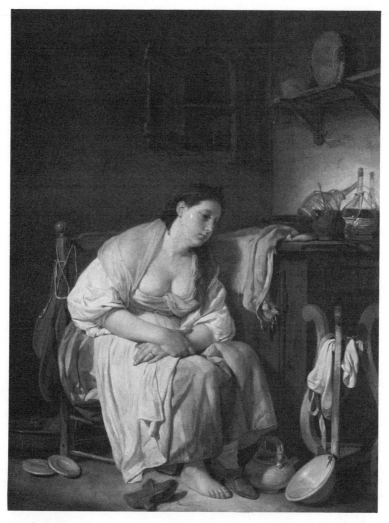

17 Jean-Baptiste Greuze, *La Paresseuse italienne,* Salon of 1757. Hart-
ford, Wadsworth Atheneum, Ella Gallup Sumner and Mary Catlin
Sumner Collection.

nonchalance, elles ne prennent aucun intérêt à l'arrivée d'Apollon. Ne devroient-elles
pas tout au moins imiter leur Souveraine, qui daigne honorer le Dieu du jour d'un
regard de complaisance?[70]

In the foreground . . . there is a beautiful group of three nereids supported upon the
water by a dolphin. The expression of these figures did not seem suitable. Abandoned
to their nonchalance, they take no interest in the arrival of Apollo. Should they not at
least imitate their sovereign, who condescends to honor the god of light with an
obliging look?

He adds that "les Néréides qui devroient le recevoir avec empressement ne le
regardent pas . . ." (the nereids, who should receive him with fervor, are not
looking at him. . .).[71] The same objection is raised by La Font de Saint-
Yenne, who observes of the *Lever:*

18 François Boucher, *Le Lever du Soleil,* Salon of 1753. London, Wallace Collection.

[L']indifférence de tout ce Cortége marin, dont presque toutes les figures tournent le dos au dieu du jour, & semblent n'être dans ce tableau que pour remplir les vides, sans prendre aucun intérêt à l'action principale qui est le départ du Soleil, est une faute essentielle, & . . . difficile à excuser.[72]

The indifference of this entire marine cortege, in which almost all the figures turn their backs upon the god of light and seem to be in this painting only to fill empty spaces without taking any interest in the main action, the departure of the sun, is a basic fault and one . . . difficult to excuse.

Of the *Coucher* La Font says: "On remarque les mêmes fautes à l'égard de la cour

19 François Boucher, *Le Coucher du Soleil,* Salon of 1753. London, Wallace Collection.

de Thétis que dans le précédent tableau. Nulle attention à l'arrivée du Soleil;
les Nayades s'entretiennent en particulier, & ne prennent aucune part à ce qui
se passe sur la scène" (One notices the same faults with respect to Thetis's court
as in the preceding painting. No attention is paid to the arrival of the sun; the
nereids converse among themselves and take no part in what is happening in
the scene).[73] For both critics, the structure of action and expression in
Boucher's pictures was antithetical to the absorptive structures they and their
colleagues admired in the art of Chardin, Van Loo, and Vien, and were soon to
admire in that of Greuze.

[39]

In the later 1750s and 1760s criticism of Boucher grew increasingly harsh, though he continued to have his supporters, as his appointment as *premier peintre* suggests. Two passages in Diderot's largely devastating discussion of Boucher's work in his *Salon de 1765* are of particular interest. The first deals with Boucher's characteristic mode of depicting children, which seemed to Diderot to epitomize the unreality of his art:

Quand il fait des enfans, il les grouppe bien; mais qu'ils restent à folâtrer sur des nuages. Dans toute cette innombrable famille, vous n'en trouverez pas un à employer aux actions réelles de la vie, à étudier sa leçon, à lire, à écrire, à tiller du chanvre. Ce sont des natures romanesques, idéales, de petits bâtards de Bacchus et de Silène.[74]

When he depicts children, he groups them well, but they should stay up there frolicking on clouds. In all that innumerable family, you will not find one to employ for the real actions of life, studying a lesson, reading, writing, stripping hemp. They are ideal, imaginary natures, young bastards of Bacchus and Silenus.

It hardly needs to be pointed out that Diderot's examples of the real actions of life are essentially absorptive, or that such actions abound in the work of Chardin and Greuze (and to a much lesser extent Van Loo).[75]

The second passage mentions Boucher only in conclusion. When Carle Van Loo died in 1765 he had recently finished seven oil sketches of scenes from the life of St. Gregory.[76] One of them, *St. Grégoire dictant ses homélies* (Fig. 20),[77] depicted the saint seated in his study, inspired by the Holy Ghost in the form of a dove at his ear and dictating to a secretary seated opposite him. Diderot considered it the most beautiful of the sketches and described it in the following terms:

Il n'y a cependant que deux figures; le saint qui dicte ses homélies, et son secrétaire qui les écrit. Le saint est assis, le coude appuyé sur la table. . . . La belle tête! on ne sait si l'on arrêtera les yeux sur elle ou sur l'attitude si simple, si naturelle et si vraie du secrétaire. On va de l'un à l'autre de ces personnages, et toujours avec le même plaisir. La nature, la vérité, la solitude, le silence de ce cabinet, la lumière douce et tendre qui l'éclaire de la manière la plus analogue à la scène, à l'action, aux personnages, voilà, mon ami, ce qui rend sublime cette composition, et ce que Boucher n'a jamais conçu.[78]

There are, however, only two figures—the saint who dictates his homilies and his secretary who writes them down. The saint is seated with his elbow resting on the table. . . . What a beautiful head! One does not know whether to fix one's eyes upon it or upon the secretary's attitude, so simple, natural, and true. One looks from one personage to the other, and always with the same pleasure. The naturalness, the truth, the solitude, the silence of this study, the sweet and tender light that pervades it in a manner perfectly suited to the scene, the action, and the characters—there, my friend, is what makes this composition sublime and what Boucher has never imagined.

The theme of dictation—and here it is as if not just the secretary but the saint as well is being dictated to—recalls Van Loo's *St. Augustin disputant contre les Donatistes*; and in general it seems clear that Diderot regarded *St. Grégoire*

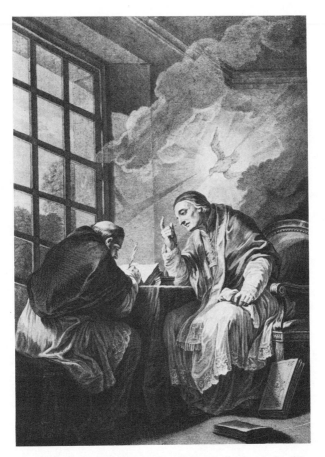

20 After Carle Van Loo, *St. Grégoire dictant ses homélies,*
Salon of 1765, engraved by Martinet.

dictant ses homélies as a masterpiece of absorption and for that reason as beyond
the range of Boucher's imagination. Diderot's praise for Van Loo's evocation of
solitude and silence may be contrasted with a statement that almost im-
mediately precedes the remarks on Boucher's depiction of children quoted
above: "Toutes ses [Boucher's] compositions font aux yeux un tapage insup-
portable. C'est le plus mortel ennemi du silence que je connoisse; il en est aux
plus jolies marionnettes du monde . . ." (All his [Boucher's] compositions
make an unbearable racket for the eyes. It is the deadliest enemy of silence I
know; he is showing us the prettiest marionettes in the world . . .).[79]
Throughout Diderot's *Salons* the notions of silence and solitude, already en-
countered in commentaries on Vien's *Ermite endormi* and Greuze's *Repos,* are
associated with absorptive themes and effects. And of course the characteriza-
tion of Boucher's figures as marionettes asserts their lack of the capacity for
inwardness on which absorption depends.[80]

As for the claim that earlier works held to be exemplary for painting were
also seen as paradigms of absorption, a few examples will show what I mean.
In an anonymous article of 1757 the principal group of figures in Poussin's *Le
Testament d'Eudamidas* (Fig. 21), a work that came to have almost talismanic

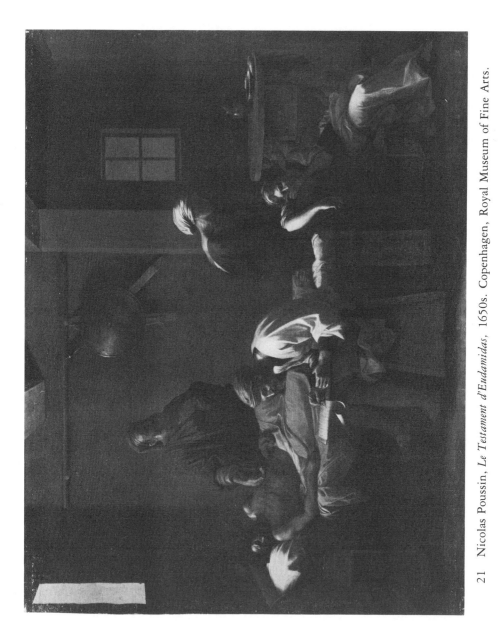

21 Nicolas Poussin, *Le Testament d'Eudamidas*, 1650s. Copenhagen, Royal Museum of Fine Arts.

significance for French artists and critics in the decades that followed, is described in these words:

Eudamidas est sur son lit, dans l'attitude d'un homme épuisé par la maladie. . . . Le Médecin est à côté de lui, de bout, la tête inclinée (pour marquer son attention); de la main droite il calcule, par les mouvements appésantis de son coeur, le peu d'instans qui lui restent: on lit le cruel arrêt dans ses traits. Le Notaire écrit ses dernières volontés, & par son étonnement fait sentir le sublime qu'elles renferment.[81]

Eudamidas lies on his bed in the attitude of a man exhausted by illness. . . . The doctor stands at his side with head bent (to show his attentiveness); with his right hand he calculates, from Eudamidas's slowing heartbeat, what little time the latter has left. One reads the cruel sentence in the doctor's expression. The notary records Eudamidas's last wishes, and by his astonishment conveys their sublimity.

The absorptive character of the notary's occupation does not call for comment. That of the doctor's activity of taking the dying man's pulse—a kind of listening—is acknowledged between parentheses in the passage itself.

Other works by seventeenth-century masters that appear to have been admired at least partly on absorptive grounds include Eustache Le Sueur's paintings of the life of St. Bruno at the Charterhouse of Paris (Figs. 22 and 23),[82] Domenico Feti's *Melancholy* (Fig. 24),[83] the painting of the blind Belisarius receiving alms then thought to be by Van Dyck (Fig. 63),[84] and various paintings and etchings by Rembrandt. Among these last we may note in particular *A Scholar in a Room with a Winding Stair,* engraved by Surugue in 1755 as *Le Philosophe en contemplation* (Fig. 25),[85] the *Tobias Healing His Father's Blindness,* engraved by Marcenay de Ghuy the same year as *Tobie recouvrant la vüe* (Fig. 26),[86] and the etching of Jan Six reading (Fig. 27), a work adapted by Greuze around 1763 or 1764 in a portrait of Watelet which the latter subsequently etched (Fig. 28).[87]

The concept of absorption is not one that we are accustomed to apply systematically to the art of the past. But on examination it turns out that subjects involving absorptive states and activities are present in abundance in earlier painting, and that in the work of some of the greatest seventeenth-century masters in particular—Caravaggio, Domenichino (in the *Last Communion of St. Jerome*), Poussin, Le Sueur, Georges de La Tour, Velázquez, Zurbarán, Vermeer, and, supremely, Rembrandt come at once to mind—those states and activities are rendered with an intensity and a persuasiveness never subsequently surpassed. In this sense there *had been* a tradition of absorptive painting, one whose almost universal efflorescence in the seventeenth century was everywhere followed by its relative decline. Obviously we need to know a great deal more about that tradition—about its sources, internal development, spiritual and other affinities, characteristic manifestations in different countries, and so on.[88]

22 Eustache Le Sueur, *Prédication de Raymond Diocrès,* 1645–1648. Paris,
Louvre.

Even at this early stage in our inquiry, however, it is clear that the repre-
sentation of absorption did not wholly disappear from French painting with
the rise of the Rococo. Watteau himself is on occasion an absorptive painter of
an inimitable and idiosyncratic sort.[89] In the course of the 1720s, 1730s, and
1740s, a few artists, notably Jean-François De Troy and Maurice-Quentin de
La Tour, now and then produced work whose absorptive character is undeni-
able.[90] The expatriate artist Pierre Subleyras, who worked mostly in Rome,
should also be mentioned in this connection.[91] And starting in the early
1730s, a major figure with whom we are already familiar, Chardin, made

[44]

23 Eustache Le Sueur, *St. Bruno en prière*, 1645–1648. Paris, Louvre.

painting after painting in which engrossment, reflection, reverie, oblivious-
ness, and related states are represented with a persuasiveness equal to that
achieved by the greatest masters of the past, and by so doing perpetuated as
much of what I shall call the absorptive tradition as it was in one man's power
to keep alive.[92] Indeed Chardin did more than simply perpetuate that tradi-
tion. He concentrated or "purified" it by separating the representation of ab-
sorption from other objects and concerns with which previously it had been
mixed. In particular he secularized the absorptive tradition—more accurately,
it is in his genre paintings that the process of secularization begun in the
previous century (chiefly in the Low Countries) and continued by Watteau and

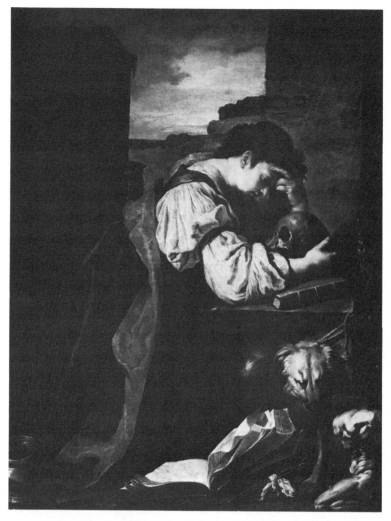

24 Domenico Feti, *Melancholy,* ca. 1620. Paris, Louvre.

De Troy was brought to completion—though naturally painters such as Van Loo, Vien, and Greuze, along with others we have not considered, remained free to exploit religious subject matter for absorptive ends in the 1750s.[93] Finally, he both naturalized and domesticated that tradition, by which I mean that largely owing to his endeavors the representation of absorption became a peculiarly French concern, and that, again following Northern precedents, he located the experience of absorption in the home, or at any rate in absolutely ordinary surroundings.

The special character of Chardin's achievement is perhaps the most evident in his depictions of children and young people playing games or engaged in apparently trivial amusements—for example, *The Soap Bubble* (ca. 1733; Fig. 29), *The Game of Knucklebones* (ca. 1734; Fig. 30), and *The Card Castle* (ca. 1737; Fig. 31).[94] This is true despite the fact that it is not at all clear to what extent Chardin himself intended such paintings to be seen as *Vanitas* images,

[46]

as has been suggested by various scholars on the strength both of an earlier tradition in which genre scenes and still lifes were invested with symbolic significance and of the moralizing verses that were often appended to contemporary engravings after Chardin's canvases.[95] Other scholars have resisted the suggestion, seeing in Chardin's art the liquidation rather than the continuation of a moralizing tradition and insisting that the cast of mind at work in the verses is alien to the paintings themselves.[96] However one resolves this question in one's own mind, and there is much to be said for both positions, two observations seem to me of crucial importance. First, it is impossible to discern the least difference in Chardin's attitude toward his subject matter between the pictures of games and amusements on the one hand and ostensibly more serious or morally exemplary scenes on the other. And second, far from seeming to have wished to characterize the activities depicted in the former as shallow pastimes or mere distractions, Chardin appears to have been struck precisely by the depth of absorption which those activities tended naturally to elicit from those engaged in them. At any rate, he appears to have done all he could to make that depth of absorption manifest to the beholder, most importantly by singling out in each picture at least one salient detail that functions as a sign of the figure's obliviousness to everything but the operation he or she is intent upon performing. Thus in the *Soap Bubble* our attention is caught by

25 After Rembrandt van Rijn, *Le Philosophe en contemplation,* 1633, engraved by Surugue.

26 After Rembrandt van Rijn, *Tobie recouvrant la vüe,* 1636, engraved by Marcenay de Ghuy.

the tear in the young man's jacket; in the *Game of Knucklebones* by the upper corner of the young woman's apron that has come unpinned; and in the *Card Castle,* in the immediate foreground, by the negligently half-opened drawer containing a pair of playing cards. The last of these in particular is a highly sophisticated device. By virtue of fronting the beholder and what is more opening toward him, the drawer serves to enforce a distinction between the beholder's point of view and perception of the scene as a whole and the quite different point of view and limited, exclusive focus of the youth balancing the cards. There is even a sense in which the contrast between the two cards—one facing the beholder, the other blankly turned away from him—may be seen as

[48]

27 Rembrandt van Rijn, *Jan Six*, 1647.

an epitome of the contrast between the surface of the painting, which of course faces the beholder, and the absorption of the youth in his delicate undertaking, a state of mind that is essentially inward, concentrated, closed. (The radicalness of the difference between the two points of view does not seem to have presented the painter of the *Card Castle* with a fundamental problem; from the retrospect of certain developments of the 1750s and 1760s, however, it may come to seem that the elements of such a problem are already in place.)

Chardin's paintings of games and amusements, in fact all his genre paintings, are also remarkable for their uncanny power to suggest the actual duration of the absorptive states and activities they represent. Some such power necessarily characterizes all persuasive depictions of absorption, none of which would *be* persuasive if it did not at least convey the idea that the state or activity in question was sustained for a certain length of time. But Chardin's genre paintings, like Vermeer's before him, go much further than that. By a technical feat which virtually defies analysis—though one writer has remarked

28 After Jean-Baptiste Greuze, *Portrait de Watelet,* ca. 1763–1764, etched by Watelet.

helpfully on Chardin's characteristic choice of "a natural pause in the action which, we feel, will recommence a moment later"[97]—they come close to translating literal duration, the actual passage of time as one stands before the canvas, into a purely pictorial effect: as if the very stability and unchanging-ness of the painted image are perceived by the beholder not as material proper-ties that could not be otherwise but as manifestations of an absorptive state— the image's absorption in itself, so to speak—that only happens to subsist. The result, paradoxically, is that stability and unchangingness are endowed to an astonishing degree with the power to conjure an illusion of imminent or gradual or even fairly abrupt change. In the *Soap Bubble* the transparent, slightly distended globe at the tip of the young man's blowpipe seems almost to swell and tremble before our eyes; in the *Card Castle* the youth placing a card in position appears on the verge of drawing back his hand; while in the

29 Jean-Baptiste-Siméon Chardin, *The Soap Bubble,* ca. 1733. Washington, D.C., National Gallery of Art, Gift of Mrs. John W. Simpson.

Game of Knucklebones a single moment has been isolated in all its plenitude and density from an absorptive continuum the full extent of which the painting masterfully evokes. Images such as these are not of time wasted but of time *filled* (as a glass may be filled not just to the level of the rim but slightly above). Whatever their iconographic precedents or even their actual symbolic connotations, they embody a new, unmoralized vision of distraction as a vehicle of absorption; or perhaps one should say of that vision that it distills, from the most ordinary states and activities, an unofficial morality according to which absorption emerges as good in and of itself, without regard to its occasion; or perhaps it is simply that Chardin found in the absorption of his figures both a natural correlative for his own engrossment in the act of painting and a proleptic mirroring of what he trusted would be the absorption of the beholder before the finished work.

30 Jean-Baptiste-Siméon Chardin, *The Game of Knucklebones,* ca. 1734. Baltimore, Museum of Art.

Available evidence suggests that Chardin, always the most private of artists, was during the 1730s and 1740s supported by little if any explicit communal concern with absorptive values and effects.[98] He was not on that account unappreciated by his contemporaries. Throughout this period his art was admired for the truthfulness with which it depicted "les petits details de la vie commune" (the little details of ordinary life),[99] a virtue in keeping with the "lesser" genres he practiced. Around the middle of the century, however, the reaction against the Rococo began to gather force; the persuasive representation of absorption emerged in the criticism of the time as a conscious and explicit desideratum; and concomitantly Chardin's genre paintings, including those of the 1730s and 1740s, were seen not only as satisfying such a desideratum but as exemplary, in that crucial respect, for the pictorial enterprise as such.[100] The success in the Salon of 1759 of the *Dessinateur,* a work based on a prototype invented ca. 1738, is a case in point. But the most dramatic instance of this sort concerns the exhibition of the *Philosophe occupé de sa lecture*

31 Jean-Baptiste-Siméon Chardin, *The Card Castle,* ca. 1737. Washington, D.C., National
Gallery of Art, Andrew W. Mellon Collection.

in the Salon of 1753. Actually it had been painted in 1734, almost twenty
years earlier. Thereafter it had been exhibited in the Salon of 1737[101] under
the title *Un Chimiste dans son laboratoire;* in 1744 it had been engraved by
Lépicié as *Le Soufleur (The Alchemist),* an epithet sometimes applied to the
painting itself;[102] when it was shown publicly again in the Salon of 1753
Chardin changed its title to one that implied the primacy of absorptive con-
cerns; and as we have seen, the persuasiveness of its representation of absorp-
tion was on that occasion specifically admired by Laugier and Huquier.[103]

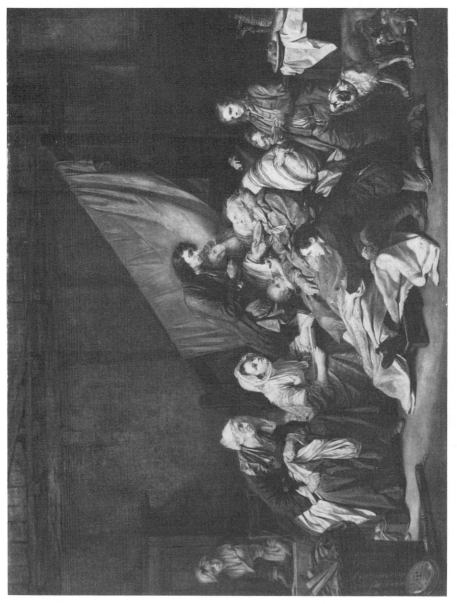

32 Jean-Baptiste Greuze, *La Piété filiale*. Salon of 1763. Leningrad, Hermitage.

The early and mid-1750s are a watershed in the evolution of French painting. In fact the advent of Greuze in 1755 marks a decisive turning in the development of painting in France—though it is not until the first half of the 1760s that his mature manner becomes stabilized. Even more than in the case of the *Père de famille,* we must resist the usual characterizations of his pictures of those years if we would grasp their motivation. For a long time now it has been traditional, almost obligatory, to remark that we, the modern public, no longer find it in ourselves to be moved by the sentimentality, emotionalism, and moralism of much of Greuze's production. But the truth is that we take those qualities at face value, as if they and nothing more were at stake in his pictures; and that we therefore fail to grasp what his sentimentalism, emotionalism, and moralism, as well as his alleged mania for plotting,[104] are in the service of, pictorially speaking—viz., a more urgent and extreme evocation of absorption than can be found in the work of Chardin, Van Loo, Vien, or any other French painter of the time.[105]

Let me try to clinch this point by discussing a few paintings by Greuze of the first half of the 1760s as they were seen by the greatest critic of the age, Denis Diderot. In *La Piété filiale* (Fig. 32), which when exhibited in the Salon of 1763[106] literally moved beholders to tears, a paralyzed old man reclining in an armchair is fed by his son-in-law; the paralytic, touched by the younger man's kindness, proffers him his thanks; while other members of the family, themselves deeply stirred, break off whatever they are doing to look and listen.[107] As always in Greuze, the various figures are differentiated psychologically and emotionally from one another.[108] But as in the *Père de famille,* the primary emphasis is not on the variety and multiplicity of individual responses to a central event so much as on the merging of those responses in a single collective act of heightened attention. This is spelled out by Diderot in his defense of Greuze's composition against certain criticisms:

On dit encore que cette attention de tous les personnages n'est pas naturelle; qu'il fallait en occuper quelques-uns du bonhomme et laisser les autres à leurs fonctions particulières; que la scène en eût été plus simple et plus vraie, et que c'est ainsi que la chose s'est passée, qu'ils en sont sûrs. . . . [But in fact:] Le moment qu'ils demandent est un moment commun, sans intérêt; celui que le peintre a choisi est particulier; par hasard il arriva ce jour-là que ce fut son gendre qui lui apporta des aliments, et le bonhomme, touché, lui en témoigna sa gratitude d'une manière si vive, si pénétrée, qu'elle suspendit les occupations et fixa l'attention de toute la famille.[109]

Some say too that this attention on the part of all the characters is not natural; that a few of them should have been concerned with the old man and the others left to their own occupations; that the scene would have been simpler and truer, and that this is how the event actually happened—of that they are certain. . . . [But in fact:] The moment for which they ask is commonplace, uninteresting; whereas the one chosen by the artist is special. By chance it happened that, on that particular day, it was his son-in-law who brought the old man some food, and the latter, moved, showed his gratitude in such an animated and earnest way that it interrupted the occupations and attracted the attention of the whole family.

33 Jean-Baptiste Greuze, *Une Jeune fille qui a cassé son miroir,* Salon of 1763. London, Wallace Collection.

Diderot's statement is the most forthright assertion of the primacy of considerations of absorption that we have so far encountered. He seems almost to be saying that Greuze was compelled first to paralyze the old man and then to orchestrate an entire sequence of ostensibly chance events in order to arrive in the end at the sort of emotionally charged, highly moralized, and dramatically unified situation that alone was capable of embodying with sufficient perspicuousness the absorptive states of suspension of activity and fixing of attention that painter and critic alike regarded as paramount. I believe that such a formulation comes very close to the truth, and that it is precisely the lengths to

34 Jean-Baptiste Greuze, *Le Tendre Ressouvenir,* Salon of 1763. London,
Wallace Collection.

which Greuze was compelled to go, the measures he found it necessary to take,
that have led modern scholars to condemn the *Piété filiale* as meretricious and
Diderot's admiration for it as jejune.

Other paintings of the period such as *Une Jeune Fille qui a cassé son miroir*
(Salon of 1763;[110] Fig. 33), *Le Tendre Ressouvenir* (Salon of 1763;[111] Fig. 34),
and *Une Jeune Fille qui pleure son oiseau mort* (Salon of 1765;[112] Fig. 35) repre-
sent female figures wholly absorbed in extreme states and oblivious to all else.
Mathon de la Cour, in a long rapturous commentary on the last of these, notes
that the young girl's costume is artlessly arranged and comments: "Le soin de
son ajustement ne l'affecte plus; elle n'est occupée que de son chagrin" (The
appearance of her dress no longer concerns her; she is preoccupied only by her
sorrow).[113] And Diderot, whose admiration for the picture was no less keen,
observes of the young girl: "Sa douleur est profonde; elle est à son malheur,
elle y est toute entière" (Her grief is profound; she is immersed in her unhap-
piness, she is totally given over to it).[114] After touching briefly on various

[57]

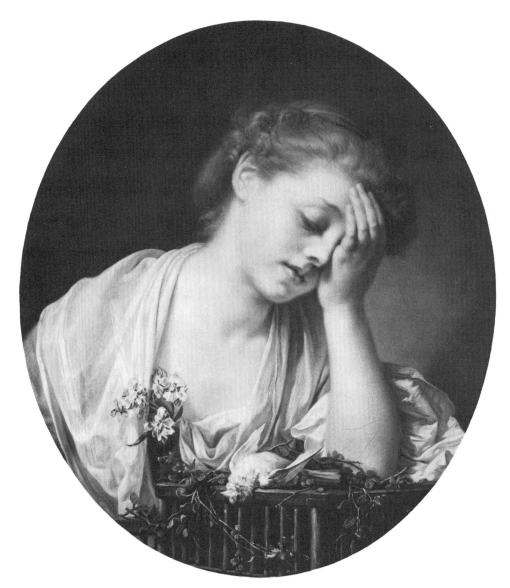

35 Jean-Baptiste Greuze, *Une Jeune fille qui pleure son oiseau mort,* Salon of 1765.
Edinburgh, National Gallery of Scotland.

details that seemed to him especially fine, he remarks: "Quand on apperçoit ce morceau, on dit: *délicieux!* Si l'on s'y arrête, ou qu'on y revienne, on s'écrie: *délicieux! délicieux!* Bientôt on se surprend conversant avec cette enfant, et la consolant. Cela est si vrai, que voici ce que je me souviens de lui avoir dit à différentes reprises" (When one sees this picture, one says: *delicious!* If one pauses to look at it or if one comes back to it, one exclaims: *delicious, delicious!* Soon one catches oneself conversing with this child and consoling her. This is so true that here is what I remember having said to her on various occasions).[115] And in a marvelously voiced passage of several hundred words he rehearses his attempts to distract the girl from her grief. The passage begins:

Mais, petite, votre douleur est bien profonde, bien réfléchie! Que signifie cet air rêveur et mélancolique? Quoi! pour un oiseau! vous ne pleurez pas. Vous êtes affligée, et la pensée accompagne votre affliction. Çà, petite, ouvrez-moi votre coeur: parlez-moi vrai; est-ce bien la mort de cet oiseau qui vous retire si fortement et si tristement en vous-même? . . . Vous baissez les yeux; vous ne me répondez pas. . . [116]

But, my child, your sadness is very profound, very considered! What is the meaning of this abstracted, melancholy air? What! For a bird! You are not crying. You are grieved, and thought accompanies your grief. There, there, my child, open up your heart to me. Tell me the truth. Is the death of this bird really what makes you withdraw so firmly and sadly within yourself? . . . You lower your eyes; you do not answer me. . . .

(As these remarks suggest, Diderot finds in Greuze's canvas a scarcely veiled allegory of the young girl's loss of virginity, an interpretation he extends retrospectively to the *Jeune Fille qui a cassé son miroir* in the previous Salon.) In the same spirit Mathon de la Cour writes: "[O]n voudroit sur-tout la consoler. J'ai passé plusieurs fois des heures entieres à la considérer attentivement; je m'y suis enivré de cette tristesse douce & tendre, qui ressemble à la volupté; & je suis sorti pénétré d'une mélancolie délicieuse" (One would like above all to comfort her. Several times I have spent whole hours contemplating her attentively; I have been intoxicated by that sweet and tender sadness that is akin to voluptuousness; and I have gone away imbued with a delicious melancholy).[117] Both commentaries have been ridiculed as typical specimens of the excessively "literary" and sentimental art criticism of the period. I believe, however, that Greuze's painting was intended at once *to elicit and to resist* such attempts at consolation, and thereby to make perspicuous the depth and intensity of the young girl's absorption in her grief. (If I am right, Greuze reckoned without Diderot's formidable powers of enticement; long before the end of the passage in question the critic succeeds in engaging her in conversation.)

Both the sexual theme and the refusal to acknowledge the beholder's presence are made even more explicit in another painting of 1765, *Une Jeune Fille qui envoie un baiser par la fenêtre, appuyée sur des fleurs, qu'elle brise,* familiarly called *Le Baiser envoyé* (Fig. 36). The young woman, in deshabille, has just received a note from her lover. Diderot's account of her condition includes the following:

Il est impossible de vous peindre toute la volupté de cette figure. Ses yeux, ses paupières en sont chargés! . . . Elle est ivre; elle n'y est plus; elle ne sait plus ce qu'elle fait; ni moi, presque ce que j'écris. . . . Ce bras gauche qu'elle n'a plus la force de soutenir, est allé tomber sur un pot de fleurs qui en sont toutes brisées; le billet s'est échappé de sa main; l'extrémité de ses doigts s'est allée reposer sur le bord de la fenêtre qui a disposé de leur position. Il faut voir comme ils sont mollement repliés . . . et la mollesse voluptueuse qui règne depuis l'extrémité des doigts de la main, et qu'on suit de-là dans tout le reste de la figure. . . .[118]

It is impossible to depict for you all the voluptuousness of this figure. Her eyes, her eyelids are fraught with it! . . . She is intoxicated; she is no longer there; she no

36 After Jean-Baptiste Greuze, *Une Jeune Fille qui envoie un baiser par la fenêtre, appuyée sur des fleurs, qu'elle brise,* Salon of 1769, engraved by Augustin de Saint-Aubin.

longer knows what she is doing; nor, almost, do I know what I am writing That left arm that she no longer has the strength to support has come to fall on a flower-pot, crushing the flowers; the letter has slipped from her hand; the tips of her fingers have come to rest on the window-sill which has given them their position. See how indolently bent they are . . . and the voluptuous indolence that prevails from the tips of the fingers of the hand and that can be traced from there throughout the rest of the figure. . . .

To speak of absorption in the face of a passage like this puts it mildly. What Diderot conjures up, and what Greuze sought to represent, is self-aban-

donment, nearly to the point of extinction of consciousness, via sexual longing. In the context of the paintings and criticism previously discussed, there is no question but that the young woman's involuntary or unconscious actions—in particular that of leaning on and crushing the flowers—were meant to be seen as expressions of intense absorption. (Note too that Greuze chose to call attention to that action in the picture's title.) Furthermore, the denial of the beholder that her condition implies is given added point by the way in which, although facing the beholder, she appears to look through him to her lover. It is hardly necessary to remark that such a conception is a highly sophisticated one and that we are by now far from the Greuze of common repute.

The decisive turning in the evolution of French painting that Greuze represents is epitomized by his relationship to Chardin. On the one hand, Greuze was unquestionably the chief continuator in his generation of the absorptive essence of Chardin's art. On the other, the sentimentalism, emotionalism, moralism, exploitation of sexuality, and invention of narrative-dramatic structures characteristic of Greuze's treatment of absorption contrast sharply with the concentration and "purity" of Chardin's rendering of absorptive motifs. The impression Chardin's paintings convey is that the persuasive representation of absorption is the result simply of the objective representation of ordinary absorptive states and activities. Whereas in Greuze's work absorption emerges as something else entirely, a specifically artistic effect which the painter was compelled to pursue and so to speak build into his paintings if it was to be there at all.[119] And the means by which this was accomplished suggest that by the first half of the 1760s absorption was increasingly becoming assimilated to expression rather than the other way round, as had been the case in the early and mid-1750s. Furthermore, absorption in Chardin strikes us not only as an ordinary, everyday condition but as that condition which, more than any other, characterizes ordinary, everyday experience: as the hallmark or *sine qua non* of the everyday as such. In contrast the seeming incapacity of Greuze's figures to become absorbed in the everyday—the impression they convey of not being at home in it—accounts for our conviction that Chardin and Greuze represent different *worlds*.[120] (In this connection it is significant that around 1760 Chardin gave up genre painting almost completely, concentrating for the remainder of his career on still lifes and, starting around 1770, portraits chiefly in pastel.)[121]

All this might be summed up by saying that by the first half of the 1760s if not earlier deliberate and extraordinary measures came to be required in order to persuade contemporary audiences of the absorption of a figure or group of figures in the world of the painting, and that consequently the everyday as such was in an important sense lost to pictorial representation around that time. The latter was a momentous event, one of the first in the series of losses that together constitute the ontological basis of modern art.

[61]

37 Joseph-Marie Vien, *La Marchande à la toilette*, Salon of 1763. Fontainebleau, Château.

38 *Seller of Loves*, engraved by C. Nolli, 1762. From *Le Antichità di Ercolano*, III (1762), pl. VIII.

With these developments in mind, let us look briefly at one of the most famous paintings of the early 1760s. Vien's *La Marchande à la toilette* (Salon of 1763;[122] Fig. 37) has traditionally been considered the key work of early Neoclassicism in France and it is not my intention to take issue with this view.[123] The setting, costumes, and accessories bespeak an effort of historical reconstruction; the system of drapery, far from seeming to have been based on actual observation of living models, plainly alludes to antique prototypes; the figures are arranged in a single plane parallel to that of the picture-surface while the composition as a whole has an almost geometric clarity; and the actions and expressions of the figures are marked by a quality of deliberate restraint—some have said coldness and immobility—which Vien's contemporaries regarded as antique (or "Greek") in inspiration. Even more to the point, Vien's canvas is based on a specific source in ancient art—a Hellenistic fresco of the same subject discovered near Naples in 1759 and reproduced in an engraving by Nolli published in *Le Antichità di Ercolano* in 1762 (Fig. 38).[124] It is hard to say to what extent Vien could have assumed that his audience would be familiar with that engraving and thus would be in a position to recognize his source. In any event, he not only explicitly acknowledged the connection in the Salon *livret* but also—and this I find particularly interesting—went on to invite his audience "à remarquer les différences entre les deux compositions" (to remark the differences between the two compositions).[125] In what principally do those differences consist?

[63]

I submit that they consist in the elaboration, refinement, and outright invention of absorptive relations and effects. In the engraving by Nolli the objects of the gazes of the principal figures are not absolutely precise; the facial expressions of two of those figures, the seated mistress of the house and her standing friend, are pretty much inscrutable; there is only one gesture, that of the seller of loves hawking her wares; and altogether the structure of the antique image is one of stark, quasi-dramatic contrast between the mistress and her friend on the one hand and the seller of loves on the other.[126] In Vien's canvas, however, each of the principal figures is shown gazing attentively at a particular object: the seller of loves herself peers searchingly across the central space of the painting into the face of her client, as if gauging her response, while both the mistress and her standing servant have their eyes fixed on the suspended cupid. (There is also a meeting of gazes between that cupid and his dark-haired fellow kneeling in the basket at the lower left, which I think of as tying shut, as with a ribbon, that otherwise relatively open portion of the composition.) In addition each of the principal figures has been differentiated socially, psychologically, and even morally from each of the others by virtue of the quality of her attentiveness. In particular we are clearly meant to register the distinction between the dignity and self-control of the seated mistress and the rapt attention, verging on distraction or *oubli de soi,* expressed by the face, posture, and gesture of the servant. (The latter's state of mind recalls that of the young girls in the *Lecture espagnole.*) As for the composition as a whole, that of Vien's painting consists essentially in the interweaving of the principal figures' acts of attention, as well as the exchange of glances between the two cupids, to form a lucid and hermetic structure of absorptive relations. Lucid, in that almost every feature of the principal figures, including ostensibly merely "formal" aspects of their presentation, has a meaning that can be read. For example, that the head of the mistress is depicted in profile while those of her servant and the seller of loves depart progressively from that privileged because antique norm amounts to a further encoding of the differentiation between their acts of attention that has already been remarked. And hermetic, in that the structure that results is self-sufficient, a closed system which in effect seals off the space or world of the painting from that of the beholder.[127] Or perhaps it is the antique and in that sense manifestly esthetic tenor of the painting as a whole—the fact that we are encouraged from the first to view it as a piece of deliberate artifice—that gives that closed and self-sufficient structure its hermetic character.

It is therefore not surprising that the success of Vien's painting when it was exhibited in the Salon of 1763 appears to have owed much to an appreciation of its refined handling of absorptive effects. Diderot, for example, singles out for special praise Vien's treatment of the facial expressions of the three principal figures and describes the unity of the painting as consisting largely in the minute adjustment to one another of their respective acts of attention. Thus he writes: "La suivante . . . dévore des yeux toute la jolie couvée. La

maîtresse a de la réserve dans le maintien. L'intérêt de ces trois visages est mesuré avec une intelligence infinie; il n'est pas possible de donner un grain d'action ou de passion à l'une sans les désaccorder toutes en ce point" (The servant . . . devours with her eyes all the pretty brood. The mistress of the house is reserved in expression. The interest of each of these three faces is measured with infinite intelligence; it is impossible to add a grain of action or passion to one without disturbing the equilibrium among them).[128] A page or so later Diderot implies that some viewers have objected to the gesture of the standing servant who, "d'un bras qui pend nonchalamment, va, de distraction ou d'instinct relever avec l'extrémité de ses jolis doigts le bord de sa tunique à l'endroit . . ." (with a nonchalantly hanging arm, inadvertently or instinctively lifts up the hem of her tunic with the tips of her pretty fingers in the region . . .) [of her crotch, obviously, though Diderot does not actually say so].[129] Diderot himself does not seem to have been troubled by this particular piece of business. And as we have had occasion to remark, precisely that sort of unconscious, automatic action had previously emerged in both painting and criticism as a sign of intense absorption. In contrast to the figure of the servant, that of the mistress strikes us as in complete control of her demeanor: it is the efficacy of that control, rather than any particular meaning, that we infer from the gesture of *her* left hand.

One more point remains to be made about Vien's *Marchande à la toilette.* In my discussion of Greuze's *Piété filiale* and related pictures I concluded by saying that by the first half of the 1760s deliberate and extraordinary measures came to be required in order to persuade contemporary audiences of the absorption of a figure or group of figures in the world of the painting. Now in almost every obvious respect Vien's canvas is the polar opposite of Greuze's: its subject matter is quasi-allegorical not ostensibly realistic, its setting and costumes are patrician antique not rural bourgeois contemporary, its emotional tenor is conspicuously cool and detached not hot and agitated. But this is to say that the formal and expressive system of the *Marchande à la toilette* is fully as extreme as that of the *Piété filiale,* though in an opposite direction. And this suggests in turn that the extremeness of each may be understood as the result of an attempt to depict absorptive states and activities under conditions that no longer favored such an undertaking. In the case of the *Piété filiale* the artist has been led to emphasize the sheer intensity of the emotional states of the dramatis personae as a means of immuring them within the painting; while in that of the *Marchande à la toilette,* as I have tried to show, a strategy of deliberate stylization has been employed to confer absorptive significance upon an entire network of comparatively very slight and often arbitrary distinctions among the principal figures: as though by 1763 it was only by virtue of such stylization that small differences, analogous in magnitude to those found in Chardin's canvases of the previous decades, could be made meaningful as signs of absorption once more.[130] Seen in this light, Greuze's sentimental, moralistic, and emotionalistic genre paintings and Vien's seemingly antithetical rep-

[65]

39 Unknown artist, after Jean-Baptiste-Siméon Chardin, *L'Aveugle*,
Salon 1753. Original painting destroyed. Cambridge, Mass., Fogg
Art Museum, Grenville L. Winthrop Bequest.

resentations of antique subjects turn out to be two faces of the same coin, two
complementary expressions of a single state of affairs.

It has become clear, I think, that the developments analyzed in this chap-
ter involve a major shift in the relationship between painting and beholder. I
shall have a great deal more to say about that shift in the next two chapters but
something at least should be said about it here. We have seen that for French
painters of the early and mid-1750s the persuasive representation of absorption
entailed evoking the perfect obliviousness of a figure or group of figures to
everything but the objects of their absorption. Those objects did not include
the beholder standing before the painting. Hence the figure or figures had to
seem oblivious to the beholder's presence if the illusion of absorption was to be
sustained. In Chardin's art that necessity remained mostly implicit: it was

[66]

40 Jean-Baptiste-Greuze, *L'Aveugle trompé,* Salon of 1755. Moscow, Pushkin Museum.

satisfied by seeming merely to ignore the beholder—the torn jacket, unpinned apron, and half-open drawer that I have characterized as signs of absorption show that Chardin himself was not forgetful that his paintings would be beheld—and by portraying ordinary absorptive states and activities with remarkable fidelity. By the first half of the 1760s, however, the presence of the beholder could no longer be dealt with in this way; it demanded to be counteracted and if possible obliviated in or by the painting itself; and the deliberate intensification of absorptive effects that we have traced in Greuze's paintings of those years, as well as the combination of those effects to form a drama-

tic compositional unity in works such as the *Piété filiale,* were, I wish to claim, means to that end. Put just barely figuratively, it is as though the presence of the beholder threatened to distract the dramatis personae from all involvement in ordinary states and activities, and as though the artist was therefore called upon to neutralize the beholder's presence by taking whatever measures proved necessary to absorb, or reabsorb, those personae in the world of the painting. (A similar argument can be made for Vien's *Marchande à la toilette,* in which the absorption of the figures in the world of the painting seems patently—and, I suggest, was meant to seem—a work of artifice.)

41 Jean-Baptiste Greuze, *Le Fils ingrat,* 1777. Paris, Louvre.

It follows that the very characteristics of Greuze's art which modern taste finds most repugnant, and which are usually attributed to a desire to solicit as wide an audience as possible, had virtually the opposite function—to screen that audience out, to deny its existence, or at least to refuse to allow the fact of its existence to impinge upon the absorbed consciousnesses of his figures. Precisely that refusal, however, seems to have given Greuze's contemporaries a deep thrill of pleasure and in fact to have transfixed them before the canvas. We have arrived at a paradox, one made all the harder to grasp by the utter transformation of sensibility between Greuze's age and ours. Those aspects of Greuze's art traditionally perceived as appealing most egregiously to the be-

[68]

holder functioned largely to neutralize the latter's presence. And because his presence was neutralized in that way, the beholder was held and moved by Greuze's paintings as by the work of no other artist of his time. It is also true that in certain of his multifigure genre paintings—the *Oeufs cassés* is an early example—one or more small children are allowed to make eye-contact with the beholder. But this chiefly serves to throw into relief the absorption of the principal figures and thereby to confirm, not contradict, the interpretation of the painting-beholder relationship that I have put forward here.[131]

42 Jean-Baptiste Greuze, *Le Fils puni,* 1778. Paris, Louvre.

In this respect too the early and mid-1750s are a watershed. Laugier's observation of 1753 that Chardin's philosopher appears so deeply absorbed in his reading and meditation that it would be hard to distract him not only indicates that Chardin's contemporaries perceived the philosopher as unconscious of their very existence but comes close to identifying the beholder as a potential agent of distraction. But perhaps the most telling evidence of an incipient problematic involving the beholder is provided by two paintings shown in the Salons of 1753[132] and 1755[133] respectively, Chardin's *L'Aveugle* (Fig. 39) and Greuze's *L'Aveugle trompé* (Fig. 40).

Greuze's canvas depicts a young wife and her lover wholly engrossed in an

effort to deceive her blind and aged husband. Indeed the young man apparently is so intent on not making a sound that without knowing it he has begun to spill the contents of the jug he carries in his right hand. In short the theme of blindness is made the basis for a narrative-dramatic structure which, as frequently in Greuze's art, asserts the primacy of absorption.[134] Chardin's painting of a blind beggar and his dog, on the other hand, does not represent an absorptive activity or condition (though probably the beggar's attitude should be seen as one of patient waiting and listening). I suggest, however, that the depiction of blindness in L'Aveugle implies a relation to the beholder that goes beyond that implied by the depiction of absorption in his other genre paintings—more precisely, that the blindness of the beggar is in effect a guarantee that that figure is unaware of the beholder's presence and is likely to remain so. In this regard the painting is a harbinger, if nothing more, of the problematic summarized above. It is characteristic of Greuze's relation to Chardin's art that he sought at once to improve on his great predecessor's invention—to make it all the more resistant to the presence of the beholder—by exploiting the theme of blindness for manifestly absorptive ends.[135]

A concern with absorption continues to play a major role in French painting and criticism throughout the rest of the eighteenth century and on into the nineteenth. In the course of the 1760s, 1770s, and 1780s, however, it is more and more assimilated to a concern with action and expression as the latter are traditionally understood—though we have only to turn to Diderot's Salons and related writings to see how important specifically absorptive considerations remain.[136] Nevertheless, it is fair to say that the emphasis both in criticism and in painting itself shifts from the representation of absorption to the representation of heroic or grandly pathetic action and expression. The contrast between the paintings by Greuze that we have examined and his dramatic masterpieces of the second half of the 1770s, Le Fils ingrat (1777; Fig. 41) and Le Fils puni (1778; Fig. 42), may be taken as illustrating this shift.[137] Only after the final collapse of the Davidian tradition, a tradition which itself epitomizes that shift of emphasis, will absorption return with a vengeance in the art of Courbet.[138]

Toward a Supreme Fiction

IN THIS CHAPTER I attempt to reinterpret a notorious crux in the theory and criticism of painting. The crux is this: How, ultimately, are we to understand the renewed importance given to the sister doctrines of the hierarchy of genres and the supremacy of history painting in the writings of Diderot and his contemporaries? As Rensselaer Lee and others have noted, both doctrines were implicit in humanist theory of painting from Alberti onwards, received explicit formulation in the writings and institutions of the Académie Royale de Peinture, and were central to the classical system that dominated artistic thinking in France until the death of Louis XIV.[1] Both were eclipsed in practice by the rise of the Rococo, whose emphases on intimacy, sensuousness, and decoration effected a sharp though only partly conscious revision of classical values. And both became crucial once more shortly before the middle of the eighteenth century when a powerful reaction against the Rococo in the name of artistic and moral reform began to take shape along a broad front.[2]

Locquin and subsequent scholars have shown that the anti-Rococo movement was promoted at the highest levels of the government by the Directeurs-Généraux des Bâtiments du Roi Lenormant de Tournehem and Marigny, in part as a deliberate attempt to recreate the grandeur of the reign of Louis XIV. For example, the official scale of fees was altered so that artists would be paid more for history paintings than for portraits; a new Ecole Royale was established to provide young painters with the background knowledge that history painting required; and altogether royal patronage was exploited to encourage history painting over other genres. As Locquin recognized, however, the reactivation of the doctrines of the hierarchy of genres and the supremacy of history painting was not simply the result of official policy. From the

start of the reaction against the Rococo in the late 1740s the leading critics and theorists of the period, men as intellectually heterodox as La Font de Saint-Yenne, Laugier, Grimm, and Diderot himself, insisted upon the axiomatic importance of those doctrines and characterized the almost complete lapse of history painting in the decades before midcentury as a cultural disaster. At the same time, they and other anti-Rococo writers responded warmly to what they felt were outstanding paintings in "lesser" genres: Diderot's praise of Chardin's still lifes in his *Salons* of the 1760s is only the most famous instance of a general state of affairs. But their appreciation of work other than history painting in no sense undercuts their often passionate advocacy of the doctrines in question. If anything it makes the fact of that advocacy all the more compelling.[3]

Historians of eighteenth-century art have without exception interpreted the doctrines of the hierarchy of genres and the supremacy of history painting in terms of an underlying and in effect determining hierarchy of categories of subject matter;[4] while some historians, going further, have represented the adherence to those doctrines on the part of anti-Rococo critics and theorists as a mistake, a glaring example of misconceived and retardataire academicism, or, alternatively, of the substitution of "literary" and moralistic values for truly "pictorial" ones. In this connection the gradual abandonment of both doctrines by nineteenth-century painters has been portrayed as an unmasking of their inessentialness if not indeed of their fallaciousness, and the achievement of Chardin has been invoked as evidence that they were without relevance to the best and most progressive paintings of the mid- and late eighteenth century.

The trouble with this account, whose authority within art history has perhaps begun to expire,[5] is that it is anachronistic. It projects upon an earlier and radically different state of affairs a vision of painting and in particular of the neutrality of subject matter precipitated by the realist art of the 1860s and 1870s and ratified by subsequent developments. It fails to give sufficient weight to the fact that the history of modern painting is traditionally—in my view, rightly—seen as having begun with David's masterpieces of the 1780s, most importantly the *Serment des Horaces* (1784, exhibited 1785), which at once established itself as paradigmatic for ambitious painting: as exemplifying, down to the smallest details of its execution, what painting had to do and be if it were to realize the highest aims open to it.[6] Now the *Horaces,* like the *Bélisaire* (1781) that preceded it and the *Socrate* (1787) and the *Brutus* (1789) that followed it, was a history painting according to the most rigorous current definition of the genre, and it is inconceivable that any works that were *not* history paintings could have had a comparably profound impact on contemporary sensibility and subsequent artistic practice. Certainly Chardin's still lifes, for all their marvelous quality and wide renown in their own time, did not have that significance for painters who came after him. This suggests that, far from having been retardataire in its implications, the adherence to the

doctrines by anti-Rococo critics and theorists ought instead to be seen as having been progressive—as having anticipated, even as having helped prepare, the next major phase in the evolution of French painting.

It is true that the critics and theorists I shall be discussing viewed their undertaking in other terms. They believed that the conception of the nature and function of painting put forward in their writings consisted essentially in the recovery, after a period of decadence, of fundamental principles discovered by the ancients and embodied in the work of the greatest sixteenth- and seventeenth-century painters (e.g., Raphael, Domenichino, Poussin, Le Sueur, Van Dyck). But the fact that they saw themselves in this light, looked to a canon of previous masters in this way, and openly derived many of their basic ideas from the writings of classical theorists does not mean that their conception of painting was merely a reformulation of earlier assumptions and imperatives.[7] And the fact that the principles they believed they found in the art of those masters are seen in retrospect to have been something other than the absolute or universal truths they took them to be in no way implies that the principles themselves were not germane to the actual situation of French painting in their time.

This is not to deny the close connection of the sister doctrines of the hierarchy of genres and the supremacy of history painting with the idea of a hierarchy of categories of subject matter. In their classical versions the sister doctrines had been grounded in the conviction, derived from Aristotle and stated forcefully by Alberti, that the art of painting at its highest consisted in the representation of significant human action;[8] and with their reactivation shortly before 1750 that conviction too became important once more.

The terms in which it was reasserted owed a great deal to the Abbé Du Bos, whose *Réflexions critiques sur la poésie et sur la peinture* (1719) strongly influenced French artistic thought of the second half of the century. Du Bos argued on empirical grounds that a painting's power to move the beholder and thereby to command his attention (and ultimately to divert him from *ennui*) was a function of the power of its subject matter to do so in real life.[9] The effect of this argument was inevitably to exalt the subject matter of history painting as traditionally conceived, in which significant action and strong passions were primary, and to downgrade subject matter wholly devoid of these, such as bowls of fruit, views of countryside without human figures, portraits of unknown men and women, genre scenes in which humble persons engage in trivial activities, and so on. "La plus grande imprudence que le Peintre ou le Poëte puissent faire," Du Bos wrote, "c'est de prendre pour l'objet principal de leur imitation des choses que nous regarderions avec indifférence dans la nature" (The most imprudent thing that a painter or poet can do is to take for the principal object of his imitation something that we would regard with indifference in nature).[10] He did not claim that paintings of still-life, landscape, or genre subjects were in all cases literally unable to interest the beholder. But he argued that the beholder's interest could be elicited only

[73]

by their technique, not their subject matter, and that consequently their power to command the beholder's attention was much weaker than that of an equally well executed painting of action and passion.[11]

The imprint of Du Bos's arguments on the thought of anti-Rococo critics and theorists is unmistakable. Thus we find the Comte de Caylus, in a lecture of 1748 to the painters of the Académie Royale, criticizing Watteau, under whom he had studied as a very young man, for the subjectlessness of all but a few of his paintings:

[Most of Watteau's compositions] n'ont aucun objet. Elles n'expriment le concours d'aucune passion, et, par conséquent, elles sont dépourvues d'une des plus piquantes parties de la peinture, je veux dire l'action. Ce genre de composition, surtout dans l'héroïque [i.e., history painting], est le sublime de votre art; c'est la partie qui parle à l'esprit, qui l'entraîne, l'occupe, l'attache et le détourne de toute autre idée.[12]

[Most of Watteau's compositions] have no subject. They express the manifestation of no passion and, consequently, they are deprived of one of the most alluring resources of painting, that is, action. That genre of composition, especially in the heroic mode [i.e., history painting], is the sublime of your art. It is the part that speaks to the mind, that transports it, engages it, holds it, and diverts it from any other idea.

A year earlier, La Font de Saint-Yenne had said: "De tous les genres de la Peinture, le premier sans difficulté est celui de l'Histoire. Le Peintre Historien est seul le Peintre de l'ame,"—that is, of the passions of the soul as they are manifested in action—"les autres ne peignent que pour les ïeux" (Of all the genres of painting, the highest is without doubt that of history. The history painter alone is the painter of the soul, the others paint only for the eyes).[13] As for Diderot, who was thoroughly familiar with Du Bos's ideas,[14] the same priorities are directly or indirectly affirmed throughout the *Salons, Essais sur la peinture* (1766), and *Pensées détachées sur la peinture* (1775–1781).[15] "La peinture est l'art d'aller à l'âme par l'entremise des yeux," he writes in the *Salon de 1765.* "Si l'effet s'arrête aux yeux, le peintre n'a fait que la moindre partie du chemin" (Painting is the art of reaching the soul through the medium of the eyes. If the effect stops at the eyes, the painter has travelled less than half the road).[16] And in his view the actions and passions of human beings were inherently more compelling, more attuned to the natural interests of the soul, than any other class of subject matter.

Diderot's admiration for Chardin, often construed as a sign of inconsistency in this regard, is in fact nothing of the sort. For Diderot as for others among his contemporaries, Chardin's greatness consisted preeminently in his ability to overcome the triviality of his subject matter by virtue of an unprecedented mastery of the means of imitation, an all but miraculous power to evoke the reality of objects, space, and air. "Si le sublime du technique n'y étoit pas," Diderot writes with characteristic vigor, "l'idéal de Chardin seroit misérable" (If the sublime of technique were not there, Chardin's ideal would be a wretched one).[17] Conversely, he believed that history paintings that were not well executed could nevertheless manage to hold the spectator's attention

[74]

on the strength of their subject matter and overall conception.[18] Even his proposed revision of the traditional distinctions among genres, far from expressing uneasiness with these priorities, radically confirmed them. For example, he suggested that Greuze and Joseph Vernet, both of whom were officially classed as painters of genre subjects, ought instead to be considered history painters because of their mastery of the representation of action. More generally, he proposed reducing the traditional multiplicity of genres to a single basic opposition, between works that imitated "la nature brute et morte" (coarse, dead nature), to be called genre painting, and works that imitated "la nature sensible et vivante" (sensitive, living nature), to be called history painting:[19] the chief virtue of that simplification being that it would encourage painters who ordinarily did not think of themselves as history painters to recognize the primacy of considerations of action for their own work. Neither suggestion broke in principle with the notion of a hierarchy of genres, and in later writings Diderot backed away from the simplifications he had earlier proposed.[20]

In sum, for Diderot and his contemporaries, as for the Albertian tradition generally, the human body *in action* was the best picture of the human soul; and the representation of action and passion was therefore felt to provide, if not quite a sure means of reaching the soul of the beholder, at any rate a pictorial resource of potentially enormous efficacy which the painter could neglect only at his peril.

But far more was at stake in the doctrines of the hierarchy of genres and the supremacy of history painting as they were held by anti-Rococo critics and theorists than simply a hierarchy of categories of subject matter. While the importance to their thought of such a hierarchy, and more broadly of considerations of subject matter, cannot be denied, the question remains whether that hierarchy and those considerations were truly fundamental, as historians of the period have supposed, or whether they were largely determined by other, ontologically prior concerns and imperatives. I believe that the latter is the case, and in the pages that follow I distinguish three functionally interdependent and in my view progressively more fundamental contexts of concern which bear directly on the opening question of this chapter. A summary of these contexts of concern will serve as a guide to the argument I now wish to pursue:

1. The repeated assertion of the primacy of subject matter of action and passion in the writings of the major critics and theorists of the anti-Rococo reaction is to be seen as one expression of a new *explicitly dramatic* conception of painting. That conception tended naturally to entail the representation of action and passion—hence the exaltation of these in contemporary criticism and theory—but cannot reciprocally be understood in terms of subject matter alone. In other words, the doctrines of the hierarchy of genres and the supremacy of history painting as they were then held evince the priority not so much of a class of subject matter as of a class of values and effects, the values and effects of the dramatic as such.

2. The new dramatic conception of painting is to be understood in turn

as the expression of a still more fundamental preoccupation with *pictorial unity*. As I shall try to show, French criticism and theory of the period insisted from the outset on the need for painting to achieve an absolutely perspicuous mode of pictorial unity, one in which the causal necessity of every element and relationship in the painting would be strikingly and instantaneously apparent. And that mode of unity, with its emphasis on compulsion, intelligibility, and instantaneousness, called for realization in and through the dramatic representation of a single moment in a single heroic or pathetic action.

3. Finally, the preoccupation with unity is itself to be seen in terms of the accomplishment of an ontologically prior relationship, at once literal and fictive, *between painting and beholder*. The nature of that relationship was fully articulated only by Diderot, but his account of it enables us to understand much that appears obscure, arbitrary, or otherwise inexplicable not merely in the criticism and theory of the age but in its painting as well. As will emerge, the relationship is identical with that adumbrated at the end of chapter one. But I shall not appeal to either the pictorial or the critical evidence brought forward in that chapter in the present discussion.

Here I might remark that throughout this chapter Diderot's writings on painting receive more attention by far than those of anyone else. There are two reasons for this. First, Diderot was not only the greatest critical intelligence but also the most prolific writer on art in France during the period in question. Second, although his *Salons* and related writings are the most extreme expression of what I think of as the radical wing of the anti-Rococo movement, the conception of painting those writings expound was in large measure characteristic of the movement as a whole. This is not to impugn the originality of his views, as is sometimes done. But it is to insist that the magnitude and nature of his originality become clear only within the context of his agreement with others. Unlike Baudelaire's art criticism, which for all its points of contact with the work of other critics represents an eccentric or at least highly idiosyncratic point of view, Diderot's criticism gives us access to a vision of painting that was held almost communally, though in crucial respects unconsciously, by a considerable number of contemporaries—painters as well as writers on painting. It is as though almost before his debut as a *salonnier* Diderot pursued to their logical and ontological conclusions a body of assumptions about the nature and purposes of painting which were widely shared but which in the writings of all but a handful of his colleagues remained mostly unexplored, undeveloped, and divorced from their profoundest implications.

<center>∽⌀⌇</center>

The new explicitly dramatic conception of painting that began to emerge in France around 1750 had important sources in previous theory. Here for example is a characteristic passage from Antoine Coypel:

Aristote dit que la tragédie est une imitation d'une action, et par conséquent elle est principalement une imitation de personnes qui agissent. Ce que ce philosophe dit de

la tragédie convient également à la peinture, qui doit par l'action et par les gestes exprimer tout ce qui est du sujet qu'elle représente. . . .[21]

Aristotle says that tragedy is an imitation of an action, and consequently it is first and foremost an imitation of people in action. What the philosopher says of tragedy applies equally well to painting, which must express by means of action and gestures all that pertains to the subject that it represents. . . .

Or, to take another example, here is Du Bos's explanation of why, despite what he believed to be painting's greater power over the soul, tragedies in the theater often made one weep whereas paintings with very rare exceptions did not:

[U]ne Tragédie renferme une infinité de tableaux. Le Peintre qui fait un tableau du sacrifice d'Iphigénie, ne nous représente sur la toile qu'un instant de l'action. La Tragédie de Racine met sous nos yeux plusieurs instans de cette action, & ces différens incidens se rendent réciproquement les uns les autres plus pathétiques.[22]

A tragedy contains an infinite number of *tableaux*. The painter who makes a painting of the sacrifice of Iphigenia represents for us on the canvas only one moment of the action. Racine's tragedy puts before our eyes several moments of this action, and these various incidents enhance one another's pathos.

In Roger De Piles's succinct formulation: "On doit considérer un tableau comme une scène, où chaque figure joue son rôle" (One must think of a painting as a stage, on which each figure plays its role).[23]

More broadly, the view that "expressive movement is the life blood of all great painting" had been central to the critical tradition of classicism in Italy and had been codified and adapted to prevailing Cartesian ideas by the theorists of the Académie Royale.[24] But there is nothing in the writings of Coypel and Du Bos, or Dufresnoy, Fréart de Chambray, Le Brun, Testelin, Félibien, and De Piles, or for that matter the Englishmen Shaftesbury, Richardson, and Harris, that more than prepared the ground for the comprehensive rapprochement between the aims of painting and drama that took place in France in the second half of the eighteenth century. Greuze's multifigure genre paintings from 1755 onwards mark a crucial sequence of phases in that rapprochement within painting itself. In criticism, the *Salons* of Grimm (1753, 1755, and 1757) and Laugier (1753) are early statements whose historical significance has perhaps never fully been appreciated.[25] But it is in Diderot's writings of the 1750s and 1760s that the new relations between painting and drama received their fullest and most influential articulation, and in the interests of economy of exposition I shall restrict myself to them.

Diderot's vision of those relations is expounded in his two early treatises on the theater, the *Entretiens sur le Fils naturel* (1757) and the *Discours de la poésie dramatique* (1758),[26] in which he called for the development of a new stage dramaturgy that would find in painting, or in certain exemplary paintings, the inspiration for a more convincing representation of action than any provided by the theater of his time. (The single painting that meant most to him in that regard was Poussin's *Testament d'Eudamidas,* a work already discussed in con-

nection with the primacy of considerations of absorption.) Specifically, Diderot urged playwrights to give up contriving elaborate *coups de théâtre* (surprising turns of plot, reversals, revelations), whose effect he judged to be shallow and fleeting at best, and instead to seek what he called *tableaux* (visually satisfying, essentially silent, seemingly accidental groupings of figures), which if properly managed he believed were capable of moving an audience to the depths of its collective being.[27] The spectator in the theater, he maintained, ought to be thought of as before a canvas, on which a series of such *tableaux* follow one another as if by magic.[28] Accordingly he stressed the values of pantomime as opposed to declamation, of expressive movement or stillness as opposed to mere proliferation of incident, and called for the institution of a stage space devoid of spectators which in conjunction with painted scenery would allow separate but related actions to proceed simultaneously, thereby providing a more intense because more pictorial dramatic experience than the French theater had hitherto envisaged.[29] The *Entretiens* and the *Discours* were not Diderot's first explorations of these ideas. As early as 1751, in the *Lettre sur les sourds et muets,* he put forward a notion of the gestural or situational sublime, citing as an example Lady Macbeth walking in her sleep and obsessively washing her hands:

[I]l y a des gestes sublimes que toute l'éloquence oratoire ne rendra jamais. Tel est celui de Mackbett dans la tragédie de Shakespear. La somnambule Mackbett s'avance en silence & les yeux fermés sur la scene, imitant l'action d'une personne qui se lave les mains, comme si les siennes eussent encore été teintes du sang de son Roi. . . . Je ne sais rien de si pathétique en discours que le silence & le mouvement des mains de cette femme. Quelle image du remords![30]

There are sublime gestures that no oratorical eloquence will ever express. One such is that of Lady Macbeth in Shakespeare's tragedy. The sleepwalking Lady Macbeth advances in silence and with closed eyes, imitating the action of a person washing her hands, as if her own were still stained with the blood of her king. . . . I know of no discourse so full of pathos as the silence and the motions of this woman's hands. What an image of remorse!

He went on to compare the position of a beholder of a painting with that of a deaf person watching mutes converse among themselves by sign language on subjects known to him:

Ce point de vue est un de ceux sous lesquels j'ai toujours regardé les tableaux qui m'ont été présentés; & j'ai trouvé que c'étoit un moyen sûr d'en connoître les actions amphibologiques & les mouvemens équivoques; d'être promptement affecté de la froideur ou du tumulte d'un fait mal ordonné ou d'une conversation mal instituée; & de saisir dans une scene mise en couleurs tous les vices d'un jeu languissant ou forcé.[31]

This point of view is one from which I have always examined paintings presented to me. And I have found that it is a sure means of recognizing ambiguous actions and equivocal movements, of being quickly affected by the coldness or the confusion of a poorly organized incident or of a poorly arranged conversation, and of perceiving in a painted scene all the vices of a dull or strained performance.

And he recounted how when he wanted to gauge the expressive power of actors' gestures he would attend a performance of a play familiar to him, sit far back in the hall, and stop his ears.[32]

Diderot's first *Salon* was written for Grimm's *Correspondance littéraire* in 1759, the year after the composition of the *Discours,* and, as some historians have recognized, the same emphases and priorities that characterize his writings on theater inform his criticism of painting.[33] Probably the most striking of these is his abhorrence of the conventional, the mannered, and the declamatory, and his unqualified insistence that representations of action, gesture, and facial expression actually convey what they ostensibly signify. That insistence stood in implicit opposition to Academic practice, which despite profuse verbal acknowledgment of the virtues of naturalness and truth of expression by Academic theorists tended mostly to perpetuate a limited repertory of postures and attitudes derived from the work of a few sixteenth- and seventeenth-century painters, notably Raphael and Poussin. And it signalled a major difference between Diderot's dramatic conception of painting on the one hand and late seventeenth- and early eighteenth-century equations of painting and tragedy on the other. Far from agreeing with Coypel that "tout contribue dans les spectacles à l'instruction du peintre" (everything in theatrical productions contributes to the instruction of the painter),[34] a claim advanced just a few paragraphs before the passage quoted above, Diderot held that the actual influence on painting of traditional theatrical conventions had been catastrophic, and called for the reform of the theater through a conception of the pictorial which, although based in part on a canon of works by the same sixteenth- and seventeenth-century masters, affirmed as never before the radical primacy of dramatic and expressive considerations.[35] Similarly, when Du Bos wrote that "une Tragédie renferme une infinité de tableaux" he meant by *tableaux* simply the visual component of the stage action at different points in the play, whereas Diderot contended that the stage conventions of the classical theater produced artificial, inexpressive, and undramatic groupings of figures, groupings that were the antithesis of what the concept of the *tableau* meant to him. This too affirmed the primacy of dramatic and expressive considerations for painting at least as much as it asserted the importance of visual or pictorial considerations for drama.

The new and in a sense anticlassical emphasis on violent emotion and extreme effects that stamps Diderot's writings on painting almost from the first is chiefly to be seen in this light. "On peut, on doit en sacrifier un peu au technique," he writes in the *Essais.* "Jusqu'où? je n'en sais rien. Mais je ne veux pas qu'il en coûte la moindre chose à l'expression, à l'effet du sujet. Touche-moi, étonne-moi, déchire-moi; fais-moi tressaillir, pleurer, frémir, m'indigner d'abord; tu récréeras mes yeux après, si tu peux" (One can, one must sacrifice something to technique. How much? I do not know. But I do not want that sacrifice to cost anything as regards the expression, the effect of the subject. First touch me, astonish me, tear me apart; startle me, make me cry, shudder,

arouse my indignation; you will please my eyes afterward, if you can).[36] Thus his attraction to subject matter verging on the horrific, such as scenes of Christian martyrdom, and in general his taste for subjects and effects which modern scholars are perhaps too quick to call melodramatic;[37] his recommendation that the passions be represented at their most extreme relative to a given subject;[38] his claim that in every genre extravagance is preferable to coldness;[39] his involvement as early as the *Lettre sur les sourds et muets* with notions of the sublime;[40] and his admiration for the "verve brûlante" and "chaleur d'âme" (ardent verve [and] warmth of soul), the innate dramatic and expressive powers, of artists like Vernet, Van Loo at his best, Greuze, the Fragonard of the *Corésus et Callirhoé,* Deshays, Doyen, Casanove, Loutherbourg, Durameau, and the young David.[41] I suggest too that his insistence that a painting be an *exemplum virtutis* or lesson in virtue, a position usually taken at face value as indicating a moralistic if not grossly sentimental attitude toward art, ought instead to be understood as urging a body of subject matter and an approach toward that subject matter which together not only enabled but demanded maximum intensity of dramatic effect. As Diderot has Dorval argue in the *Entretiens:* inasmuch as the object of a dramatic composition is to inspire in men a love of virtue and a horror of vice, "dire qu'il ne faut les émouvoir que jusqu'à un certain point, c'est prétendre qu'il ne faut pas qu'ils sortent d'un spectacle, trop épris de la vertu, trop éloignés du vice. Il n'y aurait point de poétique pour un peuple qui serait aussi pusillanime. Que serait-ce que le goût; et que l'art deviendrait-il, si l'on se refusait à son énergie, et si l'on posait des barrières arbitraires à ses effets?" (to say that one can move them only up to a certain point is to claim that they must not leave a performance too taken with virtue, too estranged from vice. There would be no poetics for a people so pusillanimous. What would taste be, and what would become of art, if one rejected its energy and if one set arbitrary limits to its effects?)[42] The same validation of unconstrained intensity of expression, and the same vision of the conflict between good and evil, virtue and vice, justice and injustice, as a natural medium of drama are implicit in the famous passage in the *Essais* that begins: "Rendre la vertu aimable, le vice odieux, le ridicule saillant, voilà le projet de tout honnête homme qui prend la plume, le pinceau ou le ciseau" (To make virtue attractive, vice odious, the ridiculous striking, such is the aim of any honest man who takes up the pen, the brush, or the chisel).[43]

Moreover, the morality that such a view of art implies is not exactly that of ordinary life. As Diderot writes in the *Salon de 1767:* "Nous aimons mieux voir sur la scène l'homme de bien souffrant que le méchant puni, et sur le théâtre du monde, au contraire, le méchant puni que l'homme de bien souffrant. C'est un beau spectacle que celui de la vertu sous les grandes épreuves; les efforts les plus terribles tournés contre elle ne nous déplaisent pas" (On stage we prefer to see the righteous man suffering rather than the wicked man punished, and in the theater of life, on the contrary, we prefer to see the wicked man punished rather than the righteous man suffering. The spectacle of virtue undergoing

great ordeals is a beautiful one; the most dreadful efforts directed against virtue do not displease us).[44] Indeed his feeling for the dramatic conflict of moral opposites has even more unorthodox, not to say Balzacian, consequences: "Je hais toutes ces petites bassesses qui ne montrent qu'une ame abjecte; mais je ne hais pas les grands crimes: premièrement, parce qu'on en fait de beaux tableaux et de belles tragédies; et puis, c'est que les grandes et sublimes actions et les grands crimes, portent le même caractère d'énergie" (I hate all those petty base actions that reveal nothing but an abject soul, but I do not hate great crimes: first, because they are the stuff of beautiful paintings and beautiful tragedies; and also, because great and sublime actions and great crimes embody the same character of energy).[45] And in a striking passage he embraces the possibility that the morality of artistic creation itself is perhaps the reverse of ordinary morality:

[J]'ai bien peur que l'homme n'allât droit au malheur par la voie qui conduit l'imitateur de Nature au sublime. Se jetter dans les extrêmes, voilà la règle du poëte, garder en tout un juste milieu, voilà la règle du bonheur. Il ne faut point faire de poésie dans la vie. Les héros, les amants romanesques, les grands patriotes, les magistrats inflexibles, les apôtres de religion, les philosophes à toute outrance, tous ces rares et divins insensés font de la poésie dans la vie, de là leur malheur. Ce sont eux qui fournissent après leur mort aux grands tableaux, ils sont excellens à peindre.[46]

I am afraid that the man goes straight to misfortune by the same path that leads the imitator of nature to the sublime. Going to extremes is the poet's rule; observing the golden mean in everything is the rule of happiness. Poetry has no place in life. Heroes, romantic lovers, great patriots, unyielding magistrates, apostles of religion, philosophers to the death, all these rare and divine madmen create poetry in life, hence their misfortune. They are the ones who, after they die, provide the subject matter of great paintings; they are excellent to paint.

Of course moral considerations mattered to Diderot in their own right. But his advocacy of the moral mission of painting must also be understood in the context of his dramatic conception of that art, a conception that was itself far from unambiguously moral in its implications.

The reach of that conception was not limited to representations of action and passion. A version of it extended even to the genre of still life, improbable though this may seem. "Il y a une loi pour la peinture de genre et pour les groupes d'objets pêle-mêle entassés," Diderot writes in the *Pensées détachées*. "Il faudrait leur supposer de la vie, et les distribuer comme s'ils s'étaient arrangés d'eux-mêmes, c'est-à-dire avec le moins de gêne et le plus d'avantage pour chacun d'eux" (There is a law for genre painting and for groups of objects piled up pell-mell. One must suppose that they are animated and must distribute them as if they had arranged themselves, that is, with the least constraint and to the best advantage of each of them).[47] In other words, the still-life painter had to persuade the beholder that the objects in his painting had arrived as if without intervention at their own best expression; and this, it is clear, amounted to an essentially dramatic illusion. In the *Salons* themselves a drama-

tic component in Diderot's vision of Chardin's still lifes comes to the fore in his attempts to provide an account of the latter by giving directions for staging them. "Choisissez son site; disposez sur ce site les objets comme je vais vous les indiquer, et soyez sûr que vous aurez vu ses tableaux" (Choose his site. Arrange the objects on that site according to my instructions, and you may be assured that you will have seen his paintings), he writes in the *Salon de 1765*,[48] and goes on to recreate several paintings in this manner. The same *Salon* contains Grimm's announcement, in an editorial aside, that he has seen "des sociétés choisies, rassemblées à la campagne, s'amuser pendant les soirées d'automne à un jeu tout-à-fait intéressant et agréable. C'est d'imiter les compositions de tableaux connus avec des figures vivantes" (select companies, gathered in the country during autumn evenings, playing at a wholly interesting and pleasant game. It consists in imitating compositions of well-known paintings with living figures).[49] Diderot's evocations of Chardin's still lifes in the *Salon de 1765* may be read as directions for staging them as *tableaux vivants,* just as the contemporary practice of staging *tableaux vivants* may be seen in turn as an expression of the same demand for the dramatization of painting that was active in Diderot's artistic thought from the beginning.

Finally, his strong distaste for symmetry in painting expressed that demand in almost abstract terms. As he argues in the *Pensées détachées:* "La symétrie, essentielle dans l'architecture, est bannie de tout genre de peinture. La symétrie des parties de l'homme y est toujours détruite par la variété des actions et des positions; elle n'existe pas même dans une figure vue de face et qui présente ses deux bras étendus" (Symmetry, essential in architecture, is banished from every genre of painting. There the symmetry of the parts of the human body is always destroyed by the variety of actions and positions. It does not even exist in a figure seen from the front and presenting its two arms outstretched).[50] The close connection, as Diderot saw it, between asymmetry on the one hand and action and movement on the other could not be more explicit; and this strongly suggests that his call for the banishment of symmetry from all genres of painting, including those from which the human figure is absent, is a further index of the primacy of dramatic considerations in his vision of painting altogether.[51] Not surprisingly, however, such a vision tended principally to seek fulfillment in and through the representation of action and passion, the raw materials of drama par excellence, and therefore to affirm the doctrine of a genre hierarchy rather than to grant all genres equal status.

<p style="text-align:center">❧</p>

The demand for unity, expressed in concepts derived from classical drama, had been a cornerstone of seventeenth- and early eighteenth-century pictorial theory in France. As Lee has remarked, Academicians like Le Brun and Testelin habitually analyzed pictures "in terms of the logical dramatic relationship of each figure in the painting to the cause of his emotion," on the principle

that "every element in a painting whether formal or expressive must . . . unfailingly contribute to the demonstration of a central thematic idea."[52] Thus Le Brun praised Poussin's *Israelites Gathering Manna* for its unity of action, which he seems to have regarded as all the more impressive because of the painting's many figures and diversity of actions and expressions. "Comme l'auteur de cette peinture est admirable dans la diversité des mouvements," Le Brun is reported to have said, "et qu'il sait de quelle sorte il faut donner la vie à ses figures, il a fait que toutes leurs diverses actions et leurs expressions différentes ont des causes particulières qui se rapportent à son principal sujet" (How admirably the author of this painting captures the diversity of movements, and how well he knows how to give life to his figures; he has managed it so that all their diverse actions and various expressions have particular causes related to his main subject).[53] The notion of unity of action was closely linked to one of unity of time, which like the first was based on an analogy with drama. Roughly, a painter was held to be limited to the representation of a single moment in an action, an idea that brought certain crucial differences between the two arts, if not yet into focus, at least into view.[54] Classical theorists were by no means in complete agreement as to the strictness with which this law was to be observed.[55] By and large, however, what was felt to be important was not the apparent instantaneousness of the representation but rather that the painter, having made the best possible choice among the principal phases of the action, confine himself to that phase and not trespass upon the others more than was absolutely necessary for the most effective presentation of his subject. Above all, the juxtaposition within the same canvas of manifestly incompatible or contradictory phases of the same action was to be avoided in the interest of *vraisemblance.* Failure to observe these strictures was held to result in a loss not only of unity but also of intelligibility. Shaftesbury for example stated as an axiom "that what is principal or chief, should immediately shew itself, without leaving the mind in any uncertainty." And this was plainly not the case when the beholder was "left in doubt, and unable to determine readily, which of the distinct successive parts of the history or action is that very one represented in the design."[56] (Unity of action and of time were inconceivable apart from unity of place, which is probably why that notion, as distinguished from questions of the historical or archaeological accuracy of particular sites, appears to have been taken more or less for granted by classical writers.) Intelligibility also depended in large measure on the beholder's familiarity with the subject represented, as Du Bos recognized perhaps more clearly than any theorist before him.[57] In addition, classical writers, especially De Piles, stressed the role of *clair-obscur,* chiaroscuro, in promoting unity of effect.[58]

All these concerns were shared by critics and theorists of the anti-Rococo reaction, whose preoccupation with unity was an extension of the views of their classical predecessors. But there is a shift of emphasis and in particular an assertion of the claims of actual experience in the writings of the later men that

signal not just a revised order of priorities but a transformed vision of the aims and essence of painting. Diderot's conception of unity of action, indebted as it was to earlier ideas, is a case in point. In contrast for example to Le Brun and Du Bos he called for the elimination of all incident, however appealing in its own right, that did not contribute directly and indispensably to the most dramatic and expressive presentation of the subject that could be imagined:

[L]es groupes qui multiplient communément les actions particulières doivent aussi communément distraire de la scène principale. Avec un peu d'imagination et de fécondité, il s'en présente de si heureuses qu'on ne saurait y renoncer; qu'arrive-t-il alors? c'est qu'une idée accessoire donne la loi à l'ensemble au lieu de la recevoir. Quand on a le courage de faire le sacrifice de ces épisodes intéressans, on est vraiment un grand maître, un homme d'un jugement profond; on s'attache à la scène générale qui en devient tout autrement énergique, naturelle, grande, imposante et forte.[59]

The groups that usually multiply the number of individual actions will also usually distract from the main scene. If the artist has even a little imagination and fecundity, the groups that will occur to him will be so attractive that they can hardly be renounced. What happens then? An accessory idea governs the whole instead of being governed by it. When one has the courage to sacrifice those compelling episodes, one is truly a great master, a man of profound judgment. The latter applies himself to the general scene which becomes all the more energetic, natural, grand, imposing, and powerful.

A composition, he argued, cannot afford "aucune figure oisive, aucun accessoire superflu. Que le sujet en soit un" (any idle figure, any superfluous accessory. The subject must be one).[60] In that spirit he praised an oil sketch by Carle Van Loo for having "un intérêt, un, une action, une. Tous les points de la toile disent la même chose: chacun à sa façon" (an interest that is one, an action that is one. Every bit of the canvas says the same thing, each in its own way).[61] And in the *Pensées détachées* he summed up one of the major themes of his criticism in the statement: "Rien n'est beau sans unité; et il n'y a point d'unité sans subordination. Cela semble contradictoire; mais cela ne l'est pas" (Nothing is beautiful without unity, and there is no unity without subordination. This appears contradictory, but it is not).[62] Any failure to declare the unity of action as strongly and as perspicuously as possible amounted, in Diderot's view, to a failure of composition, a term that comprised considerations of action and expression, though not necessarily to a failure of *ordonnance*, which concerned the arrangement of figures and objects across the surface of the canvas. That distinction, under various names, was fundamental to seventeenth- and eighteenth-century criticism and theory but disappeared in the nineteenth. In Diderot's writing the distinction is underscored and at the same time rendered almost otiose by his assertion of the absolute primacy of drama and expression: "On a prétendu que l'ordonnance était inséparable de l'expression. Il me semble qu'il peut y avoir de l'ordonnance sans expression, et que rien même n'est si commun. Pour de l'expression sans ordonnance, la chose me paraît plus rare, surtout quand je considère que le moindre accessoire superflu

nuit à l'expression, ne fût-ce qu'un chien, un cheval, un bout de colonne, une urne" (It has been claimed that *ordonnance* is inseparable from expression. It seems to me that there can be *ordonnance* without expression, and that in fact nothing is more common. As for expression without *ordonnance,* such a thing seems to me more rare, especially when I consider that the smallest superfluous accessory injures expression, be it only a dog, a horse, the base of a column, an urn).[63] The point is not simply that in his view compositional unity entailed unity of *ordonnance* whereas the reverse was not the case. It is also that for Diderot, as to a greater or lesser degree for other anti-Rococo critics and theorists, a painting had to do more than demonstrate a central dramatic idea: it had to set that idea in motion, in dramatic action, right before his eyes. And the question he seems always to have asked himself is not whether a particular painting could be shown to possess an internal rationale that justified and in that sense bound together the different actions, incidents, and facial expressions represented in it, but whether his actual experience of the painting, prior to any conscious act of reflection or analysis, persuaded him beyond all doubt of the work's dramatic and expressive unity.

Perhaps the sharpest difference between Diderot's and the classical theorists' respective conceptions of pictorial unity concerns the idea of causality, which as already noted played a major role in French Academic thought (cf. Le Brun's remarks on Poussin quoted above). "La principale idée [of a painting], bien conçue, doit exercer son despotisme sur toutes les autres," Diderot writes in the *Essais.* "C'est la force motrice de la machine qui, semblable à celle qui retient les corps célestes dans leurs orbes et les entraîne, agit en raison inverse de la distance" (The principal idea [of a painting], properly conceived, must exercise its despotism over all the others. It is the driving force of the machine, which, like the force that maintains the celestial bodies in their orbits and carries them along, acts in inverse ratio to distance).[64] The machine-painting analogy was a traditional one, as in De Piles's statement that a painting ought to be regarded "comme une machine dont les pièces doivent être l'une pour l'autre & ne produire toutes ensembles qu'un même effet" (as a machine the parts of which must exist for each other and produce all together a single effect).[65] But for De Piles and other classical writers the point of the simile was chiefly the idea of an internal accord and mutual adjustment of parts—in general, what in classical theory were characterized as causes are perhaps better described as ostensible occasions for the action or expression of individual figures or groups of figures—whereas for Diderot unity of action and beyond that the unity of the painting as a whole involved nothing less than an illusion of the inherent dynamism, directedness, and compulsive force of causation itself. "Une composition doit être ordonnée de manière à me persuader qu'elle n'a pu s'ordonner autrement," he writes in one of the most important of the *Pensées détachées,* "une figure doit agir ou se reposer, de manière à me persuader qu'elle n'a pu agir autrement" (A composition must be organized so as to persuade me that it could not be organized otherwise; a

figure must act or rest so as to persuade me that it could not do otherwise).[66] He demanded persuasion not demonstration, determinism not logic.

Moreover, as Diderot's reference to the celestial bodies and the force of gravity suggests, there was in his view a strict parallel between nature and art, or rather between what nature is and what art ought to be. An explicit and wholly characteristic statement to that effect appears in his review of Watelet's didactic poem, *L'Art de peindre* (1760):

Tout détruit l'ensemble dans une figure supposée parfaite; l'exercice, la passion, le genre de vie, la maladie; il paraît qu'il n'y eut jamais qu'un homme, et dans un instant, en qui l'ensemble fût sans défaut: c'est Adam au sortir de la main de Dieu; mais ne peut-on pas dire, en prenant l'ensemble sous un point de vue plus pittoresque, qu'il n'est jamais détruit ni dans la nature, où tout est nécessaire, ni dans l'art, lorsqu'il sait introduire dans ses productions cette nécessité? Mais quelle suite d'observations, quel travail cette science ne demande-t-elle pas? En revanche, le succès de l'ouvrage est assuré. Cette nécessité introduite fait le sublime. . . . [67]

Everything destroys the ensemble in a supposedly perfect figure: exercise, passion, style of life, illness. It seems that only one man ever existed, and he only for a moment, in whom the ensemble was flawless—Adam as he issued from God's hand. But cannot one say, considering the ensemble from a more pictorial point of view, that it is never destroyed either in nature, where everything is necessary, or in art, when art knows how to introduce that necessity into its productions? But what a host of observations, what labor are required by this science. On the other hand, the success of the work is assured. That necessity bodied forth in it produces the sublime. . . .

The implications of this view for the representation of the human figure were irrevocably opposed both to any abstract or ideal canon of proportion and to any excessive demonstration of anatomical knowledge.[68] In Herbert Dieckmann's summary:

Chaque fonction que le corps remplit exerce un effet non seulement sur une de ses parties, mais sur le corps tout entier. Il y a une "conspiration générale des mouvements," une interdépendance de toutes les parties, que l'artiste doit connaître et sentir pour les représenter. . . . Ce qui est "imité," c'est la manifestation de certaines lois, l'expression de certaines fonctions; l'une et l'autre n'existent que pour celui qui sait former l'idée d'un tout, d'un ensemble de causes et d'effets.[69]

Each function performed by the body has an effect not only upon one of its parts but upon the whole body. There is a "general conspiracy of movements," an interdependency of all the parts, which the artist must know and feel in order to represent them. . . . What is "imitated" is the manifestation of certain laws, the expression of certain functions. The one and the other exist only for him who knows how to form the idea of a whole, of an ensemble of causes and effects.

And as Diderot insisted, the painting as a whole had also to be just such a dramatic and expressive system of causes and effects: "L'on dit l'ensemble d'une figure, on dit aussi l'ensemble d'une composition. L'ensemble de la figure consiste dans la loi de nécessité de nature, étendue d'une de ses parties à

l'autre; l'ensemble d'une composition, dans la même nécessité, dont on étend la loi à toutes les figures combinées" (One speaks of the ensemble of a figure, one also speaks of the ensemble of a composition. The ensemble of the figure consists in the law of natural necessity extending from one of its parts to the other; the ensemble of a composition consists in the same necessity, whose law is extended to the combination of all the figures).[70] In short, for Diderot pictorial unity was a kind of microcosm of the causal system of nature, of the universe itself; and conversely the unity of nature, apprehended by man, was, like that of painting, at bottom dramatic and expressive.[71]

It is in this connection that Diderot's account of the dramatic significance of *clair-obscur* ought chiefly to be seen. Its principal function, he writes, is "d'empêcher l'oeil de s'égarer, en le fixant sur certains objets" (to prevent the eye from straying, by fixing its gaze on certain objects):[72] thus a few large and strong contrasts of light and dark were usually preferable to a multiplicity of smaller ones, which tended to produce the attention-dispersing effect known as *papillotage*.[73] Once again Diderot went further than pre-Rococo theorists, and further too than his contemporaries, in his characterization of *clair-obscur* as a medium of the unity of dramatic effect of nature itself, for example in a remarkable passage that describes the play of late afternoon light and shadow among actual trees, branches, and leaves, and concludes:

Nos pas s'arrêtent involontairement; nos regards se promènent sur la toile magique, et nous nous écrions: "Quel tableau! Oh! que cela est beau!" Il semble que nous considé-rions la nature comme le résultat de l'art; et, réciproquement, s'il arrive que le peintre nous répète le même enchantement sur la toile, il semble que nous regardions l'effet de l'art comme celui de la nature. Ce n'est pas au Salon, c'est dans le fond d'une forêt, parmi les montagnes que le soleil ombre et éclaire, que Loutherbourg et Vernet sont grands.[74]

Our steps halt involuntarily, our eyes wander over the magic canvas, and we exclaim: "What a painting! Oh! How beautiful!" It seems that we consider nature to be the result of art, and, conversely, if the painter happens to repeat for us the same en-chantment on the canvas, it seems that we consider the effect of art to be that of nature. It is not at the Salon but rather in the heart of a forest, amid mountains shaded and lit by the sun, that Loutherbourg and Vernet are great.

What made so powerful and enthralling an experience possible was the convic-tion of absolute necessity elicited by painting through the management of *clair-obscur* and by nature through its infinitely subtle and of course causally determined effects of light and shade.[75] Except in very rare cases, however, this illusion lay beyond the power of the landscape painter's art. And in gen-eral Diderot's causal conception of pictorial unity tended overwhelmingly to reinforce the doctrines of the hierarchy of genres and the supremacy of history painting, for the simple reason that subjects involving action and passion lent themselves far more readily than any others to an overtly dramatic and express-ive presentation both of causal relations in their multifariousness and of the entire subsumption of those relations in a necessary whole.

If Diderot's contemporaries could not match his vision of the relationship between pictorial unity and causality, he and they were very nearly of one mind in demanding that pictorial unity be instantaneously apprehensible and in maintaining that to the extent that a painting did not satisfy that condition the painter had failed to achieve his proper objective. As Caylus argues in "De la Composition" (1750):

[La composition] n'a qu'un instant pour objet, auquel il est nécessaire que tout se rapporte et que tout concoure, mais si parfaitement que rien ne peut excuser les altérations de ce rapport; l'oeil le moins sévère ne peut les pardonner; dès l'instant que ce même oeil aperçoit, il doit tout embrasser, et ne peut souffrir d'être arrêté par la plus légère bagatelle dont l'ordre et la convenance puissent être blessés; en un mot, il est indispensable de l'éclairer, de l'attirer et de le retenir. Ces impressions qui doivent saisir le premier coup d'oeil sont exigées, non par des lois qu'on se soit imposées, mais par l'essence de la peinture et par la seule obligation où l'esprit se trouve alors de parler directement à l'esprit.[76]

[Composition] has only one moment for its object, to which everything must be related and in terms of which everything must be organized, but so perfectly that nothing can excuse any departure from that relationship. The least severe eye cannot forgive such a departure; from the very moment when that eye perceives the painting, it must embrace everything and cannot bear to be stopped by the slightest trifle that might offend order or propriety. In short, it is indispensable that the eye be informed, attracted, and held. These impressions that must seize the first glance are required not by laws that one has imposed upon oneself but by the very essence of painting and by the obligation that the mind is under to speak directly to other minds.

And in the *Correspondance littéraire* for 15 December 1756, Grimm expands on the double theme of unity and instantaneousness in a long passage whose extraordinary importance has to my knowledge never been recognized:

Les grandes machines en peinture et en poésie m'ont toujours déplu. S'il est vrai que les arts en imitant la nature n'ont pour but que de toucher et de plaire, il faut convenir que l'artiste s'en écarte aussi souvent qu'il entreprend des poëmes épiques, des plafonds, des galeries immenses, en un mot, ces ouvrages compliqués auxquels on a prodigué dans tous les temps des éloges si peu sensés. La simplicité du sujet, l'unité de l'action, sont non-seulement ce qu'il y a de plus difficile en fait de génie et d'invention, mais encore ce qu'il y a de plus indispensable pour l'effet. Notre esprit ne peut embrasser beaucoup d'objets, ni beaucoup de situations à la fois. Il se perd dans cette infinité de détails dont vous croyez enrichir votre ouvrage. Il veut être saisi au premier coup d'oeil par un certain ensemble, sans embarras et une [*sic*] manière forte. Si vous manquez ce premier instant, vous n'en obtiendrez que ces éloges raisonnés et tranquilles qui sont la satire et le désespoir du génie. . . . Pour moi, j'avoue franchement que jamais je n'ai vu une galerie ou un plafond, ni lu un poëme épique sans une certaine fatigue et sans sentir diminuer cette vivacité avec laquelle nous recevons les impressions de la beauté.[77]

I have always disliked enormous constructions in painting and in poetry. If it is true that in imitating nature the arts have no other aim than to move and to please, one must admit that the artist strays from his aim as often as he undertakes epic poems, painted ceilings, immense galleries, in a word, those complicated works that

throughout the ages have received such injudicious praise. Simplicity of subject and unity of action are not only what is most difficult when it comes to genius and invention, but also what is most indispensable as regards overall effect. Our mind cannot embrace many objects or many situations at the same time. It gets lost in that infinity of details with which you believe you enrich your work. It wants to be struck at first glance by a certain ensemble, without hindrance and in a strong manner. If you miss this first instant, you will obtain nothing but those reasoned and tranquil praises that constitute the satire and the despair of genius. . . . As for myself, I frankly admit that I have never seen a gallery or ceiling nor read an epic poem without a certain weariness and without feeling a diminution of that vivacity with which we receive impressions of beauty.

Grimm's remarks signal the end of the Renaissance and Baroque—and Rococo—elision of easel painting and decoration. The new emphasis on unity and instantaneousness was by its very nature an emphasis on the *tableau,* the portable and self-sufficient picture that could be taken in at a glance, as opposed to the "environmental," architecture-dependent, often episodic or allegorical project that could not.[78]

The articulation of that emphasis marks an epoch in the prehistory of modern painting (or perhaps I should say modern pictorial thought). Its closest anticipation is found in Shaftesbury's "A Notion of the Historical Draught or Tablature of the Judgment of Hercules" (1712), which begins:

Before we enter on the examination of our historical sketch, it may be proper to remark, that by the word Tablature (for which we have yet no name in English, besides the general one of picture) we denote, according to the original word Tabula, a work not only distinct from a mere portraiture, but from all those wilder sorts of painting which are in a manner absolute and independent [i.e., not subject to the demand for unity]; such as the paintings in fresco upon the walls, the ceilings, the staircases, the cupola's, and other remarkable places either of churches or palaces.[79]

Shaftesbury goes on to explain: "[W]e may give to any particular work the name of Tablature, when the work is in reality 'a single piece, comprehended in one view, and formed according to one single intelligence, meaning, or design; which constitutes a real whole, by a mutual and necessary relation of its parts, the same as of the members in a natural body.'"[80] The French equivalent of Tabula, used by Shaftesbury in the original version of his treatise published in the *Journal des Sçavans,* was of course *tableau,* which carried something of the same honorific connotations—roughly, of an achieved unity— that he tried to bring over into English by the word *Tablature.* But it was only around the middle of the eighteenth century in France that advanced taste began decisively to turn against the decorative and architecture dependent in the name of unity, instantaneousness, and self-sufficiency, and when that happened the concept of the *tableau* emerged with greatly enhanced significance.[81]

Furthermore, as the passages from Caylus and Grimm suggest, the demand that pictorial unity be apprehended at a glance, in a single *coup d'oeil,* was implicitly a demand that the painting as a whole be instantaneously and,

within reasonable limits, universally intelligible. Indeed what might be called radical intelligibility was a major theme of anti-Rococo criticism and theory, though once again the implications of that theme were developed more fully by Diderot than by anyone else. "Une composition, qui doit être exposée aux yeux d'une foule de toutes sortes de spectateurs, sera vicieuse, si elle n'est pas intelligible pour un homme de bon sens tout court" (A composition, which must be exposed to the eyes of a crowd of all sorts of beholders, will be faulty if it is not intelligible to a man of simple common sense), he writes in the *Essais*.[82] This was rarely true of allegorical paintings, which Diderot along with others among his contemporaries, and unlike almost all pre-Rococo writers, found cold, obscure, and uninteresting: "[J]e tourne le dos à un peintre qui me propose un emblème, un logogriphe à déchiffrer. Si la scène est une, claire, simple et liée, j'en saisirai l'ensemble d'un coup d'oeil" (I turn my back upon a painter who offers me an emblem, a logogriph to decipher. If the scene is one, clear, simple, and unified, I will grasp its ensemble at a glance).[83] His point, however, was not just that allegorical paintings made use of abstruse symbolism whereas historical subjects, chosen with care, could be taken as known. It was also that historical subject matter provided the context required for the representation of action and gesture to assume the fullness and precision of meaning without which true dramatic unity was unrealizable. "Quand le sujet d'une proposition oratoire ou gesticulée n'est pas annoncé," Diderot writes in the *Lettre sur les sourds et muets*, "l'application des autres signes reste suspendue" (When the subject of an oratorical or gestural proposition is not announced, the application of the other signs remains suspended).[84] Or as he remarks in the article "Encyclopédie" (1755): "[C]'est à l'histoire à lever l'équivoque" (It is up to history [to the story] to remove the ambiguity).[85]

A few years later he might have said history and morality. "Tout morceau de sculpture ou de peinture doit être l'expression d'une grande maxime, une leçon pour le spectateur; sans quoi il est muet" (Every piece of sculpture or painting must be the expression of a great maxim, a lesson for the beholder; otherwise it is mute), he states in the *Pensées détachées*.[86] This is always cited as proof of the moralistic bias of his vision of art. But it may also be read as calling for the achievement in painting of the decisiveness, memorability, and sententiousness—in short the radical intelligibility—epitomized in discourse by maxims of conduct, and as implying that any work of visual art not directed to a moral end must inevitably fall short in those respects.

Finally, the anti-Rococo preoccupation with unity and intelligibility was accompanied by a far more rigorous and exacting conception of the unity of time than any envisaged by classical writers. Such a conception is implicit in the passage from Caylus quoted above as well as in Diderot's equation of pictorial unity with the continuously changing, and in that sense new every instant, causal unity of nature.[87] And it may be seen at work in Caylus's detailed analysis of Carle Van Loo's *Sacrifice d'Iphigénie* (1757)[88] as well as throughout Diderot's *Salons*.[89] One might say that for Diderot and his contemporaries a

painter's failure to declare the singleness and instantaneousness of his chosen moment with sufficient clarity was felt to undermine and often to destroy the dramatic illusion of causal necessity on which the conviction of unity depended. More generally, the demand that pictorial unity be made instantaneously apprehensible found natural expression in the almost universal tendency among anti-Rococo critics and theorists to define the essence of painting in terms of instantaneousness as such.[90] That tendency reinforced still further their belief in the primacy of subject matter of action and expression, which far more than any other class of subject matter was suited to the specification and perspicuous representation of a single instant.

In this connection it is interesting to note that in a famous passage in the *Lettre sur les sourds et muets* Diderot attributed to the human soul an integralness and an instantaneousness which he specifically likened to those of a painting. His aim in the passage was to call attention to the disparity between one's psycho-physical condition—one's presence to oneself—at a given moment and the representation of that condition or presence in verbal language, which is to say by a number of signs that succeed one another in time:

Autre chose est l'état de notre ame, autre chose le compte que nous en rendons, soit à nous-mêmes, soit aux autres, autre chose la sensation totale & instantanée de cet état, autre chose l'attention successive & détaillée que nous sommes forcés d'y donner pour l'analyser, la manifester & nous faire entendre. Notre ame est un tableau mouvant d'après lequel nous peignons sans cesse: nous employons bien du temps à le rendre avec fidélité; mais il existe en entier & tout à la fois: l'esprit ne va pas à pas comptés comme l'expression.[91]

The state of our soul is one thing, the account we give of it, to ourselves and others, is another. The total and instantaneous sensation of that state is one thing, the successive and detailed attention that we are forced to give it in order to analyze it, to manifest it, and to make ourselves understood, is another. Our soul is a moving *tableau* which we depict unceasingly; we spend much time trying to render it faithfully, but it exists as a whole and all at once. The mind does not proceed one step at a time as does expression.

Toward the beginning of this chapter I remarked that for Diderot and his contemporaries as for the Albertian tradition generally the human body in action was the best picture of the human soul. The passage that I have just quoted suggests that Diderot found in the fully realized *tableau* an external, "objective" equivalent for his own sense of himself as an integral yet continuously changing being, and that his insistence that the art of painting satisfy the most exigent requirements of unity and instantaneousness may in part be understood as an insistence that it generate objects capable of measuring up to that equivalence—of confronting him on equal terms—and thereby of confirming precisely that sense of self that the passage as a whole expresses so vividly. It goes without saying that any object possessing those capabilities was no ordinary object.

Two more points might be mentioned very briefly before bringing this

section to a close. First, the new, more rigorous conception of unity of time was attended by a more rigorous conception of unity of place than had hitherto been entertained. Thus Diderot notes of Doyen's *Miracle des Ardens* that few people will be able to grasp the exact nature of its setting (the front porch of a hospital) and surmises that the painter first imagined separate scenes of terror and only afterwards devised a locale capable of bringing them together.[92] And second, no doubt influenced by Shaftesbury but going far beyond him, Diderot adds to the traditional unities of action, time, and place a fourth unity, that of point of view, which he builds into his definition of pictorial composition from the start and articulates most forcefully in the *Essais:* "Toute scène a un aspect, un point de vue plus intéressant qu'aucun autre; c'est de là qu'il faut la voir. Sacrifiez à cet aspect, à ce point de vue, tous les aspects, ou points de vue subordonnés; c'est le mieux" (Every scene has an aspect, a point of view more interesting than any other; it is from there that it must be seen. Sacrifice all subordinate aspects or points of view to that aspect, that point of view. It is the best).[93]

It is I think hardly necessary to add that point of view so conceived is essentially dramatic. There is nothing ideal or *a priori* about the beholder's relation to what is represented. Rather the specific character of both action and moment determines that relation and positions the beholder before the painted scene. And reciprocally it is in and through the representation of action and moment that point of view so conceived is made most strongly felt.[94]

<p style="text-align:center">❧</p>

We are now in a position to try to define the relationship between painting and beholder mentioned earlier, a relationship which I believe lies at the heart of the anti-Rococo conception of painting. For Diderot and his colleagues, as we have seen, the painter's task was above all to reach the beholder's soul by way of his eyes. This traditional formulation was amplified by another, which like the first was widely shared: a painting, it was claimed, had first to attract (*attirer, appeller*) and then to arrest (*arrêter*) and finally to enthrall (*attacher*) the beholder, that is, a painting had to call to someone, bring him to a halt in front of itself, and hold him there as if spellbound and unable to move. The terms themselves derived from previous writers—in particular De Piles, who emphasized the need for paintings to attract, surprise, and stop the beholder, and Du Bos, who was chiefly concerned with their power to command his attention—but it was in the writings of Diderot and some of his contemporaries that they first broadly assumed critical as distinct from mainly rhetorical significance: that the idea that a painting must attract, arrest, and enthrall the beholder was not just taken literally but was systematically matched against the actual experience of specific pictures.[95] (The results of the procedure were not flattering to current painting. As the reader of Diderot's *Salons* quickly becomes aware, the number of canvases that seemed to him to pass this almost behavioristic test was relatively small.)

This new emphasis on the responsiveness of a painting to a beholder may not entitle us to say that until a particular moment and place the presence of the beholder (though not his enthrallment) could be taken for granted (and thus exploited or disregarded, as the painter chose). But it seems clear that starting around the middle of the eighteenth century in France the beholder's presence before the painting came increasingly to be conceived by critics and theorists as something that had to be accomplished or at least powerfully affirmed by the painting itself; and more generally that the existence of the beholder, which is to say the primordial convention that paintings are made to be beheld, emerged as problematic for painting as never before.

From a slightly different perspective this development may be seen as yet another aspect of the rapprochement between the aims of painting and drama that took place in France during these years. The recognition that the art of painting was inescapably addressed to an audience that must be gathered corresponds to the exactly concurrent recognition that the theater's audience was inescapably a gathering not simply of auditors but of beholders. In both cases what was recognized had been glimpsed earlier in the century—the second insight was pioneered by Du Bos—but until now had not presented problems of a fundamental character. And in both cases the problems were to be resolved through the instrumentality of the *tableau*, whose significance for each art was in a sense complemetary to its significance for the other. Thus unity of point of view, implicit in the construction of the dramatic *tableau*, followed almost as a logical consequence from the recognition that an audience of beholders was already in place; while in painting it was required in order to position the beholder not just before the depicted scene but in front of the painting, the *tableau*, itself. ("Deux qualités essentielles à l'artiste, la morale et la perspective" [Two qualities essential to the artist, morality and perspective], reads one of Diderot's *Pensées détachées*.)[96] By the same token, Diderot was not thinking of the theater when he argued that compositional unity consisted in the law of the necessity of nature extended to the interaction of the various figures in the painting. But his emphasis on necessity was in effect an emphasis on manifest dramatic motivation; and it was only by persuading the theatrical audience of such motivation via the *tableau* that the visuality of the audience, which had come to threaten the very possibility of drama, could be made to serve its ends.

I have so far described merely the literal or situational component of the relationship between painting and beholder I am seeking to define. Just as important, and still more fundamental, is what might be called the fictive component of that relationship. By now the reader will not be surprised to learn that the first extended discussions of the latter are to be found in Diderot's *Entretiens sur le Fils naturel* and *Discours de la poésie dramatique*, and that those discussions chiefly concern the conditions necessary for dramatic illusion as such. The basic idea was first stated in the *Entretiens* in connection with Diderot's campaign against the classical *tirade:* "Dans une représentation

dramatique, il ne s'agit non plus du spectateur que s'il n'existait pas. Y a-t-il quelque chose qui s'adresse à lui? L'auteur est sorti de son sujet, l'acteur entraîné hors de son rôle. Ils descendent tous les deux du théâtre. Je les vois dans le parterre; et tant que dure la tirade, l'action est suspendue pour moi, et la scène reste vide" (In a dramatic representation, the beholder is no more to be taken into account than if he did not exist. Is there something addressed to him? The author has departed from his subject, the actor has been led away from his part. They both step down from the stage. I see them in the orchestra, and as long as the speech lasts, the action is suspended for me, and the stage remains empty).[97] This was expanded and its ramifications explored in the *Discours:*

> Si l'on avait conçu que, quoiqu'un ouvrage dramatique ait été fait pour être représenté, il fallait cependant que l'auteur et l'acteur oubliassent le spectateur, et que tout l'intérêt fût relatif aux personnages, on ne lirait pas si souvent dans les poétiques: Si vous faites ceci ou cela, vous affecterez ainsi ou autrement votre spectateur. On y lirait au contraire: Si vous faites ceci ou cela, voici ce qui en résultera parmi vos personnages.
>
> Ceux qui ont écrit de l'art dramatique ressemblent à un homme qui, s'occupant des moyens de remplir de trouble toute une famille, au lieu de peser ces moyens par rapport au trouble de la famille, les pèserait relativement à ce qu'en diront les voisins. Eh! laissez là les voisins; tourmentez vos personnages; et soyez sûr que ceux-ci n'éprouveront aucune peine, que les autres ne partagent.[98]

> Had it been understood that, even though a dramatic work is made to be represented, it is necessary that author and actor forget the beholder, and that all interest be concentrated upon the personages, one would not read so often in poetics: if you do this or that, you will affect your beholder in such and such a way. On the contrary, one would read in them: if you do this or that, here is what the result will be among your personages.
>
> Those who have written about the art of drama resemble a man who, looking for means to torment a whole family, instead of weighing those means in relation to the trouble they would cause the family, would weigh them according to what the neighbors will say. Come, forget about the neighbors; torment your personages; and rest assured that they will not suffer any grief that the others will not share.

The penalties for violating this fundamental principle were severe: "Et l'acteur, que deviendra-t-il, si vous vous êtes occupé du spectateur? Croyez-vous qu'il ne sentira pas que ce que vous avez placé dans cet endroit et dans celui-ci n'a pas été imaginé pour lui? Vous avez pensé au spectateur, il s'y adressera. Vous avez voulu qu'on vous applaudît, il voudra qu'on l'applaudisse; et je ne sais plus ce que l'illusion deviendra" (And the actor, what will become of him if you have concerned yourself with the beholder? Do you think he will not feel that what you have placed here or there was not imagined for him? You thought of the spectator, he will address himself to him. You wanted to be applauded, he will wish to be applauded. And I no longer know what will become of the illusion).[99] The conclusion was obvious: "Soit donc que vous composiez, soit que vous jouiez, ne pensez non plus au spectateur que s'il

n'existait pas. Imaginez, sur le bord du théâtre, un grand mur qui vous sépare du parterre; jouez comme si la toile ne se levait pas" (Whether you compose or act, think no more of the beholder than if he did not exist. Imagine, at the edge of the stage, a high wall that separates you from the orchestra. Act as if the curtain never rose).[100]

Throughout the remainder of the essay Diderot returns to this theme. On the subject of extravagant costumes he remarks: "Si c'est pour le spectateur que vous vous ruinez en habits, acteurs, vous n'avez point de goût; et vous oubliez que le spectateur n'est rien pour vous" (Actors, if you ruin yourselves buying costumes for the sake of the beholder, you have no taste, and you forget that the beholder means nothing to you).[101] He further observes that "dans les pièces italiennes, nos comédiens italiens jouent avec plus de liberté que nos comédiens français; ils font moins de cas du spectateur. Il y a cent moments où il en est tout à fait oublié" (in Italian plays, our Italian actors act with more freedom than our French actors. They take the beholder less into account. There are a hundred moments when he is completely forgotten by them).[102] And he explains why actors who play subordinate characters tend in his view to remain true to their roles while those who play principal characters do not: "La raison, ce me semble, c'est qu'ils sont contenus par la présence d'un autre qui les commande: c'est à cet autre qu'ils s'adressent; c'est là que toute leur action est tournée" (It seems to me that the reason for this is that they are constrained by the presence of someone else who governs them. They address themselves to this other; toward him they orient all their action). Free of that constraint, the leading actors "s'arrangent en rond; ils arrivent à pas comptés et mesurés; ils quêtent des applaudissements, ils sortent de l'action; ils s'adressent au parterre; ils lui parlent, et ils deviennent maussades et faux" (arrange themselves in a circle; they arrive with careful, measured steps; they seek applause, they depart from the action; they address themselves to the audience; they talk to it and become dull and false).[103]

Diderot's advocacy of *tableaux* as opposed to *coups de théâtre* is to be understood chiefly in this light. "Un incident imprévu qui se passe en action, et qui change subitement l'état des personnages, est un coup de théâtre," he writes in the *Entretiens*. "Une disposition de ces personnages sur la scène, si naturelle et si vraie, que, rendue fidèlement par un peintre, elle me plairait sur la toile, est un tableau" (An unexpected incident that happens in the course of the action and that suddenly changes the situation of the characters is a *coup de théâtre*. An arrangement of those characters on the stage, so natural and so true to life that, faithfully rendered by a painter, it would please me on canvas, is a *tableau*).[104] In other words, a *coup de théâtre* took place as it were *within* the action and marked a sudden change in the consciousness of the characters involved; whereas the grouping of figures and stage properties that constituted a *tableau* stood *outside* the action, with the result that the characters themselves appeared unaware of its existence and hence of its effect on the audience. "Celui qui agit et celui qui regarde, sont deux êtres très différents" (He who acts and he who

[95]

beholds are two very different beings), Diderot observes in the opening pages of the *Entretiens*.[105] The concept of the *tableau* at once hypostatized that difference and defined it as above all one of point of view. A *tableau* was visible, it could be said to exist, only from the beholder's point of view. But precisely because that was so, it helped persuade the beholder that the actors themselves were unconscious of his presence.[106]

The usual interpretation of Diderot's concept of the *tableau,* as asserting the importance of visual considerations in the achievement of dramatic illusion, and moreover as implying an exaltation of vision itself, is therefore somewhat misleading. The primary function of the *tableau* as Diderot conceived it was not to address or exploit the visuality of the theatrical audience so much as to neutralize that visuality, to wall it off from the action taking place on stage, to put it out of mind for the dramatis personae and the audience alike. More generally, the *Entretiens* and the *Discours* are often read as calling for stage realism pure and simple. But it would be truer to say that they called primarily for the illusion that the audience did not exist, that it was not really there or at the very least had not been taken into account. In the absence of that illusion no amount of realism could provide the dramatic experience that Diderot sought.

As might be expected, the same dramaturgical principle was fundamental to Diderot's vision of painting. He writes in the *Pensées détachées:*

Lairesse prétend qu'il est permis à l'artiste de faire entrer le spectateur dans la scène de son tableau. Je n'en crois rien; et il y a si peu d'exceptions, que je ferais volontiers une règle générale du contraire. Cela me semblerait d'aussi mauvais goût que le jeu d'un acteur qui s'adresserait au parterre. La toile renferme tout l'espace, et il n'y a personne au delà. Lorsque Suzanne s'expose nue à mes regards, en opposant aux regards des vieillards tous les voiles qui l'enveloppaient, Suzanne est chaste et le peintre aussi; ni l'un ni l'autre ne me savaient là.[107]

Lairesse claims that the artist is permitted to have the beholder enter the scene of his painting. I do not believe it, and there are so few exceptions that I would gladly make a general rule of the opposite. That would seem to me in as poor taste as the performance of an actor who would address himself to the audience. The canvas encloses all the space, and there is no one beyond it. When Susannah exposes her naked body to my eyes, protecting herself against the elders' gaze with all the veils that enveloped her, Susannah is chaste and so is the painter. Neither the one nor the other knew I was there.

The subject of *Susannah and the Elders* presented special problems because beholding, specifically illicit beholding, belonged to its theme. It therefore threatened to call attention to the actual beholder and in effect to implicate him along with the elders: "Je regarde *Suzanne;* et loin de ressentir de l'horreur pour les vieillards, peut-être ai-je désiré d'être à leur place" (I look at Susannah, and far from feeling abhorrence toward the elders, perhaps I have wished to be in their place).[108] The solution that Diderot advocated and to which he referred in the passage just quoted engaged directly with that threat: "Un

peintre italien a composé très-ingénieusement ce sujet. Il a placé les deux vieillards du même côté. La Susanne porte toute sa draperie de ce côté, et pour se dérober aux regards des vieillards, elle se livre entièrement aux yeux du spectateur. Cette composition est très-libre, et personne n'en est blessé. C'est que l'intention évidente sauve tout, et que le spectateur n'est jamais du sujet" (An Italian painter composed this subject very ingeniously. He placed the two elders on the same side. Susannah covers herself with all her veils on that side, with the result that in order to escape the elders' gaze she exposes herself entirely to the eyes of the beholder. This composition is very free and no one is offended by it. It is because the obvious intention saves everything and because the beholder is never part of the subject).[109] Or as Diderot was later to remark: "C'est la différence d'une femme qu'on voit et d'une femme qui se montre" (It is the difference between a woman who is seen and a woman who exhibits herself).[110]

Another subject that raised the issue of the beholder's presence with special acuteness was the one popularly known as *Roman Charity*, in which a woman nourishes her aged imprisoned father at her breast. Thus Diderot writes in the *Salon de 1765:* "Je ne veux pas absolument que ce malheureux vieillard, ni cette femme charitable, soupçonnent qu'on les observe; ce soupçon arrête l'action et détruit le sujet" (I absolutely do not want this poor old man or this charitable woman to suspect that they are being observed; that suspicion stops the action and destroys the subject).[111] And a few pages further: "Cette frayeur dénature le sujet, en ôte l'intérêt, le pathétique, et ce n'est plus une charité" (That fear denatures the subject, deprives it of any interest or pathos, and it is no longer a charitable act).[112] Somewhat more generally he observes in the *Pensées détachées:* "Toutes les scènes délicieuses d'amour, d'amitié, de bien-faisance, de générosité, d'effusion de coeur se passent au bout du monde" (All delicious scenes of love, friendship, charity, generosity, outpourings of the heart take place at the ends of the earth).[113] By *au bout du monde* he meant a setting that conveyed an impression of silence, solitude, and—most important—the absence of witnesses, of beholders.[114]

The crucial point is not the special problems that came with these subjects but the general principle that gave rise to the problems in the first place: "Ne pensez non plus au spectateur que s'il n'existait pas." And: "La toile renferme tout l'espace, et il n'y a personne au delà." Or as Diderot remarks in the *Salon de 1767:* "Une scène représentée sur la toile, ou sur les planches, ne suppose pas de témoins" (A scene represented on canvas or on stage does not suppose witnesses).[115] This more than anything else was the basis of his abhorrence both in painting and in the theater of the mannered working up of physical gesture and facial expression that he called *grimace.* "Ne voyez-vous pas que la douleur de cette femme est fausse, hypocrite," he writes of a figure in a picture by Lagrenée, "qu'elle fait tout ce qu'elle peut pour pleurer et qu'elle ne fait que grimacer . . . ?" (Can you not see that this woman's grief is insincere, hypocritical, that she does her best to cry but manages only to grimace . . . ?).[116]

As early as the *Salon de 1763* he warns: "Il ne faut pas prendre de la grimace pour de la passion; c'est une chose à laquelle les peintres et les acteurs sont sujets à se méprendre. Pour en sentir la différence, je les renvoie au *Laocoon* antique, qui souffre et ne grimace point" (Grimacing should not be confused with passion; this is a point about which painters and actors are apt to be mistaken. To make them feel the difference, I refer them to the ancient *Laocoon*, who suffers but does not grimace).[117] And in general Diderot was repelled by every form of exaggeration in painting and drama that seemed to him to indicate a desire to play to the crowd. "Je ne saurais supporter les caricatures, soit en beau, soit en laid," he writes in the *Discours*, "car la bonté et la méchanceté peuvent être également outrées" (I cannot stand caricatures either of the beautiful or of the ugly, for goodness and wickedness can be equally exaggerated);[118] while in the *Essais* he maintains that *dessin,* color, and *clair-obscur* are all liable to be caricatured and that "toute caricature est de mauvais goût" (all caricature is in bad taste).[119] It is also true that in his view a kind of exaggeration was implicit in history painting as such. "Le peintre de genre a sa scène sans cesse présente sous ses yeux; le peintre d'histoire, ou n'a jamais vu, ou n'a vu qu'un instant la sienne," Diderot states in the *Essais*. "Et puis l'un est pur et simple imitateur, copiste d'une nature commune; l'autre est, pour ainsi dire, le créateur d'une nature idéale et poétique. Il marche sur une ligne difficile à garder. D'un côté de cette ligne, il tombe dans le mesquin; de l'autre, il tombe dans l'outré" (The genre painter has his scene always present before his eyes; whereas the history painter either has never seen his or has seen it only for an instant. Then, too, one is a pure and simple imitator, a copyist of ordinary nature; the other is, so to speak, the creator of an ideal and poetic nature. He walks a narrow line that is difficult to maintain. On one side of that line, he falls into pettiness; on the other, he falls into exaggeration).[120] In the introduction to the *Salon de 1767* he goes further and suggests that it is only by a sort of exaggeration or embellishment of nature that what he calls the "ligne vraie" and "modèle idéal de la beauté" (true line [and] ideal model of beauty) are finally achieved.[121] In the short essay "De la Manière" that follows that *Salon* he writes: "Tout ce qui est romanesque est faux et *maniéré*. Mais toute nature exagérée, agrandie, embellie au delà de ce qu'elle nous présente dans les individus les plus parfaits n'est-elle pas romanesque? Non. Quelle différence mettez-vous donc entre le romanesque et l'exagéré? Voyez-le dans le préambule de ce Salon" (Everything that is fanciful is false and mannered. But all nature that is exaggerated, magnified, embellished beyond what we see even in the most perfect individuals—is not that fanciful? No. What difference do you see, then, between the fanciful and the exaggerated? You will find it in the introduction to this *Salon*).[122] And in his *Salon de 1769* Diderot criticizes Greuze's *Septime Sévère et Caracalla* for falling short of "la sorte d'exagération qu'exige la peinture historique" (the sort of exaggeration demanded by history painting).[123] In other words, Diderot by the late 1760s appears to have

held that each genre had its own characteristic mode or "beau idéal" (ideal beauty) of exaggeration, embellishment, or transformation of nature, and that unless a painter was able to intuit and as it were to internalize that mode his efforts in a particular genre would be doomed to failure. In short, there existed a kind of exaggeration that had its origin in the nature of artistic representation rather than in a wish to make an impression on an audience.

Any evidence of that wish Diderot found intolerable. He argues in "De la Manière" that whereas ugliness is natural, "et n'annonce par elle-même aucune prétention, aucun ridicule, aucun travers d'esprit," *la manière* is unnatural, hypocritical, and concerned exclusively with appearances, all of which make it "plus insupportable à l'homme de goût que la laideur" (and bespeaks in itself nothing pretentious, ridiculous, or bizarre . . . more unbearable to the man of taste than ugliness).[124] This was a primary ground of his antagonism to the art of the Rococo, which in his view clearly reflected the manners and conventions of polite society:

Une autre chose qui ne choque pas moins, ce sont les petits usages des peuples civilisés. La politesse, cette qualité si aimable, si douce, si estimable dans le monde, est maussade dans les arts d'imitation. Une femme ne peut plier les genoux, un homme ne peut déployer son bras, prendre son chapeau sur sa tête, et tirer un pied en arrière, que sur un écran. Je sais bien qu'on m'objectera les tableaux de Watteau; mais je m'en moque, et je persiste.[125]

Something else no less shocking are the common usages of civilized peoples. Politeness, that quality so agreeable, so charming, so worthy of esteem in society, is disagreeable in the arts of imitation. A woman can curtsy, a man can remove his hat from his head with a grand gesture while bowing elaborately, only on a painted screen. I know Watteau's paintings will be cited against me; but I do not care, and I persist in my belief.

("[J]'aime mieux la rusticité que la mignardise," he writes in the *Pensées détachées,* "et je donnerais dix Watteau pour un Téniers" [I prefer rusticity to prettiness, and I would give ten Watteaus for one Teniers].)[126] The object of his distaste was not exaggeration or caricature or *politesse* as such but the awareness of an audience, of being beheld, that they implied. And it was above all else the apparent extinction of that awareness, by virtue of a figure's absolute engrossment or absorption in an action, activity, or state of mind, that he demanded of works of pictorial art. To quote from "De la Manière":

Il est rare qu'un être qui n'est pas tout entier à son action ne soit pas *manièré*.
Tout personnage qui semble vous dire: "Voyez comme je pleure bien, comme je me fâche bien, comme je supplie bien," est faux et *manièré*.
Tout personnage qui s'écarte des justes convenances de son état ou de son caractère, un magistrat élégant, une femme qui se désole et qui cadence ses bras, un homme qui marche et qui fait la belle jambe, est faux et *manièré*.[127]

It is rare that a being who is not totally engrossed in his action is not *mannered*.
Every personage who seems to tell you: "Look how well I cry, how well I become angry, how well I implore," is false and *mannered*.

[99]

Every personage who departs from what is appropriate to his state or his character—an elegant magistrate, a woman who grieves and artfully arranges her arms, a man who walks and shows off his legs—is false and *mannered*.

A figure entirely engrossed or absorbed in an action, activity, or state of mind and therefore oblivious to the beholder's presence may be described as *alone* relative to the beholder—and in fact Diderot exploited that metaphor in a remarkable pair of sentences in the *Essais:* "Si vous perdez le sentiment de la différence de l'homme qui se présente en compagnie et de l'homme intéressé qui agit, de l'homme qui est seul et de l'homme qu'on regarde, jetez vos pinceaux dans le feu. Vous académiserez, vous redresserez, vous guinderez toutes vos figures" (If you lose your feeling for the difference between the man who presents himself in society and the man engaged in an action, between the man who is alone and the man who is looked at, throw your brushes into the fire. You will academicize all your figures, you will make them stiff and unnatural).[128] In that event the painting would no longer be "une rue, une place publique, un temple" (a street, a public square, a temple); it would become "un théâtre" (a theater),[129] that is, an artificial construction in which persuasiveness was sacrificed and dramatic illusion vitiated in the attempt to impress the beholder and solicit his applause.

Diderot's use of the term *théâtre* in this connection reveals the depth of his revulsion against the conventions then prevailing in the dramatic arts. But it also suggests that he despaired that those conventions, and the consciousness of the beholder they embodied, would ever fully be overcome once and for all. This appears to be the implication of his next remark: "On n'a point encore fait, et l'on ne fera jamais un morceau de peinture supportable, d'après une scène théâtrale; et c'est, ce me semble, une des plus cruelles satires de nos acteurs, de nos décorations, et peut-être de nos poètes" (No one has yet made, no one will ever make, a tolerable painting based on a theatrical scene. This seems to me one of the cruelest satires of our actors, our decorations, and perhaps our poets).[130] Presumably Diderot felt that if the theater were to be reformed along the lines proposed in the *Entretiens* and the *Discours,* painters would be able to look to the stage for inspiration without dooming themselves to mediocrity or worse.[131] But he continued to express his distaste for the theater as he knew it and in his writings on painting used the term *le théâtral,* the theatrical, implying consciousness of being beheld, as synonymous with falseness.[132] The opposite of the grimacing, the mannered, and the theatrical was *le naïf,* the naive, characterized by Diderot in the *Pensées détachées* as "tout voisin du sublime" (very close to the sublime) and summed up in the phrase: "C'est la chose, mais la chose pure, sans la moindre altération. L'art n'y est plus" (It is the thing, but the thing itself, without the least alteration. Art is no longer there).[133] By this he meant something more striking or perspicuous than ordinary fidelity to appearances:

Tout ce qui est vrai n'est pas naïf, mais tout ce qui est naïf est vrai, mais d'une vérité

piquante, originale et rare. Presque toutes les figures du Poussin sont naïves, c'est-à-dire parfaitement et purement ce qu'elles doivent être. Presque tous les vieillards de Raphaël, ses femmes, ses enfants, ses anges, sont naïfs, c'est-à-dire qu'ils ont une certaine originalité de nature, une grâce avec laquelle ils sont nés, que l'institution ne leur a point donnée.[134]

All that is true is not naive, but all that is naive is true, but with a truth that is alluring, original, and rare. Almost all Poussin's figures are naive, that is, perfectly and purely what they ought to be. Almost all Raphael's old men, women, children, and angels are naive, that is, they have a certain originality of nature, a grace with which they were born and which is not the product of instruction.

In sum, naiveté was the distinctive mode of expression of the causal unity of nature, or at any rate the hallmark of that unity in art. (The definition of grace in the *Essais* as "cette rigoureuse et précise conformité des membres avec la nature de l'action" [that rigorous and precise conformity of the limbs to the nature of the action][135] is entirely consistent with this idea.) Conversely the pictorial expression of the causal unity of nature entailed negating the beholder's presence before the painting—or, more positively, establishing the fiction that "il n'y a personne au delà."

I am for my part convinced that the insistence by anti-Rococo critics and theorists that painters achieve what I have called an absolutely perspicuous mode of pictorial unity was at bottom an expression of the prior or more fundamental demand that not just each figure but the painting as a whole, the *tableau* itself, declare its unconsciousness or obliviousness of the beholder. I realize, however, that only Diderot among the writers of his time actually formulated that demand, and that even he cannot be said to have made its connection with unity fully explicit.

These considerations lie behind the distinction drawn in the *Essais* between actions and attitudes: "Autre chose est une attitude, autre chose une action. Les attitudes sont fausses et petites, les actions toutes belles et vraies" (An attitude is one thing, an action is another. Attitudes are false and petty, actions are all beautiful and true).[136] Nothing quite like this can be found in the writings of Diderot's predecessors or contemporaries. It had always been recognized that individual painters were to a greater or lesser degree masters of action and expression. But Diderot's distinction between actions and attitudes asserted a difference not of degree but of kind, i.e., between natural, spontaneous, largely automatic realizations of an intention or expressions of a passion on the one hand and conventional, mannered, and (in the pejorative sense of the term just given) theatrical simulacra of those on the other: so that to describe something as an action was already to have passed a favorable, though not necessarily a final or complete, judgment upon it. Significantly, each of the three major sources of what might be called the attitudinization of action singled out by Diderot in the *Essais*—the Academic pedagogy of drawing from a model holding a fixed pose, the false ideal of grace taught by dancing masters like Marcel, and the Academic principle of deliberately arranged contrast be-

tween figures in a painting and even between the limbs of individual figures[137]—institutionalized the consciousness of being beheld that he deplored.

Diderot's originality, as well as his alignment with the main impulse of the anti-Rococo movement, become evident if his thought is compared with Caylus's. As early as 1747, in his "Réflexions sur la peinture," Caylus distinguished between two sorts of studies of the human figure:

La figure que nous appelons *académie* n'a été posée que pour l'exercice du dessin en général, le professeur n'a eu avec raison d'autre objet en la posant que celui de présenter un beau choix, un heureux contraste dans les parties, d'y répandre une belle lumière avec un beau jeu de muscles, tandis que la figure que nous connaissons sous le nom d'*étude* posée pour un sujet determiné, est remplie d'une intention et d'une action qui parle à l'esprit.[138]

The figure we call an *academy* was posed only for the practice of drawing in general. The professor rightly had no other aim in posing it than that of presenting a beautiful choice, a happy contrast of parts, of distributing a beautiful illumination across a handsome play of muscles, whereas the figure we know under the name of a *study* posed for a specific subject is filled with an intention and an action that speak to the mind.

By emphasizing the importance of considerations of action and intention, Caylus's distinction anticipated Diderot's. But Caylus used the word *posée* in connection with both sorts of studies, and in fact never questioned the value of working from a model holding a stationary pose or attitude. More generally, both Diderot and Caylus advocated a return to truth and nature after what they regarded as the mannerism of the Rococo. But there is a world of difference between Caylus's exhortation, "Songeons que toute la nature est à nous et qu'elle pose continuellement pour augmenter nos connaissances" (Let us think that all of nature belongs to us and that it poses continually to increase our knowledge),[139] or his reference to "la Nature, toujours prête à *poser*" (Nature, always ready to *pose*),[140] and Diderot's vision of nature as intelligible to man in its causal unity only to the extent that it is *not* represented as posing for him, as existing to be beheld.

Why, it may be asked, did not Diderot's antagonism to the theatrical militate against the doctrines of the hierarchy of genres and the supremacy of history painting? In particular why was he not led to extol the virtues of still-life painting, whose subject matter being inanimate was literally incapable of evincing awareness of the beholder? The answer is implicit in much that has gone before: inanimate subject matter made the artistic and presentational aspects *of the painting itself* all the more obtrusive by imposing almost desperate demands on technique and by calling attention to the fact that the objects depicted by the painter were chosen by him, arranged by him, illuminated by him, and in general exhibited by him to the beholder. The same argument would hold for landscape painting, especially when the role of figures was reduced to a minimum, or for any picture in which action and incident were

lacking. "Il faut un faire, un naturel bien surprenant pour arrêter, pour intéresser avec si peu de chose" (It requires astonishing technique and naturalness to arrest the attention, to interest with so little), Diderot writes of a canvas by Casanove.[141] In the case of history painting, however, the beholder's vastly greater interest in the actions and passions of human beings relieved the pressure on technique; the illusion that the dramatis personae had arrived by themselves at their positions and groupings was on the face of it more plausible; most important, the painter could aim to engross or absorb his figures in action or feeling—to render each "tout entier à son action"—and thereby to declare their aloneness relative to the beholder or at any rate their obliviousness of his presence.

The last point bears elaborating. The problems which, in Diderot's view, the still-life painter faced—and which only Chardin among his contemporaries seemed to him to surmount—suggest that simply disregarding the beholder was not enough. It was necessary to obliviate him, to deny his presence, to establish positively insofar as that could be done that he had not been taken into account. And Diderot seems clearly to have felt that there was in principle no more efficacious means to that end than to take as subject matter the deeds and sufferings of conscious agents who were, to say the least, fully capable of evincing awareness of the beholder, and then to forestall or extinguish all traces of such awareness in and through the dramatic representation of those deeds and sufferings. Furthermore, I have suggested that the demand for an absolutely perspicuous mode of pictorial unity was at bottom a demand for the negation of the beholder's presence before the painting; and because, as I have tried to show, action and passion lent themselves more readily than any other subject matter to the achievement of that unity, the history painter was on these grounds also better equipped than his colleagues in other genres to bring that negation about. All this may be summed up by saying that Diderot's conception of painting rested ultimately upon the supreme fiction that the beholder did not exist, that he was not really there, standing before the canvas; and that the dramatic representation of action and passion, and the causal and instantaneous mode of unity that came with it, provided the best available medium for establishing that fiction in the painting itself.

Once again we have arrived at a paradox,[142] analogous to that arrived at earlier in connection with Greuze. As we have seen, the recognition that paintings are made to be beheld and therefore presuppose the existence of a beholder led to the demand for the actualization of his presence: a painting, it was insisted, had to attract the beholder, to stop him in front of itself, and to hold him there in a perfect trance of involvement. At the same time, taking Diderot's writings as the definitive formulation of a conception of painting that up to a point was widely shared, it was only by negating the beholder's presence that this could be achieved: only by establishing the fiction of his absence or nonexistence could his actual placement before and enthrallment by the painting be secured. This paradox directs attention to the problematic charac-

ter not only of the painting-beholder relationship but of something still more fundamental—the *object*-beholder (one is tempted to say object-"subject") relationship which the painting-beholder relationship epitomizes. In Diderot's writings on painting and drama the object-beholder relationship as such, the very condition of spectatordom, stands indicted as theatrical, a medium of dislocation and estrangement rather than of absorption, sympathy, self-transcendence; and the success of both arts, in fact their continued functioning as major expressions of the human spirit, are held to depend upon whether or not painter and dramatist are able to undo that state of affairs, to *de-theatricalize beholding* and so make it once again a mode of access to truth and conviction,[143] albeit a truth and a conviction that cannot be entirely equated with any known or experienced before. (The antidualistic implications of this project are consistent with the dominant tendency of Diderot's thought in all fields.) What is called for, in other words, is at one and the same time the creation of a new sort of object—the fully realized *tableau*—and the constitution of a new sort of beholder—a new "subject"—whose innermost nature would consist precisely in the conviction of his absence from the scene of representation. It should be noted, too, that the call for the constitution of this new sort of beholder envisioned a narrowing, a heightening, and an abstracting of the functions traditionally associated with beholding: a narrowing in that an entire universe of sources of interest and delight was now conceived to be, if not irrelevant to the experiencing of pictures, at any rate secondary in importance to the crucial issue of theatricality; a heightening in that the concern with theatricality signalled the attainment of an unprecedented level of cognitive acuteness with regard to the detection of proscribed actions and effects; and an abstracting in that the activity of beholding was now imagined to have found its rightest occasion and most intense satisfaction in its engagement with the fully realized *tableau*.*

Put simply and assertively: the criticism and theory we have been considering expressed an implicit apprehension of the beholder's alienation from the objects of his beholding (and therefore, in a manner of speaking, from himself,

*One might go on to contrast this new sort of beholder (or new "subject") with the profoundly different conception of the self, as in some sense *brought before* itself in the activity of representation (*Vorstellung*), which emerges as a central theme in the writings of late eighteenth- and early nineteenth-century German Idealist philosophers, Fichte in particular. This would be worth doing if only because such a conception of the self may be held to be posited by the art of Caspar David Friedrich and other Northern painters of the period; indeed it provides a key to the interpretation of some of the most salient (and un-French) features of that art, e.g., the predilection for symmetrical compositions, the use of foreground figures depicted from the rear cognizing a landscape or similar scene, the minimizing of surface qualities in favor of effects of transparency, and so on. (My remarks on the concept of the self in Fichte are indebted to a course of lectures on German Idealism taught at Harvard University in the spring of 1973 by Professor Dieter Henrich of the University of Heidelberg and Harvard University. For the prevailing view of Friedrich, which emphasizes the symbolic content of his imagery, see Helmut Börsch-Supan, *Caspar David Friedrich,* trans. Sarah Twohig [New York, 1974].)

both in his capacity as beholder and as a potential object of beholding for others); insisted on the need for painters to overcome that alienation in their work if painting was to be restored to its former status as a major art; and propounded a strategy by which this could be accomplished. That strategy involved the reactivation of the doctrines of the hierarchy of genres and the supremacy of history painting which had fallen into desuetude with the rise of the Rococo. But the meaning of those doctrines in the writings of Diderot and his contemporaries was fundamentally different from the meaning they had had in late seventeenth- and early eighteenth-century Academic theory. So their reactivation must be understood not as a return to an intellectualist and by then outmoded ideal, and not as a confusion about the proper aims of painting, but as a cogent, deeply motivated, and, events were to prove, artistically fecund adaptation of traditional materials to a radically transformed structure of pictorial and ontological priorities.

Two final observations: first, the problem of the theatrical remained central to painting in France until well into the second half of the nineteenth century.[144] And second, with the advent of Realism in the late 1840s and 1850s the sister doctrines of the hierarchy of genres and the supremacy of history painting lost, or lost again, their fundamental importance, largely because the deeper issues of theatricality and the relation of painting to beholder no longer required the instrumentality of those doctrines for their resolution. But it was only after Manet's paradigmatic canvases of the first half of the 1860s, in which various tensions inherent in those issues may be said to have reached a climax, that ambitious painting found it possible to ignore genre considerations entirely.[145]

CHAPTER THREE

Painting and Beholder

IT WILL BE SEEN that chapters one and two are consonant with one another. In the first chapter, an analysis of selected criticism and painting of the 1750s and early 1760s disclosed the importance of a body of concerns that I characterized under the general rubric of the primacy of absorption. Those concerns had always been tacitly at work in Western painting, much of which, especially in the seventeenth century, can in retrospect be described as absorptive to a high degree. But it was not until the mid-1750s in France that the persuasive representation of absorption began to emerge in both criticism and painting as a conscious and explicit desideratum, which is to say as a specifically artistic effect that increasingly required a special kind of virtuosity to be brought off. (It began to emerge as such a desideratum at the moment when it could no longer be taken for granted as a pictorial resource.) Thus a painter like Greuze found himself compelled to depart ever more drastically from the formal and expressive norms of Chardin's art in order to persuade contemporary audiences of the absorption of the dramatis personae in the world of the painting, earning for his most resourceful efforts the scorn and incomprehension of later generations. This development was part of a larger shift from the primacy of absorption toward the primacy of action and expression—more accurately, from the representation of figures absorbed in quintessentially absorptive states and activities toward the representation of figures absorbed in action or passion (or both). The shift, in other words, was in the direction of the values and effects of pictorial drama, as may be seen by comparing Greuze's *Père de famille* (1755; Fig. 1) with his *Piété filiale* (1763; Fig. 32), or, more strikingly, either or both of these with his dramatic blockbusters of the later 1770s, *Le Fils*

[107]

ingrat (1777; Fig. 41) and *Le Fils puni* (1778; Fig. 42). A critical commonplace holds that the latter canvases point the way toward David, and they do.

The second chapter examined a different sort of issue, the renewal of interest among critics and theorists of the anti-Rococo reaction in the sister doctrines of the hierarchy of genres and the supremacy of history painting. There also we descried the features of a dramatic conception of painting, one which, although in essential respects new, sought historical sanction in certain great paintings of the past, above all Poussin's intensely absorptive *Testament d'Eudamidas* (Fig. 21). (The strong appeal of Poussin's composition to French painters throughout the later eighteenth century is perhaps partly explained by the starkness with which it conjoins the two modalities of absorption just mentioned.) In the second chapter too I called attention to the importance of a highly dramatic—i.e., a rigorously causal—conception of pictorial unity, which may be seen to have been exemplified by Greuze's *Piété filiale* among the paintings of the time. The intimate connection between that conception of pictorial unity on the one hand and absorptive considerations on the other finds clear expression in Diderot's defense of the *Piété filiale* in the *Salon de 1763,* or, on the level of theory, in his "loi des énergies et des intérêts" (law of energies and interests), according to which a man reading aloud to other men provides a model for understanding the exigencies of pictorial composition generally.[1] In short, the dramatic conception of painting promoted by the revitalization of the sister doctrines and that progressively actualized by the evolution of absorptive painting from the mid-1750s on were in important respects one and the same.

Furthermore, and this is the heart of my argument, underlying both the pursuit of absorption and the renewal of interest in the sister doctrines is the demand that the artist bring about a paradoxical relationship between painting and beholder—specifically, that he find a way to neutralize or negate the beholder's presence, to establish the fiction that no one is standing before the canvas. (The paradox is that only if this is done can the beholder be stopped and held precisely there.) That demand is adumbrated in Diderot's writings on drama of the late 1750s and is spelled out in his writings on painting of the second half of the 1760s, most fully in the *Essais sur la peinture.* It also seems to be implicit in some criticism and painting of the early and mid-1750s, e.g., in Laugier's remarks of 1753 on Chardin's *Philosophe occupé de sa lecture* (1734; Fig. 2) and in Greuze's *Aveugle trompé* (1755; Fig. 40), among other works. One might say that the dramatic conception of painting that was gradually being evolved during these years depended for its successful realization upon the establishment of the supreme fiction of the beholder's nonexistence. (That would be to think of that fiction as a sort of metaphysical illusion anterior to and necessary for dramatic illusion.) Alternatively, one might say that the dramatic conception was at bottom a means to an end: that it was chiefly by virtue of the persuasive representation of the complete absorption of a figure or group of figures in various actions, activities, and states of mind—a dramatic

illusion if there ever was one—that the painter was able to establish the fiction of the aloneness of those figures, and by implication of the painting as a whole, relative to the beholder. (That would be to consider the metaphysical illusion as a product not a cause of the dramatic illusion.) It should be clear, however, that neither formulation wholly excludes the other, and that in fact it is precisely their circularity that must be kept in mind.

In this third and final chapter I seek to amplify these conclusions in a number of ways. First, I consider several passages from Diderot's most ambitious piece of art writing, his *Salon de 1767,* that reveal the depth and the persistence of his involvement with absorption. Second, I try to elucidate a further development of his thought, in which a concern with absorptive values and effects leads in the end to an alternative conception of painting as well as to a vision of the relationship between painting and beholder that seems, and up to a point is, antithetical to the one that I have claimed his writings expound. Third, I suggest that the two conceptions of painting and visions of the relationship between painting and beholder present in Diderot's criticism correspond to actual tendencies in the art of his time. And fourth, I close the chapter with an extended discussion of several versions of a historical subject that exerted a powerful fascination on late eighteenth-century artists and writers—the blind Belisarius receiving alms. The discussion takes its point of departure in Diderot's analysis of a composition then attributed to Van Dyck and concludes by examining David's monumental canvas of 1781, the painting which, more than any other, marks the beginning of his artistic maturity. My account of French painting and criticism in the age of Diderot ends on the very threshold of modern art.

A particularly instructive example of Diderot's involvement with absorption is his commentary in the *Salon de 1767* on a portrait of himself by Carle Van Loo's nephew, Louis-Michel Van Loo. But some background is necessary if the full import of his remarks is to be appreciated.

As Jean Locquin noted more than sixty years ago,[2] French art critics of the 1750s and 1760s were troubled by what seemed to them the highly questionable status of portraiture in their time. One objection frequently raised was that almost all contemporary portraits required the exercise of merely mechanical skills and so were unworthy of serious consideration as works of art. Another objection was that most of those who commissioned portraits of themselves were relatively obscure and unimportant persons whose likenesses could be of interest only to their friends. But there was, I suggest, still another source of critical misgiving—the inherent theatricality of the genre. More nakedly and as it were categorically than the conventions of any other genre, those of the portrait call for exhibiting a subject, the sitter, to the public gaze; put another way, the basic action depicted in a portrait is the sitter's presentation of himself or herself to be beheld. It follows that the portrait as a genre was singularly

[109]

43 Louis-Michel Van Loo, *Portrait de Carle Van Loo et sa famille,* ca. 1757. Versailles. Replica of original exhibited in the Salon of 1757 and today at Paris, Ecole des Arts Décoratifs.

ill equipped to comply with the demand that a painting negate or neutralize the presence of the beholder, a demand that I have tried to show became a matter of urgent, if for the most part less than fully conscious, concern for French art critics during these years.

This is not to say that all contemporary portraits were regarded by the critics with distaste. A few artists, La Tour preeminently, largely escaped

[110]

negative criticism on the strength of the sheer vibrancy and verisimilitude of their representations.[3] In addition La Tour was seen as having made a point of portraying famous and accomplished persons, whose likenesses were for that reason presumed to be of interest to a wide audience.[4] But what I find arresting are those cases in which a portraitist was praised for devising a composition in which his sitter or sitters appeared to be engaged in a characteristic activity and thus were rendered proof against the consciousness of being beheld that compromised the genre. The outstanding example of a painting of the 1750s that was perceived in those terms is Louis-Michel Van Loo's *Portrait de Carle Van Loo et sa famille* (Salon of 1757;[5] Fig. 43). To modern eyes, the portraitist's attempt to bind together six figures in a single quasi-dramatic scene is less than fully successful. In particular, the figure of Mme. Van Loo, who was well known as a singer, seems to take no part in the proceedings and instead gazes directly out of the canvas. On the other hand, three of the most prominent figures—Carle Van Loo at work on a portrait drawing of his daughter, the daughter posing for him but not for us, and the son who looks on, engrossed, over his father's shoulder—form an absorptive group of a type familiar to us from chapter one (cf. Chardin's *Dessinateur d'après le Mercure de M. Pigalle* [Fig. 3]). It is therefore not surprising that a critic as exacting as Grimm felt that Louis-Michel had found the secret "de faire d'un recueil de portraits un tableau d'histoire" (of how to make a history painting of a collection of portraits),[6] while Fréron, writing in *L'Année Littéraire,* commented specifically on the issue of the painting's relation to the beholder. "Les figures ne paroissent point occupées du soin de se faire voir au Spectateur," he observes with approval, "comme il n'est que trop ordinaire dans les portraits de famille. Ici tout agit, tout tend à un but qui, encore une fois, n'est pas de se montrer" (The figures do not seem concerned with showing themselves to the beholder, as is all too customary in family portraits. Here everything acts, everything tends toward an aim which, again, is not one of self-exhibition).[7]

Ten years later Louis-Michel exhibited in the Salon of 1767[8] his *Portrait de Diderot* (Fig. 44). The *philosophe,* shirt open at the throat and wearing a rather sumptuous *robe de chambre,* is shown seated at a table or desk. He holds a pen in his right hand and gestures with his left; the meaning of the gesture is unclear: but he seems to have been writing—sheaves of paper form a small heap at the lower right—and now looks up from his work, as if someone in front of him and to his right (our left) had a moment before engaged him in conversation. In his *Salon* of that year Diderot criticized the portrait fairly harshly. Referring to his own image, Diderot writes:

On le voit de face. Il a la tête nue. Son toupet gris avec sa mignardise lui donne l'air d'une vieille coquette qui fait encore l'aimable, la position, d'un secrétaire d'Etat et non d'un philosophe. La fausseté du premier moment a influé sur tout le reste. C'est cette folle de Mad[e] Van Loo qui venoit jaser avec lui, tandis qu'on le peignoit, qui lui a donné cet air-là et qui a tout gâté. Si elle s'étoit mise à son clavecin et qu'elle eût prélude ou chanté *Non ha ragione, ingrato, Un core abbandonato,* ou quelqu'autre mor-

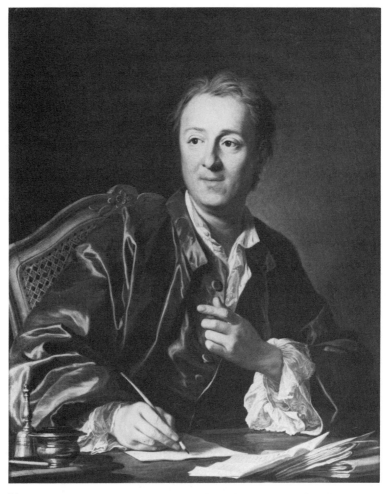

44 Louis-Michel Van Loo, *Portrait de Diderot,* Salon of 1767. Paris, Louvre.

ceau du même genre, le philosophe sensible eût pris un tout autre caractère, et le portrait s'en seroit ressenti. Ou mieux encore, il fallait le laisser seul et l'abandonner à sa rêverie. Alors sa bouche se serait entrouverte, ses regards distraits se seroient portés au loin, le travail de sa tête fortement occupée se seroit peint sur son visage, et Michel eût fait une belle chose.[9]

He is seen from the front. He is bareheaded. His gray tuft of hair and his affectedness give him the air of an old coquette who still tries to charm, while his pose makes him seem a secretary of state and not a philosopher. The falseness of the first moment has influenced all the rest. That mad Mme. Van Loo, who would come and chatter with him while he was being painted, is the one who gave him such an air and spoiled everything. Had she sat at her harpsichord and played the prelude of or sung *Non ha ragione, ingrato, Un core abbandonato,* or some other piece of the same type, the sensitive philosopher would have taken on a very different character, and the portrait would have benefited from it. Or better still, he should have been left alone and abandoned to his reverie. Then his mouth would have come open, his distracted gaze would have been focussed somewhere far away, the labors of his deeply preoccupied mind would have been depicted on his face, and Michel would have made a beautiful thing.

[112]

Diderot goes on to say that the extreme changeableness of his moods and expressions makes the task of capturing his likeness especially difficult and adds that he has been portrayed accurately only once, by "un pauvre diable appelé Garant [Garand]" (a poor devil named Garand).[10] The portrait to which he alludes has since been lost, but a drawing after it by Garand survives (Fig. 45). The painting was described by Diderot at the time it was made in a letter to Sophie Volland: "Je suis représenté la tête nue; en robe de chambre; assis dans un fauteuil; le bras droit soutenant le gauche, et celui ci servant d'appui à la tête; le col débraillé, et jetant mes regards au loin, comme quel-

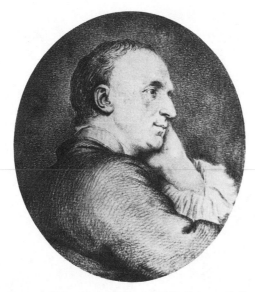

45 Garand, *Portrait de Diderot,* 1760. Private Collection.

qu'un qui médite. Je médite en effet sur cette toile. J'y vis, j'y respire, j'y suis animé; la pensée paroît à travers le front" (I am portrayed bareheaded; wearing a dressing-gown; seated in an armchair; my right arm supporting my left arm, and the latter propping up my head; with my collar untidy, and gazing into the distance, like one who meditates. I am, in fact, meditating in this canvas. I am living in it, I am breathing in it, I am alive in it; thought is visible on my brow).[11] The point of Diderot's discussion of Van Loo's portrait is not simply that he was convinced that a representation of himself meditating or in a state of reverie would have been truer to his nature. His statement that, had Louis-Michel so depicted him, the painter would have made "une belle chose" as much as says that such a portrait would have been superior as art. In fact Diderot's choice of words in the previous sentence—"il fallait le laisser seul et l'abandonner à sa rêverie"—suggests an intimate connection between the portrayal of reverie and the fiction of the aloneness of both sitter and painting relative to the beholder. Indeed it suggests that in Diderot's view the painter ought somehow to have absented himself from the making of the painting: so

[113]

46 Joseph-Marie Vien, *St. Denis prêchant la foi en France,* Salon of 1767. Paris, Saint-Roch.

that the authentic Diderot might appear, but also, even more importantly, so that the fiction that no one is standing before the canvas might be established from the first.[12]

Another fascinating series of passages concerns perhaps the two most renowned paintings in the Salon of 1767, Vien's *St. Denis prêchant la foi en France* (Fig. 46) and Gabriel-François Doyen's *Le Miracle des Ardens* (Fig. 47).[13] (The latter illustrates St. Genevieve interceding with heaven to bring an end to a plague that in A.D. 1129 ravaged Paris.) Although both paintings were intended as altarpieces for the Church of Saint-Roch in Paris, where they have remained, the contrast between them—roughly, between the classical gravity and restraint of the Vien and the Baroque (more precisely, Rubensian) colorism, dramatic chiaroscuro, and exploitation of violence, horror, and pathos of the Doyen—leaps at once to the eye. Diderot's *Salon de 1767* devotes a considerable amount of space to a detailed comparison of the merits and defects of the two works. In the end, the *St. Denis* is placed above the *Miracle des Ardens,* despite Diderot's feeling that Vien's canvas lacked the imaginative warmth, poetry, and movement present in abundance in Doyen's. More generally, he was struck by the complementary nature of the strengths and weaknesses of the artists themselves:

Toutes les qualités qui manque [*sic*] à l'un de ces artistes, l'autre les a. Il règne ici [in the *St. Denis*] la plus belle harmonie de couleur, une paix, un silence qui charment. C'est toute la magie secrette de l'art, sans apprêt, sans recherche, sans effort. C'est un éloge qu'on ne peut refuser à Vien; mais quand on tourne les yeux sur Doyen qu'on voit sombre, vigoureux, bouillant et chaud, il faut s'avouer que dans la *Prédication de Saint Denis* tout ne se fait valoir que par une foiblesse supérieurement entendue; foiblesse que la force de Doyen fait sortir; mais foiblesse harmonieuse qui fait sortir à son tour toute la discordance de son antagoniste.[14]

All the qualities lacking in one of these artists are present in the other. Here [in the *St. Denis*] prevail the most beautiful coloristic harmony, a peace, a silence, which together give delight. It is the whole secret magic of art, unaffected, unstudied, effortless. This praise cannot be refused Vien; but when one turns one's eyes upon Doyen, who appears somber, vigorous, impetuous, and warm, one must admit that in the *Preaching of St. Denis* everything makes itself felt only by virtue of a masterfully understood weakness, a weakness that Doyen's power throws into relief; but it is a harmonious weakness which, in turn, throws into relief all that is discordant in the work of his antagonist.

As will become evident, Diderot often uses notions like harmony, peace, and silence to evoke the distinctive effects of absorptive paintings, and in fact his high regard for Vien's *tableau de prédication* seems largely to have been based on an appreciation of its absorptive qualities. Thus he minutely describes various and subtle inflections of attention among St. Denis's audience.[15] And in the first of two remarkable passages he expresses his disagreement with what appears to have been the general preference for Doyen in terms that leave no doubt as to the importance to him of absorptive considerations:

[115]

47 Gabriel-François Doyen, *Le Miracle des Ardens,* Salon of 1767. Paris, Saint-Roch.

Je vous ai dit que le public avoit été partagé sur la supériorité des tableaux de Doyen et de Vien. Mais comme presque tout le monde se connoit en poésie et que très peu de personnes se connoissent en peinture, il m'a semblé que Doyen avoit eu plus d'admirateurs que Vien. Le mouvement frappe plus, que le repos. Il faut du mouvement aux enfants, et il y a beaucoup d'enfants. On sent mieux un forcené qui se déchire le flanc de ses propres mains [i.e., the figure in the left foreground of the *Miracle des Ardens*], que la simplicité, la noblesse, la vérité, la grâce d'une grande figure qui écoute en silence. Peut-être même celle-cy est-elle plus difficile à imaginer, et imaginée, plus difficile à rendre. Ce ne sont pas les morceaux de passion violente qui marquent dans l'acteur qui déclame le talent supérieur, ni le goût exquis dans le spectateur qui frappe des mains.[16]

I told you that the public had been divided on the matter of the superiority of the paintings by Doyen and Vien. But as almost everyone is a connoisseur of poetry and very few know anything about painting, it seemed to me that Doyen had more admirers than Vien. Movement is more striking than rest. Children must be in movement, and there are many children. People are more affected by a madman tearing out his entrails with his own hands than by the simplicity, the nobility, the truth, the grace of a tall figure who listens in silence. It may even be the case that the latter is more difficult to imagine, and, once imagined, more difficult to render. Scenes of violent passion are not those that reveal superior talent in the declaiming actor nor exquisite taste in the applauding spectator.

The second passage occurs more than a hundred pages later:

Le public paraît avoir regardé le tableau de Doyen comme le plus beau morceau du Sallon, et je n'en suis pas surpris. Une chose d'expression forte, un démoniaque qui se tord les bras, qui écume de la bouche, dont les yeux sont égarés, sera mieux senti de la multitude qu'une belle femme nue qui sommeille tranquillement et qui vous livre ses épaules et ses reins; la multitude n'est pas faite pour recevoir toutes les chaînes imperceptibles qui émanent de cette figure, en saisir la mollesse, le naturel, la grâce, la volupté.[17]

The public seems to have regarded Doyen's painting as the most beautiful work in the Salon, and I am not surprised. Anything highly expressive—a demoniac contorting his arms, foaming at the mouth, with wild eyes—will make a deeper impression on the multitude than a beautiful nude woman who sleeps peacefully and exposes her shoulders and back to your gaze. The crowd is not capable of taking in all the imperceptible bonds that emanate from that figure, of perceiving its indolence, its naturalness, its grace, its voluptuousness.

There is no beautiful sleeping nude in the *St. Denis*—in fact Diderot's invocation of such a figure may have been touched off by his admiration for that of the dead or dying woman who lies head back just below the stone platform on which the saint kneels in the *Miracle des Ardens*[18]—but the import of the two passages is clear. Diderot preferred a painting that he regarded as a masterpiece of absorption to one that seemed to him not quite a masterpiece of violent expression, though characteristically he faulted Vien for not having infused greater variety, intensity, and even violence of expression into the representation of absorption itself.[19] It should also be noted that we find in these passages further proof of a connection between manifestly absorptive activities like that of Vien's "grande figure qui écoute en silence" and the state of sleep,

which I earlier claimed was sometimes rendered by artists and perceived by critics of the 1750s and after as an absorptive condition in its own right.

I will cite just one more example from the *Salon de 1767*. The works under discussion are two oil sketches of heads of children by Louis-Jean Durameau:[20]

Ce sont deux belles choses. Le premier enfant est sérieux, attentif, il a les yeux baissés, attachés sur quelque chose; il vit, il pense; et puis il faut voir comme ses cheveux sont arrangés et torchés. Si cette esquisse m'appartenait, je ne permettrais jamais à l'artiste de l'achever.

Le second est peint avec plus de vigueur et de verve encore, il est plein de chaleur. Sur le sommet de sa tête ses cheveux sont partagés en deux tresses relevées de la gauche, le reste est en désordre. J'en aime moins l'expression que du précédent, il regarde et puis c'est tout; mais le faire en est incomparablement plus libre, plus fougueux, plus hardi, plus chaud et plus beau. Plus de sagesse dans l'un, plus d'enthousiasme dans l'autre; ce sont deux tours de cervelle, deux momens de génie tout à fait opposés. Les artistes préféreront le second et ils auront raison. Moi, j'aime mieux le premier.[21]

These are two beautiful things. The first child is serious, attentive, his eyes are lowered, fixed on something; he is alive, he thinks. And it is necessary too to see how his hair is arranged and done. If this sketch belonged to me, I would never allow the artist to finish it.

The second is painted with still more strength and verve, he is full of warmth. On the top of his head his hair is parted in two braids drawn up on the left, the rest is in disorder. I like his expression less than that of the first, he looks and that is all. But the execution of this sketch is incomparably freer, more impetuous, bolder, warmer, and more beautiful. More wisdom in one, more enthusiasm in the other; they are two turns of mind, two altogether opposed moments of genius. Artists will prefer the second and they will be right. Personally, I prefer the first.

The distinction Diderot draws is between a child absorbed in something and one who seems merely to look. And his preference for the first oil sketch, in spite of his recognition of the superior execution of the second, says a great deal about the priorities which he himself knew to be at work in his criticism.

Earlier in this chapter I said that I intended to discuss the way in which Diderot's concern with absorptive values and effects leads ultimately to an alternative conception of painting as well as to a vision of the relationship between painting and beholder that goes against almost everything that I have claimed about that relationship until now. I have in mind Diderot's infrequent but nevertheless far from arbitrary use of the fiction of *physically entering* a painting or group of paintings he is reviewing, a fiction conspicuously at odds with the doctrine of the radical exclusion of the beholder that I have argued his writings expound. Clear-cut instances of that fiction include his remarks on a landscape with shepherds by the young Loutherbourg in the *Salon de 1763;* his account of a similar picture by Le Prince in the *Salon de 1765;* the long and brilliant section on Joseph Vernet in the *Salon de 1767;* and the pages on Hubert Robert in the same *Salon.* No one, to my knowledge, has ever con-

nected those passages, or devoted to any one of them the attention each deserves, or taken seriously—regarded as other than a stylistic or a rhetorical device without intellectual content—Diderot's reiterated assertion that he is inside the paintings with which they deal. No one seems to have suspected that the fiction in question might be an essential component of Diderot's critical response to those particular works, much less that it might embody a conception of the pictorial enterprise that the student of eighteenth-century French art and culture cannot afford to ignore. But this is indeed the case.

Diderot's discussion in his *Salon de 1763* of Philippe-Jacques de Loutherbourg's *Un Paysage avec figures et animaux* (Fig. 48)[22] begins straightforwardly

48 Philippe-Jacques de Loutherbourg, *Un Paysage avec figures et animaux,* Salon of 1763. Liverpool, Walker Art Gallery.

enough. Astonished by the young painter's precocity—Loutherbourg was then only twenty-two—and thoroughly charmed by the painting, Diderot remarks in turn on the nobility of certain masses of rock, the persuasivenesss of the rendering of space, the sheer lifelikeness of the animals, the transparency of the verdure, and so on.[23] He then exclaims (as usual, to Grimm):

Ah! mon ami, que la nature est belle dans ce petit canton! arrêtons-nous-y; la chaleur du jour commence à se faire sentir, couchons-nous le long de ces animaux. Tandis que nous admirerons l'ouvrage du Créateur, la conversation de ce pâtre et de cette paysanne nous amusera; nos oreilles ne dédaigneront pas les sons rustiques de ce bouvier, qui charme le silence de cette solitude et trompe les ennuis de sa condition en jouant de la flûte. Reposons-nous; vous serez à côté de moi, je serai à vos pieds tranquille et en sûreté, comme ce chien, compagnon assidu de la vie de son maître et garde fidèle de son troupeau; et lorsque le poids du jour sera tombé nous continuerons notre route, et dans un temps plus éloigné, nous nous rappellerons encore cet endroit enchanté et l'heure délicieuse que nous y avons passée.[24]

[119]

Ah! My friend, how beautiful nature is in this little spot! Let us stop there. The heat of the day is beginning to be felt, let us lie down next to these animals. While we admire the work of the Creator, the conversation of this shepherd and this peasant woman will divert us. Our ears will not disdain the rustic sounds of the cowherd who charms the silence of this solitude and beguiles the tedium of his condition by playing the flute. Let us rest. You will be next to me, I will be at your feet, tranquil and safe, like this dog, diligent companion of his master's life and faithful keeper of his flock. And when the weight of the light has diminished we will go our way again, and at some remote time we will still remember this enchanted place and the delicious hour that we spent there.

49 Jean-Baptiste Le Prince, *Pastorale russe,* Salon of 1765. Collection Baumgarten.

Two years later, in the *Salon de 1765,* Diderot describes in similar terms a picture by a young artist recently returned from a stay of several years in Russia, Jean-Baptiste Le Prince. By and large, Diderot tended to be less than enthusiastic about Le Prince's work; but one painting in particular, a *Pastorale russe* (Fig. 49),[25] seemed to him a triumph, the fruit of a perfect marriage between the artist's limitations and the nature of the subject:

[120]

Les artistes diront de celui-ci tout ce qu'il leur plaira; mais il y a un sombre, un repos, une paix, un silence, une innocence qui m'enchantent. Il semble qu'ici le peintre ait été secondé par sa propre foiblesse [cf. Diderot's remarks in the *Salon de 1767* on the "foiblesse supérieurement entendue" of Vien's *St. Denis*]. Le sujet simple demandoit une touche légère et douce, elle y est; peu d'effet de lumière, il y en a peu. C'est un vieillard qui a cessé de jouer de sa guitarre pour entendre un jeune berger jouer de son chalumeau. Le vieillard est assis sous un arbre. Je le crois aveugle; s'il ne l'est pas, je voudrois qu'il le fût. Il y a une jeune fille debout à côté de lui. Le jeune garçon est assis à terre, à quelque distance du vieillard et de la jeune fille. Il a son chalumeau à la bouche. Il est de position, de caractère, de vêtement, d'une simplicité qui ravit; la tête surtout est charmante. Le vieillard et la jeune fille écoutent à merveille. Le côté droit de la scène montre des rochers, au pied desquels on voit paître quelques moutons. Cette composition va droit à l'ame.[26]

Artists will say what they please about this one, but there is in it a shade, a calm, a peace, a silence, an innocence that I find enchanting. It seems that here the painter was helped by his own weakness. The simple subject demanded a gentle and sweet touch, it is here; not much contrast of light and dark, and that is what we find. There is an old man who has stopped playing his guitar in order to hear a young shepherd playing his reed-pipe. The old man is seated under a tree. I think he is blind; if he is not, I wish he were. A young girl stands next to him. The boy is seated on the ground, a short distance away from the old man and the girl. He has his reed-pipe in his mouth. His position, his character, his dress are of a ravishing simplicity; his head is especially charming. The old man and the girl are listening intently. On the right-hand side of the scene are some rocks at the foot of which a few grazing sheep can be seen. This composition goes straight to the soul.

At this point Diderot discovers that he has entered the painting:

Je me trouve bien là. Je resterai appuyé contre cet arbre, entre ce vieillard et sa jeune fille, tant que le jeune garçon jouera. Quand il aura cessé de jouer, et que le vieillard remettra ses doigts sur sa balalaye, j'irai m'asseoir à côté du jeune garçon; et lorsque la nuit s'approchera, nous reconduirons tous les trois ensemble le bon vieillard dans sa cabane. Un tableau avec lequel on raisonne ainsi, qui vous met en scène, et dont l'âme reçoit une sensation délicieuse, n'est jamais un mauvais tableau.[27]

I actually find myself there. I shall remain leaning against this tree, between this old man and his young girl, as long as the boy plays. When he will have stopped playing, and when the old man places his fingers on his balalaika once again, I shall go and sit next to the boy; and when the night draws near, all three of us together will accompany the good old man to his hut. A painting with which one reasons in this way, which puts you in the scene, and from which the soul receives a delicious sensation, is never a bad painting.

The absorptive basis of Le Prince's painting emerges plainly, as does a connection between the old man's blindness—not merely noted but actually wished on him by Diderot—and the same figure's absorption in listening. (Like absorption, blindness implies a lack of awareness of being beheld; cf. the discussion of Chardin's *Aveugle* and Greuze's *Aveugle trompé* in chapter one, as well as the analysis of versions of the blind Belisarius receiving alms toward the end of

[121]

the present chapter.) As in the Loutherbourg passage, the critic's fictive trans-
position into the picture takes place midstream, as if brought about or at any
rate given impetus by the descriptive writing that precedes it. Moreover, there
is an obvious similarity between the mini-narratives in future tense that im-
mediately follow the transposition in the two passages. And one is aware also
of a shared vocabulary of key terms, perhaps the most important of which,
placed climactically in each, is the adjective *délicieuse*.[28]

The fiction of physically entering a painting or group of paintings plays a
much larger role in the *Salon de 1767* than in the two previous ones. It is first
touched on at the end of a brief section on Chardin's still lifes, which Diderot
had come to regard as nothing short of miraculous. Chardin's compositions, he
writes,

> appellent indistinctement l'ignorant et le connaisseur. C'est une vigueur de couleur
> incroyable, une harmonie générale, un effet piquant et vrai, de belles masses, une
> magie de faire à désespérer, un ragoût dans l'assortiment et l'ordonnance. Eloignez-
> vous, approchez-vous, même illusion, point de confusion, point de symmétrie non
> plus, point de papillotage; l'oeil est toujours recréé, parce qu'il y a calme et repos. On
> s'arrête devant un Chardin comme d'instinct, comme un voyageur fatigué de sa route
> va s'asseoir, sans presque s'en appercevoir, dans l'endroit qui lui offre un siège de
> verdure, du silence, des eaux, de l'ombre et du frais.[29]

attract the ignorant and the connoisseur alike. They are characterized by incredible
coloristic vigor, a general harmony, an alluring and true effect, beautiful masses, a
magic of execution to make one despair, a stimulating mixture of variety and order.
Move away, come closer, same illusion, no confusion, no symmetry either, no *papil-
lotage;* the eye is always entertained because there is calm and rest. One stops in front
of a Chardin as if by instinct, as a traveller tired of his journey sits down almost
without being aware of it in a spot that offers him a bit of greenery, silence, water,
shade, and coolness.

Diderot does not say that the beholder physically enters Chardin's still lifes, a
proposition that could not avoid seeming absurd. But the extended metaphor
with which his remarks conclude strongly implies that his experience of Char-
din's still lifes had much in common with his earlier experiences of landscapes
with figures by Loutherbourg and Le Prince. By the same token, Diderot's use
of that metaphor in connection with Chardin suggests that the natural imagery
that abounds in the earlier passages ought even there to be understood as
resonant with other than simply descriptive significance. It ought to be under-
stood as at least partly metaphorical in import—as aiming not merely to tran-
scribe the scenery and other natural objects depicted by Loutherbourg and Le
Prince but also to conjure the distinctive effect of their paintings as imagina-
tive wholes.

But it is in the long and famous section on Joseph Vernet (1714–1789),
unanimously regarded by French critics of the 1750s and 1760s as the greatest
landscape and marine painter of the age,[30] that the fiction of physically enter-
ing a group of paintings receives its fullest, most intensive development. The

[122]

section comes right after the one on Chardin, and it may be that Diderot was prompted by the metaphor we have just examined to exploit that fiction as a means of articulating his experience of Vernet's canvases. In any case, the Vernet section begins with the statement: "J'avais écrit le nom de cet artiste au haut de ma page, et j'allais vous entretenir de ses ouvrages, lorsque je suis parti pour une campagne voisine de la mer et renommée par la beauté de ses sites" (I had written this artist's name at the top of my page, and I was going to talk to you about his works, when I departed for a stretch of country near the sea and renowned for the beauty of its sites).[31] And it goes on to recount, for almost thirty pages in the standard modern edition of the *Salons*, three long *promenades* that Diderot claims to have made in and through no less than six of those sites, in the company of a guide—an *abbé* employed as a children's tutor—who took special pleasure in revealing the charms of the region to travellers visiting it for the first time. Diderot's account of the *promenades* includes detailed descriptions of the several vistas each site contained, evocations of his responses to those vistas as he was led from one to another by his *cicerone,* and reports of conversations between himself and the *abbé* on a number of related topics in esthetics. The result is an extremely rich and complex text, in which narrative, descriptive, lyric, and dialogic elements alternate and intermix; in which tenses fluctuate from one sentence to the next (the dominant tense is the imperfect but the writing continually modulates to the past definite and on one occasion shifts to the present); and in which the fictive nature not only of the character Diderot but also of the critic Diderot, the author of the Vernet section, is repeatedly underscored. (I shall not try to register the subtle distinctions between those fictions in the pages that follow, not because they are unimportant but because to attempt to do so would distract from the issue at hand.) In addition the conversations with the *abbé* are of interest in themselves to the student of Diderot's thought. For example, in the course of their wanderings through the first two sites, Diderot expounds to the *abbé* his view of the causal necessity of all of nature, while in their travels through the fourth and fifth sites he puts forward his theory that ordinary morality and artistic morality are fundamentally at odds. More generally, it is in the Vernet section that the influence on Diderot of Burke's *Enquiry* shows itself in force, both in the descriptions of mountains, waterfalls, and other "sublime" items of natural scenery and in the theoretical excursus—a paraphrase of Burke—that brings the section to a close. Obviously a text of this sort demands careful reading if even a fraction of its complexities are to be fathomed. But rather than undertake such a reading here, a project that would require more space than I have at my disposal and in any case would divagate from my principal argument, I want simply to examine Diderot's portrayal of his responses to some of the vistas that he came across as he explored "les plus beaux sites du monde" (the most beautiful sites in the world).[32]

The first site visited by Diderot, the *abbé,* and the latter's young charges was a mountain landscape with a torrent and fishermen (Fig. 50).[33] The *abbé*

[123]

50 After Claude-Joseph Vernet, *La Source abondante,* Salon of 1767, en-
graved by Le Bas. Whereabouts of painting unknown.

challenged Diderot to name a single artist capable of imagining its particular beauties; Diderot not surprisingly proposed Vernet and a heated discussion ensued, after reporting which he comments: "Toute cette conversation se fesait d'une manière fort interrompue. La beauté du site nous tenait alternativement suspendus d'admiration, je parlais sans trop m'entendre, j'étais écouté avec la même distraction. . . ." (The whole of this conversation was conducted in a very interrupted fashion. The beauty of the site held us alternately suspended with admiration, I spoke without hearing myself very well, I was listened to with the same distraction. . .).[34] A few pages later we are told how, when a sudden duststorm temporarily blinded the *abbé,* Diderot seized the occasion to advance his case (the quotation begins with Diderot addressing the *abbé*): "Ce tourbillon qui ne vous semble qu'un chaos de molécules dispersées au hazard, eh bien, cher abbé, ce tourbillon est tout aussi parfaitement ordonné que le

[124]

monde . . . et j'allais lui donner des preuves, qu'il n'était pas trop en état de goûter, lorsqu'à l'aspect d'un nouveau site [the second], non moins admirable que le premier, ma voix coupée, mes idées confondues, je restai stupéfait et muet" (This swirling cloud which seems to you to be only a chaos of molecules scattered at random, well, my dear *abbé,* this swirling cloud is just as perfectly organized as the world . . . and I was going to give him proofs, which he was not in much of a state to appreciate, when, at the appearance of a new site, no less admirable than the first, my voice broken, my thoughts confused, I was left astounded and dumb).[35] Diderot goes on to describe the second site, largely by recapitulating his movements through and across its difficult terrain (it is in order to keep pace with those movements that the writing shifts briefly to the present tense), until at last we are told that he and his companions came to rest on the shore of a lake surrounded by mountains and fed by torrents. Nearby a dark cavern opened in the rocks, and here and there along the shore, just where an intelligent painter would have placed them, were various figures. Diderot characterizes his response to the vista as follows:

J'étais immobile, mes regards erraient sans s'arrêter sur aucun objet, mes bras tombaient à mes côtés, j'avais la bouche entr'ouverte. Mon conducteur respectait mon admiration et mon silence; il était aussi heureux, aussi vain que s'il eût été le propriétaire ou même le créateur de ces merveilles. Je ne vous dirai point quelle fut la durée de mon enchantement; l'immobilité des êtres, la solitude d'un lieu, son silence profond suspendent le temps, il n'y en a plus, rien ne le mesure, l'homme devient comme éternel.[36]

I was motionless, my eyes wandered without fixing themselves on any object, my arms fell to my sides, my mouth opened. My guide respected my admiration and my silence; he was as happy, as vain as if he were the owner or even the creator of these marvels. I shall not tell you how long my enchantment lasted. The immobility of beings, the solitude of a place, its profound silence, all suspend time; time no longer exists, nothing measures it, man becomes as if eternal.

One might say that Diderot portrays himself as if he were a figure in a painting. At any rate, by delineating the physical or behavioral component of his response, Diderot encourages the reader not only to see the landscape through his eyes—it is the task of the preceding paragraphs to bring that about—but also to visualize his presence at the scene, a very different thing.

Similar passages occur elsewhere in the Vernet section. For example, Diderot's account of the fourth site (Fig. 51) begins:

J'en étais là de ma rêverie, nonchalamment étendu dans un fauteuil, laissant errer mon esprit à son gré, état délicieux où l'âme est honnête sans réflexion, l'esprit juste et délicat sans effort, où l'idée, le sentiment semble naître en nous de lui-même comme d'un sol heureux; mes yeux étaient attachés sur un paysage admirable, et je disais: L'abbé a raison, nos artistes n'y entendent rien, puisque le spectacle de leurs plus belles productions ne m'a jamais fait éprouver le délire que j'éprouve, le plaisir d'être à moi, le plaisir de me reconnaître aussi bon que je le suis, le plaisir de me voir et de me complaire, le plaisir plus doux encore de m'oublier: où suis-je dans ce

51 After Claude-Joseph Vernet, *Les Occupations du rivage*, Salon of 1767, engraved by Le Bas. Whereabouts of painting unknown.

moment? qu'est-ce qui m'environne? Je ne le sais, je l'ignore. Que me manque-t-il? Rien. Que désiré-je? Rien. S'il est un Dieu, c'est ainsi qu'il est, il jouit de lui-même.[37]

I was at that point in my reverie, nonchalantly stretched out in an armchair, letting my mind wander freely—delicious state in which the soul is honest without reflecting, the mind exact and delicate without effort, in which ideas and feelings seem to be born in us of themselves as from some favorable soil. My eyes were fixed on an admirable landscape, and I was saying: "The *abbé* is right, our artists understand nothing, since the spectacle of their most beautiful productions has never made me feel the delirium I feel now, the pleasure of belonging to myself, the pleasure of knowing myself to be as good as I am, the pleasure of seeing myself and of pleasing myself, the even sweeter pleasure of forgetting myself. Where am I at this moment? What surrounds me? I do not know, I am not aware of it. What am I lacking? Nothing. What do I desire? Nothing. If there is a God, this is how he is, he takes pleasure in himself."

At that moment a noise, the sound of a woman beating her washing, came from far away and the spell was broken. But, Diderot acknowledges, if divine existence is sweet, human existence is sometimes sweet enough as well; and he proceeds to describe the scene that had entranced him, urging, in the course of his description, his absent friend Vernet to sketch portions of it for future use in paintings.[38]

Finally, in his account of the sixth site Diderot follows a paragraph of detailed description with the remarks:

Si vous ne faites pas un effort pour vous bien représenter ce site, vous me prendrez pour un fou, lorsque je vous dirai que je poussai un cri d'admiration, et que je restai immobile et stupéfait. . . . Ô Nature, que tu es grande! Ô Nature, que tu es imposante, majestueuse et belle! C'est tout ce que je disais au fond de mon âme, mais comment pourrais-je vous rendre la variété des sensations délicieuses dont ces mots répétés en cent manières diverses étaient accompagnés. On les aurait sans doute toutes lues sur mon visage, on les aurait distinguées aux accens de ma voix, tantôt faibles, tantôt véhémens, tantôt coupés, tantôt continus. Quelquefois mes yeux et mes bras s'élevaient vers le ciel, quelquefois ils retombaient à mes côtés comme entraînés de lassitude. Je crois que je versai quelques larmes. . . .

Qui sait le temps que je passai dans cet état d'enchantement? Je crois que j'y serais encore sans un bruit confus de voix qui m'appellaient: c'étaient celles de nos petits élèves et de leur instituteur.[39]

If you do not make an effort to picture this site to yourself accurately, you will take me for a madman when I tell you that I uttered a cry of admiration and that I was left motionless and dumbfounded. . . . Oh, Nature, how great you are! Oh, Nature, how imposing, majestic, and beautiful you are! That was all I said in the depths of my soul, but how could I convey to you the variety of delicious sensations that accompanied these words repeated in a hundred different ways? The sensations undoubtedly could all have been read on my face, they could have been distinguished in the tones of my voice, now weak, now vehement, now broken, now continuous. Sometimes my eyes and my arms were raised to the sky, sometimes they fell back to my sides as if brought down by weariness. I think I shed a few tears. . . .

Who knows how long I spent in that state of enchantment? I think I would still be there were it not for a confused noise of voices calling me—they were the voices of our young students and their tutor.

In obvious respects this last passage is more extreme than the others we have considered. But the basic experience it evokes—of being enchanted, flooded with *sensations délicieuses,* made oblivious to the passage of time—is essentially the same in all.

Toward the end of his *promenade* through the sixth site Diderot lets drop the admission that he has all along been describing paintings by Vernet, and explains that he adopted the fiction that they were actual sites "pour rompre l'ennui et la monotonie des descriptions" (in order to break the boredom and the monotony of the descriptions).[40] Modern commentators have taken him at his word, and his explanation may even be true as far as it goes. But it does not go nearly far enough.

Just how short it falls is indicated by Diderot's criticism further on in the

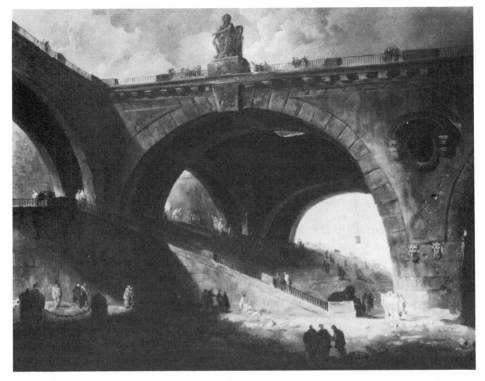

52 Hubert Robert. *Le Pont ancien,* ca. 1760–1761. New Haven, Yale University Art Gallery, Gift of Mr. and Mrs. James W. Fosburgh.

Salon de 1767 of the work of a painter who made a highly successful public debut in that year's exhibition, Hubert Robert (1733–1808).[41] In the Robert section of the *Salon* the fiction of being in the picture is for the first time presented explicitly as a vital desideratum for an entire class or genre of paintings. Robert's specialty was the depiction of ancient ruins, a type of painting suited to appeal to Diderot's predilection for "sublime" effects. Nor did Diderot fail to recognize the magnitude of the young artist's gifts. But he believed that Robert had not yet fully grasped the imaginative essence of his chosen genre and that until he did his mastery would be incomplete. For example, although Diderot greatly admired Robert's *Grande Galerie éclairée du fond,*[42] he nevertheless was moved to write (addressing Robert):

Vous êtes un habile homme, vous excellerez, vous excellez dans votre genre; mais étudiez Vernet, apprenez de lui à dessiner, à peindre, à rendre vos figures intéressantes; et puisque vous vous êtes voué à la peinture des ruines, sachez que ce genre a sa poétique; vous l'ignorez absolument, cherchez-la. Vous avez le faire, mais l'idéal vous manque. Ne sentez-vous qu'il y a trop de figures ici, qu'il en faut effacer les trois quarts? Il n'en faut réserver que celles qui ajouteront à la solitude et au silence. Un seul homme, qui aurait erré dans ces ténèbres, les bras croisés sur la poitrine et la tête penchée, m'aurait affecté davantage; l'obscurité seule, la majesté de l'édifice, la grandeur de la fabrique, l'étendue, la tranquillité, le retentissement sourd de l'espace m'aurait fait frémir; je n'aurais jamais pu me défendre d'aller rêver sous cette voûte, de m'asseoir entre ces colonnes, d'entrer dans votre tableau. Mais il y a trop d'importuns; je m'arrête, je regarde, j'admire et je passe.[43]

[128]

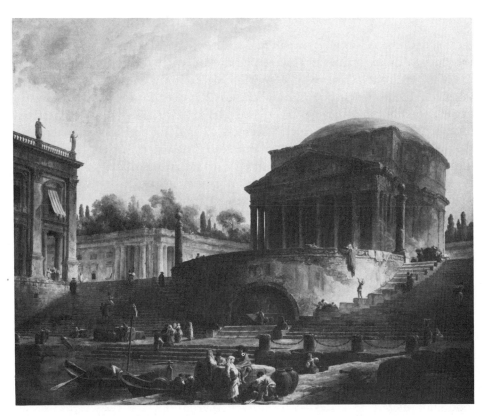

53 Hubert Robert, *Le Port de Rome,* Salon of 1767. Paris, Louvre.

You are a gifted man, you will excel, you already excel in your genre. But study Vernet, learn from him how to draw, how to paint, how to make your figures interesting. And since you have devoted yourself to painting scenes of ruins, you should know that this genre has its poetics. You are absolutely unaware of that poetics, seek it out. You have the technique, but you lack the ideal. Do you not feel that there are too many figures here, that three-quarters of them should be eliminated? Only those which add to solitude and the silence should be kept. A lone man wandering through this darkness, his arms crossed on his chest and his head bent, would have affected me more than all these. The darkness alone, the majesty of the edifice, the grandeur of the construction, the dimensions, the tranquility, the dull resonance of the space would have made me shudder. I could never have avoided going and dreaming under this vault, sitting down between its columns, entering your painting. But there are too many intruders; I stop, I look, I admire, and I walk past.

(Because the painting criticized in this passage has since been lost, I have reproduced another early Robert, *Le Pont ancien* [ca. 1760–1761; Fig. 52], which illustrates what was in fact his tendency to people his canvases with a large number of auxiliary figures.) Of another painting, *Le Port de Rome* (Fig. 53),[44] Diderot observes: "Ce morceau est très-beau, il est plein de grandeur et de majesté; on l'admire, mais on n'en est pas plus ému, il ne fait point rêver. . . . La beauté de l'idéal frappe tous les hommes, la beauté du faire n'arrête que le connaisseur; si elle le fait rêver, c'est sur l'art et l'artiste, et non sur la chose, il reste toujours hors de la scène, il n'y entre jamais" (This work is

[129]

very beautiful, it is full of grandeur and majesty; one admires it, but one is not more moved by it, it does not make one dream. . . . The beauty of the ideal strikes all men, the beauty of execution arrests only the connoisseur. If it makes him dream, it is about art and the artist, not about the thing, he always remains outside the scene, he never enters it).[45] A single work by Robert, an oil sketch of a temple interior,[46] seemed to Diderot to succeed where the others failed. "On s'oublie devant ce morceau," he writes, "c'est la plus forte magie de l'art. Ce n'est plus au Sallon ou dans un attelier qu'on est, c'est dans une église, sous une voûte; il règne là un calme, un silence qui touche, une fraîcheur délicieuse" (One forgets oneself in front of this work, that is the strongest magic of art. One is no longer at the Salon or in a studio, but in a church, beneath a vault. A calm, a silence that touches, a delicious coolness reign there).[47] In short, Diderot held that the poetics or imaginative essence of depictions of ruins required that the beholder be compelled to enter the painting, to meditate not only on but among the remains of ancient civilizations.

If we now consider together the passages we have surveyed—those on Loutherbourg (1763), Le Prince (1765), Chardin (1767), Vernet (1767), and Robert (1767)—three main points become clear. First, there is an obvious and direct relation between Diderot's use of the fiction of physically entering a painting or group of paintings and his admiration for the works that turn out to have been described in those terms. The fiction must therefore be understood, not merely as a device to enliven matters for the reader, but as an essential component of Diderot's critical response to certain paintings and not others. Second, all the paintings with which the passages just cited are concerned belong to certain "lesser" genres: pastoral scenes, landscapes with figures, depictions of ruins, still lifes.[48] This suggests, and the Robert section tends to confirm the suggestion, that the fiction of being in the picture functions in Diderot's *Salons* as a sign of his conviction of the success as art of works belonging to those genres. Put another way, the suggestion is that for Diderot the success as art of works in those genres depended on whether they compelled the beholder to imagine—or at least on whether they led the critic to adopt the fiction—that he was inside the painting, though it was not until 1767, and probably not until Diderot came to write the section on Robert, that he appears to have understood that this was the case.[49] And third, the basic affinity of the "lesser" genres in question is with the representation of nature rather than of action and passion. (Paintings of ruins depict the cumulative destruction, or reclamation, by natural forces of the works of man.)[50] Accordingly, Diderot seems to have held that an essential object of paintings belonging to those genres was to induce in the beholder a particular psychophysical condition, equivalent in kind and intensity to a profound experience of nature, which for the sake of brevity might be characterized as one of existential reverie or *repos délicieux*.[51] In that state of mind and body a wholly passive receptivity becomes the vehicle of an apprehension of the fundamental beneficence of the natural world; the subject's awareness of the passage of time

and, on occasion, of his very surroundings may be abolished; and he comes to experience a pure and intense sensation of the sweetness and as it were the self-sufficiency of his own existence. It should be noted too that the second and third points are closely bound up with one another. Thus it often seems that it is because a given painting induced in Diderot the psycho-physical condition to which I have just referred that he was led to adopt the fiction that it is a real scene in which he finds himself and which he proceeds to explore. Probably, though, it would be more accurate to say that the two went hand in hand, so that a painting that lacked the power to induce the one would have been incapable of inspiring him to adopt the other, and vice versa.

It hardly seems possible that the vision of the painting-beholder relationship that comes to a head in the Vernet and Robert sections of the *Salon de 1767* can be reconciled with the vision of that relationship that emerged in the previous chapters of this study as central to French painting and art criticism of the 1750s and 1760s. But further analysis reveals that there is a deep connection between the two.

In order to locate that connection, it is necessary to recognize that works that belonged to the "lesser" genres we have been discussing simply did not provide the painter with the means that were needed radically to exclude the beholder from the painting. They did not represent dramatic actions, passionate feelings, extreme states of mind; they did not lend themselves to the invention of powerfully unified compositional structures of the type Diderot admired in Greuze's *Piété filiale;* and although they characteristically depicted figures engaged in absorptive activities—e.g., shepherds listening to one of their number play a musical instrument, a man engrossed in meditation among ancient ruins—the role of those figures was chiefly to enhance the effect, to give point to the solitude, of the natural settings in which they were placed. In view of these limitations, if that is what they are, Diderot's conclusion that the poetics of the "lesser" genres entailed establishing the fiction that the beholder physically enter the painting may be seen both as entirely logical and as surprisingly consistent with the vision of the painting-beholder relationship expounded in chapters one and two. Entirely logical, in that such a fiction harmonizes perfectly with the emphasis on the experience of nature that we have seen is associated with those genres; and surprisingly consistent with what has gone before, in that according to that fiction the beholder *is removed from in front of the painting* just as surely as if his presence there were negated or neutralized, indeed just as surely as if he did not exist.

It follows that my earlier presentation of Diderot's views was incomplete. I now suggest that there coexist in his *Salons* and related writings not one but two conceptions of the art of painting each of which has for its ultimate aim what I earlier termed the de-theatricalization of the relationship between painting and beholder. The primary or *dramatic* conception calls for establishing the fiction of the beholder's nonexistence in and through the persuasive representation of figures wholly absorbed in their actions, passions, activities,

[131]

feelings, states of mind. (As we have seen, increasingly strong measures came to be required in order to persuade contemporary audiences that a figure or group of figures *was* so absorbed.) Wherever possible that fiction was to be driven home by subsuming the figures in a unified compositional structure, thereby giving the painting as a whole the character of a closed and self-sufficient system. The secondary or *pastoral* conception, which in the end is probably best understood as an offshoot or even a special case of the dramatic,[52] calls for establishing the opposite but in important respects equivalent fiction of the beholder's physical presence within the painting, by virtue of an almost magical recreation of the effect of nature itself. The foremost objective difference between works satisfying the two conceptions is that of genre. There is also a difference of sorts between Diderot's subjective responses to the two classes of paintings—roughly, between the inflamed and often mixed emotions excited by the work of an artist like Greuze and the gentler, seemingly unconflicted, at times virtually mystical feelings elicited by the work of Loutherbourg, Le Prince, Vernet, and Robert. (Here too the difference is by no means absolute: in the Vernet and Robert sections of the *Salon de 1767* the "sublimity" of Diderot's surroundings engenders responses as inflamed as any provoked in him by Greuze's art; while Diderot in the *Salon de 1765* repeatedly uses the word *délicieux* to characterize Greuze's *Jeune Fille qui pleure son oiseau mort.*) According to both conceptions, however, the estrangement of the beholder from the objects of his beholding is overcome; the condition of spectatordom is transformed and thereby redeemed; and the beholder is stopped and held, sometimes for hours at a stretch if contemporary testimony is believed, in front of the painting.

Furthermore, I am convinced that what I have just called Diderot's dramatic and pastoral conceptions of the pictorial enterprise correspond to probably the two chief tendencies in French painting in the second half of the 1750s and 1760s. We have already seen that the first of those conceptions is exemplified by the art of Greuze, a painter whose crucial significance for the entire period has become increasingly evident but the meaning of whose achievement has consistently been reduced to triviality by modern commentators. Similarly, an analysis of even a single representative work by Vernet of the second half of the sixties—for example, the very fine *Landscape with Waterfall and Figures* (1768; Fig. 54)—reveals the pertinence of Diderot's pastoral conception and in particular of the Vernet section of the *Salon de 1767* to our understanding of some of the most salient features of his art.

In that painting a stretch (more accurately, a slice) of mountainous country is riven by a mighty cataract that plunges from a great height, dashes itself upon rocks, and becomes a torrent flowing largely unseen by the beholder but observed by figures in the picture through a natural chasm toward the distant sea. Vernet's artistic affinities, the major influences on a work such as this, are

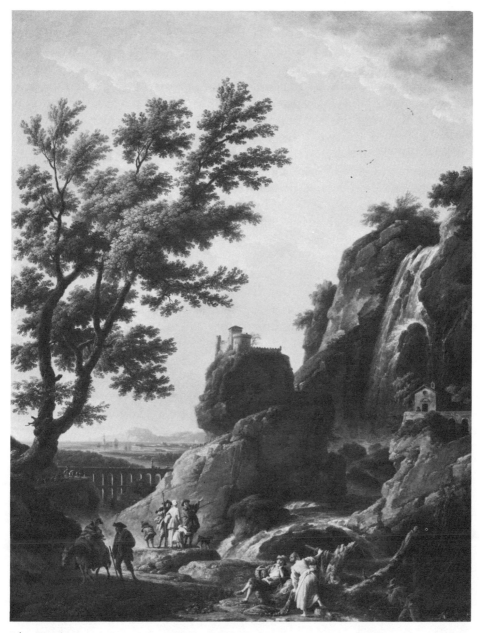

54 Claude-Joseph Vernet, *Landscape with Waterfall and Figures,* 1768. Baltimore, Walters
Art Gallery.

Salvator Rosa and Claude:[53] the first for the wildness and "sublimity" of the setting as well as for the vertical format that Vernet often employed; and the second for the quality of the light, the curiously poignant vista of a distant harbor bathed in the rays of a setting or perhaps a rising sun, and the classical spirit that suffuses the composition as a whole. But there is no real precedent in the art of either Rosa or Claude for the depiction within the painting of numerous points of view, each of which competes with all the others for the beholder's attention and in a sense for his imagined presence at that spot; for the proliferation of roads, paths, climbs, a bridge, distant ships, and so on, as well as of travellers on most or all of these, by which imagery the notion of physically exploring the painting is given explicit expression; for the multiplicity of degrees of relative distance and more generally for the extreme instability of distance and scale relations throughout the composition, which together promote a part-by-part and implicitly temporal reading of the scene; nor finally—a closely related point—for the fracturing of perspectival unity, which makes it virtually impossible for the beholder to grasp the scene as a single instantaneously apprehensible whole and by so doing tends further to call into question—to dissolve as it were beneath his feet—the imaginary fixity of his position in front of the canvas. (The contrast with Claude in this regard is acute, all the more so in that Vernet's painting characteristically includes a single Claude-like vista, that of the distant harbor and sea, which in effect points up the absence of that sort of illusion from the rest of the scene. Try as we may, for example, we cannot construe in a single act of perception the scale and distance relations among the principal figure group, the central massif with its castle, and, towering above the latter, the cliff and cataract.) It is striking too that the figure of a fisherman is shown climbing into the space of the painting at the lower right while other figures—a woman and child on muleback, a man, and a dog—appear on the verge of exiting from the painting at the lower left. This suggests the idea of a circuit that begins at the lower right, explores the entire scene, and concludes by leaving the picture at the lower left: though there is nothing fixed or predetermined about either the places of entrance and exit or the itinerary to be followed once inside.

My emphasis on the disjunctive, implicitly temporal nature of our experience of the *Landscape with Waterfall and Figures* is not intended to minimize its success as a unified piece of decoration, toward the achievement of which the large and splendid tree in the left foreground plays a vital role. Rather I wish to suggest that we find in that painting, as often in Vernet's art, a tension or contradiction between, on the one hand, a subtle but forthright mode of decorative integration, capable of being taken in at a glance, and, on the other, a network of relationships among multiple disparate centers of interest whose separation from and connection with one another within an imaginary space can be apprehended only in time. A version of that tension or contradiction may be discerned in certain early works. In the superb *Vue du golfe de Naples* (1748; Fig. 55),[54] the interplay among variously tilting masts, sails, oars, the

tree, the anchor at the left, etc., serves both to foster a perception of the painting as a decorative whole and, by virtue of the presence of numerous subtle disaccords between those elements—I am thinking of the way in which they often seem to tilt or curve *against* one another—to slow down and in effect to fragment our imaginary experience of the painted scene. Thus we find ourselves dwelling on each portion of the composition in turn, scrutinizing and where appropriate following the progress of the vessels, paying close and individual attention to the exquisitely rendered walking, conversing, or otherwise actively absorbed figures (including in the right foreground an *abbé*

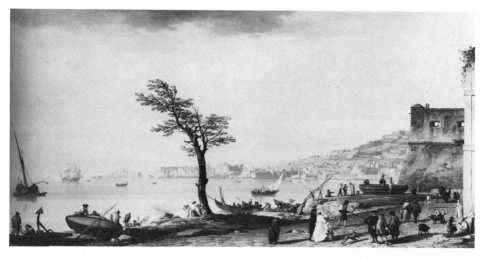

55 Claude-Joseph Vernet, *Vue du golfe de Naples,* 1748. Paris, Louvre.

guiding a wealthy tourist whose purse is meanwhile being lifted by a thief), and even reading in the flight of gulls above the bay the sweep of diverse breezes across different sectors of the sky. In the series of monumental representations of French ports commissioned by Marigny in 1753 and executed by Vernet between 1754 and 1765—one of the supreme pictorial accomplishments of the period—the tension in question is mostly suppressed by a double concern with topographical accuracy and unity of point of view.[55] This is especially evident in those canvases which, like the *Vue du Port de Rochefort* (Salon of 1763;[56] Fig. 56), make use of dramatic perspective recession, though there too we are invited to lose ourselves in the minute examination of the workings of the port and in particular of the engrossment in various activities of numerous figures and figure groups.[57] In the *Landscape with Waterfall and Figures,* however, topographical accuracy is beside the point; unity of point of view does not exist; the multiple centers of interest may be said to form a simultaneous order, but one that is merely decorative, a matter of surface organization or *ordonnance;* which is to say that they are experienced *as* centers of interest only separately, in whatever sequence they happen to be encountered.

[135]

56 Claude-Joseph Vernet, *Vue du Port de Rochefort*, Salon of 1763. Paris, Musée de la Marine.

Finally, though, these observations may make too sharp a distinction be-tween the realms of the decorative and the imaginary in Vernet's art. The formidable charm of the *Landscape with Waterfall and Figures* stems largely from the fact that it is indeed a tissue of solicitations (including solicitations of color, as components of the central color-chord of the principal figure-group—red, yellow, aquamarine—are dispersed throughout the composi-tion). But because those solicitations are subsumed within a unified and im-mediately apprehensible decorative scheme, the cumulative effect of their dis-persal and resistance to any resolving hegemony is one neither of dissociation nor of discord but of what may be thought of as deferral (of the *satisfaction* of unity)—a deferral, and a satisfaction, analogous to those evoked by Diderot's fictive *promenades* through Vernet's paintings in the *Salon de 1767*.[58]

There is even a sense in which the developments that most fully exemplify the two conceptions were still in the future when Diderot arrived at his views. In particular, a strong case could be made for the claim that the dramatic conception found its most complete realization in the flowering of history painting that began around the mid-1770s and climaxed within a short span of time in four masterpieces by Jacques-Louis David (1748–1825)—the *Bélisaire* (1781), the *Horaces* (1784), the *Socrate* (1787), and the *Brutus* (1789). I re-marked earlier that the history of modern art is traditionally conceived as having begun with those canvases, most importantly with the *Horaces*, which from the moment it was exhibited in the Salon of 1785 was seen by David's contemporaries as a paradigm for ambitious painting. What I did not say before but believe to be true is that much of the subsequent evolution of

57 Jean-Honoré Fragonard, *La Lecture*, 1780s. Paris, Louvre.

painting in France may be described in terms of the vicissitudes of that
paradigm, including the coming to the fore of conflicts and contradictions
which appear in retrospect to have been implicit in it from the first. I shall
discuss the *Bélisaire* in some detail further on in this chapter, while the other
paintings just mentioned, along with the larger questions of the evolution of
David's art and its significance for later developments, lie outside the compass
of this book. For the present, then, it must suffice to say that a determined
pursuit of naiveté and a passionate revulsion against the theatrical in Diderot's
sense of the terms were central preoccupations of David's maturity, and that
issues of dramaturgy involving the relationship of painting to beholder were
fundamental to his accomplishment from the *Bélisaire* through the last of his
history paintings, the *Léonidas à Thermopyles* (begun 1800, finished 1814) and

[137]

perhaps beyond.[59] One other point is worth remarking: the possibility that David may have been influenced in this regard by Diderot himself. That possibility has received almost no serious consideration from modern scholars for the simple reason that the *Salons* and *Essais sur la peinture* began to be published in France only in the second half of the 1790s, too late to have played a part in the formation of David's conception of his enterprise. But this line of reasoning ignores a few pertinent facts. In the first place, the *Entretiens sur le Fils naturel* and the *Discours de la poésie dramatique,* which as we have seen contained the rudiments of his pictorial dramaturgy, were readily available. In addition, one or more of Diderot's *Salons* appear to have been in limited circulation in France by the 1770s if not earlier.[60] And starting in the late 1760s, despite a difference of 35 years between their ages, the *philosophe* and the painter were linked by their common friendship with the playwright Michel-Jean Sedaine, with the result that David was in a better position than any other painter of his generation to be familiar with Diderot's ideas.[61]

Diderot's pastoral conception is perhaps most fully exemplified by the work of the greatest painter of the generation before David's, Jean-Honoré Fragonard (1732–1806).[62] Although it is natural to see in Fragonard a late Rococo master in the vein, though not the manner, of his teacher Boucher, he actually combines Rococo motifs and attitudes with a penchant for intensely absorptive themes and effects, often involving reverie or even outright dreaming. That penchant emerges with particular clarity in his drawings—see for example the ravishing *La Lecture* (Fig. 57)[63]—but is evident throughout his painted oeuvre as well, in various paintings of men and women reading a book or a letter,[64] or, more characteristically, in his treatment of amorous subjects, which under his rapid, caressing, volatilizing brush become images not merely of absorption but of rapture and transport, and not merely images but infinitely seductive tokens of the states themselves.[65] Another group of absorptive paintings comprises the so-called *Portraits de Fantaisie,* representations of figures seemingly in the grip of an idea or inspiration, one of which is held to portray Diderot (ca. 1769; Fig. 58).[66] (There are no eighteenth-century references to the supposed *Portrait de Diderot,* but the latter is consistent with Diderot's views, expressed in the *Salon de 1767* and quoted earlier in this chapter, on how he ought to be portrayed.) Still other paintings depict dreaming figures together with their dreams,[67] and altogether Fragonard's art is suffused with an almost palpable dreamlike atmosphere—the product in part of an unequalled lightness and suppleness of touch—which the Goncourts compared with the illusionistic effects of the opera of his day[68] but which might be associated at least as fittingly with an experience of nature. Thus Fragonard's first truly original productions, the drawings in sanguine crayon of the gardens of the Villa d'Este at Tivoli (ca. 1760),[69] evoke the condition that I have called *repos délicieux* with an intensity far exceeding anything to be found in the work of his French contemporaries or immediate predecessors. (It is

58 Jean-Honoré Fragonard, *Portrait de Diderot,* ca. 1769. Paris, Louvre.

striking that one of his favorite motifs in those drawings, as in the famous sheet at Besançon [Fig. 59],[70] was a long *allée* bordered on both sides by improbably towering cypresses and depicted in perspective so as to create a spatial cleft or tunnel into whose sunlit depths the beholder feels himself ineluctably drawn.) Moreover, there is the strongest imaginable affinity between those drawings, made at the outset of his career, and the great pair of landscapes with figures, *The Swing* and *Blind Man's Buff* (ca. 1775; Fig. 60),[71] with their multiple centers of interest, large but flickering contrasts of light and shadow, and almost vertiginous metaphorizing of leafage, fountain, and cloud. But it is the magnificent decorative ensemble known as the *Progress of Love* (1771–1773), commissioned and then rejected by Mme. du Barry, which perhaps more than any other work epitomizes Fragonard's transmutation of Rococo. In that group of four pictures—I reproduce *Love and Friendship* (Fig. 61), the third in the sequence[72]—a mood of sexual intoxication keyed to the doings (one can hardly say the actions) of a pair of lovers is in effect anticipated

[139]

59 Jean-Honoré Fragonard, *Les Grands Cyprès de la villa d'Este,* Salon of 1765. Besançon,
Musée des Beaux-Arts.

60 Jean-Honoré Fragonard, *Blind Man's Buff,* ca. 1775. Washington, D.C., National Gallery of Art, Samuel H. Kress Collection.

by the extravagantly lush and febrile settings in which their passion is aroused and crowned; while the fact that the beholder was meant to stand surrounded by the four scenes amounts almost to a literalization of the fiction that he enter the paintings and participate in their delirium. (An unexpected index of such literalization is the inclusion of an artist portraying the lovers in the fourth painting, *The Lover Crowned.*) Throughout Fragonard's oeuvre participation of a sort is further encouraged by a highly characteristic sketchiness or lack of finish, which may be said to confer upon the beholder the pleasure of imaginatively completing the paintings and drawings in question.[73]

One other canvas by Fragonard deserves special mention both for its own sake and for the light it throws on the distinction that I have drawn between Diderot's dramatic and pastoral conceptions. In the Salon of 1765, the first

[141]

61 Jean-Honoré Fragonard, *Love and Friendship,* 1771–1773. New York, Frick Collection.

and very nearly the last in which he exhibited, Fragonard presented a large history painting unique in his oeuvre, *Le Grand-Prêtre Corésus se sacrifie pour sauver Callirhoé* (Fig. 62).[74] Although not completely satisfied with aspects of its execution, Diderot was greatly impressed by the *Corésus et Callirhoé* and devoted to it one of the most resourceful set-pieces in all his criticism.[75] He begins by telling Grimm that he is unable to discuss Fragonard's picture because he missed seeing it at the Salon. Instead he purports to recount a recent dream, stimulated by reading Plato, in which he found himself along with many others seated in a dark cave, bound hand and foot, and compelled to face the depths of the cave across which was stretched an immense canvas. From

behind this captive audience, he explains, small transparent colored figures were projected by a kind of magic lantern onto the canvas screen, thereby producing a remarkably convincing illusion of actuality. (The illusion was made virtually complete by assistants stationed behind the screen who provided voices for the images.) Finally Diderot describes an especially memorable sequence of *tableaux* created in this manner. The subject, set in ancient Greece, was the impending sacrifice of a young woman who by rejecting the love of a priest of Bacchus had brought down a mass frenzy on her people; and the sequence culminated in a scene of horror as the priest, consumed with passion for the swooning girl, plunged the sacrificial knife into his own breast.[76]

The section as a whole has the form of a fictive dialogue with Grimm, who twice is made to remark on the similarity between the setting and the dramatis personae described by Diderot and those depicted in the *Corésus et Callirhoé,* and who at the climactic moment is made to exclaim:

Voilà le tableau de Fragonard, le voilà avec tout son effet. . . . C'est le même temple, la même ordonnance, les mêmes personnages, la même action, les mêmes caractères, le même intérêt général, les mêmes qualités, les mêmes défauts. Dans la caverne, vous n'avez vu que les simulacres des êtres, et Fragonard, sur sa toile, ne vous en auroit montré non plus que les simulacres. C'est un beau rêve que vous avez fait; c'est un beau rêve qu'il a peint. Quand on perd son tableau de vue pour un moment, on craint toujours que sa toile ne se replie comme la vôtre, et que ces fantômes intéressans et sublimes ne se soient évanouis comme ceux de la nuit.[77]

There is Fragonard's painting, there it is with all its effect. . . . It is the same temple, the same *ordonnance*, the same personages, the same action, the same expressions, the same general interest, the same qualities, the same flaws. In the cave, you saw only the simulacra of beings, and Fragonard, on his canvas, has shown you nothing more than simulacra. You had a beautiful dream; he has painted a beautiful dream. When one loses sight of his painting for a moment, one always fears that his canvas might disappear as yours did, and that these interesting and sublime phantoms might vanish like those of the night.

These remarks and others like them leave no doubt that Diderot meant his "dream" of a phantasmagoric—one is tempted to say cinematic[78]—*Corésus et Callirhoé* to be understood as corresponding to the painting's most salient features and overall atmosphere, in particular to the partial dissolution of solid form under the influence of a colored chiaroscuro which, as if borne aloft upon the clouds of incense rising from behind the principal group, envelops the entire scene. (The real Grimm, in an editorial postscript, reiterates the objection that all the figures have "plutôt un air de fantômes et de spectres que de personnages réels" [an air of phantoms and ghosts rather than of real personages] and concludes by saying that he prefers Diderot's dream to Fragonard's.)[79] But there is more to Diderot's dream-narrative than this. His emphasis on dreaming together with his use of the notion of finding himself in an actual situation, bound and seated inside the cave, connect the *Corésus et*

62 Jean-Honoré Fragonard, *Le Grand-Prêtre Corésus se sacrifie pour sauver Callirhoé*, Salon of 1765. Paris, Louvre.

Callirhoé with his pastoral conception of painting, a conception exemplified, I have suggested, by much of Fragonard's oeuvre. At the same time, Diderot's narrative acknowledges both the intensely dramatic character of the picture[80] and the highly emotional nature of the response it seeks to arouse; and it is surely significant that his alleged dream involves physically entering not the scene of the action but a situation of which that scene is merely a part and an illusory one at that. (The illusory or immaterial nature of the projected images, and even more the physical constraints imposed upon the audience, signal the latter's radical exclusion from the scene, i.e., from the painting.) In short, Diderot's account of the *Corésus et Callirhoé* combines crucial features of both his pastoral and his dramatic conceptions. And this clearly implies that in his view the *Corésus et Callirhoé* itself embraced both conceptions, as surprising and even as contradictory as this may seem.[81]

It must be borne in mind that in 1765 Diderot's pastoral conception was not yet fully articulated and that both conceptions as they have been presented in these pages have been abstracted from his writings, where they appear in quite another form: dispersed rather than concentrated, spontaneous rather than systematic, the residue of acts of judgment and interpretation rather than the object of fixed canons and laws. But this in no way compromises our analysis, which here as elsewhere finds in Diderot's criticism the provocation to a new understanding of the art of his time. On an important occasion early in his career Fragonard committed his energies to the genre then considered supreme, history painting. Already, however, his propensity for an altogether different sort of painting could not be denied. The result was a fusion of opposites, brought about by sheer intensity of inspiration, as fascinating to contemplate as it seems to have been impossible to repeat.

In the remainder of this chapter I want to examine several versions of a subject that became extremely popular in the last four decades of the eighteenth century, that of the blind Belisarius receiving alms. I shall begin by discussing a brief but pregnant text by Diderot in which the case is made for the paradigmatic significance of a seventeenth-century treatment of that subject—an engraving of a painting then almost universally attributed to Van Dyck and today assigned to the Genoese painter Luciano Borzone (Fig. 63).[82] (To avoid the appearance of conflict with Diderot's text I shall refer to the composition as Van Dyck's throughout the pages that follow.) I shall then try to show the pertinence of Diderot's arguments to subsequent versions of the Belisarius theme by the writer Marmontel and the painters Vincent and David, not in order to demonstrate the lasting influence of the earlier work—the notion of influence is what I wish to see beyond—but as a means, first, of understanding the nature of the fascination that Van Dyck's composition held for Diderot and his contemporaries, and second, of focussing attention upon certain hitherto largely unremarked aspects of the later works and in particular of David's

63 After Luciana Borzone, *Belisarius Receiving Alms,* 1620s?, engraved by Bosse.

monumental canvas. Our inquiry will recapitulate some of the fundamental concerns of this book and by so doing will help to bring it to a close. More important, it will enable us to scrutinize and to compare several widely separated moments in the unfolding over time of what might be termed the Diderotian problematic of painting and beholder, as that problematic found expression in successive transformations of a subject and a composition with which, as will become apparent, it was intimately linked.

Before quoting the text by Diderot that I want to examine, a few words about Belisarius and his legend are in order.[83] Briefly, Belisarius was an outstanding general of the later Roman Empire, a man who in the course of a mostly illustrious career won important victories over the Vandals, Goths, Bulgarians, and other formidable enemies. As far as is known, he never wavered in his loyalty to Justinian. Nevertheless, he more than once incurred the emperor's suspicions and late in life was stripped of his household guard, deprived of his fortune, and imprisoned for a time in his own palace. Partly restored to favor in A.D. 563, he died from natural causes two years later. Our knowledge of his life derives chiefly from Procopius of Caesaria's *Wars* or *Histories in Eight Books,* a contemporary narrative that says nothing about Belisarius having been blinded or reduced to beggary. But by the twelfth century if not earlier he had come to be portrayed in those terms, and in the fifteenth,

[146]

sixteenth, and seventeenth centuries the legend of the aged Belisarius, blind and dependent on charity, entered the mainstream of European literature. Marmontel's *Bélisaire* of 1767, usually called a *roman* but actually a *conte moral* hauling behind it a long sequence of excruciatingly dull dialogues on state-craft, marks a critical stage in the dissemination of that legend in modern times. For although Marmontel made use of Procopius, he also exploited the fiction of Belisarius's blindness and poverty in order to dramatize his hero's courage, steadfastness, and magnanimity. The popularity of Marmontel's novel despite—and no doubt partly because of—its condemnation by the Sorbonne[84] helps explain the resurgence of interest in the subject of Belisarius on the part of French painters of the last three decades of the century. In this connection it might be noted that Van Dyck's depiction of Belisarius was not the only previous one with which French artists and critics of the age were familiar. In particular, Salvator Rosa's altogether different treatment of the subject was known and admired.[85] But Van Dyck's composition enjoyed in France by far the greatest repute, and one aim of our inquiry will be to suggest why this was so.

The Diderot text in which Van Dyck's composition is discussed is a passage from one of his characteristically vivid and brilliant letters to Sophie Volland. The letter is dated 18 July 1762. Among other riches, it contains Diderot's summary of an argument that he recently had had with two friends, Suard and Mme. d'Houdetot:

> Autre querelle avec Suart et Madᵉ d'Houdetot sur une estampe de Vandick qui représente Bélisaire aveugle, assis contre un arbre, au bord d'un grand chemin, son casque à ses pieds, dans lequel quelques femmes charitables jettent un liard, et debout devant lui, de l'autre côté, un grand soldat appuyé sur son épée et qui le regarde. On voit que ce soldat a servi sous lui, et qu'il dit: "Eh bien, le voilà donc cet homme qui nous commandoit. O sort! O mortels! etc."
>
> Il est certain que c'est la figure de ce soldat qui attache, et qu'elle semble faire oublier toutes les autres. Suart et la comtesse disoient que c'étoit un défaut. Moi, je prétendois que c'étoit là précisément ce qui rendoit la peinture morale, et que ce soldat faisoit mon rôle. Vandick a rendu la chose même, et on lui en fait un reproche. Il y eut bien des choses délicates et subtiles dites pour et contre. Si quand on fait un tableau, on suppose des spectateurs, tout est perdu. Le peintre sort de sa toile, comme l'acteur qui parle au parterre sort de la scène. En supposant qu'il n'y a personne au monde que les personnages du tableau, celui de Vandick est sublime. Or, c'est une supposition qu'il faut toujours faire. Si l'on étoit à côté du soldat, on auroit sa physionomie, et on ne la remarqueroit pas en lui. Le Bélisaire ne fait-il pas l'effet qu'il doit faire? Qu'importe qu'on le perde de vue![86]

Another quarrel with Suard and Mme. d'Houdetot over an engraving by Van Dyck that represents the blind Belisarius, seated against a tree, at the side of a highway, his helmet at his feet, into which a few charitable women are dropping a coin, and, standing in front of him on the other side, a tall soldier leaning on a sword and gazing at him. One sees that the soldier has served under him, and that he is saying: "Well, here is the man who commanded us. Oh, fate! Oh, mortals! etc."

It is certain that it is the figure of the soldier that holds our interest, and that it seems to make us forget all the others. Suard and the countess said that this was a

flaw. As for me, I claimed that it was precisely that which made the painting moral, and that the soldier was playing my role. Van Dyck has rendered the thing itself and is reproached for having done so. Many delicate and subtle things were said on both sides. If, when one makes a painting, one supposes beholders, everything is lost. The painter leaves his canvas, just as the actor who speaks to the audience steps down from the stage. In supposing that there is no one else in the world except the personages of the painting, Van Dyck's painting is sublime. Now this is a supposition that must always be made. If one were alongside the soldier, one would have his facial expression, and one would not notice it in him. Does not the figure of Belisarius achieve the effect that he must achieve? What does it matter if one loses sight of him?

It should be noted at once that Diderot's description of the engraving is inaccurate in several respects. Belisarius is depicted seated not against a tree but in a chair, the woman giving him alms does not drop the coin in his helmet but places it in his hand, and the soldier who stands facing Belisarius is not leaning on his sword. Evidently Diderot did not own an impression of the engraving and so was forced to rely on his memory when he wrote to Sophie. But none of his errors invalidates the basic points he makes or for that matter detracts from the distinction of the passage as a whole. As an analysis of an individual work of art it is as penetrating as anything in his first three *Salons,* while as a statement of theory it marks a new stage in his thought. The passage shows that as early as 1762 Diderot had arrived at the dramatic conception of painting that informs the great *Salons* of 1765 and 1767 and is expounded in the *Essais sur la peinture* and other theoretical writings of the second half of the 1760s and 1770s. In addition, it analogizes the art of the actor and that of the painter in terms that make manifest the connection between Diderot's dramatic conception of painting and his foreshadowing of that conception in the *Entretiens sur le Fils naturel* and the *Discours de la poésie dramatique.* It is also true that the passage as it stands is somewhat obscure, that the relation of one statement to another is not always apparent, and that there are leaps and elisions that need to be filled in. But by placing Diderot's remarks in the context of ideas and issues that have already been canvassed, his meaning may be shown to be clear.

In the first place, we are I think entitled to surmise that what he found so compelling about the figure of the soldier was the persuasiveness with which the artist seemed to him to have represented that figure's entire absorption in the act of beholding Belisarius and meditating on his condition. Admittedly the notion of absorption is not found in the passage. But it is implicit in Diderot's observation that it is precisely the dominance of the figure of the soldier that makes the painting moral, by which I take him to mean that it is the viewer's conviction of the soldier's utterly concentrated and intense response to the sight of Belisarius that establishes the hero's full identity and thus secures the moral meaning of the composition as a whole. The notion of absorption is also implicit in Diderot's statement that Belisarius's effect — which can only mean on the soldier — is exactly what it ought to be. But the

[148]

clearest evidence in this regard is found in Diderot's *Salon de 1767,* where he criticizes without mercy a painting by Nicolas-René Jollain of Belisarius receiving alms (the painting has since been lost).[87] Among the figures in that work that Diderot especially disliked was a soldier who, recognizing Belisarius, flung out his arms in surprise. There was, he felt, simply no comparison between "l'étonnement de ce soldat et [le] morne silence du soldat de Van Dyck, qui, la tête penchée, les mains posées sur le pommeau de son épée, regarde et pense" (the astonishment of this soldier and the gloomy silence of Van Dyck's, who, head bent and hands resting on the pommel of his sword, gazes and thinks).[88] The features of Van Dyck's soldier singled out by Diderot can without hesitation be called absorptive.

Furthermore, Diderot's defense of the engraving addresses itself directly to the problematic of painting and beholder that I have claimed was fundamental to his vision of the pictorial enterprise. Specifically, he attributes the sublimity of Van Dyck's composition to its success in establishing what I earlier called the supreme fiction of the beholder's nonexistence. In his words: "Si quand on fait un tableau, on suppose des spectateurs, tout est perdu. Le peintre sort de sa toile, comme l'acteur qui parle au parterre sort de la scène. En supposant qu'il n'y a personne au monde que les personnages du tableau, celui de Vandick est sublime." I suggest that, in Diderot's view, that effect was achieved in and through the persuasive representation of absorption, above all the absorption of the figure of the soldier, who thus was felt to determine not just the expressive tenor and moral significance but also, more importantly, the ontological status of the painting as a whole. And of course Belisarius's blindness, which rendered him unaware of being beheld, at once set the stage for the soldier's absorption and could be perceived as an exemplary mode of obliviousness in its own right. The passage goes on to say: "Or, c'est une supposition qu'il faut toujours faire," a statement that indicates both that as early as 1762 Diderot saw the problematic of painting and beholder as a general one, to be confronted by all paintings without exception, and that in his estimation Van Dyck's composition was exemplary for contemporary painting on those grounds. (Exemplary but not unique in its exemplariness. One can imagine Diderot praising in much the same terms other manifestly absorptive seventeenth-century works that he admired, starting with Poussin's *Testament d'Eudamidas.*)

One other aspect of Diderot's defense of Van Dyck's composition, perhaps the most interesting of all, has still to be considered. According to Diderot, the figure of the soldier held the viewer's attention to the extent of making him forget or ignore the other figures in the engraving, including that of Belisarius. Suard and Mme. d'Houdetot agreed that this was so but considered it a fault. Presumably they would have argued, in keeping with classical doctrine, that since Belisarius was the composition's principal figure he ought properly to be the focus of the viewer's attention. Diderot himself sometimes reasoned along similar lines in the *Salons*[89] but in this instance he did not.

[149]

Instead he claimed that the dominance of the figure of the soldier made the painting moral, a notion I have already discussed, and in a remark of singular interest and importance went on to assert that "le soldat faisoit mon rôle," by which he seems to have meant that the figure of the soldier functioned in the composition as a kind of surrogate beholder who in effect mediated between the actual beholder and the figure of Belisarius—and, by a natural synecdoche, between the actual beholder and the painting as a whole, the *tableau* itself. This too is to be understood in the context of the problematic of painting and beholder that we have been pursuing all along. On the one hand, the actual beholder, in this instance Diderot, was led as it were to see himself in the figure of the soldier and thus was granted an especially intimate mode of access to the world of the painting. (This is to suggest not that Diderot felt himself drawn into the painting, as would later be the case with regard to works exemplifying the pastoral conception, but rather that he discovered that some-one identical with himself in his capacity as beholder was already there.) On the other hand, that mode of access by its very nature involved a blindness, or at least a degree of indirection or inadvertence, which effectively removed the actual beholder from in front of the principal figure—Belisarius—whose ex-emplary obliviousness to being beheld was in that way made all the more secure. In fact by virtue of the same synecdoche, one might say that removing or displacing the beholder from in front of the principal figure went a long way toward neutralizing the fact of his presence before the painting as a whole. Both aspects of the relationship are spelled out in the remarks that close the passage from the letter to Sophie: "Si l'on étoit à côté du soldat"—a phrase that designates not a place inside the painting but rather a position outside it which exactly mirrors that of the figure of the soldier—"on auroit sa physionomie, et on ne la remarqueroit pas en lui. Le Bélisaire ne fait-il pas l'effet qu'il doit faire? Qu'importe qu'on le perde de vue!"

Considered in its entirety, the passage states unequivocally that Diderot's admiration for Van Dyck's composition was far more deeply grounded in on-tological considerations than in moral or sentimental ones. I do not mean by this to deny that both subject and engraving engaged his interest on moral and sentimental grounds as well. But as we have seen, Diderot held that it was the figure of the soldier that made the painting moral, a claim that I have read as implying that the moral meaning of the work was dependent on the persuasive representation of absorption. Similarly, the status of the blind Belisarius as a uniquely compelling *exemplum virtutis* or image of virtue was for Diderot inex-tricably bound up with that hero's status as a special, almost sacred, object of beholding. Finally, and it is this point that I wish particularly to emphasize, Diderot's statement that the soldier "faisoit mon rôle" as much as says that in his view the relationship between the figure of Belisarius and that of the soldier exemplified—almost literally provided a model for—the relationship between painting and beholder that by July 1762 had become central to his conception of the art. In other words, Diderot saw in Van Dyck's composition a double

paradigm, or paradigm of paradigms: for pictorial composition generally *and* for the painting-beholder relationship on the establishment of which the success, indeed the validity, of the pictorial enterprise seemed to him to depend.

Diderot's discussion of Van Dyck's composition merits close attention for its own sake. But it assumes added significance once we recognize that French contemporaries shared his admiration for that composition and that they too seem to have been particularly struck by the figure of the soldier. Grimm, in one of his editorial asides in Diderot's *Salon de 1765,* appealed to Van Dyck's soldier as a touchstone of sublimity.[90] And as we have seen, Suard and Mme. d'Houdetot criticized the composition precisely because the figure of the soldier so monopolized their attention. Another piece of evidence is supplied by that disappointing classic of literary pictorialism, Jean-François Marmontel's *Bélisaire.*

I have already noted that the popularity of Marmontel's *Bélisaire,* first published in 1767, played a major role in the resurgence of interest in the subject of Belisarius on the part of French painters of the later eighteenth century. It is therefore more than just amusing to discover that, according to Marmontel himself, his novel was inspired by the engraving after Van Dyck, under somewhat extraordinary circumstances that need not concern us here.[91] For our purposes, what matters is that in the course of the early chapters of the novel the reader is presented with several quasi-dramatic scenes or *tableaux* which depict not Belisarius himself so much as the profound effect that his blind face and noble bearing have on those who behold him. In the first chapter, for example, the young Tiberius, who encounters Belisarius without knowing it is he, is described as "frappé de l'air vénérable de cet aveugle à cheveux blancs" (struck by the venerable air of this blind man with white hair).[92] And when further on in that chapter Belisarius reveals his identity to a group of discontented young officers whose fire he is sharing, the impact of the revelation on the company is described as follows: "L'immobilité, le silence exprimeroit d'abord le respect dont ils étaient frappés; & oubliant que Bélisaire étoit aveugle, aucun d'eux n'osoit lever les yeux sur lui" (The stillness, the silence would first express the respect with which they were struck; and forgetting that Belisarius was blind, none of them dared to raise his eyes to him).[93] Nothing could be more characteristic of Marmontel's style than the too deliberate artfulness with which he connects Belisarius's blindness and accessibility to being beheld.

The relationship between novel and engraving is closest in chapter four, where the figure of the soldier is quoted twice in succession. In that chapter Belisarius and his young guide, forced to seek shelter for the night, are welcomed by an elderly peasant and his family. It soon emerges that the old man's son had served under Belisarius in the field. The old man goes on to offer Belisarius everything they have, and the narrative comes to rest in another one-sentence *tableau:* "Tandis que le pere lui tenoit ce langage, le fils, debout

devant le Héros, le regardoit d'un air pensif, les mains jointes, la tête baissée, la consternation, la pitié, & le respect sur le visage" (All the while the father was speaking to him thus, the son, standing in front of the hero, gazed thoughtfully at him, hands clasped, head bent, consternation, pity, and respect on his face).[94] After further conversation a simple meal is served, the son is again depicted—Marmontel would have said painted—in language clearly meant to recall the figure of the soldier, and his state of mind is explicated in a brief exchange that could serve as a commentary on the engraving:

Pendant ce repas le fils de la maison, muet, rêveur, préoccupé, avoit les yeux fixés sur Bélisaire; & plus il l'observoit, plus son air devenoit sombre, & son regard farouche. Voilà mon fils, disoit le vieux bon homme, qui se rappelle vos campagnes. Il vous regarde avec des yeux ardens. Il a de la peine, dit le Héros, à reconnoître son général. On a bien fait ce qu'on a pu, dit le jeune homme, pour le rendre méconnoissable; mais ses Soldats l'ont trop présent pour le méconnoître jamais.[95]

During this meal, the young man of the house, mute, thoughtful, preoccupied, had his eyes fixed upon Belisarius; and the more he observed him, the more somber his expression became and the fiercer his gaze. "Here is my son," the old man said, "who is recalling your campaigns. He is gazing at you with ardent eyes." "He can hardly recognize his general," the hero said. "Everything possible was done to make him unrecognizable," said the young man, "but his soldiers remember him too well ever to fail to recognize him."

Both passages, especially the second, dramatize the son's engrossed contemplation of Belisarius. And by so doing they evoke the latter's complete unawareness of being beheld, in which, I have suggested, his exemplary status largely consisted.[96]

Following the publication of Marmontel's *Bélisaire* and the exhibition shortly afterwards of Jollain's canvas in the Salon of 1767, the subject of Belisarius did not recur in French painting until the mid-1770s, when it was treated successively by four leading younger artists: Durameau (1775), Vincent (1777), Peyron (1779), and David (1781). Two of those works in particular are relevant to our discussion.

François-André Vincent's *Bélisaire, réduit à la mendicité, secouru par un officier des troupes de l'Empereur Justinien* (Salon of 1777;[97] Fig. 64), appears to owe little or nothing to Van Dyck's composition, with which however it was compared. But we cannot fail to observe that the subject has been treated so as to minimize its moral and sentimental connotations and to emphasize instead the palpably fraught relationship that obtains between Belisarius and those who behold him. The officer who places a coin in Belisarius's helmet gazes anxiously, almost mistrustfully, at the sightless eyes of the great general; the young guide who holds the helmet looks up at him as well; while further back the heads of three other figures stare intently and, it seems, uneasily at the blind hero, who instead of being seated to one side as in the engraving after Van Dyck moves toward the middle of the canvas as if to confront his beholders.[98] The result is a singularly concentrated and disquieting composition,

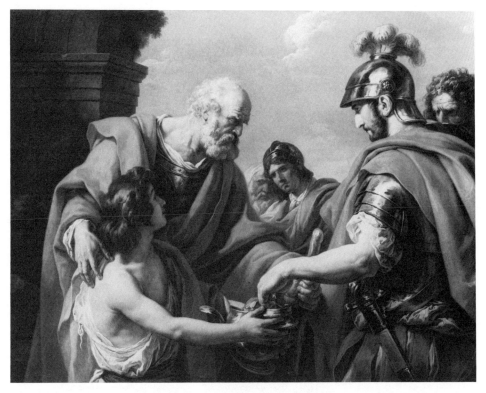

64 François-André Vincent, *Bélisaire, réduit à la mendicité, secouru par un officier des troupes de l'Empereur Justinien,* Salon of 1777. Montpellier, Musée Fabre.

made all the more immediate in its impact by its use of half-length figures, in which the manifest absorption of the officer and onlookers in the act of beholding Belisarius has been clouded but not broken by their equally manifest discomfort at finding themselves in his presence.[99] In an obvious sense this aspect of Vincent's painting is consistent with Marmontel's novel, in which Belisarius's moral greatness sometimes shames those who meet him. But it may be permissible as well to see in Vincent's painting a further stage in the unfolding of the problematic of painting and beholder that I have tried to show played a crucial role in the evolution of French painting starting around the mid-1750s. That is, the anxieties and tensions that seem to be experienced by the officer and bystanders gazing at Belisarius are perhaps to be understood as a reflection of what by 1777 was on the way to becoming the thoroughly equivocal position of the actual beholder, as with the passage of time the fiction of the beholder's nonexistence became ever more difficult to sustain. One might say that the presence of the beholder before the painting, which from the beginning of the development charted in this book had been the focus of contradictory demands, tended increasingly to be cast—to make itself felt to painter and beholder alike—as an alien influence if not indeed as a theatricalizing force, and that more than anything else it is that turn of events which gives to Vincent's *Bélisaire* its singular atmosphere of anxiety, embarrassment, and barely suppressed violence. (The presence of the beholder does

[153]

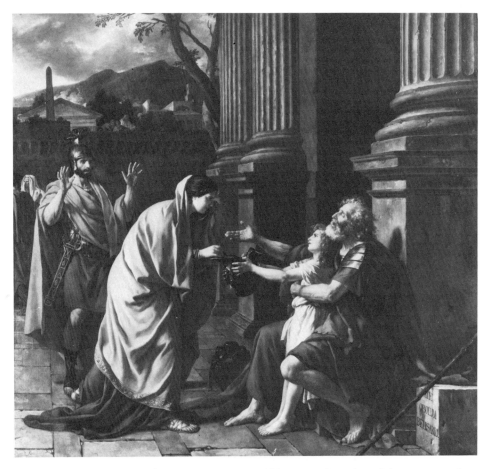

65 Jacques-Louis David, *Bélisaire, reconnu par un soldat qui avait servi sous lui au moment qu'une femme lui fait l'aumône,* Salon of 1781. Lille, Musée Wicar.

not emerge as an *insuperable* problem for painting for some time. I think of Géricault as the first painter who found himself compelled to assume the burden of that problem in its insuperable or tragic form and of the *Raft of the Medusa* as the principal monument to that compulsion. By this I mean that the strivings of the men on the raft to be beheld by the tiny ship on the horizon, by startling coincidence named the *Argus,* may be viewed as motivated not simply by a desire for rescue from the appalling circumstances depicted in the painting but also by the need to escape our gaze, to put an end to being beheld by us, to be rescued from the ineluctable fact of a presence that threatens to theatricalize even their sufferings.)

The other painting I want to discuss is the last of the four cited above, Jacques-Louis David's *Bélisaire, reconnu par un soldat qui avait servi sous lui au moment qu'une femme lui fait l'aumône* (Salon of 1781;[100] Fig. 65). David's *Bélisaire* is by far the most impressive representation of the Belisarius story in late eighteenth-century art. But its importance for the art historian does not stop there. Although until fairly recently it has tended to be overshadowed by

David's masterpieces of the second half of the 1780s, scholars by and large have recognized that the decisive phase of his art associated with those master-pieces was initiated by the *Bélisaire*, whose significance for our understanding of David's achievement and, more broadly, of the genesis of modern painting is therefore considerable. I have already suggested that David's history paint-ings of the 1780s may be seen as fulfilling the dramatic conception of painting put forward in Diderot's *Salons* and related writings. Now I want to go further and contend that the *Bélisaire* marks the beginning in David's art of a persis-tent engagement with the problematic of painting and beholder that Diderot was the first to define. And I would add that there may be more than just coincidence in the fact that David's engagement with that problematic had its inception in a representation of that particular subject.

At any rate, I regard it as virtually certain that David had the engraving after Van Dyck in mind when he composed his version of the Belisarius story. The basic action depicted in the two works is nearly identical: a woman gives alms to the seated Belisarius while a soldier who had served under him witnes-ses the event. In addition, certain specific motifs, notably Belisarius's out-stretched arm and hand, appear to allude to Van Dyck's composition. It is also true that David's painting is a great deal more complex than that composition as regards both intention and realization. For one thing, the momentary char-acter of the soldier's gesture of surprise contrasts sharply with the seeming immobility of pose and constancy of mood of the soldier in the engraving; and in general David's attempt to achieve an instantaneous mode of pictorial unity through the perspicuous representation of a single moment in an action has no equivalent in the Van Dyck.[101] For another, the woman who gives Belisarius alms also gazes intently at his face, thus combining aspects of the figures of the woman and the soldier in Van Dyck's composition while strictly resembling neither; and as she does this she is gazed at in turn by Belisarius's young guide, an action that further binds together the foreground group into an absorptive unit of a sort familiar to us from earlier paintings like Van Loo's *Lecture espag-nole* (Fig. 11) and Vien's *Marchande à la toilette* (Fig. 37). (Aspects of the foreground group may also be indebted to Greuze's *Dame de charité,* painted in the first half of the 1770s and itself perhaps distantly related to the Van Dyck.) But these and other differences must be seen in the context of David's evident admiration for and partial dependence upon the earlier work. It scarcely seems too much to say that David sought at once to place his painting under the auspices of the earlier work, whose exemplary status was by then universally recognized, and to go beyond that work in significant respects.

Moreover, in David's *Bélisaire* as in the engraving after Van Dyck the figure of the soldier may be described as mediating between the actual behol-der and the figure of Belisarius. But whereas in the engraving the soldier faces Belisarius in the foreground, in the painting he is positioned further back in space: as though by virtue of being our surrogate David's soldier has come to stand on a somewhat different footing from that of the other figures. The

[155]

difficulty which David seems to have encountered in situating or finding a place for the soldier spatially—his right foot is much too near the woman's left heel given the disparity in scale between the two figures—bears witness to the soldier's problematic, even intrusive character. So perhaps does the warm red of the soldier's cloak, which not only attracts but seems to advance upon our gaze. These observations raise the further question of the function in the *Bélisaire* of the extremely conspicuous and emphatically off-center perspective structure by means of which the composition has been organized. To a certain extent the answer is obvious. David's use of perspective in the *Bélisaire* can be seen as a natural concomitant of the dramatic conception of painting that made its first full-blown appearance in his art in that canvas. Such a conception necessitated the construction of a stagelike space similar to that found (for example) in Raphael or Poussin, and it is that type of space, more or less, that characterizes David's great history paintings of the 1780s.[102] The off-centeredness itself has been attributed to a desire on David's part to avoid the monotony of a central vanishing point.[103] But there is another aspect of the perspective structure of the *Bélisaire* that concerns not the construction of a space or the organization of a composition so much as the positioning of the beholder. By this I mean that whereas traditional perspective projects a spatial illusion whose integrity and coherence are independent of the presence of the beholder at a specific position before the painting,[104] perspective and spatial illusion in the *Bélisaire* serve on the contrary *to project the beholder*—more precisely, to place the beholder to one side of the painting, away from the figure of Belisarius and almost directly in front of the mediating figure of the soldier. The lateral component of the beholder's position is indicated by the row of narrow flagstones that appears to recede almost vertically not far from the left-hand edge of the canvas, a singularly awkward device that largely destroys the credibility as illusion of that portion of the picture. And his position is confirmed by the siting of the distant obelisk, a monument whose traditional function involved hypostatizing a particular location.

David himself is known to have felt that his knowledge of perspective was deficient and to have urged his students not to suffer under the same handicap.[105] I suggest, however, that his difficulties may have had their origin not in any mere lack of training or ability but in the urgency of his compulsion to structure the relationship between painting and beholder, a compulsion that not only could but did come into conflict with the demands of perspective illusion as such. In the *Bélisaire,* precisely because it is not the case that the perspective structure would have worked only when the beholder stood directly in front of the vanishing point, David appears to have found it necessary to take extreme measures—to emphasize as strongly as possible the "head-on-ness" of the row of narrow flagstones—in order to station the beholder exactly there. It is that overload of emphasis that saps the efficacy of the illusion.

There is in short an analogy, which David could not possibly have in-

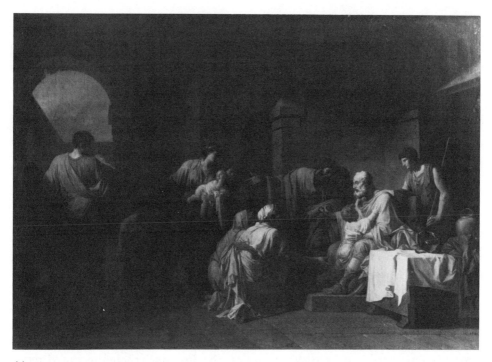

66 Jean-François Peyron, *Bélisaire recevant l'hospitalité d'un paysan qui avait servi sous lui,* 1779. Toulouse, Musée des Augustins.

tended, between the literal placing of the beholder by David's *Bélisaire* and Diderot's account of his response to Van Dyck's composition. In his letter to Sophie it emerged that Diderot and his friends Suard and Mme. d'Houdetot, captivated by the figure of the soldier, simply lost sight of the other figures, including that of Belisarius; while our analysis has shown that David's painting, independently of Diderot's text, seeks to achieve an equivalent effect by quasi-physical means. This suggests that by the 1780s in France no representation of absorbed beholding, perhaps no representation of absorption as such, was capable in itself of bringing that result about: that by then the bare fact of the beholder's existence—a fact posited by the primordial convention that paintings are made to be beheld—threatened to become so disruptive of the Diderotian ideal that it needed to be dealt with, to be structured, by means such as those just described. In this connection it should be stressed that David would have been aware of numerous precedents from the fifteenth century on both for the use of off-center perspective and for the translation of the principal action away from the main axis (that of the vanishing point) as a means of retarding the viewer's grasp of what is taking place and thereby heightening the dramatic impact of the composition.[106] (See for example Jean-François Peyron's *Bélisaire recevant l'hospitalité d'un paysan qui avait servi sous lui* [1779; Fig. 66], a work familiar to David and perhaps a proximate source of his adaptation of both conventions two years later.)[107] But I know of no precedent for the special use David made of those conventions, for the distinct effect they produce, not only in the *Bélisaire* but in the *Socrate* as well.[108]

[157]

We are not yet done with the *Bélisaire.* The problematic of painting and beholder that has been the central concern of this book is founded on the assumption that a painting *faces* its beholder, or, to put this another way, that the surface plane of painting is in fact its *front.* By placing a surrogate beholder, the figure of the soldier, further back in space than the principal group of figures, David seems to have envisioned the possibility of opening up his painting from the rear—of installing the source of beholding or spectatordom back there, in the direction of the obelisk, an object that I have suggested serves to fix the position of the actual beholder.* But there is in the *Bélisaire* another plane that is asserted against both front and rear, surface and depth: I am thinking of the one defined by the arch of triumph against whose base Belisarius sits, by the direction in which he faces, and, most graphically, by the plane of the masonry block on which is inscribed the traditional motto, *Date Obolum Belisario.* In other words, there is or seems to be in David's canvas an attempt to rotate the frontal plane of the representation 90 degrees clockwise on the axis of the right-hand edge; to open the composition sideways, so to speak: as if the painting contained within itself a second, more essential, at any rate more nearly emblematic *tableau,* consisting of Belisarius and his guide, placed at right angles to the first and therefore not directly exposed to the actual beholder's gaze.[109] (One way of thinking of that *tableau* is as a painting not made to be beheld.) The position of the figure of the soldier, at once further back in space than the foreground figures and near the left-hand edge of the canvas, thus reflects a compromise between the two solutions I have just outlined (i.e., opening the painting from the rear and opening it sideways); while the two figures conversing behind the soldier and to his right (our left), who seem on the verge of leaving the scene, convey a sense both of their entire unawareness of Belisarius and the others—a small touch that subtly points up the isolation of the principal actors—and of the unboundedness of the representation in that direction.

It is customary to emphasize the importance in Neoclassic painting of line, plane, profile, tautness of surface, and two-dimensional organization generally. One implication of my description of the *Bélisaire,* however, is that David

*The connection between the obelisk and beholder is even closer than this implies. There exists a striking congruence between the upper torso and head of the figure of the soldier and the temple pediment almost directly above and beyond him. Now, the actual beholder is posited by the perspective structure to stand in more or less the same relation to the soldier that the obelisk does in relation to the pediment (i.e., in front and slightly to the left). This suggests that the obelisk and pediment together may be regarded as a transposition far back in the illusionistic depth of the painting of the unit formed by the beholder and the soldier; that is, it suggests that not just the soldier but the obelisk as well *stands for* the beholder: as though David felt that the placing of the soldier in the near middle distance (or however his position is characterized) did not go far enough toward opening the painting from the rear and so created this second, abstract surrogate beholder as a means to that end; or as though he found himself driven to intimate that the principal action of the painting, including the soldier's act of recognition of his former general, takes place *behind the back* of that abstract surrogate beholder, an even more radical possibility that cannot be discounted.

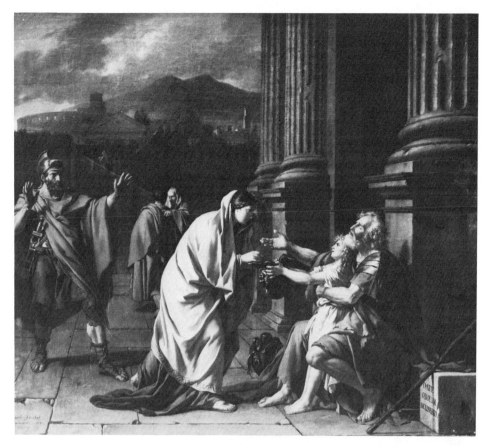

67 Jacques-Louis David with the assistance of François-Xavier Fabre, *Bélisaire,* Salon of 1785. Paris, Louvre.

turned those conventions *against* the absolute dominance of the picture-plane which ordinarily they subserved—that he wielded and in a sense reinterpreted them so as to open the painting to a number of points of view other than that of the beholder standing before the canvas.

Diderot's defense of the engraving after Van Dyck illustrates perfectly the reverence in which certain earlier works of art were held by French critics and painters of the second half of the eighteenth century. But it also enables us to see in the making, at the level of perception and sensibility, a revolution or at least a profound change in the ontological status of the class of objects that we call paintings. Diderot's interpretation of Van Dyck's composition invests that work with an entire universe of properties and considerations fundamentally alien to sixteenth- and seventeenth-century painting. In particular the need to obliviate the beholder, to establish the fiction "qu'il n'y a personne au monde que les personnages du tableau," simply was not an issue for painting until shortly after the middle of the eighteenth century, and even then it became an issue only in France. I do not mean by this to imply that Diderot was wrong to

[159]

admire Van Dyck's composition or that the grounds on which he did so were misconceived or inappropriate. It would be truer to say that the object of his admiration amounted to a new version of the subject: the first to have been shaped in decisive respects by the emerging problematic of painting and beholder.

Diderot lived to see and to write about David's *Bélisaire* in his last *Salon* but his brief remarks say nothing directly about that problematic. On the one hand, Diderot finds that the young David "montre de la grande manière dans la conduite de son ouvrage, il a de l'âme, ses têtes ont de l'expression sans affectation, ses attitudes sont nobles et naturelles, il dessine, il sait jetter une draperie et faire de beaux plis, sa couleur est belle sans être brillante" (displays the grand manner in everything he does. He has soul, his heads have expression without affectation, his attitudes are noble and natural, he draws, he knows how to arrange drapery and make handsome folds, his color is beautiful without being too bright).[110] On the other hand, he makes several specific criticisms and concludes by suggesting that Belisarius's gesture of asking for alms is unworthy and ought to be revised.[111] The overall tone of the passage is strongly positive.

Three years later Diderot died. One year after that David exhibited in the Salon of 1785 along with the *Horaces* a reduced replica of the *Bélisaire* (Fig. 67),[112] the work largely of his student Fabre, in which he ordered to be made a a number of changes—but not the revision of Belisarius's gesture that Diderot would have liked to have seen—whose cumulative effect is to moderate the compositional strategies analyzed in the previous pages. The nearly square format of the original, which does much to make the rotation of the frontal plane of the painting away from the beholder an imaginary possibility, has been abandoned in favor of one that is plainly wider than it is high; the intractable row of narrow flagstones has been replaced by a broad and rapidly receding pavement avenue; the vanishing point has been moved to the right, between the figure of the soldier and that of the woman; the conversing figures have been shifted even further to the right; and the obelisk has been eliminated. All this suggests that within just a few years David had become somewhat uncomfortable with the extremeness of the measures by which the original of 1781 attempts to structure its relationship to the beholder.[113] But the replica by no means abandons the preoccupations with absorption and beholding that lie at the heart of the original. And in the *Horaces*, the *Socrate*, and the *Brutus*, as well as in later canvases such as the *Sabines* and the *Léonidas*, those preoccupations are made the basis of a series of works which David's contemporaries regarded—not, it may be argued, without some justification—as reinventing the art of painting.[114]

APPENDIX A

Grimm on
Unity, Instantaneousness,
and Related Topics

15 décembre 1756

LES GRANDES MACHINES en peinture et en poésie m'ont toujours déplu. S'il est vrai que les arts en imitant la nature n'ont pour but que de toucher et de plaire, il faut convenir que l'artiste s'en écarte aussi souvent qu'il entreprend des poëmes épiques, des plafonds, des galeries immenses, en un mot, ces ouvrages compliqués auxquels on a prodigué dans tous les temps des éloges si peu sensés. La simplicité du sujet, l'unité de l'action, sont non-seulement ce qu'il y a de plus difficile en fait de génie et d'invention, mais encore ce qu'il y a de plus indispensable pour l'effet. Notre esprit ne peut embrasser beaucoup d'objets, ni beaucoup de situations à la fois. Il se perd dans cette infinité de détails dont vous croyez enrichir votre ouvrage. Il veut être saisi au premier coup d'oeil par un certain ensemble, sans embarras et une [*sic*] manière forte. Si vous manquez ce premier instant, vous n'en obtiendrez que de ces éloges raisonnés et tranquilles qui sont la satire et le désespoir du génie. On croit faire l'apologie de ces grandes machines en disant qu'elles sont moins faites pour toucher que pour exciter l'admiration. Mais l'admiration est un sentiment rapide, un saisissement subit qui n'a point de durée et qui devient fatigant et froid dès qu'on veut le prolonger. Il est toujours produit par la simplicité et la sublimité d'une pensée ou poésie, en peinture et en musique; au lieu que ces ouvrages compliqués ne sauraient que causer une espèce d'étonnement froid. L'éclatant le plus artistement arrangé lasse et rebute bientôt. Je ne parle point de cette foule d'ornements postiches, et d'accessoires toujours déplacés, qu'un ouvrage composé et d'une certaine étendue entraîne nécessairement. Le moins de mal qu'on en puisse dire, c'est qu'ils jettent dans l'esprit je ne sais quelle distraction de l'objet principal, et qu'ils achèvent de détruire l'effet de l'ensemble. On a beau vanter [*sic*] l'unité de l'action, la subordination des détails

et leur rapport au sujet principal, dans tous les grands ouvrages de poésie et de peinture, il n'y en a point dont on ne retranchât les deux tiers s'il était question de n'y conserver que ce qui tient essentiellement au sujet. Combien d'épisodes qui nous font perdre de vue les personnages véritables de l'action et nous mettent dans une compagnie de gens que nous n'avions pas lieu d'attendre et qui ne devaient pas nous occuper! Pour moi, j'avoue franchement que jamais je n'ai vu une galerie ou un plafond, ni lu un poëme épique sans une certaine fatigue et sans sentir diminuer cette vivacité avec laquelle nous recevons les impressions de la beauté.

Ces réflexions en amènent nécessairement une autre. Il est incroyable combien dans tous les arts l'imitation a amené de ravages et de maux. C'est à elle seule qu'il faut imputer l'audace et les succès des gens médiocres, la timidité des hommes d'un vrai génie, et les dégoûts qu'ils éprouvent. Homère, obéissant à ce feu divin dont il se sentait échauffé, composa cette histoire de la fameuse querelle des Grecs et des Troyens. La sublimité de son imagination, la simplicité de son âme et de son temps, donnent à tous les détails de son poëme, quelque diffus qu'ils soient, un charme inexprimable. Mais en écoutant cette muse qui l'inspirait en chantant la colère d'Achille, il ne comptait certainement pas de laisser à ses successeurs le modèle d'un poëme épique. Raphaël et les grands peintres de son temps, obligés de remplir toute l'étendue d'un plafond, d'une vaste galerie, se livraient à l'abondance d'idées, à la fécondité de leur imagination, et, répandant sur toutes leurs figures ce souffle divin dont ils étaient eux-mêmes animés, ils nous ont laissé des monuments de leur génie et de leur gloire; mais ils ne comptaient point donner par leurs ouvrages les règles et la théorie des grandes machines en peinture. Peut-être n'y fallait-il admirer que la difficulté vaincue par le génie de l'artiste. Que leur exemple a été contagieux, et que nous avons payé cher leur succès! Leur exemple est devenu d'une si grande autorité que le génie le plus hardi et le plus décidé n'oserait s'en écarter à un certain point, et que l'homme le plus médiocre, en les imitant servilement, se persuade sans peine d'être leur égal et de participer à leur gloire. Le goût et la critique ont achevé de rendre les ouvrages des plus grands hommes dangereux pour leurs successeurs en prononçant sur ce qui était en droit de plaire et en dictant les moyens d'y réussir. Au moyen des règles, le génie, devenu timide et craintif, n'ose plus prendre son essor. On lui en impose par l'autorité et par les exemples. Les gens sans talent, au contraire, sont devenus hardis. Ils ne doutent point que pour égaler le mérite d'un grand architecte, pour faire des édifices semblables à ceux qui excitent l'admiration, on n'a qu'à étudier l'échafaud qui a servi à les élever. On a fait de mauvaises copies et, malgré toutes les répétitions sans nombre, les premiers modèles sont restés seuls. En ce sens on peut dire qu'il n'y a jamais eu qu'un seul poëme épique, celui d'Homère. Le plus beau génie poétique, Virgile lui-même, n'a fait que le copier, et les modernes l'ont imité encore bien plus servilement. La machine d'Homère a servi à tous ses successeurs. Tous les poëmes épiques se ressemblent si fort qu'on ne peut les regarder que comme

une reproduction de *l'Iliade* et de *l'Odyssée.* C'est cette uniformité puérile qui a donné lieu à l'idée plaisante du docteur Swift de faire des recettes de poëmes épiques comme l'on prescrit une ordonnance de médecine. Il est certain qu'un poëme épique aurait mauvaise grâce de paraître sans combat, sans récit d'un voyage dangereux et de périls effrayants, sans descente aux enfers, sans prédictions et prophéties, etc. La meilleure satire qu'on puisse faire de toutes ces puérilités, c'est le poëme épique sur un sujet comique. Pourquoi *le Lutrin, la Boucle de cheveux enlevée,* nous font-ils tant de plaisir? Ce n'est pas par leur fond, qui n'est rien; c'est qu'outre les détails qui prêtent à la plaisanterie, le poëte paraît se moquer sans cesse de la machine et de l'échafaudage de l'épopée que les successeurs d'Homère ont trouvé moyen de rendre ridicules. On ne fait pas de bonnes plaisanteries sur un sujet qui n'en comporte point. En vain voudrait-on ridiculiser la tragédie par des parodies et par des tragédies burlesques, on ne fera jamais que des farces et de plates bouffonneries; au lieu que l'idée des poëmes épi-comiques est devenue une source de bonnes plaisanteries. On en est là à l'égard des plafonds et des galeries, on peut les rédiger en recettes, et leur machine est aussi puérile et plus mauvaise que celle des poëmes épiques. Une critique sage et éclairée aurait examiné ces ouvrages bien différemment que n'ont fait nos Aristarques de profession. Au lieu de confondre le mérite de l'auteur avec celui de son genre, de mettre sur le compte de l'un ce qui n'est dû qu'à l'autre, elle aurait distingué soigneusement ce que *l'Iliade* doit au génie d'Homère et ce qu'elle doit au mérite du plan général d'une épopée, ce qu'une galerie devient sans le pinceau de Raphaël ou d'Annibal Carrache d'avec la beauté du genre. On sait du reste qu'un homme de génie se retrouve partout, qu'il reste grand, lors même qu'il s'égare ou qu'on lui met des entraves; mais le genre ne devient pas bon pour avoir été traité par un grand homme, et pour l'apprécier avec une certaine justesse il faut voir comment un homme médiocre s'en tire. Si l'on eût suivi cette méthode pour examiner le genre des galeries et des plafonds en peinture, on y aurait trouvé peut-être assez d'inconvénients pour le faire abandonner.

Outre les réflexions générales que nous venons de faire, je finirai cette feuille par deux ou trois observations particulières sur les inconvénients de ce genre. En fait de galeries, le peintre est presque toujours obligé de prendre un sujet soit de l'histoire, soit de la fable, et de le traiter dans une certaine suite de tableaux. Or il y a peu de sujets qui aient plus d'un instant pittoresque; rarement ils en ont deux; presque jamais trois ou quatre. Pour un tableau excellent, vous exposez le peintre à en faire plusieurs mauvais. Souvent tout le sujet est mal choisi, comme dans la galerie de Rubens au Luxembourg. C'est l'insipide histoire de Marie de Médicis à laquelle ce grand homme a été obligé de consacrer la poésie et la magie de son coloris. Un autre inconvénient de ces grandes machines c'est qu'il a fallu avoir recours à l'allégorie, si froide en poésie, si obscure et si insupportable en peinture. Les sots l'appellent volontiers la poésie des peintres; pour moi, je trouve que rien ne dépose tant contre le génie de l'artiste que la ressource de l'allégorie. Ils en ont cherché une autre

dans le merveilleux, qui n'est pas moins absurde. Le merveilleux doit toujours être insensible. L'exposer aux yeux, c'est le rendre ridicule. L'assomption de la Vierge est donc un fort mauvais sujet, parce qu'on ne saurait le traiter sans y mettre beaucoup de ces sujets d'imagination que les peintres n'auraient jamais dû représenter. (*Corr. litt.*, III, 317–21)

I have always disliked enormous constructions in painting and in poetry. If it is true that in imitating nature the arts have no other aim than to move and to please, one must admit that the artist strays from his aim as often as he undertakes epic poems, painted ceilings, immense galleries, in a word, those complicated works that throughout the ages have received such injudicious praise. Simplicity of subject and unity of action are not only what is most difficult when it comes to genius and invention, but also what is most indispensable as regards overall effect. Our mind cannot embrace many objects or many situations at the same time. It gets lost in that infinity of details with which you believe you enrich your work. It wants to be struck at first glance by a certain ensemble, without hindrance and in a strong manner. If you miss this first instant, you will obtain nothing but those reasoned and tranquil praises that constitute the satire and the despair of genius. One thinks that one justifies those enormous constructions by saying that they are meant less to touch us than to arouse our admiration. But admiration is a rapid feeling, a sudden thrill that does not last and that becomes tiresome and cold as soon as one wants to prolong it. It is always produced by the simplicity and sublimity of a thought or a work of poetry, in painting and in music, whereas those complicated works can only cause a kind of cold astonishment. The most artistically arranged brilliance soon bores and repels. This is not to mention the numerous added ornaments and inevitably out of place accessories that a composed work of a certain size necessarily entails. The least evil that can be said of them is that they distract the mind from the principal object and that they complete the destruction of the effect of the whole. For all the praise that has been lavished on unity of action and on the subordination of details and their relation to the principal subject in all the great works of poetry and painting, there is none from which two-thirds would not be removed if it were a question of keeping only those bound essentially to the subject. How many episodes make us lose sight of the true personages of the action and introduce us to people whom we had no reason to expect and who should not occupy us! As for me, I frankly admit that I have never seen a gallery or a ceiling nor read an epic poem without a certain weariness and without feeling a diminution of that vivacity with which we receive impressions of beauty.

These reflections necessarily lead to another. It is incredible how much havoc and harm have been wrought in all the arts by imitation. Imitation alone is responsible for the audacity and the success of mediocre people, the timidity of men of true genius, and the discouragement the latter feel. Homer, obeying the divine flame that he felt burning within him, composed the story

of the famous quarrel between the Greeks and the Trojans. The sublimity of his imagination, the simplicity of his soul and of his age, give all the details of his poem, however diffuse they may be, an inexpressible charm. But in listening to the muse who inspired him to sing Achilles' anger, he certainly did not intend to leave to his successors the model for an epic poem. Raphael and the great painters of his time, obliged to fill the whole length of a ceiling or a vast gallery, gave themselves over to the abundance of ideas, to the fecundity of their imagination, and, imparting to all their figures the divine inspiration by which they themselves were animated, they left us monuments of their genius and of their glory. But they did not intend to give, through their works, the rules and theories of immense constructions in painting. Perhaps one should have admired in them only the difficulty overcome by the artist's genius. How contagious their example has been, and how high a price has been paid for their success! Their example has become so authoritative that the boldest and most determined genius would not dare to stray from it past a certain point, while the most mediocre man, by imitating them servilely, readily persuades himself that he is their equal and that he shares in their glory. Taste and criticism have completed the process of making the works of the greatest men dangerous for their successors by declaring what ought to please and by dictating the means by which to succeed in pleasing. Because of rules, genius, turned shy and timid, no longer dares to soar. It is imposed upon by authority and by examples. Men without talent, on the other hand, have become bold. They do not doubt that, to equal the achievement of a great architect, to construct edifices similar to those which excite admiration, they have only to study the scaffolding that was used to erect them. Bad copies have been made and, in spite of all the countless repetitions, the first models have remained unequalled. In that sense one can say that there has been but one epic poem, that of Homer. The most remarkable poetic genius, Virgil himself, did nothing but copy him, and the moderns have imitated him even more slavishly. Homer's construction has been used by all his successors. All epic poems resemble each other so strongly that they can only be considered reproductions of the *Iliad* and the *Odyssey*. This childish uniformity led to Dr. Swift's amusing idea of writing recipes for epic poems as one would write a medical prescription. It is certain that it would be unbecoming for an epic poem to appear without combats, without an account of some dangerous journey and frightful perils, without a descent into hell, without predictions and prophecies, etc. The most effective satire on all these puerilities is an epic poem on a comic subject. Why do *Le Lutrin* and *The Rape of the Lock* give us so much pleasure? Not because of their main subject, which is nothing, but because apart from the details that lend themselves to laughter, the poet seems to be ceaselessly mocking the construction and the scaffolding of the epic that the successors of Homer managed to render ridiculous. One does not make good jokes about something that does not lend itself to joking. Even if one wished to ridicule tragedy by parodies and by burlesque tragedies, one would never create any-

thing but farces and insipid buffooneries, whereas the idea of comic epic poems has become a source of much amusement. The same applies to ceilings and galleries—they can be written out as recipes, and their construction is fully as puerile and even less well made than that of epic poems. Wise and enlightened criticism would have examined these works in quite a different way from that of our professional Aristarchuses. Instead of confusing the author's merit with that of his genre, of crediting the one with what belongs only to the other, it would have carefully distinguished what the *Iliad* owes to Homer's genius from what it owes to the merit of the epic in general, it would have distinguished what a gallery becomes under the brush of Raphael or Annibale Carracci from the beauty of the genre. Moreover, it is a well-known fact that a man of genius remains himself under any circumstances, that he remains great even when he errs or is put in shackles. But a genre does not become good in itself for having been treated by a great man, and in order to appreciate it with a certain accuracy one must see what is made of it by a mediocrity. Had this method been followed in examining the genre of galleries and of ceilings in painting, perhaps enough drawbacks would have been found to have led to its abandonment.

Apart from the general reflections that we have just made, I shall conclude these remarks with two or three specific observations concerning the drawbacks of this genre. As regards galleries, the painter is almost always obliged to take a subject from history or fable and to treat it in a certain series of paintings. Now, few subjects have more than one pictorial moment; they rarely have two; almost never three or four. To get one excellent painting, the painter runs the risk of making several bad ones. Often the whole subject is poorly chosen, as in the Rubens gallery at the Luxembourg. It is the insipid story of Marie de Medici to which this great man was obliged to devote the poetry and the magic of his color. Another drawback of these grand constructions is that it was necessary to have recourse to allegory, so cold in poetry, so obscure and so unbearable in painting. Fools willingly call allegory the poetry of painters; for my part, I think that nothing so testifies to an artist's lack of genius as resorting to allegory. They have sought another resource in the supernatural, which is no less absurd. The supernatural must always be imperceptible; to bring it into view is to make it ridiculous. Thus the Assumption of the Virgin is a very bad subject, because it would be impossible to treat it without including many of those imaginary subjects that painters should never represent.

Two Related Texts:
The Lettre sur les spectacles *and*
Die Wahlverwandtschaften

THE ISSUE of theatricality as developed in this book is relevant to various writings by Diderot that have not been discussed, most conspicuously perhaps *Le Neveu de Rameau* (begun 1761), in which the title protagonist's ceaseless, unabashable consciousness of playing to an audience is portrayed as the source of a fascinating if morally repugnant species of naiveté. (One way of taking the *Neveu* is as a thought experiment whereby Diderot, under the influence of music, calls into question the absoluteness of the distinction between naiveté and theatricality central to his writings on painting and drama.) In this second appendix, however, I wish to make just a few observations about two major texts by other writers, Rousseau's *Lettre sur les spectacles* and Goethe's *Die Wahlverwandtschaften*, both of which seem to me to reward a reading in terms of the argument I have been pursuing.

Rousseau's *Lettre sur les spectacles*

This is not the place for an extended comparison between Diderot's and Rousseau's views on the theater. It seems clear, though, that both men share, or at least both writers express, an extreme distaste for what might be called the theatricality of the theater as they know it, together with a suspicion that the corruptness of the theater in their time is only one manifestation of a deeper or more pervasive state of affairs involving the function of beholding and the condition of being beheld. Their responses to that state of affairs are very different. Diderot is chiefly concerned with specifying measures to be taken in order that the arts of drama and painting be redeemed; while Rousseau not only argues that the theater is beyond redemption—the *Lettre* is directed

against Diderot's dramatic theories fully as much as against D'Alembert's article on Geneva—but strongly implies that there is no aspect of social life that is not comprised within the dangerous, because readily theatricalized and theatricalizing, realm of the spectacular.

This includes the institution of textuality—of the production, dissemination, and consumption of written texts—which crucially involves the sense of sight and which figures throughout the letter in a variety of ways. Consider in this regard the long footnote in which Rousseau distinguishes between what he calls *audace* and the brutalization of that quality in the man who would possess by force a woman who did not positively if tacitly consent to his advances:

Vouloir contenter insolemment ses désirs sans l'aveu de celle qui les fait naître, est l'audace d'un Satire; celle d'un homme est de savoir les témoigner sans déplaire, de les rendre intéressans, de faire en sorte qu'on les partage, d'asservir les sentimens avant d'attaquer la personne. Ce n'est pas encore assés d'être aimé, les désirs partagés ne donnent pas seuls le droit de les satisfaire; il faut de plus le consentement de la volonté. Le coeur accorde en vain ce que la volonté refuse. L'honnête homme et l'amant s'en abstient, même quand il pourroit l'obtenir. Arracher ce consentement tacite, c'est user de toute la violence permise en amour. Le lire dans les yeux, le voir dans les manières, malgré le refus de la bouche, c'est l'art de celui qui sait aimer; s'il achève alors d'être heureux, il n'est point brutal, il est honnête; il n'outrage point la pudeur, il la respecte, il la sert; il lui laisse l'honneur de défendre encore ce qu'elle eut peut-être abandonné.[1]

To wish to satisfy one's desires insolently without the consent of the woman who engendered them is the audacity of a satyr; that of a man is to know how to give expression to them without displeasing, to make them interesting, to make the other share them, to subdue the feelings before attacking the person. It is not yet enough to be loved, sharing desires does not by itself confer the right to satisfy them; there must also be the consent of the will. The heart grants in vain what the will refuses. The honorable man and the lover abstains, even when he could obtain it. To win this tacit consent is to use all the violence that love permits. To read it in the eyes, to see it in the manner, despite the mouth's refusal, is the art of one who knows how to love; if he then succeeds in being happy, he is not at all brutal, he is honorable; he does not outrage decency, he respects it, he serves it; he leaves to decency the honor of still defending what it perhaps would have abandoned.

Underlying these remarks is the assumption that women, in particular beautiful women, traditionally regarded as objects of beholding par excellence, are especially prone to give themselves up to the tainted and debasing pleasures of self-exhibition. And it is the charge of sexual love as defined by Rousseau—of *audace* in the proper sense of the term—to rescue such women from theatricality by making them at once the agents and the objects (in that order) of two distinct but mutually reinforcing acts of *reading*: that by which the woman first comes to share the feelings which the man expresses; and that by which the man proceeds to discern in the woman's eyes and general demeanor the tacit consent he seeks. Throughout these operations the relationship between man and woman remains asymmetrical: the woman, it appears, is made a reader

and consequently a text only in response to an initial act of textual self-representation on the part of the man; the successful lover is the author, at one remove, of the text the woman becomes. For our purposes, however, the asymmetry is less important than that the woman's innermost being, her very "self," is in this way oriented to a textual as opposed to a theatrical paradigm.

Elsewhere in the *Lettre* the conventions of textuality turn out to bear a deeply equivocal relation to the issue of theatricality. I am thinking, for example, of the long passage in which Rousseau specifies the sort of ball, analogue to the festival, that he advocates for the winter season (what follows are excerpts):

L'hiver, tems consacré au commerce privé des amis, convient moins aux fêtes publiques. Il en est pourtant une espece dont je voudrois bien qu'on se fît moins de scrupule, savoir les bals entre de jeunes personnes à marier. . . . L'homme et la femme ont été formés l'un pour l'autre. Dieu veut qu'ils suivent leur destination, et certainement le premier et le plus saint de tous les liens de la Société est le mariage. . . . [M]ais qu'on me dise où de jeunes personnes à marier auront occasion de prendre du goût l'une pour l'autre, et de se voir avec plus de décence et de circonspection que dans une assemblée où les yeux du public incessamment ouverts sur elles les forcent à la réserve, à la modestie, à s'observer avec le plus grand soin? . . . Le devoir de se chérir réciproquement n'emporte-t-il pas celui de se plaire, et n'est-ce pas un soin digne de deux personnes vertueuses et chrétiennes qui cherchent à s'unir, de préparer ainsi leurs coeurs à l'amour mutuel que Dieu leur impose?

. .

Pour moi, loin de blâmer de si simples amusemens, je voudrois au contraire qu'ils fussent publiquement autorisés, et qu'on y prévînt tout désordre particulier en les convertissant en bals solemnels et périodiques, ouverts indistinctement à toute la jeunesse à marier. . . . Je voudrois que les peres et meres y assistassent, pour veiller sur leurs enfans, pour être témoins de leur grace et de leur adresse, des applaudissemens qu'ils auroient mérités, et jouir ainsi du plus doux spectacle qui puisse toucher un coeur paternel. Je voudrois qu'en géneral toute personne mariée y fût admise au nombre des spectateurs et des juges, sans qu'il fût permis à aucune de profaner la dignité conjugale en dansant elle-même: car à quelle fin honnête pourroit-elle se donner ainsi en montre au public?[2]

Winter, a time consecrated to the private association of friends, is less suitable for public festivals. However, there is one type about which I wish we had fewer scruples, that is, balls for young marriageable persons. . . . Man and woman were formed for one another. God wants them to fulfill their destiny, and certainly the first and holiest of all the bonds of society is marriage. . . . [B]ut will someone tell me where young marriageable persons will have occasion to acquire a taste for one another, and to see one another with more propriety and circumspection than in a gathering where the eyes of the public are constantly open and upon them, forcing them to be reserved, modest, and to watch themselves with greatest care? . . . Does not the duty of cherishing one another imply that they should please one another, and is it not an attention worthy of two virtuous and Christian persons who seek to be united to prepare their hearts in this way for the mutual love which God imposes on them?

. .

As for me, far from blaming such simple amusements, I wish on the contrary that they were publicly authorized and that all private disorder were prevented by converting them into solemn and periodic balls, open without distinction to all the mar-

[169]

riageable young. . . . I wish that the fathers and mothers would attend, to watch over their children, to witness their grace, their address, and the applause they may have merited, and thus to enjoy the sweetest spectacle that can touch a paternal heart. I wish that in general all married persons be admitted among the number of spectators and judges, without allowing them to profane conjugal dignity by dancing themselves; for to what honorable end could they thus show themselves off in public?

A striking feature of the passage is the repeated use of the feminine noun "personne" and related pronouns and word endings. This may appear innocuous, a matter of standard grammar and nothing more. But it may also be read as motivating the imposition of strict spectacular controls over the activities of the engaged and married couples in question: as if by virtue of being subsumed under a feminine noun, *all* the persons, male and female, participating in the ball are rendered equally vulnerable to the risk of theatricalization that Rousseau chiefly associates with women. (A complementary device is the use of the masculine "coeur paternel," attributed to both mothers and fathers, as a means of confirming their identity as observers—an identity which the very next sentence proceeds to put into question.) In short, the play of genders in the passage quoted above exploits the constitutive conventions of the French language for ontologically tendentious ends. By doing so, however, it suggests that those conventions are *already* implicated in a problematic of *spectacle* and theater; and this suggests in turn that one function of the passage in the larger economy of Rousseau's text is to bring to light—to make available to our attention—precisely that state of affairs.

It should be noted, too, that the *Lettre* acknowledges at crucial junctures an apprehension of its own theatricality both as the sign of an act of writing that seeks to present itself in a certain light (cf. the opening references to taking up the pen[3] and the much later one to the pen falling from his hands,[4] the use of the plural intimating that Rousseau has been wielding a truly massive instrument) and as a finished product destined to be consumed in a particular fashion (cf. the footnote in which the author anticipates its being read aloud in Parisian society).[5] Two other passages are of special interest in this connection. About two-thirds of the way through the *Lettre*, Rousseau explains that the reason he has not yet discussed Geneva is the repugnance he feels at the thought of putting his fellow citizens "sur la Scène" (on the stage),[6] a remark that explicitly equates text and theater. He goes on to describe that city in the following terms: "Il me semble que ce qui doit d'abord frapper tout étranger entrant dans Geneve, c'est l'air de vie et d'activité qu'il y voit régner. Tout s'occupe, tout est en mouvement, tout s'empresse à son travail et à ses affaires. Je ne crois pas que nulle autre aussi petite ville au monde offre un pareil spectacle" (It seems to me that what first must strike any stranger entering Geneva is the air of life and activity that reigns there. Everyone is busy, everyone is moving, everyone is eagerly pursuing his work and his affairs. I do not believe that any other equally small city in the world offers such a spectacle).[7] One might say that the sentences just quoted solve the problem posed by his reluctance to theatricalize his beloved Genevans by representing the latter

as wholly absorbed in activity and thus as oblivious to the existence of the stranger (a figure for the reader). The parallel with Diderot is as distinct as it is unexpected.

The other passage is a footnote that I give in its entirety:

J'ai lu dans ma jeunesse une tragédie de l'Escalade [an independence holiday at Geneva], où le Diable étoit en effet un des Acteurs. On me disoit que cette pièce ayant une fois été représentée, ce personnage, en entrant sur la Scène, se trouva double, comme si l'original eût été jaloux qu'on eût l'audace de le contrefaire, et qu'à l'instant l'effroi fit fuir tout le monde, et finir la représentation. Ce conte est burlesque, et le paroîtra bien plus à Paris qu'à Geneve: cependant, qu'on se prête aux suppositions, on trouvera dans cette double apparition un effet théatral [in the non-pejorative sense of highly dramatic] et vraiment effrayant. Je n'imagine qu'un Spectacle plus simple et plus terrible encore, c'est celui de la main sortant du mur et traçant des mots inconnus au festin de Balthazar. Cette seule idée fait frissonner. Il me semble que nos poètes lyriques sont loin de ces inventions sublimes; ils font, pour épouvanter, un fracas de décorations sans effet. Sur la Scène même il ne faut pas tout dire à la vue, mais ébranler l'imagination.[8]

In my youth I read a tragedy of the Escalade in which the devil was in effect one of the actors. I was told that at one of the performances of this play, the character of the devil, upon stepping onstage, appeared double, as if the original had been jealous of the fact that someone had the audacity to counterfeit him. At that instant terror made everyone flee and put an end to the performance. This story is comical and will seem even more so in Paris than in Geneva. However, if one accepts its presuppositions, one will find in this double apparition a dramatic and truly frightening effect. I can imagine only one simpler and more terrible spectacle, that of the hand coming out of the wall and tracing the unknown words at Belshazzar's feast. The idea alone makes me shudder. It seems to me that our lyric poets fall short of these sublime inventions; seeking to terrify, they deploy a riot of decorations without effect. Even on the stage it is necessary not to address everything to the sense of sight, but to shake the imagination.

Not only does the footnote as a whole display a willingness to attempt to imagine a valid theatrical experience that by this point comes as something of a surprise. The anecdote of the double apparition of the devil is perhaps to be understood as a figure for the desire for self-representation that plays so important a role throughout the *Lettre,* or perhaps I should say for the vertiginous doubling and redoubling of texts in which that desire is fated to issue. And the allusion to the biblical episode of Belshazzar's feast holds up as a spectacular and indeed as a theatrical ideal an act of writing (and publication) that must, I think, be seen as an image of Rousseau's authorial aspirations.

Goethe's *Die Wahlverwandtschaften*

Another famous text that invites comparison with Diderot's writings on painting and drama is *Die Wahlverwandtschaften* (1809). It is well known that Goethe admired Diderot's *Essais sur la peinture* and *Salon de 1765* when they were published for the first time in 1795, and that thereafter Diderot's ideas exerted a considerable influence on Goethe's pictorial thought.[9] But it has not

[171]

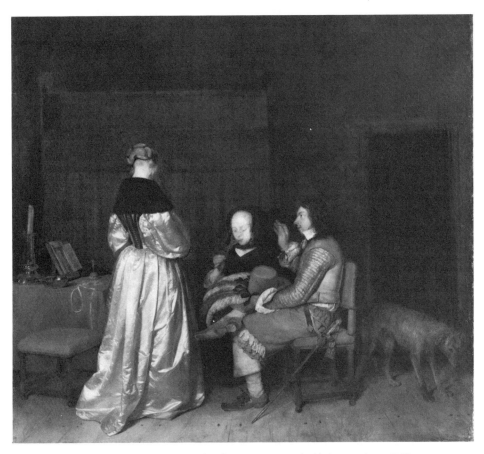

68 Gerard Ter Borch, *The Paternal Admonition,* ca. 1654. Amsterdam, Rijksmuseum.

been remarked that the *tableaux vivants* scene in Goethe's novel reflects those ideas, not merely as regards the choice of works represented—both Van Dyck's *Bélisaire* and Poussin's *Esther devant Assuérus* are praised in the *Salon de 1765*—but, more importantly, in Goethe's adaptation of the strategy of denying the presence of the beholder as a means of fixing his attention. This occurs in the description of the third *tableau vivant*, based on Ter Borch's *Father's Admonition* (Fig. 68),[10] a work to which Diderot does not refer. The passage from the novel deserves to be quoted at length:

. . . who does not know Wille's admirable engraving of this picture? One foot thrown over the other, sits a noble knightly-looking father; his daughter stands before him, to whose conscience he seems to be addressing himself. She, a fine striking figure, in a folding drapery of white satin, is only to be seen from behind, but her whole bearing appears to signify that she is collecting herself. That the admonition is not too severe, that she is not being utterly put to shame, is to be gathered from the air and attitude of the father, while the mother seems as if she were trying to conceal some slight embarrassment—she is looking into a glass of wine, which she is on the point of drinking.

Here was an opportunity for Luciana to appear in her highest splendor. Her back hair, the form of her head, neck, and shoulders, were beyond all conception beautiful;

[172]

and the waist, which in the modern antique of the ordinary dresses of young ladies is hardly visible, showed to the greatest advantage in all its graceful, slender elegance in the really old costume. The Architect had contrived to dispose the rich folds of the white satin with the most exquisite nature, and, without any question whatever, this living imitation far exceeded the original picture, and produced universal delight.

The spectators could never be satisfied with demanding a repetition of the performance, and the very natural wish to see the face and front of so lovely a creature, when they had done looking at her from behind, at last became so decided that a merry impatient young wit cried out aloud the words one is accustomed to write at the bottom of a page, "Tournez, s'il vous plaît," which was echoed all round the room.

The performers, however, understood their advantage too well, and had mastered too completely the idea of these works of art to yield to the most general clamor. The daughter remained standing in her shame, without favoring the spectators with the expression of her face. The father continued to sit in his attitude of admonition, and the mother did not lift nose or eyes out of the transparent glass, in which, although she seemed to be drinking, the wine did not diminish.[11]

The behavior of the spectators may be compared with Diderot's efforts in the *Salon de 1765* to engage in conversation the girl mourning her dead bird in Greuze's canvas, though Goethe also appears to have wished to call attention to the ease with which Ter Borch's ostensibly antitheatrical composition is exploited by Luciana to serve as a perfect theater for her charms. The use of the conventional textual notation, "Tournez, s'il vous plaît," as an expression of the spectators' desire to have Luciana turn and face them underscores the point by suggesting that the words are in effect *read off,* if not from the composition as such, at any rate from the circumstances of its representation. The entire *tableaux vivants* scene may thus be understood to show that there can be no such thing as an absolutely antitheatrical work of art—that any composition, by being placed in certain contexts or framed in certain ways, can be made to serve theatrical ends.

David's Homer *Drawings of 1794*

DAVID'S CANVAS of 1781 and the replica of 1784 were not the last representations of the blind Belisarius in French painting of the late eighteenth and early nineteenth centuries. In this third and final appendix, however, I want briefly to consider, rather than subsequent versions of the Belisarius theme itself, two drawings by David of the blind Homer, a figure who may be seen as a transformation of that of the Byzantine general. It is widely agreed that both drawings were made in the autumn of 1794, during David's incarceration in the Luxembourg following the fall of Robespierre and the rout of the Jacobins. The simpler of the two, apparently unfinished, depicts Homer asleep in an architectural setting while two women in Greek dress bring him gifts of food (Fig. 69).[1] The more complex and by far the more impressive of the two represents Homer reciting his poetry to the assembled populace of a Greek township, and in that drawing too several young women bring him gifts of food (Fig. 70).[2] We know that David around this time intended to base a history painting on a subject involving Homer: presumably it was the second of the drawings that he had in mind, since he wrote to a friend from prison to say that the subject was "totalement composé" (totally composed).[3] But owing to his imprisonment David found it impossible to carry the project through to completion, and by the time he was released his attention had turned to the project of the *Sabines,* on which he worked throughout most of the second half of the 1790s.

I think it is fair to say that the *Homer* drawings have not received the attention they deserve. The second of them in particular, *Homère récitant ses vers aux Grecs,* which David's intention to make the basis of a history painting should encourage us to treat especially seriously, illuminates his thought at a

69 Jacques-Louis David, *Homère endormi*, 1794. Paris, Louvre.

critical moment in his career. I have already suggested that the evolution of David's art between the 1780s and 1814, when the *Léonidas* was completed, reveals a drastic loss of conviction in action and expression as resources for ambitious painting, that is, in the very possibility that either could be represented other than as theatrical.[4] It would require another study to explain exactly how the *Sabines* and the *Léonidas* embody that loss of conviction. But the *Homer* drawings as I see them also document the loss—one might say they are its harbingers—and it is that point more than any other that I hope to establish.

The first observation to be made is that David adapted the figure of the poet in the *Homère récitant* from that of Belisarius receiving alms in his painting of thirteen years before. By so doing he closed a circle, Belisarius's physiognomy having been derived in part from ancient images of Homer.[5] One has the impression that for David and his contemporaries, Belisarius and Homer constituted a single mythic identity, in which the characteristics and circumstances normally associated with each were mingled and interfused.[6] This is the case, for example, in André Chénier's great poem, *L'Aveugle,* in which the figure of Homer reduced to mendicancy but heroic, even physically magnificent in his destitution seems deliberately to recall that of Belisarius in David's canvas. (As a matter of fact, the possibility exists that David's *Homer* drawings reflect the influence of Chénier, who had been close to the painter throughout the later 1780s and who had died on the guillotine just a few months before the drawings were made.)[7]

[176]

70 Jacques-Louis David, *Homère récitant ses vers aux Grecs,* 1794. Paris, Louvre.

Furthermore, the composition of the *Homère récitant* is itself an adaptation of that of David's *Bélisaire.* In my discussion of the latter I suggested that David envisioned the possibility of opening up the composition from the rear as a means of neutralizing the ineluctable fact of the beholder's presence. Now I want to suggest that in the *Homère récitant* that strategy has been carried further by the provision of an entire audience, from which the beholder feels himself to be excluded, listening to and presumably absorbed in Homer's recitation. In addition, the poet himself is depicted as aware of the presence of that audience, for which indeed he is performing. The position of the beholder in this regard is at once deprived and privileged, much like one backstage or in the wings at a theatrical production. It is as though David's composition asserts the beholder's exclusion from Homer's audience precisely in order to make of the fact of that exclusion an ostensible guarantee of the *non-* or *anti-* theatrical nature of his relation to the composition as a whole.

The same basic concerns emerge even more forcefully when we consider the role in the two compositions of the young women bringing Homer gifts. In both, the women are shown approaching Homer from the rear as well as from behind a massive architectural pier, which even if he were not blind would shield them from his sight; and in the *Homère récitant* they are shielded too from at least part of Homer's audience. The strong impression is thereby conveyed that the young women wish not to be beheld—that they hope to ac-

[177]

complish their act of homage and charity in secrecy, unseen by anyone and undetected by Homer himself. But of course by shielding themselves behind the pier, they inadvertently disclose themselves to the beholder, whose exclusion from Homer's audience is made all the more pointed and whose attention is largely diverted from the poet to the young women. (The hushed and ostensibly accidental drama of their self-disclosure is given subtle emphasis by the contrast between the bright illumination that strikes three of the four women and the shadowed face of the pier against which they are silhouetted.) In short, it seems clear that the young women would not thus disclose themselves to the beholder if they had the least awareness that he is there; and I suggest that it is the chief purpose of their actions and of the staging of their actions to make this as perspicuous as it can be made. In Diderot's words to Sophie of more than thirty years before, we may say that the young women bringing Homer gifts were intended by the painter to be seen as acting upon the belief "qu'il n'y a personne au monde que les personnages du tableau," and by virtue of being seen in those terms to help establish that fiction in and for the composition as a whole. But the engraving after Van Dyck as described by Diderot differs from the *Homère récitant* in this fundamental respect: that in Diderot's view the persuasiveness with which Van Dyck represented the soldier's absorbed contemplation of Belisarius was enough in itself to secure the aloneness of that figure, and of the composition as a whole, relative to the beholder; whereas in the later work, in order to achieve an analogous result, David found himself compelled to make the dramatic focus of his composition actions whose manifest content is the conviction of those who perform them that action and performer are unobserved.

A similar comparison may be drawn between David's *Bélisaire* and the *Homère récitant*. In both, the primordial convention that paintings are made to be beheld confronted the painter with a problem that mobilized the resources of his compositional art. It remains questionable, however, whether the *Homère récitant* ultimately envisions any more radical solution than contriving to *hide* the beholder, to confer upon him the status of a *voyeur*.[8] If this is the most that could be done, the problem was indeed on its way to proving insuperable.

Notes

Abbreviations

Salons, I	Diderot, *Salons,* I, ed. Jean Seznec and Jean Adhémar, 2nd ed. (Oxford, 1975); contains the *Salon de 1759, Salon de 1761,* and *Salon de 1763.*
Salons, II	Diderot, *Salons,* II, ed. Jean Seznec and Jean Adhémar (Oxford, 1960); contains the *Salon de 1765.*
Salons, III	Diderot, *Salons,* III, ed. Jean Seznec and Jean Adhémar (Oxford, 1963); contains the *Salon de 1767* and the essay, "De la Manière."
Salons, IV	Diderot, *Salons,* IV, ed. Jean Seznec (Oxford, 1967); contains the *Salon de 1769, Salon de 1771, Salon de 1775,* and *Salon de 1781.*
Oeuvres esthétiques	Diderot, *Oeuvres esthétiques,* ed. Paul Vernière (Paris, 1966); includes the *Entretiens sur le Fils naturel, Discours de la poésie dramatique, Essais sur la peinture,* and *Pensées détachées sur la peinture.* References will be either to the *Oeuvres esthétiques* (for editorial remarks by Vernière) or to the individual works just cited.
Correspondance	Diderot, *Correspondance,* ed. Georges Roth and Jean Varloot, 16 vols. (Paris, 1955–70).
Oeuvres complètes	Diderot, *Oeuvres complètes,* ed. Herbert Dieckmann, Jean Fabre, Jacques Proust, Jean Varloot, and others (Paris, 1975–).
Corr. litt.	Friedrich Melchior Grimm, *Correspondance littéraire, philosophique, et critique par Grimm, Diderot, Raynal, etc.,* ed. Maurice Tourneux, 16 vols. (Paris, 1877–82).

Introduction

1. Something should be said at the outset about the institution of the Salon, or official exhibition of paintings, sculptures, and engravings by members of the Académie Royale de Peinture et de Sculpture, which provided by far the most conspicuous vehicle by which French artists of the period made and sustained their reputations. The earliest such exhibition was held in 1667, after which others followed, for the most part every other year, until 1699. After an almost complete lapse of several decades, the institution was revived on a regular basis in 1737 and, except for 1744 and 1749, was held annually until 1751; from 1751 until 1795, which is to say throughout the period treated in this book, one took place every other year. Starting in 1725 the exhibition occupied the Salon Carré of the Louvre—hence the term "Salon"—although on occasion other spaces were used as well. Throughout our period the Salon ran from 25 August until at least the end of September; it was open to the public free of charge and always drew large crowds. On the occasion of each exhibition the Académie published a brochure or *livret* in which were listed by number all the works on view; in this study I cite that number for each painting that I discuss. One slightly confusing point that should be noted is that critical commentaries on those exhibitions are known generically as *Salons* (italicized). For a brief discussion of the history of the Salon down to Diderot's time, including further details about the organization of the exhibitions, see Jean Adhémar, "Les Salons de l'Académie au XVIIIe siècle," *Salons*, I, 8–15.

2. No one has contributed more to that triumph than Robert Rosenblum, whose *Transformations in Late Eighteenth Century Art* (Princeton, 1967) is probably the most influential treatment of the subject since Locquin (see below, n. 4). See also Rosenblum's doctoral dissertation, *The International Style of 1800: A Study in Linear Abstraction*, Diss., New York University, 1956 (New York, 1976).

3. "Internationalism was, indeed, to become one of the prime aims of [Neo-Classicism's] protagonists who sought to create an art of universal significance and eternal validity," writes Hugh Honour ("Neo-Classicism," in the exhibition catalogue *The Age of Neo-Classicism* [London, Royal Academy and the Victoria and Albert Museum, September-November 1972], p.xxii). See also idem, *Neo-Classicism* (Harmondsworth and Baltimore, 1968), pp. 29–32.

4. In particular the priority of British art and at least by implication its influence on French painting have been asserted by a number of scholars. See for example Jean Locquin, *La Peinture d'histoire en France de 1747 à 1785* (Paris, 1912), pp. 153–57, esp. p. 157, n. 9; idem, "Le Retour à l'antique dans l'école anglaise et dans l'école française avant David," *La Renaissance de l'art français et des industries de luxe*, 5 (1922), 473–81; Ellis K. Waterhouse, "The British Contribution to the Neo-Classical Style in Painting," *Proceedings of the British Academy*, 40 (1954), 57–74; Robert Rosenblum, "Gavin Hamilton's *Brutus* and Its Aftermath," *Burlington Magazine*, 103 (1961), 8–16; idem, *Transformations*, pp. 34–35, n. 107, p. 65, n. 54, p. 69; and David Goodreau, "Pictorial Sources of the Neo-Classical Style: London or Rome?," *Studies in Eighteenth-Century Culture IV*, ed. Harold E. Pagliaro (Madison, 1975), pp. 247–70.

5. I owe to the late Anthony M. Clark the suggestion that significant affinities may exist between the French painting that I describe as absorptive and contemporaneous painting in Rome. Almost all the painters I discuss spent several years in Rome at an

early stage of their careers; indeed Vien painted in Rome his *Ermite endormi,* a work whose absorptive character I analyze at some length (see chapter one, pp. 28–32).

6. Two pioneering studies of that development are André Fontaine, *Les Doctrines d'art en France. Peintres, Amateurs, Critiques, de Poussin à Diderot* (1909; rpt. Geneva, 1970), pp. 252–98; and Albert Dresdner, *Die Entstehung der Kunstkritik in Zusammenhang der Geschichte des europäischen Kunstlebens* (1915; rpt. Munich, 1968), pp. 119–230. The first writer generally regarded as an art critic in the modern sense of the term is La Font de Saint-Yenne, about whom relatively little is known. But see Fontaine, pp. 252–59; and Roland Desné, "La Font de Saint-Yenne, précurseur de Diderot," *La Pensée,* 73 (May–June 1957), 82–96. Cf. also Lionel Gossman, *Medievalism and the Ideologies of the Enlightenment: The World and Work of La Curne de Sainte-Palaye* (Baltimore, 1968), pp. 128, 130, 132–34.

7. Modern discussions of Greuze's art abound with the use of criticism as illustration. For example, it is by now traditional to assert simply on the basis of a superficial description of paintings such as the *Piété filiale* and the *Jeune Fille qui pleure son oiseau mort* that they were intended by their creator to satisfy the "literary" tastes of the public of his time, and then to quote portions of Diderot's admiring commentaries on those paintings as "proof" that that was indeed their appeal. The sterility of this procedure will I trust become clear long before the end of the first chapter.

8. Diderot composed *Salons* for the exhibitions of 1759, 1761, 1763, 1765, 1767, 1769, 1771, 1775, and 1781. The only *Salon* not to appear in the *Corr. litt.* is that of 1771, a problematic text in several respects. See the discussion of that *Salon* by Jean Seznec, "Préface," *Salons,* IV, viii–xv.

9. Subscribers to the *Corr. litt.* in the late 1750s and 1760s probably numbered less than twenty; they included the empress of Russia, the queen of Sweden, the king of Poland, the duchess of Saxe-Gotha, and other prominent figures of royal rank. For a discussion of this and other questions connected with the production and distribution of the *Corr. litt.* see Jeanne R. Monty, *La Critique littéraire de Melchior Grimm* (Geneva and Paris, 1961), pp. 26–31. One consequence of the appearance of Diderot's *Salons* only in the *Corr. litt.* is that they along with the *Essais sur la peinture* remained almost wholly unknown in France during his lifetime. Their actual publication in France began in 1795 (eleven years after his death); it was not until 1857 that all the *Salons* had been published at least once. For details of their publication see Seznec, "Préface," *Salons,* I, vii, n. 1.

10. In Seznec's words, Diderot in the 1770s "n'est pas seulement un guide intermittent; c'est un guide fatigué" (is not only an intermittent guide; he is a tired guide) ("Préface," *Salons,* IV, viii). Seznec also remarks astutely: "Ces lacunes [the Salons of the 1770s Diderot did not review] sont d'autant plus regrettables que pendant ces dix années s'est affirmée cette double évolution de l'art français vers le 'grand goût' néoclassique et vers l'inspiration nationale que Diderot lui-même avait contribué à favoriser; les Expositions de 1773, 1777, et 1779 marquent à cet égard des étapes capitales. . . . [C]ette discontinuité reste déplorable; elle fausse, pour nous, la perspective de cette décade" (These lacunae are all the more regrettable because, during those ten years, that double evolution of French art toward Neoclassic taste and toward national sources of inspiration that Diderot himself had helped to promote grew stronger. The Salons of 1773, 1777, and 1779 mark important stages in this development. . . . This discontinuity remains deplorable; it distorts our perspective on that decade) (ibid.).

11. For Géricault see the brief remarks in chapter three of this study, p. 154, as well as the discussion of his art in Michael Fried, "Thomas Couture and the Theatricalization of Action in 19th-Century French Painting," *Artforum*, 8, No. 10 (1970), 43. In that essay, too, I observe that Manet's great paintings of the first half of the 1860s "may be said to take account of the beholder; in any event they refuse to accept the fiction that the beholder is not there, present before the painting, which Diderot a century before had insisted was crucial to the convincing representation of action" (45). See also Fried, "Manet's Sources: Aspects of His Art, 1859–65," *Artforum*, 7, No. 7 (1969), nn. 27, 46, 72, 74. Theodore Reff on the other hand finds in Olympia's gaze merely an adaptation of "one of the most familiar conventions of the erotic prints and photographs of the time, the enticement of a coyly inviting or contemptuously cool glance" (*Manet: "Olympia"* [London, 1976], p.58). On Courbet's self-portraits see Fried, "The Beholder in Courbet: His Early Self-Portraits and Their Place in His Art," *Glyph 4: Johns Hopkins Textual Studies* (1978), pp. 85–129.

12. It may be objected that the concept of "artistic level or quality" is merely ideological, at once a specimen and an instrument of bourgeois mystification. This is not the place to address that issue, but it should be noted that the pioneering study of late eighteenth-century French art and literature, G[eorgi] V[ladimirovich] Plekhanov's essay "French Dramatic Literature and French Eighteenth-Century Painting from the Sociological Standpoint" (1905), closes with an attempt to reconcile a social-historical interpretation of the art in question with a Kantian view of the nature of aesthetic judgment (Andrew Rothstein, ed., *Art and Social Life*, trans. Eleanor Fox and Eric Hartley [London, 1953], pp. 164–65). The Kantian elements in Plekhanov's thought have been repudiated by Lenin and others, but it may be doubted whether the questions raised by Plekhanov concerning the status of the individual's experience of works of art have ever been answered satisfactorily from within a Marxist perspective.

13. See for example "Art and Objecthood," *Artforum*, 5, No. 10 (1967), 12–23, reprinted in Gregory Battcock, ed., *Minimal Art: A Critical Anthology* (New York, 1968), and in George Dickie and R.J. Sclafani, eds., *Aesthetics: A Critical Anthology* (New York, 1977). See also my "Two Sculptures by Anthony Caro," *Artforum*, 6, No. 6 (1968), 24–25, and "Caro's Abstractness," *Artforum*, 9, No. 1 (1970), 32–34, both reprinted in Richard Whelan and others, *Anthony Caro* (Harmondsworth, 1974). The issue of theatricality is also central to writings by Stanley Cavell, in particular "The Avoidance of Love: A Reading of *King Lear*," in *Must We Mean What We Say? A Book of Essays* (New York, 1969), pp. 267–353, and *The World Viewed: Reflections on the Ontology of Film* (New York, 1971). Between Cavell's work and my own there exists a community of concept and purpose which will be apparent to anyone reading us both.

CHAPTER ONE
The Primacy of Absorption

1. See Edmond and Jules de Goncourt, *L'Art du dix-huitième siècle* (Paris, 1882), II, 3–101. The most recent monograph is Anita Brookner, *Greuze: The Rise and Fall of an Eighteenth-Century Phenomenon* (London, 1972). For a brief discussion of Greuze's art in historical context see Michael Levey and Wend Graf Kalnein, *Art and Architecture of the Eighteenth Century in France*, Pelican History of Art (Harmondsworth, 1972), pp.

144–49; the sections on painting and sculpture are by Levey. Cf. also the important article by Willibald Sauerländer, "Pathosfiguren im Oeuvre des Jean-Baptiste Greuze," in G. Kauffman and W. Sauerländer, eds., *Walter Friedlaender zum 90 Geburtstag; eine Festgabe* . . . (Berlin, 1965), pp. 146–50. The *Père de famille* is viewed in terms of Protestant devotional practice by Edgar Munhall, "Greuze and the Protestant Spirit," *Art Quarterly,* 27 (1964), 5–8. Munhall also organized and wrote the catalogue for the recent exhibition, *Jean-Baptiste Greuze, 1725–1805* (Hartford, Wadsworth Atheneum; San Francisco, The California Palace of the Legion of Honor; and Dijon, Musée des Beaux-Arts; December 1976–July 1977).

2. No. 146 in the Salon *livret* for that year.

3. Levey, *Art and Architecture,* p. 47.

4. *Sentimens sur plusieurs des tableaux exposés cette année au grand sallon du Louvre* (1755), p. 15; consulted in the unique collection of eighteenth-century Salon criticism and related writings assembled by Mariette, Cochin, and Deloynes and at present in the Cabinet des Estampes of the Bibliothèque Nationale (hereafter cited as the Deloynes Collection). The *Sentimens sur plusieurs des tableaux* is signed D——p——te P.D.M.; according to Deloynes the author is [Abbé Joseph] de La Porte, "professeur de mathématiques." For the contents of the Deloynes Collection see Georges Duplessis, *Catalogue de la collection de pièces sur les beaux-arts imprimées et manuscrites recueillie par Pierre-Jean Mariette, Charles-Nicolas Cochin et M. Deloynes* . . . (Paris, 1881). A recent article on critics and criticism through 1759 based on material in the Deloynes Collection is Hélène Zmijewska, "La Critique des Salons en France avant Diderot," *Gazette des Beaux-Arts,* 6e pér., 76 (1970), 1–144. Throughout this chapter an effort has been made to transcribe literally the quotations from eighteenth-century critics.

5. The persistence of this view may be gauged by comparing Louis Hautecoeur, *Greuze* (Paris, 1913), and the monograph by Brookner cited in n.1. See also Hautecoeur, "Le Sentimentalisme dans la peinture française de Greuze à David," *Gazette des Beaux-Arts,* 4e pér., 51 (1909), 159–76, 269–86. The tendentious *a priori* distinction between "literary" and "pictorial" qualities and values, which continues to bedevil studies of eighteenth-century art, has its *locus classicus* in the Goncourts' brilliant essay on Greuze, where it expresses the Flaubertian, art-for-art's-sake esthetic of the French avant-garde of the 1860s and 1870s. Such an esthetic, resting as it does on ahistorical assumptions about the nature or essence of painting, is hardly a reliable guide to the situation of painting in France more than a hundred years before.

6. The OED defines "absorption" as "the entire engrossment or engagement of the mind or faculties"; and defines "to absorb" as "to engross, or completely engage the attention or faculties." This is consistent with the definitions given in Diderot's article "Absorber" in the *Encyclopédie* (1751):

ABSORBER, ENGLOUTIR, synonymes. *Absorber* exprime une action générale à la vérité, mais successive, qui en ne commençant que sur une partie du sujet, continue ensuite & s'étend sur le tout. Mais *engloutir* marque une action dont l'effet général est rapide, & saisit tout à la fois sans le détailler par parties.

Le premier a un rapport particulier à la consommation & à la destruction: le second, dit proprement quelque chose qui enveloppe, emporte & fait disparaître tout d'un coup: ainsi le feu *absorbe,* pour ainsi dire, mais l'eau *engloutit.*

C'est selon cette même analogie qu'on dit dans un sens figuré être absorbé en Dieu, ou dans la contemplation de quelque objet, lorsqu'on s'y livre dans toute l'étendue de sa pensée, sans se permettre la moindre distraction. Je ne crois pas qu'*engloutir* soit d'usage au figuré. (*Oeuvres complètes,* V, 231–32)

TO ABSORB, TO ENGULF, synonyms. *To absorb* expresses a general but successive action, which, beginning only in one part of the subject, continues thereafter and spreads over the whole. But *to engulf* indicates an action whose general effect is rapid, and seizes everything at the same time without breaking it up into parts.

The first is particularly related to consumption and destruction; the second properly designates something that envelops, sweeps away, and causes suddenly to disappear. Thus fire *absorbs*, so to speak, but water *engulfs*.

It is according to the same analogy that one speaks in a figurative sense of being absorbed in God, or in the contemplation of some object, when one gives oneself up to it with all one's thought without allowing oneself the least distraction. I do not think that *to engulf* can be used in a figurative sense.

7. [Louis-Guillaume] Baillet de Saint-Julien, *Lettre à un partisan du bon gout sur l'exposition des tableaux faite dans le grand sallon du Louvre le 28 aout 1755,* p. 10. Attributed by Mariette to Estève in the Deloynes Collection; the present attribution is by Zmijewska, "La Critique des Salons," 139.

8. No. 60. Georges Wildenstein, *Chardin,* rev. and enlarged by Daniel Wildenstein, trans. Stuart Gilbert (Greenwich, Conn., 1969), Cat. No. 145.

9. [Abbé Marc-Antoine] Laugier, *Jugement d'un amateur sur l'exposition des tableaux. Lettre à M. le marquis de V——* [Vence] (1753), pp. 42–43. The especially high quality of Laugier's criticism of painting, like that of Grimm's, deserves general recognition. He is better known for his architectural theories, for which see Wolfgang Herrmann, *Laugier and Eighteenth-Century French Theory* (London, 1962).

10. [Gabriel] Huquier, le fils, *Lettre sur l'exposition des tableaux au Louvre, avec des notes historiques* (1753), pp. 27–28.

11. No. 59. Wildenstein, *Chardin,* Cat. No. 225.

12. [Abbé] Garrigues de Froment, *Sentimens d'un amateur sur l'exposition des tableaux du Louvre et la critique qui en a été faite* (Paris, 1753). Quotation taken from Georges Wildenstein, *Chardin* (Paris, 1933), p. 90.

13. No. 39. Wildenstein, *Chardin,* Cat. No. 268.

14. "Lettre sur l'exposition publique des ouvrages de l'Académie royale de peinture & de sculpture de France dans le salon du Louvre à Paris," *Journal Encyclopédique,* 15 October 1759, p. 116.

15. No. 59. Wildenstein, *Chardin,* Cat. No. 226.

16. *Jugement d'un amateur,* p. 43.

17. [Abbé Jean-Bernard] Le Blanc, *Observations sur les ouvrages de MM. de l'Académie de peinture et de sculpture, exposés au sallon du Louvre en l'année 1753, et sur quelques écrits qui ont rapport à la peinture. A M. le président de B——* [Bourbonne] (1753), p. 24.

18. No. 119.

19. It is worth noting, too, that the theme of reading occurs with some frequency in Greuze's oeuvre, as for example in his *Le Retour de soy-même* (ca. 1760, whereabouts unknown, engraved by Binet), *La Bonne Education* (ca. 1760, engraved by Moreau and Ingouf from a drawing by Greuze), and *Une Petite Fille lisant la Croix de Jésus* (announced but not exhibited in the Salon of 1763, whereabouts unknown). In fact the activity of reading, whether aloud to others or silently to oneself, emerges in French painting and criticism of the 1750s and 1760s as paradigmatically absorptive, though of course not all representations of reading during those years had that significance.

20. The pioneering study by Louis Réau, "Carle Vanloo (1705–65)," *Archives de l'art français,* nouv. pér., 19 (1938), 9–96, has recently been superseded by the informative catalogue—in effect a *catalogue raisonné* of the artist's oeuvre—by Marie-

Cathérine Sahut for the exhibition, *Carle Vanloo, premier peintre du roi (Nice, 1705– Paris, 1765)* (Nice, Musée Chéret; Clermont-Ferrand, Musée Bargoin; Nancy, Musée des Beaux-Arts; January–August 1977). See also Levey, *Art and Architecture,* pp. 117–19; and two exhibition catalogues by Pierre Rosenberg, *French Master Drawings of the Seventeenth and Eighteenth Centuries,* trans. Catherine Johnston (Toronto, Art Gallery of Ontario; Ottawa, National Gallery of Canada; San Francisco, California Palace of the Legion of Honor; New York, New York Cultural Center; September 1972–May 1973), pp. 216–18; and *The Age of Louis XV: French Painting 1715– 1774,* trans. J. Patrice Marandel and Susan Wise (Toledo, Toledo Museum of Art; Chicago, Art Institute of Chicago; Ottawa, National Museum of Canada, October 1975–May 1976), pp. 76–77.

21. No. 4.

22. The Augustine paintings rank among the most important projects of Van Loo's maturity. All six hang today in their original location, the choir of the Paris church of Notre-Dame-des-Victoires, formerly that of the "Augustins reformés, dits Petis-Pères" (Sahut, *Carle Vanloo,* p. 61). See Sahut, Cat. Nos. 105, 106, 112, 113, 114, 120, 132, 151, 152, and 153, for the Augustine paintings and related works. Possibly the sequence as a whole should be seen in the context of the Jansenist controversy of those years, Augustine being the patron saint of Jansenism. For the controversy and its dénouement see Dale Van Kley, *The Jansenists and the Expulsion of the Jesuits from France, 1757–1765* (New Haven, 1975).

23. For the historical circumstances of the debate see Peter Brown, *Augustine of Hippo* (London, 1967), pp. 330–34. The debate lasted three sessions; much of the stenographic record survives, and various details of the painting suggest that Van Loo made an effort to achieve historical accuracy. For example, Brown explains that because the Donatist bishops refused to be seated, Marcellinus, a layman, would not sit in their presence (p. 333). Presumably Van Loo's canvas depicts the third session, that of 8 June 411, when Augustine, "the whole Catholic case at his fingertips . . . answered, impromptu, the carefully prepared manifesto of the Donatists" (p. 334).

24. *Jugement d'un amateur,* pp. 13–14. But see the criticisms by La Font de Saint-Yenne, *Sentimens sur quelques ouvrages de peinture, sculpture et gravure écrits à un particulier en province* (1754; rpt. Geneva, 1970), pp. 15–18.

25. *Observations sur les ouvrages,* p. 8.

26. *Jugement d'un amateur,* p. 12.

27. [Jacques] Lacombe, *Le Salon, en vers et en prose ou jugement des ouvrages exposés au Louvre en 1753,* p. 12.

28. *Corr. litt.,* II, 281. Alone among the critics of his time, however, Grimm disapproved of the action of the third secretary: "Il aurait été bien plus hardi de le mettre dans la même attitude que les deux autres; et c'est peut-être une faute de nous distraire, par le mouvement qui est dans cette figure, de l'attention que nous devons aux principales" (It would have been much bolder to put him in the same attitude as the two others; and it may be a flaw to distract us, by the movement in this figure, from the attention that we owe to the principal ones) (ibid.).

29. *Jugement d'un amateur,* p. 15.

30. Ibid., pp. 14–15.

31. Ibid., p. 14.

32. Ibid., p. 15.

33. Ibid.

34. For English tendencies see Ronald Paulson, "The Pictorial Circuit and Related Structures in 18th-Century England," Peter Hughes and David Williams, eds., *The Varied Pattern: Studies in the 18th Century* (Toronto, 1971), pp. 165–87; and idem, *Emblem and Expression: Meaning in English Art of the Eighteenth Century* (Cambridge, Mass., 1975). It cannot be stressed too strongly that there is a fundamental difference between the English predilection for multiple, diverse, and incommensurable responses to a central object or event that Paulson analyzes—see in particular his chapters on "The Poetic Garden," "The Conversation Piece," and "Wright of Derby" in *Emblem and Expression*—and the French preoccupation with absorption that is the concern of this chapter.

35. *Jugement d'un amateur,* pp. 11–12.

36. In *Jugement d'un amateur* Laugier writes: "Enfin c'est de l'expression qu'on demande. Un Tableau sans expression est un corps sans ame. Il n'y a que l'expression qui plaise, qui intéresse, qui attache. C'est là le but essentiel à quoi tout le reste doit se rapporter. Il faut que tout serve à l'expression, que tout lui céde, que tout lui soit sacrifié" (Finally, it is expression that one requires. A painting without expression is a body without soul. Only expression pleases, interests, transfixes. That is the essential aim to which all the rest must be related. It is necessary that everything serve expression, everything yield to it, everything be sacrificed to it) (p. 66).

37. No. 14.

38. *Lettre à un partisan du bon gout,* pp. 3–4.

39. Another *tableau de prédication* painted at this time, Joseph-Marie Vien's *St. Thomas prêchant aux Indiens* (whereabouts unknown), was criticized by Marigny in terms that show that the new emphasis on absorption was not yet universally understood and appreciated. In Vien's words, quoted by a nineteenth-century scholar with access to autobiographical writings by the painter that have since been lost:

[Marigny] ne trouvait pas les expressions des différentes figures assez variées; il me reprocha que presque tous les auditeurs avaient l'attention portée sur le prédicateur, et il ajouta que M. Coypel aurait plus varié les sentiments des personnages. Alors, prenant fermement la parole, je lui dis: "Je croyais, monsieur le marquis, que le sermon du prédicateur devait être assez bon pour que les Indiens y fissent attention." (François Aubert, "Joseph-Marie Vien," *Gazette des Beaux-Arts,* 1er pér., 22 [1867], 506)

Marigny did not find the expressions of the various figures sufficiently varied; he complained that almost all the listeners had their attention fixed on the preacher, and he added that M. Coypel would have introduced greater variety of expression. Then, speaking firmly, I said to him: "Marquis, I thought that the preacher's sermon should be good enough so that the Indians would pay attention to it."

Vien's riposte plainly asserts the primacy of absorptive considerations. For obvious reasons, *tableaux de prédication* were especially well suited to the representation of absorption. The canonical work in that genre for French painters and critics alike seems to have been Le Sueur's *Prédication de Raymond Diocrès* (Fig. 22), then at the Charterhouse of Paris and today in the Louvre; while the work in which the revival of interest in *tableaux de prédication* may be said to have culminated is Vien's *St. Denis prêchant la foi en France* (Salon of 1767; Fig. 46), to be discussed in chapter three of this study.

One other example of the discomfort that certain critics appear to have experienced in the face of highly absorptive compositions may be cited. Discussing Carle

Van Loo's *Sacre de St. Augustin*, exhibited in the Salon of 1751, Jacques Gautier d'Agoty writes: "J'aurois voulu qu'il y eût moins de têtes posées de profil, surtout sur le devant, & que quelques-unes, essentiellement les jeunes, fussent moins tournées vers l'action pour trancher la Composition" (I would have liked there to be fewer heads in profile, especially in the foreground, and I would have wished that some of them, essentially the young ones, were less turned toward the action in order to add contrast to the composition) ("Observation III. Sur les tableaux exposés dans le salon du Louvre au mois d'Août 1751," *Observations sur l'Histoire Naturelle, sur la Physique et sur la Peinture . . . Année 1752*, p. 45; quoted by Sahut, *Carle Vanloo*, p. 63).

40. No. 13.

41. *Lettre à un partisan du bon gout*, p. 4.

42. No. 6. Sahut, *Carle Vanloo*, Cat. No. 133.

43. See for example Le Blanc, *Observations sur les ouvrages*, p. 10; Laugier, *Jugement d'un amateur*, pp. 17–18; Garrigues de Froment, *Sentimens d'un amateur*, pp. 8–9; and Huquier, *Lettre sur l'exposition des tableaux*, p. 10.

44. No. 18. Sahut, *Carle Vanloo*, Cat. No. 147.

45. No. 5; the painting is called *une Lecture* in the Salon *livret* (Sahut, ibid., Cat. No. 174). It is sometimes assumed that because the *Lecture espagnole* was not exhibited until 1761, it was painted around that time. But it seems more likely, as Réau asserts ("Carle Van Loo," p. 42), that it was painted at roughly the same moment as—probably just after—the *Conversation espagnole*. This would appear to be the implication of the remarks to Grimm with which Diderot begins his discussion of the *Lecture espagnole* in his *Salon de 1761:* "Il y a longtemps que le tableau de notre amie madame Geoffrin, connu sous le nom de la *Lecture,* est jugé pour vous" (Our friend Mme. Geoffrin's painting, known under the title of the *Reading,* was judged for you a long time ago) (*Salons,* I, 110).

46. Cf. the description of the *Lecture espagnole* by the Abbé de La Garde, *Observations d'une société d'amateurs, sur les tableaux exposés au salon cette année 1761* (Paris, 1761), pp. 10–11; this originally appeared as an article under the same title in La Porte's *Observateur Littéraire.* For the attribution to La Garde see Seznec and Adhémar, eds., *Salons,* I, 76. Cf. also Diderot's commentary on the *Lecture espagnole,* which includes the remarks: "Quant à la gouvernante qui examine l'impression de la lecture sur ses jeunes élèves . . . elle est à merveille: seulement j'aimerais mieux que son attention n'eût pas suspendu son travail. Ces femmes ont tant d'habitude d'épier et de coudre en même temps, que l'un n'empêche pas l'autre" (As for the governess who examines the impression made by the reading on her young students . . . she is marvelous; my one reservation is that I would have preferred that her attention not interrupt her work. Such women are so accustomed to spying and sewing at the same time that the one does not prevent the other (ibid., 110). The novel the young man is reading aloud, Mme. de Lafayette's *Zayde* (1670), is discussed at some length by Van Loo's friend Grimm in the *Corr. litt.* for 15 May 1755, III, 28–31, a fact that lends further support to a dating of the *Lecture espagnole* in the mid-1750s.

47. It is possible that the *Conversation espagnole* was a first attempt at such a structure. Grimm's description of it reads as follows:

M. Carle Van Loo a fait pour le cabinet de Mme Geoffrin un tableau qui a réuni les suffrages de tous les connaisseurs, et qui est regardé comme le meilleur ouvrage que nous ayons de ce peintre. Ce tableau, ordonné par Mme Geoffrin et exécuté sous ses yeux, représente une comtesse flamande, veuve, qui tient un papier de musique et qui chante. Derrière son fauteuil

on voit la soubrette qui l'accompagne de la guitare. A côté d'elle, on voit sa fille qui tient le bras gauche de sa mère dans les siens. Devant la comtesse vous voyez son amant qui arrive; elle fixe sur lui les plus beaux yeux du monde, et on voit le papier de musique lui échapper de la main. (*Corr. litt.*, II, 410–11)

M. Carle Van Loo has made for Mme. Geoffrin a painting that has obtained the unanimous approbation of the experts and is considered the best work we have by this painter. The painting, commissioned by Mme. Geoffrin and executed before her eyes, represents a Flemish countess, a widow, who is holding a sheet of music and is singing. Behind her armchair, a maid accompanies her on the guitar. Next to the countess, her daughter is seen holding her mother's left arm in her arms. In front of the countess you see her lover arriving. She fixes on him the most beautiful eyes in the world, and the sheet of music is seen to fall from her hand.

There is an approximate parallel between the action described in this passage and Van Loo's treatment of absorption in the group of secretaries in *St. Augustin disputant contre les Donatistes:* viz., the countess and the *soubrette* have been making music (an absorptive activity); the *soubrette* continues to pursue that activity as if oblivious to everything else; but the countess has broken off singing or is about to do so, gazes adoringly at her lover, and, at least according to Grimm, is on the verge of allowing the sheet of music to fall from her hand—another instance of the sort of involuntary behavior the pictorial representation of which Van Loo and his contemporaries seem clearly to have relished. Despite the parallel, however, the *Conversation espagnole* has serious weaknesses or inconsistencies as an image of absorption, if in fact it was intended as such.

48. No. 163.

49. For a brief discussion of Vien emphasizing the importance of the *Ermite endormi,* see Levey, *Art and Architecture,* pp. 122–23. See also Jean Locquin, *La Peinture d'histoire en France de 1747 à 1785* (Paris, 1912), pp. 190–98. The *Ermite endormi* was painted in Rome around 1750 (see n. 57 below).

50. See for example the remarks by La Font de Saint-Yenne, *Sentimens sur quelques ouvrages,* pp. 46–48. Locquin attributes much of the painting's success to "l'impression de sincérité fruste, de réalisme sans apprêt, presque brutal, pour l'époque, qui s'en dégage" (the impression of rough sincerity, of realism without affectation, almost brutal for the time, that emanates from it) (*La Peinture d'histoire,* p. 191).

51. *Jugement d'un amateur,* p. 59.

52. *Sentimens sur quelques ouvrages,* p. 46.

53. *Lettre sur l'exposition des tableaux,* pp. 46–47.

54. [Pierre] Estève, *Lettre à un ami sur l'exposition des tableaux, faite dans le grand sallon du Louvre le 25 août 1753,* p. 6.

55. [Jacques] Gautier d'Agoty, "Des Extraits faits dans quelques ouvrages périodiques, concernant l'exposition des tableaux de cette année 1753," *Observations sur l'Histoire Naturelle, sur la Physique et sur la Peinture* (1753), II, Part I, p. 6.

56. *Sentimens sur quelques ouvrages,* p. 48. Skulls and violins appear together in seventeenth-century *Vanitas* still lifes as well as in various *Vanitas* paintings with figures, and of course the theme of hermithood is closely related to that of the vanity of worldly pleasures (see A. P. de Mirimonde, "Les Vanités à personnages et à instruments de musique," *Gazette des Beaux-Arts,* 6e pér., 92 [1978], 115–30). The question, however, is whether the meanings de Mirimonde discusses were actively present in the *Ermite endormi,* both for Vien himself and for his audience. The responses of the critics, as well as Vien's account of the genesis of the painting (see n. 57), suggest that they were not.

57. Aubert, once again quoting Vien, provides the following account of the genesis of the *Ermite endormi:*

[Vien] avait beaucoup cherché dans Rome des têtes pouvant lui servir de modèles pour ses divers personnages. Un jour, en se promenant hors les portes, il avait rencontré un ermite qui lui convenait parfaitement: celui-ci avait consenti à le suivre et à se tenir pendant quelque temps à sa disposition. Comme il aimait beaucoup la musique, un pensionnaire lui avait fait présent d'un violon dont il raclait après le déjeuner et dans les moments de repos que le peintre lui laissait. Un jour, pendant qu'il écorchait ses airs, Vien se mit à peindre un pied après lui; au bout de quelque temps, Vien n'entendant plus le violon, lève les yeux et voit le modèle endormi, son violon et sa main reposant sur son genou. "Je quitte à l'instant ma palette; je prends du papier et un crayon et je fais un dessin de toute cette figure qui était vraiment pittoresque. A son réveil, je lui montrai mon dessin: Ah! s'écria-t-il, que cela ferait un beau tableau!—Eh bien, lui dis-je, nous voici à l'époque du carnaval; il n'aura pas lieu, parce que l'année prochaine est l'année sainte (1751); si vous voulez, notre divertissement sera de faire ce tableau." En huit jours *L'Ermite endormi* était terminé. ("Joseph-Marie Vien," 285)

[Vien] had searched a great deal in Rome for heads that could serve as models for his various personages. One day, while walking outside the gates, he had met a hermit who suited him perfectly. The hermit had agreed to follow him and to remain at his disposal for a while. Since he loved music, a *pensionnaire* had given him a violin which he would scrape after lunch and during the moments of rest that the painter allowed him. One day, while the hermit was flaying his tunes, Vien began to paint a foot using him as a model. After some time, Vien, no longer hearing the violin, raises his eyes and sees the model asleep with his violin lying on his knee. "I immediately put down my palette; I take some paper and a pencil and make a drawing of that entire figure, so truly picturesque. When he woke up, I showed him my drawing." "Oh! What a beautiful painting that would make!" he exclaimed. "Well," I said to him, "we're at carnival time; it will not take place, because next year is a holy year (1751). If you are willing, our entertainment will be to make this painting." In eight days the *Sleeping Hermit* was finished.

58. The connection between sleep and absorption is actually made by Diderot in the article "Animal," which appeared in the first volume of the *Encyclopédie* (1751). There Diderot remarks that the soul is subject to a sort of inertia,

en conséquence de laquelle elle resterait perpétuellement appliquée à la même pensée, peut-être à la même idée, si elle n'en était tirée par quelque chose d'extérieur à elle qui l'avertit, sans toutefois prévaloir sur sa liberté. C'est par cette dernière faculté qu'elle s'arrête ou qu'elle passe légèrement d'une contemplation à une autre. Lorsque l'exercice de cette faculté cesse, elle reste fixée sur la même contemplation; & tel est peut-être l'état de celui qui s'endort, de celui même qui dort, & de celui qui médite très profondément. S'il arrive à ce dernier de parcourir successivement différents objets, ce n'est point par un acte de sa volonté que cette succession s'exécute, c'est la liaison des objets mêmes qui l'entraîne; & je ne connais rien d'aussi machinal que l'homme absorbé dans une méditation profonde, si ce n'est l'homme plongé dans un profond sommeil. (*Oeuvres complètes,* V, 390)

in consequence of which it would remain perpetually applied to the same thought, perhaps to the same idea, if it were not drawn away by something outside itself that diverted it, without however doing away with its liberty. It is by virtue of the latter faculty that it stops or passes swiftly from one contemplation to another. When the exercise of this faculty ceases, the soul remains fixed on the same contemplation; and such perhaps is the state of someone falling asleep, even of someone who is sleeping, and of someone who meditates very profoundly. If the last of these happens to contemplate several different objects successively, this is brought about not by an act of his own will, but by the connections between the objects themselves. And I know of nothing so mechanical as a man absorbed in profound meditation unless perhaps it is a man plunged into a deep sleep.

More generally, it should be noted that sleep as a lived condition emerges as

thematic in French natural history at precisely this moment. In the *Corr. litt.* for 1 October 1753 Grimm discusses the recently published fourth volume of Buffon's *Histoire naturelle,* praising in particular the "Discours sur la nature des animaux" with which it opens:

"L'animal, dit M. de Buffon, a deux manières d'être: l'état de mouvement et l'état de repos, la veille et le sommeil, qui se succèdent alternativement pendant toute la vie." Voilà tout le plan de son discours. Cette division paraît d'abord ordinaire, commune, à portée de tout le monde: mais elle est de ces vérités qui, plus elles sont simples et lumineuses, plus elles sont du ressort du génie seul. Tout le monde est tenté de dire: "J'aurais envisagé cet objet sous ce point de vue." En y réfléchissant un peu, et surtout en voyant le plan admirable que M. de Buffon a tiré d'après cette seule idée, on voit que cette idée ne peut être que d'un homme de génie. Le sommeil, qui paraît être un état purement passif, une espèce de mort, est donc au contraire le premier état de l'animal vivant et le fondement de la vie: ce n'est pas une privation, un anéantissement, c'est une manière d'être, une façon d'exister tout aussi réelle et plus générale qu'aucune autre. C'est par le sommeil que commence notre existence; le foetus dort presque continuellement, et l'enfant dort beaucoup plus qu'il ne veille. Tout ce que notre auteur dit sur ce sujet est admirable. (II, 287–88)

"The animal," says M. de Buffon, "has two modes of being: the state of movement and the state of rest, waking and sleeping, which succeed each other alternately throughout its life." That is the entire scheme of his discourse. This division at first seems ordinary, commonplace, within everyone's grasp; but it is one of those truths which, the simpler and more luminous they are, the more they belong to genius alone. Everyone is tempted to say: "I would have considered the matter from that point of view." After some reflection, and especially upon seeing the admirable scheme that M. de Buffon has elaborated on the basis of this single idea, one realizes that this idea could only have been conceived by a man of genius. Sleep, which appears to be a purely passive state, a kind of death, is thus on the contrary the first state of the living animal and the foundation of life. It is not a deprivation, an annihilation, it is a mode of being, a mode of existing just as real and more general than any other. It is with sleep that our existence begins. The fetus sleeps almost continually, and the child sleeps much more than he stays awake. Everything our author says on the subject is admirable.

Grimm's remarks are basically a tissue of quotations from Buffon. The phenomenon of dreaming epitomizes the animate nature of sleep, and the special interest in and sensitivity to dream states that we find in Diderot's writings and Fragonard's paintings are a further index of the concern with sleep that I have tried to characterize. Cf. my analysis in chapter three of this study of Diderot's account of Fragonard's *Corésus et Callirhoé.*

59. No. 8. Sahut, *Carle Vanloo,* Cat. No. 129.

60. *Sentimens d'un amateur,* p. 12.

61. No. 147.

62. No. 105.

63. "Observations d'une société d'amateurs sur les tableaux exposés au salon cette année 1759," *Observateur Littéraire* (1759), Tome IV, p. 184. The attribution to La Porte is by Seznec and Adhémar, eds., *Salons,* I, 32.

64. "Lettre sur l'exposition publique," p. 118.

65. No. 103. The full title of that picture in the official *livret* is *Un Tableau représentant le Repos, caractérisé par une Femme qui impose silence à son fils, en lui montrant ses autres enfans qui dorment.* As this designation makes clear, the disruptive behavior of the eldest boy is contrasted with the sleep of the other children, a tactic that recalls the use of contrast to underscore intensity of absorption in the *Père de famille, St. Augustin prêchant, St. Augustin baptisé,* and *Lecture espagnole.* In this instance, however, the gist

of the contrast—that the younger children can easily be wakened—compels an awareness that their sleep is not an "absolute" or "universal" condition like death, but one in which they are so to speak *merely* absorbed. Cf. the description of *Le Repos* by the critic for the *Journal Encyclopédique,* ibid., pp. 117–18.

66. Nos. 112 and 114 respectively. The full title of the *Oeufs cassés* as given in the *livret* is *Une Mère grondant un jeune homme pour avoir renversé un panier d'oeufs que sa servante apportoit du marché. Un enfant tente de raccommoder un oeuf cassé.* The painting's sexual connotations are self-evident; cf. Brookner, *Greuze,* pp. 97–98. Brookner also cites specific Dutch sources for the *Tricoteuse endormie* (p. 100), *Le Repos* (ibid.), and the *Oeufs cassés* (pp. 97–98).

67. For the reaction against the Rococo see for example Rémy G. Saisselin, "Neo-Classicism: Virtue, Reason and Nature," in the exhibition catalogue, *Neo-Classicism: Style and Motif* (Cleveland, Museum of Art, 1964), pp. 1–8; James A. Leith, *The Idea of Art as Propaganda in France, 1750–1799* (Toronto, 1965), pp. 7–10; Robert Rosenblum, *Transformations in Late Eighteenth Century Art* (Princeton, 1967), passim; and Hugh Honour, *Neo-Classicism* (Harmondsworth and Baltimore, 1968), pp. 17–32.

68. See La Font de Saint-Yenne, *Réflexions sur quelques causes de l'état présent de la peinture en France* (La Haye, 1747; rpt. Geneva, 1970), pp. 74–76.

69. Both are listed together as No. 10 in the *livret.* Pertinent information concerning them is summarized by Alexandre Ananoff, *François Boucher* (Lausanne and Paris, 1976), II, 108–115, Cat. Nos. 422 and 423. See also the discussion of those paintings by Levey, *Art and Architecture,* pp. 113–14.

70. *Lettre à un ami,* p. 2.

71. Ibid.

72. *Sentimens sur quelques ouvrages,* p. 38.

73. Ibid., p. 39.

74. *Salons,* II, 76.

75. Cf. in this connection Diderot's proposal, in the *Corr. litt.* for 15 September 1755, for six scenes to ornament a *tabatière* in enamel to be executed by Durand. The subject of the ensemble was to be "L'Ecole des amours" (The School for Cupids). The first scene, to appear on the top of the *tabatière,* is described as follows:

Mercure leur donne leçon en présence de leur mère. Les uns s'exercent à écrire sur des rouleaux, les autres lisent, tous étudient et recordent leurs leçons. La scène est un paysage. Vénus est assise. Elle tient un fouet de roses sur ses genoux; elle paraît attentive et résolue à châtier ceux dont le maître sera mécontent. Mercure est assis sur un tronc d'arbre. Il donne leçon à un de ses écoliers, et lui marque ses lettres avec un stylet sur un rouleau posé sur ses genoux. L'Amour écolier a l'index de la droite sur le rouleau vers le bout du stylet de son maître. Mais au lieu de faire attention à ses lettres, le petit libertin s'occupe, de la main gauche, à tirer les cheveux à un de ses petits frères, qui est à sa portée, et détache son talon dans le derrière à un autre qui en est presque culbuté. Le maître a les yeux sur le rouleau, l'écolier les a sur le visage du maître. (III, 95)

Mercury is giving them a lesson in their mother's presence. Some are writing on scrolls, others are reading, all are studying and learning their lessons by heart. The setting is a landscape. Venus is seated. She holds a whip made of roses in her lap; she seems attentive and determined to punish those with whom the master is displeased. Mercury is seated on a tree trunk. He is giving a lesson to one of his students, and is writing his letters for him with a stylus on a scroll placed on his lap. The student Cupid has the forefinger of his right hand on the scroll near the end of his master's stylus. But instead of paying attention to his letters, the young libertine is busy, with his left hand, pulling the hair of one of his younger brothers who is within his

reach, and is kicking another in the rear with his heel, almost making him fall head over heels. The master is looking at the scroll, the student is looking at his master's face.

Such a conception is absorptive, despite its Rococo cast of characters, and may be taken to exemplify the sort of scenario Diderot looked for mostly in vain in Boucher's art.

76. On those works see Marc Sandoz, "La chapelle Saint-Grégoire de l'église Saint-Louis des Invalides: Les dessins et esquisses de Carle Van Loo et les peintures jusqu'ici méconnues de Gabriel-François Doyen," *Gazette des Beaux-Arts,* 6e pér., 77 (1971), 129–44; and Sahut, *Carle Vanloo,* Cat. Nos. 180, 218–23.

77. All seven sketches are listed together as No. 4 in the *livret.*

78. *Salons,* II, 70–71.

79. Ibid., 76.

80. All this is not to say that Boucher himself was unaffected by the new emphasis on absorptive values and effects or at any rate that none of his paintings could be seen as satisfying the new demands. For example, his *Sommeil de l'enfant Jésus,* exhibited in the Salon of 1759 (not in the *livret*) and today in the Pushkin Museum (Ananoff, *François Boucher,* II, 173–74, Cat. No. 498), is described as follows in the *Observateur Littéraire*: "Il représente une Vierge contemplant, avec une sainte & agréable joye, l'Enfant Jesus pendant son sommeil, tandis qu'elle impose silence au petit Saint Jean, dont les transports innocents pourroient troubler ce divin repos" (It represents the Virgin contemplating, with a holy and pleasing joy, the baby Jesus in his sleep, while imposing silence upon the young St. John, whose innocent transports might trouble this divine rest) (Tome IV, p. 108). For all intents and purposes, Boucher's picture is thematically equivalent to Greuze's *Le Repos,* shown in the same Salon. See also the description of Boucher's *Nativité,* exhibited in the Salon of 1750 and today in the Musée des Beaux-Arts, Lyon (Ananoff, II, 38–39, Cat. No. 340), by Baillet de Saint-Julien in his *Lettre sur la peinture, à un amateur* (Geneva, 1751; quoted by Ananoff, I, 48). (But cf. the criticism of that description by the author of the "Réponse de l'amateur à la première lettre sur la peinture," also quoted by Ananoff, ibid.)

81. "Gravure," *Mercure de France* (November 1757), p. 157. The subject of the painting is taken from Lucian's *Toxaris,* a dialogue on friendship: Eudamidas, citizen of Corinth and very poor, dictated as he was dying a will in which he left the care of his mother and daughter to two friends, who accepted the charge. The passage from the *Mercure de France* continues: "Ce grouppe, qui dit précisément ce qu'il faut . . . se lie naturellement à un autre, dont les expressions vont droit au coeur. Il est formé de la mère du mourant, & de la fille. La première assise sur le pied du lit, & baignée de ses larmes, soutient sur ses genoux sa fille abbatue sous les poids de sa douleur" (This group, which says precisely what it should . . . is linked naturally with another, whose expression goes straight to the heart. It consists of the dying man's mother and daughter. The former, seated at the foot of the bed and bathed in tears, supports on her knees the daughter, collapsed under the burden of her grief) (ibid., pp. 157–58). There is a plain sense in which the mother and daughter of the dying man may be characterized as absorbed in their grief; and when, starting in the early 1760s, French painters came increasingly to exploit overpowering emotion as a vehicle of absorption, they found in Poussin's treatment of the mother and daughter a model for what they were trying to do. The *Testament d'Eudamidas,* bought for Count Moltke and taken to Denmark in 1759, hangs today in the State Museum of Art,

Copenhagen. For discussions of that painting which emphasize its relation to Stoic thought see Walter Friedlaender, *Nicolas Poussin: A New Approach* (New York, n.d.), p. 168, pl. 35; and Anthony Blunt, *Nicolas Poussin,* The A.W. Mellon Lectures in the Fine Arts, 1958 (New York, 1967), pp. 166, 306, pl. 224. The article in the *Mercure de France* announces the publication of an engraving by Marcenay de Ghuy after a gouache copy of Poussin's canvas. Gouache and engraving are compared with the original by Richard Verdi, "Poussin's *Eudamidas:* Eighteenth-Century Criticism and Copies," *Burlington Magazine,* 113 (1971), 513–17. The mother and daughter are cited for their pathos by Diderot as early as 1758 in his *Discours de la poésie dramatique,* p. 276.

One instance of the adaptation of the *Testament d'Eudamidas* by a French painter of the later eighteenth century deserves special mention. To the best of my knowledge, it has never been remarked how profoundly the composition of David's *Serment des Horaces,* with its physical and emotional separation between the principal figure group of men swearing an oath and the subsidiary one of grieving women, is indebted to that of the *Eudamidas,* in which an analogous separation between groups underscores the absorption of each in its respective activities and states of mind. But just as the *Eudamidas* was seen by the *Mercure's* commentator and others, including Diderot, as a singularly unified work, so David's adaptation in the *Horaces* and related paintings of the 1780s (e.g., the *Socrate*) of the "divided" composition of Poussin's masterpiece should not, I think, be understood as intended to call into question the value of unity as such. On the contrary, David seems to have found in the *Eudamidas* the inspiration to a new, more assertive or emphatic ideal of pictorial unity, according to which the discreteness, realism, and isolation of the principal figures and/or figure groups would make almost diagrammatically perspicuous their recuperation in a single, life-size, intensely dramatic *tableau.* (The role of the notion of unity in the writings of Diderot and his contemporaries is treated at length in chapter two.)

82. For an early discussion of the St. Bruno series see J[ean]-B[aptiste] de la Curne de Sainte-Palaye, *Lettre à M. de B.* [Bachaumont] *sur le bon goût dans les arts et dans les lettres* (Paris, 1751). There La Curne suggestively compares the extreme simplicity and absence of artifice or exaggeration—in short the naiveté—of Le Sueur's paintings of "quelques pieux Solitaires debout, à genoux, ou dans d'autres attitudes, chacun conformément à la situation de son ame, dans la méditation, dans la prière, dans des exercices intérieurs de pénitence ou de dévotion" (some pious recluses standing, kneeling, or in other positions, each according to the situation of his soul, in meditation, in prayer, in inner exercises of penitence or devotion) with the figures on an "Etruscan" vase that belonged to his friend Bachaumont (pp. 7–8). See also Diderot's remarks on Le Sueur's paintings at the Charterhouse in his *Salon de 1759* (*Salons,* I, 64) and on the *Prédication de Raymond Diocrès* in particular in his *Salon de 1761* (ibid., 117–18). The St. Bruno pictures are treated by Gabriel Rouchès, *Eustache Le Sueur* (Paris, 1923), pp. 77–92.

83. Discussing a painting of *L'Etude* by the recently deceased Deshays in his *Salon de 1765,* Diderot writes:

C'est une femme assise devant une table. On la voit de profil. Elle médite; elle va écrire. Sa table est éclairée par un oeil-de-boeuf. Il y a autour d'elle des papiers, des livres, un globe, une lampe. La tête n'est pas belle, mais elle est bien coiffée. Son linge tombe à merveille de dessus les épaules de la figure, et ce négligé est d'esprit. Ce tableau ne vous mécontentera pas, si vous ne vous rappelez pas la Mélancolie du Feti. (Salon of 1765, No. 35; *Salons,* II, 99)

It shows a woman sitting at a table. She is seen in profile. She meditates; she is about to write. Her table is lit by an *oeil-de-boeuf.* Around her are papers, books, a globe, a lamp. Her head is not beautiful, but her hair is well arranged. The clothing falls marvelously from the figure's shoulders, and this casualness is intelligent. The painting will not displease you as long as you do not recall Feti's *Melancholy.*

84. For an analysis of Diderot's (and others') views of that work see chapter three of this book.

85. The publication of Surugue's engraving is announced in the *Mercure de France,* March 1755, pp. 152–53. The painting is described in part as follows: "Il représente un autre Philosophe [Surugue had earlier engraved a similar painting under the title *Philosophe en méditation*] assis devant une table tout proche d'une fenêtre, d'où vient la lumière qui éclaire le sujet; l'attitude attentive de la tête & des mains jointes posées sur ses genoux, font voir qu'il est absorbé, pour ainsi dire, par la contemplation de quelque idée abstraite" (It represents another philosopher seated before a table, near a window through which comes the light that illuminates the subject; the attentive attitude of the head and the hands clasped in his lap reveal that he is absorbed, so to speak, in the contemplation of some abstract idea) (p. 152).

86. Publication announced in the *Mercure de France,* August 1755, pp. 210–11. The announcement includes the remarks: "La singularité qui souvent a déterminé Rembrandt dans ses pensées, l'a fait écarter ici du texte de l'Ecriture pour transformer le jeune Tobie en oculiste, qui, l'aiguille à la main, leve la cataracte à son pere. Il est très-attentif à cette opération délicate, & le vieillard fort sensible à la douleur dont il est affecté . . ." (The singularity that often determined Rembrandt's pictorial ideas led him to depart here from the text of the Scriptures in order to turn the young Tobit into an oculist who, needle in hand, removes his father's cataract. He is very attentive to this delicate operation, and the old man is extremely sensitive to the pain he is suffering . . .) (ibid.). For a discussion of Rembrandt's attraction to subjects from the Book of Tobit, with special emphasis on his treatment of the theme of blindness, see Julius Held, "Rembrandt and the Book of Tobit," in *Rembrandt's "Aristotle" and Other Rembrandt Studies* (Princeton, 1969), pp. 104–29.

87. For Greuze's portrait of Claude-Henri Watelet and its relation to Watelet's etching see Munhall, *Jean-Baptiste Greuze,* pp. 87–88, Cat. No. 35. Three articles by Jean Cailleux should also be cited in this connection: "Watelet et Rembrandt," *Bulletin de la Société de l'Histoire de l'Art Français, 1964* (1965), pp. 131–61; "Esquisse d'une étude sur le goût pour Rembrandt en France au XVIIIe siècle," *Nederlands Kunsthistorisch Jaarboek, 1972,* 23 (1972), 159–66; and "Les Artistes français du dix-huitième siècle et Rembrandt," in Albert Châtelet and Nicole Reynaud, eds., *Etudes d'art français offertes à Charles Sterling* (Paris, 1975), pp. 287–305.

88. In a stimulating essay, "Describe or Narrate? A Problem in Realistic Representation," *New Literary History,* 8 (1976–77), 15–41, Svetlana Alpers elucidates what she sees as a realistic representational mode in seventeenth-century painting which combines "an attention to imitation or description with a suspension of narrative action" (15). From the perspective of this chapter it becomes clear that the suspension of narrative action that Professor Alpers discerns in paintings by Caravaggio, Velázquez, Rembrandt, and Vermeer is in most of those cases a function of an emphasis on the representation of absorption, and that that emphasis was indeed linked with a new realism.

89. The *Enseigne de Gersaint* (1720–1721, Berlin, Charlottenburg Castle) is perhaps

the most striking example of an absorptive painting in Watteau's oeuvre.

90. For De Troy see Cochin's engraving after *La Lecture du roman sous l'ombrage* (1735, whereabouts unknown); Beauvarlet's engraving after *La Toilette pour le bal* (probably Salon of 1737, whereabouts unknown); and Surugue's engraving after *Une Jeune Femme lisant à la lueur d'une bougie* or *L'Ornement de l'esprit et du corps* (perhaps Salon of 1737, whereabouts unknown). For La Tour see his *Portrait de M. l'Abbé——* [Huber] *assis sur le bras d'un fauteuil, lisant à la lumière un in folio* (Salon of 1742, Geneva, Musée d'Art et d'Histoire), reproduced by Levey in *Art and Architecture,* pl. 136. Pierre Francastel has interesting remarks about De Troy in the context of his time in "L'Esthétique des Lumières," in *Utopie et institutions au XVIIIe siècle: le pragmatisme des Lumières,* ed. Pierre Francastel (Paris and La Haye, 1963), pp. 331–57.

91. See for example Subleyras's *The Painter's Studio* (after 1740, Vienna, Akademie), reproduced in Levey, *Art and Architecture,* pl. 126. It should also be noted that throughout the 1730s and 1740s French engravers reproduced the work of Dutch and Flemish artists, work which was often absorptive in character. Even the Flemish painter David Teniers (d. 1690), whose anecdotal scenes of peasant life were much admired and engraved, had his absorptive moments.

92. The most cursory survey of Chardin's genre paintings will bear this out. It is worth noting that the absorptive character of those paintings is in some respects heightened in the numerous contemporary engravings that were made after them: both the translation of color into value and (in certain instances) the minimizing of surface qualities in favor of an enhanced illusion of atmosphere tend to "foreground" absorptive effects. Modern monographs in addition to that by Wildenstein first cited in n. 8 include Georges Wildenstein, *Chardin* (Paris, 1933); and Pierre Rosenberg, *Chardin,* trans. Helga Harrison (Geneva, 1963). See also Levey, *Art and Architecture,* pp. 135–41; and idem, *Rococo to Revolution: Major Trends in Eighteenth-Century Painting* (London, 1966), pp. 140–46, esp. p. 142 where Levey emphasizes the apparent absorption of Chardin's figures in their tasks and activities.

93. On the recrudescence of religious painting in France in the late 1740s and 1750s see Locquin, *La Peinture d'histoire,* pp. 258–64; and Michel Florisoone, *Le Dix-Huitième Siècle* (Paris, 1948), pp. 51–52, 93–94. A partial list of Vien's religious paintings of the late 1740s and 1750s is provided by Locquin, pp. 261–62. See also Thomas Gaehtgens, "J.M. Vien et les peintures de la Légende de sainte Marthe à Tarascon," *Revue de l'Art,* No. 22 (1974), 64–69. A work that deserves special mention is Charles-Joseph Natoire's decoration of the chapel of the Hôpital des Enfants-Trouvés in Paris (1750, now destroyed). Cf. the concern with absorptive values and effects in the anonymous "Explication des ouvrages de peinture, qui viennent d'être faits par M. Natoire dans la Nouvelle Chapelle de l'Hôpital des Enfants Trouvés . . . ," *Mercure de France* (July 1750), pp. 166–74. The decoration of the chapel is treated in the recent catalogue, *Charles-Joseph Natoire . . .* (Troyes, Musée des Beaux-Arts; Nîmes, Musée des Beaux-Arts; Rome, Villa Medicis; March–June 1977), pp. 82–87, Cat. Nos. 45–53; and in Lise Duclaux, "La Décoration de la chapelle de l'hospice des Enfants-Trouvés à Paris," *Revue de l'Art,* No. 14 (1971), 45–50.

94. Wildenstein, *Chardin* (1969), Cat. Nos. 74, 164, 207. It will be noted that Chardin depicts not just children but young adults engaged in those amusements, further evidence for what Philippe Ariès has argued was the active involvement on the part of adult society throughout the Ancien Régime with baubles and pastimes

"which we would describe today as childish, probably because they have now fallen for good and all within the domain of childhood" (*Centuries of Childhood: A Social History of Family Life,* trans. Robert Baldick [New York, 1962], p. 70). Ariès in his fundamental study makes abundant use of evidence drawn from paintings and other visual images; regrettably he mentions Chardin only once, in connection with the custom of saying grace before meals (p. 361), and in fact says relatively little about the eighteenth century. I might add that my own phrases "young adults" and "young people" are deliberately vague. Cf. Natalie Zemon Davis's analysis of the age-groupings in sixteenth-century France, in the course of which she takes issue with certain claims by Ariès, in "The Reasons of Misrule," in *Society and Culture in Early Modern France: Eight Essays* (Stanford, 1975), pp. 97–123.

95. See for example Donat de Chapeaurouge, "Chardins Kinderbilder und die Emblematik," *Actes du 22e congrès international d'histoire de l'art, Budapest 1969* (Budapest, 1972), II, 51–56. For an extreme statement of the moralistic position, which undoubtedly goes too far, see Ella Snoep-Reitsma, "Chardin and the Bourgeois Ideals of His Time," *Nederlands Kunsthistorisch Jaarboek, 1973,* 24 (1973), 147–243. A more nuanced reading of two paintings, one a version of the *Card Castle,* is given by David Carritt, "Mr. Fauquier's Chardins," *Burlington Magazine,* 116 (1974), 502–09.

96. See for example Paulson, *Emblem and Expression,* pp. 104–08. Commenting on the moralizing verses printed under an engraving of Chardin's *Mère laborieuse,* Paulson writes: "It is impossible to say whether Chardin encouraged or merely tolerated this interpretation which projected a kind of image very shortly to be elaborated and further moralized by Greuze" (p. 106). An early warning against exaggerating the significance of symbolic or allegorical meaning in the art of seventeenth-century Dutch painters was given by Seymour Slive, "Realism and Symbolism in Seventeenth-Century Dutch Painting," *Daedalus,* 91, No. 2 (1962), 469–500. Cf. also Alpers, "Describe or Narrate?," on the question of the role of moralizing symbolism in the art of Vermeer (25–26).

97. Albert Châtelet with Jacques Thuillier, *French Painting from Le Nain to Fragonard,* trans. James Emmons (Geneva, 1964), p. 204. See also the admirable article by René Demoris, "La Nature morte chez Chardin," *Revue d'Esthétique,* No. 4 (1969), 363–85, esp. 383–84.

98. This is a delicate point. I have already remarked that during the 1730s and 1740s artists like De Troy and La Tour produced works that may be characterized as absorptive. It should also be noted that Salon *livrets* for the late 1730s and 1740s list a number of titles that involve notions such as reading with attention (Coypel, *Salon de 1738,* p. 13), reflecting while holding a book (La Tour, ibid., p. 19), occupied in watching a top spin (Chardin, ibid., p. 25) or in reading a book (Desportes, *Salon de 1740,* p. 17) and so on. Perhaps the most striking indication that at least some of Chardin's paintings were seen, and presumably admired, as images of heightened attention is provided by a list of titles published in the *Mercure de France* for October 1738. The list includes three pictures by Chardin whose titles are given as *Jeune élève, assis, taillant son crayon, appliqué à regarder le dessin qu'il copie; Jeune ouvrière sur une chaise de paille, travaillant en tapisserie, interrompant son ouvrage, ses regards fixés sur le dessinateur;* and *Ecolier appuyé sur une table ayant une attention singulière à voir tourner un toton* (quoted in André Pascal and Roger Gaucheron, eds., *Documents sur la vie et l'oeuvre de Chardin* [Paris, 1931], p. 71). In addition the *Mercure de France,* in a com-

mentary of 1739 on Lépicié's engraving after Chardin's *Gouvernante,* noted with approval the naiveté with which the painter expressed the child's attentiveness to the governess's chiding (quoted in Wildenstein, *Chardin* [1933], p. 69); and the same journal in 1745 remarked of Lépicié's engraving after Chardin's *Soufleur* that it depicted "un Soufleur dans son laboratoire, lisant attentivement un livre d'alchymie" (an alchemist in his laboratory, attentively reading a book on alchemy) (ibid., p. 78). I am aware of no further evidence that suggests that the distinction of Chardin's art was associated with his mastery of absorptive values and effects until the early and mid-1750s. In this connection it is interesting to note that as late as 1730 the powerfully absorptive character of Rembrandt's art was not explicitly remarked by his commentators (see Seymour Slive, *Rembrandt and His Critics, 1630–1730* [The Hague, 1953]).

99. Abbé Desfontaines, *Observations sur les écrits modernes* (1741); quoted in Wildenstein, *Chardin* (1933), p.72.

100. In addition to the criticism already quoted see [Louis-Guillaume] Baillet de Saint-Julien, *Lettre à M. Ch.* [Chardin] *sur les caractères en peinture* (Geneva, 1753); La Font de Saint-Yenne, *Sentimens sur quelques ouvrages,* pp. 124–25; [Charles-Nicolas] Cochin, *Lettre à un amateur en réponse aux critiques qui ont paru sur l'exposition des tableaux* (1753), pp. 10–12, 29; and Lacombe, *Le Salon,* pp. 23–24. See also the announcement of the publication of Laurent Cars's engraving after Chardin's *Une Dame variant ses amusements* (Salon of 1751, Frick Collection), which depicts a woman teaching a songbird to sing, in the *Mercure de France* (November 1753), pp. 160–62. As regards his paintings of genre subjects, the year 1753 is the high-water mark of critical appreciation for Chardin in his lifetime.

101. The painting is listed on p. 18 of the official *livret.*

102. See Snoep-Reitsma, "Chardin and the Bourgeois Ideals of His Time," for a discussion of that engraving and of the derisory quatrain beneath it (231). She remarks: "Chardin's *Soufleur* is meant to appeal to the anti-intellectual stream in the same movement that praised nature, happiness and simplicity" (ibid.). But it is questionable to what extent Chardin himself stood behind the characterization of his reading figure as a man wasting his time in useless speculations. In any case, the multiplicity of titles under which that image went between 1737 and 1753 ought to alert us to some of the pitfalls involved in trying to establish a univocal moralistic or symbolic reading of his art.

103. For the provenance and exhibition history of that work, allegedly a portrait of Chardin's friend the portraitist Aved, see Wildenstein, *Chardin* (1969), p. 171, Cat. No. 145.

104. The phrase is Brookner's, *Greuze,* p. 97.

105. A qualified exception must be made for Fragonard, who made his debut in the Salon of 1765 with the fascinating *Le Grand-Prêtre Corésus se sacrifie pour sauver Callirhoé* and whose career largely overlaps Greuze's. For a discussion of his art see chapter three.

106. No. 140.

107. *Salons,* I, 233–35. As in other pictures discussed in this chapter, the activity of listening is the principal vehicle of absorption. Thus Diderot remarks that the old man's voice is weak ("il a tant de peine à parler, sa voix est si faible" [he has such difficulty speaking, his voice is so weak] [234]); it therefore requires an effort of attention, of hearkening, on the part of those around him, which of course makes us

[197]

all the more aware of their absorption in his words. Diderot also notes that the old man's wife seems hard of hearing ("Je suis sûr qu'elle a l'ouïe dure, elle a cessé son ouvrage, elle avance de côté sa tête pour entendre" [I am sure she is hard of hearing, she has stopped working, she leans her head to one side in order to hear] [ibid.]), a characteristically Greuzean touch to the same effect. The theme of suspension of activity, used by painters of the 1750s as a sign of intense absorption, is repeated in the action of the married daughter whose husband is the object of the old man's gratitude. She has been reading the Bible aloud, but now "elle a suspendu la lecture qu'elle faisait au bonhomme" and "écoute avec joie ce que son père dit à son mari" (she has broken off her reading to the old man and listens joyously to what her father is saying to her husband) (ibid.).

108. In Diderot's words:

Chacun ici a précisément le degré d'intérêt qui convient à l'âge et au caractère. . . . Les enfants les plus jeunes sont gais, parce qu'ils ne sont pas encore dans l'âge où l'on sent. La commisération s'annonce fortement dans les plus grands. Le gendre paraît le plus touché, parce que c'est à lui que le malade adresse ses discours et ses regards. La fille mariée paraît écouter plutôt avec plaisir qu'avec douleur. L'intérêt est sinon éteint, du moins presque insensible dans la vieille mère, et cela est tout à fait dans la nature. . . . (ibid., 234–35)

Each person here has precisely the degree of interest that suits his age and character. . . . The younger children are gay, because they have not reached the age of feeling. Commiseration strongly manifests itself in the older ones. The son-in-law appears to be the most touched because it is to him that the sick man addresses his remarks and his looks. The married daughter seems to be listening with pleasure rather than sadness. The involvement of the old mother is, if not extinguished, at least almost imperceptible, and that is completely natural. . . .

109. Ibid., 235.

110. No. 139.

111. No. 138. For the suggestion that the painting in the Wallace Collection known as *La Veuve inconsolable* is identical with that listed in the *livret* for the Salon of 1763 as *Le Tendre Ressouvenir* see Rosenblum, *Transformations,* p. 40, n. 125.

112. No. 110.

113. [Charles-Joseph] Mathon de la Cour, *Lettres à Monsieur — sur les peintures, les sculptures et les gravures exposées dans le sallon du Louvre en 1765* (Paris, 1765), p. 52.

114. *Salons,* II, 145. Cf. the praise of Chardin's figures by Garrigues de Froment in 1753: ". . . n'ont-elles pas toutes leur action? N'y sont-elles pas toutes entières?" (see above, n. 12).

115. Ibid.

116. Ibid.

117. *Lettres à Monsieur* ——, p. 53.

118. *Salons,* II, 205–06. The *Baiser envoyé* was not exhibited at the Salon of 1765; Diderot may have seen it in Greuze's studio. By the time it was shown in the Salon of 1769, Diderot's ardor had cooled (*Salons,* IV, 107).

119. I do not say that the impression conveyed by Chardin's genre paintings is to be taken at face value. On the contrary, our analysis of Chardin's use of signs of obliviousness in his paintings of children and others engaged in games or diversions has shown that the nature of his art is rather more complex and the contrast with Greuze rather less stark or absolute than may at first have appeared to be the case. But the fact remains that Chardin's exploitation of signs of obliviousness and related devices in no

way calls into question the objective tenor of his representations. In this sense Chardin may be seen as standing between the absorptive tradition of the seventeenth and early eighteenth centuries and the problematized continuation of that tradition in the art of Greuze and his successors.

It is interesting to note that Grimm's proposed revision in the *Corr. litt.* for 15 Februrary 1756 of a composition by Domenichino in the interests of heightened absorptive effect anticipates Greuze's single-figure inventions of the 1760s and after:

Il y a un fameux tableau du Dominiquin, dont le sujet est *la Communion de la Madeleine:* elle reçoit le saint Sacrement des mains d'un ange dans un désert; elle est à genoux, les cheveux épars, et couverte à demi d'une draperie légère et dérangée: derrière elle sont deux anges qui la soutiennent. La compassion est peinte sur le visage des trois anges; pour celui de la pénitente, c'est un chef-d'oeuvre d'expression: on y lit l'amertume et la profonde tristesse dont elle est déchirée par le souvenir de ses péchés. On y voit la pâleur et la langueur causées par une longue pénitence; on y voit un mélange de sentiments de confusion, d'humilité, de désir, de joie et d'espérance renaissante, enfin de reconnaissance dont elle est pénétrée à l'aspect du saint Sacrement. Je crois qu'on pourrait rendre la composition de cet admirable tableau encore plus touchante. Laissez la pénitente dans cette attitude, seule au milieu d'un paysage solitaire qui inspire la tristesse sans horreur: ôtez tous ces anges; que la pécheresse tourne ses beaux yeux languissants, tels qu'elle les a dans le tableau, vers le ciel; qu'elle voie venir d'en haut l'ange qui lui apporte l'Eucharistie; qu'à cet aspect elle fasse un effort comme pour se relever, et que ce soit l'effort d'une personne exténuée par les rigueurs de la pénitence; qu'on voie sur son visage tout ce mélange de sentiments et d'affections que le.peintre a su lui donner; qu'on y découvre, surtout au milieu des impressions de la tristesse et de la pénitence, les nuances subites d'une joie douce et d'un espoir renaissant: je crois la composition de ce tableau encore plus heureuse que l'autre, et d'un plus grand effet, surtout si le peintre sait lui donner un fond touchant par la solitude et le sombre du paysage. (III, 181–82)

There is a famous painting by Domenichino whose subject is the *Communion of the Magdalen.* She receives the Holy Sacrament from the hands of an angel in the desert; she is kneeling down, her hair dishevelled, and is half-covered with a light, disordered tunic. Behind her are two angels who support her. Compassion is depicted on the faces of all three angels. As for that of the penitent, it is a masterpiece of expression: one reads in it the bitterness and the profound sadness with which she is torn by the memory of her sins. One sees in it the pallor and languor caused by a long penance. One sees in it a mixture of feelings of confusion, humility, desire, joy, and reviving hope, and finally of the gratitude with which she is filled at the sight of the Holy Sacrament. I think the composition of this admirable painting could be rendered even more touching. Leave the penitent in that position, alone in the midst of a solitary landscape that inspires sadness without horror; remove all the angels; have the sinner turn her beautiful languid eyes, such as she has in the painting, toward the sky; have her see the angel who is bringing her the Eucharist coming from above. At this sight, she should make an effort as if to rise, and it should be the effort of a person exhausted by the rigors of penance; on her face should be seen the entire mixture of feelings and affections that the painter has succeeded in giving it; one should find in it, especially amid the impressions of sadness and penance, sudden nuances of sweet joy and reviving hope. I think the composition of this painting would be even more successful than the other, and would have a greater effect, especially if the painter knows how to provide a background that would be moving by the solitude and somber character of the landscape.

More generally, an analogous pursuit of absorptive effects characterizes French literary pictorialism in the 1760s. Such effects are especially vivid in Diderot's novel *La Religieuse* (composed 1760), about which he wrote to Meister in 1780: "Il est rempli de tableaux pathétiques. Il est très intéressant, et tout l'intérêt est rassemblé sur le personnage qui parle. . . . C'est un ouvrage à feuilleter sans cesse par les peintres; et si la vanité ne s'y opposait, sa véritable epigraphe serait *son pittor anch'io* (It is filled with pathos-laden *tableaux*. It is very interesting, and all the interest is

focussed on the character who is speaking. . . . It is a work to be perused ceaselessly by painters; and if it were not forbidden by modesty, its true epigraph would be *son pittor anch'io*) (quoted by Herbert Dieckmann, *Inventaire du fonds Vandeul et inédits de Diderot* [Geneva and Lille, 1951], p. 39). Cf. Georges May's fine study, *Diderot et "La Religieuse"* (Paris, 1954), esp. pp. 197–237; and Arthur M. Wilson, *Diderot* (New York, 1972), pp. 382–91. The entire topic of pictorialism in eighteenth-century writing, especially as it relates to the larger issue of theatricality, stands in need of reconsideration; on this point see chapter two of this book, nn. 132 and 143; the brief remarks in chapter three on two absorptive *tableaux* in Marmontel's *Bélisaire;* and the discussion in Appendix B of passages from Rousseau's *Lettre sur les spectacles* and Goethe's *Die Wahlverwandtschaften.*

120. An alternative description of the contrast in this regard between the respective genre paintings of Chardin and Greuze would be to say that it registers a change— more exactly, a deterioration—in the nature, quality, or structure of the everyday itself. Thus Martin Heidegger in *Sein und Zeit* associates what he calls "everydayness" with "that state-of-mind which consists of a pallid lack of mood" (*Being and Time,* trans. John Macquarrie and Edward Robinson [New York, 1962], p. 422) and continues: "In everydayness Dasein can undergo dull 'suffering,' sink away in the dullness of it, and evade it by seeking new ways in which its dispersion in its affairs may be further dispersed" (ibid.). I suggest that something of that pallid lack of mood may be found in *La Paresseuse italienne* and *Les Oeufs cassés;* that the bulk of Greuze's genre paintings may be seen as dramatizing precisely the sort of acts of evasion and dispersion that Heidegger has in mind; and in general that everydayness in Heidegger's sense of the term may be held to characterize the "world" of Greuze's paintings but not that of Chardin's. Cf. the remarks on Heidegger's concept of the "worldhood of the world" in Stanley Cavell, "Leopards in Connecticut," *The Georgia Review,* 30 (Summer 1976), 240–41.

121. Chardin appears to have given up still lifes for genre subjects around 1736 and to have begun painting them again only in 1752, as noted by Châtelet, *French Painting from Le Nain to Fragonard,* p. 204. It is sometimes suggested that Chardin's decision around 1760 to stop making genre paintings expressed an awareness of a shift of taste away from his work in favor of that of Greuze. But the only criticism consistently levelled against Chardin in the 1750s was that he produced too little. And as late as 1767 we find Diderot writing of Chardin in a survey of the current state of the French school: "Le plus grand magicien que nous ayons eu. Ses anciens petits tableaux sont déjà recherchés comme s'il n'était plus. Excellent peintre de genre, mais il s'en va" (The greatest magician that we have had. The early small paintings are already sought after as if he were no longer with us. Excellent painter of genre subjects, but he has given that up) (*Salons,* III, 317). In short I see no reason to believe that Chardin would have lacked a market for his genre paintings had he continued to paint them.

122. No. 123. By the early nineteenth century the painting came to be known as *La Marchande d'amours.* See Rosenblum, *Transformations,* p. 3, n. 1.

123. The most important recent discussion of the *Marchande à la toilette* is Rosenblum's in *Transformations* (pp. 3–10). Rosenblum emphasizes the extent to which Vien's painting "still fits most comfortably into a Rococo milieu" (p. 6). By doing so he wishes not to call into question its designation as a key work of Neoclassicism but rather to show that Neoclassic and Rococo tendencies often coexist in paintings and other art objects of the later eighteenth century. More generally, Rosenblum

is at pains to demonstrate the formal and expressive variety of the art that may be termed Neoclassic. My own emphasis in the discussion that follows on the absorptive character of the *Marchande à la toilette* is meant to amplify but not to contradict Rosenblum's account.

124. On the publication of *Le Antichità di Ercolano* see Mario Praz, "The Antiquities of Herculaneum," in *On Neoclassicism,* trans. Angus Davidson (Evanston, 1969), pp. 70–90.

125. Diderot, *Salons,* I, 165. Cf. Thomas W. Gaehtgens, "Diderot und Vien: Ein Beitrag zu Diderots klassizistischer Ästhetik," *Zeitschrift für Kunstgeschichte,* 36, No. 1 (1973), 51–82, esp. 59–63; and Herbert Dieckmann, "Diderot et Galiani," in *Problemi attuali di scienza e di cultura: Convegno italo-francese sul thema: Ferdinando Galiani* (Rome, Accademia Nazionale dei Lincei, 1975), pp. 309–31, esp. 314–19.

126. Cf. Rudolf Zeitler, *Klassizismus und Utopia* (Stockholm, 1954), pp. 62–63.

127. One detail in the painting is an exception—the obscene gesture made by the chief cupid. Of that detail Diderot writes: "C'est dommage que cette composition soit un peu déparée par un geste indécent de ce petit Amour papillon que l'esclave tient par les ailes; il a la main droite appuyée au pli de son bras gauche qui, en se relevant, indique d'une manière très-significative la mesure du plaisir qu'il promet" (It is a shame this composition is a little marred by an indecent gesture of the young Cupid whom the slave holds by the wings. His right hand is pressed against the fold of his left arm, which, being raised, indicates in a very expressive manner the measure of the pleasure he promises) (*Salons,* I, 210). I believe that Diderot objected not so much to the sexual suggestiveness of that gesture as to its inconsistency with the hermetic character of the composition as a whole.

128. Ibid.

129. Ibid., 211.

130. Compare for example Chardin's *Girl Returning from the Market* (1739, Louvre) with Vien's *Greek Girl at the Bath* (1767, Ponce, Museum of Art). The latter is reproduced in Levey, *Art and Architecture,* pl. 129.

131. In other genre-type paintings by Greuze—e.g., *La Cruche cassée* (1773, Louvre) and *La Laitière* (ca. 1780, Louvre)—a single figure is portrayed gazing directly at the beholder. Paintings of this type tend to occur relatively late in Greuze's career, and are rather less common than is often supposed. In the 1750s and 1760s he characteristically diverted the gaze of the figure so as to emphasize his or her absorption in thoughts and feelings, as is plainly the case in the *Portrait de Mademoiselle de — sentant une Rose* (Salon of 1759, No. 111, Brunswick, Herzog Anton Ulrich-Museum) and *Un Jeune Berger qui tente le sort pour sçavoir s'il est aimé de sa Bergère* (Salon of 1761, No. 101, Paris, Musée du Petit Palais). (For the last two paintings see Munhall, *Greuze,* pp. 60–61 and 68–69, Cat. Nos. 20 and 24.) There are of course numerous specimens of the type of painting Brookner calls the "tête de jeune fille" (young girl's head), many of which depict figures who gaze or glance provocatively at the beholder, but they too date for the most part from the late 1770s and after (*Greuze,* p. 126).

132. No. 61. Wildenstein, *Chardin* (1969), Cat. No. 234. In a lecture of 9 November 1979 at the Boston Museum of Fine Arts, David Carritt argued persuasively that Chardin's *Aveugle* was painted as early as 1737, and that the version in the Fogg Art Museum, usually considered a replica by the artist, is the work of a later, lesser hand.

133. No. 145.

134. The painting is described by an anonymous critic as representing

un Vieillard aveugle, dans lequel les ans ne paroissent pas avoir éteint un penchant si naturel que l'habitude fortifie; il tient avec volupté la main d'une Moitié, victime peut-être immolée par des parens avides à l'idole d'or. La compagne du Vieillard paroît avoir pour un garçon vigoureux qui sort de la cave, des sentimens que ne peut lui inspirer son vieux époux. La crainte, l'amour, tout y est rendu, on s'apperçoit que ce garçon renverse le pot de bierre qu'il rapporte; la présence du bon homme l'inquiete. *On ne peut pas penser à tout.* (*Lettre sur le salon de 1755, adressée à ceux qui la liront* [Amsterdam, 1755], pp. 42–43)

an old blind man in whom years do not seem to have extinguished an inclination so natural and strengthened by habit. He holds voluptuously the hand of his wife, a victim perhaps sacrificed by parents eager for the golden idol. The old man's companion seems to feel toward a vigorous young man climbing out of the cellar those emotions that her aged husband is incapable of inspiring. Fear, love, everything is rendered; one notices that the young man spills the pitcher of beer he is bringing back; the presence of the old man worries him. *One cannot think of everything.*

135. The currency of the theme of blindness in late eighteenth- and early nineteenth-century French painting ought to be remarked. In David's oeuvre alone we find two Belisarius subjects, blind figures in the *Serment du Jeu de Paume* and *Léonidas à Thermopyles,* and several drawings of subjects involving Homer, one of which, *Homère récitant ses vers aux Grecs* (Cabinet des Dessins, Louvre), is of great importance. I believe that throughout that period blindness serves as an ostensible guarantee that the figures in the painting are unaware of the beholder's presence and so are acting and suffering just as they would if he did not exist. On the presence of a blind figure based on Appius Claudius in the *Serment du Jeu de Paume* see Andrew A. Kagan, "A Classical Source for David's 'Oath of the Tennis Court,'" *Burlington Magazine,* 116 (1974), 395–96. See also the article by Jon Whiteley, "Homer Abandoned: A French Neo-Classical Theme," in Francis Haskell, Anthony Levi, and Robert Shackleton, eds., *The Artist and the Writer in France: Essays in Honor of Jean Seznec* (Oxford, 1974), pp. 40–51; my review of that collection in *The Art Bulletin,* 59, No. 2 (1977), 287–91; and my discussion of several versions of the subject of the blind Belisarius receiving alms in chapter three of this study. In addition David's *Homer* drawings are analyzed in Appendix C.

136. See below, chapter three.

137. See Munhall, *Greuze,* pp. 170–73, Cat. No. 84, and 178–81, Cat. No. 88. Sketches in brush and ink for both paintings were shown in the Salon of 1765, for which see ibid., pp. 112–15, Cat. Nos. 48 and 49.

138. The development and collapse of the Davidian tradition are adumbrated in Michael Fried, "Thomas Couture and the Theatricalization of Action in 19th-Century French Painting," *Artforum,* 8, No. 10 (1970), esp. 40–46. There I describe the withdrawal from outward action and expression that begins in David's *Sabines* (finished 1799) and reaches its farthest term in his *Léonidas* (finished 1814), a painting whose subject consists essentially in the chief protagonist's entire absorption in his thoughts and feelings. One source not cited in that essay illustrates the pertinence of the concerns developed in the present chapter to our understanding of David's art. In a text published in 1835, Alexandre Lenoir quotes David's account shortly before he died of Léonidas's action:

"Léonidas est, en effet, dans l'attitude d'un homme qui réfléchit. En voyant tout l'Orient fondre sur sa patrie, il a jugé qu'il était nécessaire d'étonner les Perses et de ranimer les Grecs;

il a calculé que sa mort et celle de ses compagnons produiraient ces deux effets. Il était absorbé dans ces grandes pensées lorsque la trompette a sonné. A ce signal, la main qui tient l'épée a frémi d'un mouvement presque machinal; la jambe droite s'est comme involontaire- ment portée en arrière; ce mouvement ne s'est passé que dans le corps; l'ame est encore tout entière au grand dessein qui l'occupe, mais on sent qu'elle va sortir de sa méditation et que le héros va remplir sa destinée. . . .'" ("David. Souvenirs historiques," *Journal de l'Institut Historique*, 3, 1er liv. [1835], 12–13)

"Leonidas is, in fact, in the posture of a man who is meditating. On seeing the entire Orient descend on his native land, he judged that it was necessary to astonish the Persians and to rally the Greeks; he calculated that his death and that of his companions would produce this double effect. He was absorbed in these great thoughts when the trumpet sounded. At this signal, the hand holding the sword quivered with an almost mechanical movement; the right leg moved back as if involuntarily; this movement transpired only in his body; his soul is still totally engrossed in the great conception with which it is preoccupied, but one feels that it is about to emerge from its meditation and that the hero will accomplish his destiny. . . .'"

Géricault too is at times a powerfully absorptive artist, although his primary commitment is plainly to the persuasive representation of action and expression. The absorptive essence of Courbet's art remains to be demonstrated; in a study now in preparation I argue that it is central to his accomplishment.

CHAPTER TWO
Toward a Supreme Fiction

1. Rensselaer W. Lee, *Ut Pictura Poesis: The Humanist Theory of Painting* (*Art Bulle- tin*, 1940; rpt. New York, 1967), pp. 16–23. See also André Fontaine, *Les Doctrines d'art en France. Peintres, Amateurs, Critiques, de Poussin à Diderot* (1909; rpt. Geneva, 1970), pp. 1–156; and William G. Howard, "'Ut Pictura Poesis,'" *PMLA*, 24 (1909), 40–123.

2. In addition to the works cited in chapter one, n. 67, see Fontaine, *Les Doctrines d'art*, pp. 213ff.; and Jean Locquin, *La Peinture d'histoire en France de 1747 à 1785* (Paris, 1912), pp. 1–40, 137–73. Another ground-breaking study of ideas about art in the eighteenth century that has not yet been mentioned is Władisław Folkierski, *Entre le classicisme et le romantisme: étude sur l'esthétique et les esthéticiens du XVIIIe siècle* (Paris, 1925).

3. Other writers on painting who may be characterized as participating to a greater or lesser degree in the reaction against the Rococo include Caylus, Bachaumont, La Curne de Sainte-Palaye, Cochin, Watelet, Marmontel, and most if not all of the critics quoted in the previous chapter. Let me emphasize that these men did not constitute a single homogeneous body of opinion. They disagreed strongly among themselves, and represented a number of points of view which we are learning to situate more precisely in terms of the social and political realities of the age. Cf. the important study by Lionel Gossman cited earlier, *Medievalism and the Ideologies of the Enlightenment: The World and Work of La Curne de Sainte-Palaye* (Baltimore, 1968), especially the discussion of the relation of the views of La Curne de Sainte-Palaye, Bachaumont, Caylus, and La Font de Saint-Yenne to those of the *philosophes* (pp. 126–49).

4. See for example Jean Seznec, "Diderot and Historical Painting," in Earl R. Was- serman, ed., *Aspects of the Eighteenth Century* (Baltimore, 1965), pp. 129–42; idem, introduction to the selection of texts by Diderot, *Sur l'Art et les artistes*, ed. Jean

Seznec (Paris, 1967), pp. 15–16; and idem, "Diderot critique d'art," *Salons,* I, 20. The primacy of considerations of subject matter for French painters and critics of the period has recently been emphasized by Michael Levey and Wend Graf Kalnein, *Art and Architecture of the Eighteenth Century in France,* Pelican History of Art (Harmondsworth, 1972), pp. 106–08, 140, 144–49. Cf. also Robert Rosenblum on the prevalence of moralistic subject matter in French painting after 1760 in *Transformations in Late Eighteenth Century Art* (Princeton, 1967), ch. 2: "The *Exemplum Virtutis,"* pp. 50–106.

5. Cf. Pierre Rosenberg with Nathalie Butor, "La 'Mort de Germanicus' et son influence," in the exhibition catalogue *La "Mort de Germanicus" de Poussin du Musée de Minneapolis* (Paris, Louvre, 1973), p. 55. For the distinction between "literary" and "pictorial" values see above, chapter one, n.5.

6. On the response in Rome and Paris to the *Horaces* see Louis Hautecoeur, *Louis David* (Paris, 1954), pp. 73–88. As for the paradigmatic significance of even small details of its execution, Hautecoeur writes: "Paillot de Montabert raconte dans son *Traité de Peinture* qu'à son entrée à l'école de David, on ne parlait que du pied avant du fils aîné et qu'on le citait comme un chef-d'oeuvre. 'Et l'on avait grande raison; en lui seul, il renferme tout un cours de peinture'" (Paillot de Montabert in his *Treatise on Painting* recounts that when he entered David's studio, the students spoke only of the oldest son's front foot and cited it as a masterpiece. "And they were perfectly right; it contains in itself a whole course in painting") (p. 85).

7. For a helpful discussion of general differences between Enlightenment views on art and the classical doctrine of the previous century see Herbert Dieckmann, "Esthetic Theory in the Enlightenment: Some Examples of Modern Trends," in Robert Mollenauer, ed., *Introduction to Modernity: A Symposium on Eighteenth-Century Thought* (Austin, 1965), pp. 63–105.

8. Lee, *Ut Pictura Poesis,* pp. 9–23. See also Anthony Blunt, *Poussin* (New York, 1967), p. 219.

9. Jean-Baptiste Du Bos, *Réflexions critiques . . . ,* 6e éd. (Paris, 1755), I, 25–28. All references to Du Bos are to this edition. Modern studies of Du Bos include Alfred Lombard, *L'Abbé Du Bos, un initiateur de la pensée moderne* (Paris, 1913); Basil Muntaneo, "Les Prémisses rhétoriques du système de l'abbé Du Bos," *Rivista di Letterature Moderne e Comparate,* 10, No. 1 (1957), 5–30; idem, "Survivance antiques: L'Abbé Du Bos, esthéticien de la persuasion passionnelle," *Revue de Littérature Comparée,* 30, No. 3 (1956), 318–50; Enrico Fubini, *Empiricismo e Classicismo: Saggio su Du Bos,* Università di Torino, Publicazioni della Facoltà di lettere e filosofia, 16, fasc. 5 (Turin, 1965); and Charlotte Hogsett, "Jean-Baptiste Du Bos on Art as Illusion," *Studies on Voltaire and the Eighteenth Century,* 73 (1970), 147–64. See also Rémy G. Saisselin, "'Ut Pictura Poesis': Du Bos to Diderot," *Journal of Aesthetics and Art Criticism,* 20, No. 2 (1961), 145–56; idem, *Taste in Eighteenth-Century France* (Syracuse, 1965), pp. 67–71; and idem, *The Rule of Reason and the Ruses of the Heart* (Cleveland and London, 1970), pp. 263–66 et passim.

10. Ibid., p. 52.

11. Ibid., pp. 69–72. For example: "On ne regarde pas aussi long-temps un panier de fleurs de Baptiste, ni une fête de village de Teniers, qu'on regarde un des sept Sacremens du Poussin, ou une autre composition historique, exécuté avec autant d'habileté, que Baptiste & Teniers en font voir dans leur exécution. Un tableau d'histoire aussi bien peint qu'un corps-de-garde de Teniers, nous attacheroit bien plus que

ce corps-de-garde" (One does not look equally long at a basket of flowers by Baptiste or a village festival by Teniers and at one of the seven Sacraments by Poussin or any other history painting executed with as much skill as Baptiste and Teniers show in their execution. A history painting painted as well as a *corps-de-garde* by Teniers would hold our attention much more than that *corps-de-garde*) (p. 70).

12. "Vie d'Antoine Watteau," André Fontaine, ed., *Vies d'artistes du XVIIIe siècle, discours sur la peinture et la sculpture, salons de 1751 et 1753, lettre à Lagrenée* (Paris, 1910), p. 18.

13. *Réflexions sur quelques causes de l'état présent de la peinture en France* (La Haye, 1747; rept. Geneva, 1970), p. 8.

14. For Diderot's early reading in pictorial theory see Jacques Proust, "L'Initiation artistique de Diderot," *Gazette des Beaux-Arts,* 6e pér., 55 (1960), 225–32. According to Proust, Diderot borrowed the *Réflexions critiques* from the Bibliothèque du Roi on 25 January 1748 (231–32, n. 32). Du Bos's influence on later French critics and theorists, Diderot among them, is assessed by Lombard, *L'Abbé Du Bos,* pp. 313–45. See also Jacques Chouillet, *La Formation des idées esthétiques de Diderot, 1745–1763* (Paris, 1973), pp. 238–40, 283–84, et passim.

15. For a discussion of the dates of composition and publication of the *Essais sur la peinture* and *Pensées détachées sur la peinture* see Paul Vernière, ed., *Oeuvres esthétiques,* pp. 659–63 and 743–47.

16. *Salons,* II, 174.

17. Ibid., 108.

18. "Otez aux tableaux flamands et hollandais la magie de l'art, et ce seront des croûtes abominables. Le Poussin aura perdu toute son harmonie; et le *Testament d'Eudamidas* restera une chose sublime" (Take the magic of art away from Flemish and Dutch paintings, and they will be abominable daubs. Even if Poussin will have lost all his harmony, the *Testament of Eudamidas* will remain sublime) (*Pensées détachées,* p. 793). See also his discussion of paintings by Durameau in *Salons,* III, 287–98, esp. 291.

19. *Essais,* pp. 725–26.

20. The failure, as Diderot and his contemporaries saw it, of Greuze's attempt at history painting proper, the *Septime Sévère et Caracalla* (Salon of 1769, No. 151), may have been instrumental in sharpening his sense of the importance of traditional distinctions among genres. At any rate, Diderot observes in his *Salon* of that year: "Greuze est sorti de son genre: imitateur scrupuleux de la nature, il n'a pas su s'élever à la sorte d'exagération qu'exige la peinture historique" (Greuze has gone outside his genre; scrupulous imitator of nature, he did not know how to rise to the kind of exaggeration required by history painting) (*Salons,* IV, 106). In the same *Salon* Diderot remarks of Greuze's *Une Jeune Fille qui fait sa prière à l'autel de l'Amour* (No. 153): "Greuze connaît le beau idéal de son genre, mais il ne le connaît pas dans celui-ci" (Greuze knows the ideal beauty of his genre, but he does not know it in this one) (ibid., 107); and in the *Salon de 1771* he notes of Vernet's *Une Tempête avec le naufrage d'un vaisseau* (No. 38, with other works): "Il règne dans tout ce tableau un certain air humide qui prouve qu'en peinture chaque genre a sa magie propre pour rendre la nature dans tous ses points de vérité" (There reigns throughout this painting a certain humid atmosphere that proves that, in painting, each genre has its own magic for rendering nature in all its points of truth) (ibid., 178). Recent accounts of Greuze's failure to win acceptance as a history painter by the Académie Royale—he was offered

admission as a genre painter instead—include Jean Seznec, "Diderot et l'affaire Greuze," *Gazette des Beaux-Arts,* 6e pér., 67 (1966), 339–56; Anita Brookner, *Greuze: The Rise and Fall of an Eighteenth-Century Phenomenon* (London, 1972), pp. 66–71; and Edgar Munhall, *Jean-Baptiste Greuze, 1725–1805* (Hartford, San Francisco, and Dijon, 1976–1977), pp. 146–49.

21. "Sur l'Esthétique du peintre," in Henry Jouin, ed., *Conférences de l'Académie Royale de Peinture et de Sculpture* (Paris, 1883), p. 351. The collection is hereafter referred to as Jouin, ed., *Conférences.* Coypel was born in 1661 and died in 1722; for an analysis of his views see Fontaine, *Les Doctrines d'art,* pp. 165–71.

22. *Réflexions critiques,* I, 425–26.

23. *Elemens de peinture pratique* (Amsterdam and Leipzig, 1766), p. 401. De Piles was born in 1635 and died in 1709. For his views see Fontaine, *Les Doctrines d'art,* pp. 120–56; Bernard Teyssèdre, *Roger de Piles et les débats sur le coloris au siècle de Louis XIV* (Paris, 1957); and idem, *Histoire de l'art vue du Grand Siècle: recherches sur l'Abrégé de la vie des peintres, par Roger de Piles (1699), et ses sources* (Paris, 1964). More generally, Howard in "'Ut Pictura Poesis'" emphasizes the importance of the analogy with drama in classical pictorial theory. Cf. also James Henry Rubin, "Painting as Theater: An Approach to Painting in France from 1791 to 1810" (Diss., Harvard University, 1972); Rubin reiterates this point in the course of demonstrating the importance of the theater as a source for late eighteenth- and early nineteenth-century French painting.

24. The phrase is Lee's, *Ut Pictura Poesis,* p. 24. See also his section on "Expression," pp. 23–32. The chief document of that codification was Le Brun's *Méthode pour apprendre à deviner les passions,* first published in 1702. For Le Brun's alleged influence on Diderot see Jacques Proust, "Diderot et la physionomie," *Cahiers de l'association internationale des études françaises,* No. 13 (June 1961), pp. 317–29.

25. For Grimm's criticism of those Salons see the *Corr. litt.,* II, 279–85; III, 90–95; III, 427–35. On the strength of those articles, plus several other passages on painting in the *Corr. litt.* (including that quoted in its entirety in Appendix A), Grimm must be considered one of the major critics of the 1750s and quite possibly a significant influence on Diderot. On Grimm as a critic of literature see Jeanne R. Monty, *La Critique littéraire de Melchior Grimm* (Geneva and Paris, 1961).

Laugier's *Jugement d'un amateur* was praised in the *Corr. litt.* for 15 December 1753 (II, 304) and is discussed by Fontaine, *Les Doctrines d'art,* p. 268, and Hélène Zmijewska, "La Critique des Salons en France avant Diderot," *Gazette des Beaux-Arts,* 6e pér., 76 (1970), 89. The latter suggests that Diderot's views most resemble those of Le Blanc and Baillet de Saint-Julien among his immediate predecessors (128); in fact his *Salons* are far closer in spirit and approach to those of Grimm and Laugier, the most radical of the early anti-Rococo critics. The Diderot–Le Blanc connection is particularly inappropriate.

26. For the circumstances of their composition see Arthur M. Wilson, *Diderot* (New York, 1972), pp. 260–74, 320–31. Recent discussions of Diderot's dramatic theory as propounded in the *Entretiens* and the *Discours* include John French, Jr., "Diderot's Treatment of Dramatic Representation in Theater and Painting" (Diss., Princeton University, 1961), pp. 1–130; Hans Robert Jauss, "Diderots Paradox über das Schauspiel (Entretiens sur le 'Fils Naturel')," *Germanisch-Romanische Monatsschrift,* Neue Folge, 11 (1961), 380–413; Hans Mølbjerg, *Aspects de l'esthétique de Diderot* (Copenhagen, 1964), pp. 117–34; Raymond Joly, *Deux Etudes sur la préhistoire du*

réalisme: Diderot, Rétif de la Bretonne (Quebec, 1969); and Marian Hobson, "Notes pour les 'Entretiens sur "le Fils naturel" '," *Revue d'Histoire Littéraire de la France,* 74, No. 2 (1974), 203–13. Cf. also Roland Barthes, "Diderot, Brecht, Eisenstein," in Stephen Heath, trans., *Image-Music-Text* (New York, 1977), pp. 69–78.

27. "Il faut . . . laisser là ces coups de théâtre dont l'effet est momentané, et trouver des tableaux. Plus on voit un beau tableau, plus il plaît" (It is necessary . . . to forget about *coups de théâtre,* whose effects are momentary, and to find *tableaux.* The more one sees a beautiful *tableau,* the more it pleases) (*Entretiens,* p. 139). See also ibid., pp. 88–90, 94, 148–49, 167; and the exchange of letters with Mme. Riccoboni published in *Correspondance,* II, 86–103.

28. *Discours,* p. 276.

29. *Entretiens,* pp. 100–02, 114–15; *Discours,* pp. 250–51, 264–65, 268–74. The seating of a portion of the audience on the stage provided the Comédie-Française with needed revenue. Starting in the Easter vacation of 1759, however, an endowment from a private individual, the Comte de Lauraguais, made it possible to clear the stage of spectators (Wilson, *Diderot,* pp. 327–28). See also John Lough, *Paris Theatre Audiences in the Seventeenth and Eighteenth Centuries* (London, 1957), pp. 228–29.

30. *Lettre sur les sourds et muets,* critical edition by Paul Hugo Meyer, *Diderot Studies VII* (1965), pp. 47–48. Another excellent recent edition, by Norman Rudich, is included in Diderot, *Premières oeuvres 2,* ed. Norman Rudich and Jean Varloot (Paris, 1972), pp. 65–156. All references in this chapter will be to the Meyer edition but Rudich's introduction (pp. 65–89) and notes are essential reading as well. See also Meyer, "The 'Lettre sur les sourds et muets' and Diderot's Emerging Concept of the Critic," *Diderot Studies VI* (1964), pp. 133–55; and the review essay by Rudich, "Lettre sur les sourds et muets, Critical Edition by Paul Meyer," *Diderot Studies X* (1968), pp. 265–83. Diderot's dissatisfaction with the conventions of the classical theater was expressed even earlier, in *Les Bijoux indiscrets* (1747), chs. xxxvii and xxxviii. For more on Diderot's concern with expressive gesture see Herbert Dieckmann, "Le Thème de l'acteur dans la pensée de Diderot," *Cahiers de l'association internationale des études françaises,* No. 13 (June 1961), pp. 157–72; Herbert Josephs, *Diderot's Dialogue of Language and Gesture: Le Neveu de Rameau* (Ohio State University Press, 1969); and Michael T. Cartwright, "Diderot critique d'art et le problème de l'expression," *Diderot Studies XIII* (1969), esp. pp. 80–98.

31. Ibid., p. 52.

32. Ibid.

33. See especially Philippe Van Tieghem, "Diderot à l'école des peintres," *Actes du Ve congrès international de langues et littératures modernes* (Florence, 1955), pp. 255–63; French, "Diderot's Treatment of Dramatic Representation," pp. 131ff.; and Paul Vernière in his introduction to Diderot's *Oeuvres esthétiques,* where he uses the formulae *Ut pictura theatrum* and *Ut theatrum pictura* to express the reciprocal relations between the two arts in Diderot's thought (pp. vii, xv). Cf. also Yvon Belaval, *L'Esthétique sans paradoxe de Diderot* (Paris, 1950), and the review of Belaval by Herbert Dieckmann in the *Romanic Review,* 42, No. 1 (1951), 61–65.

34. Jouin, ed., *Conférences,* p. 350.

35. A conspicuous example of a painter influenced by contemporaneous theatrical practice is Charles-Antoine Coypel (1694–1752), son of the Antoine Coypel quoted above. For an informative study of his art from this point of view see Antoine Schnapper, "A Propos de deux nouvelles acquisitions: 'Le Chef-d'oeuvre d'un muet' ou la

tentative de Charles Coypel," *La Revue du Louvre et des Musées de France,* 18, Nos. 4–5 (1968), 253–64. I am grateful to Pierre Rosenberg for calling this article to my attention.

36. *Essais,* p. 714.

37. See for example *Salons,* I, 114, 121, 214; II, 157–59, 188–97; III, 178–91, 314–16; and the *Essais,* pp. 718–19. Cf. Jean Seznec's important article, "Diderot et le *Génie du Christianisme," Journal of the Warburg and Courtauld Institutes,* 15, Nos. 3–4 (1952), 229–41; and more generally Herbert Dieckmann, "Das Abscheuliche und Schreckliche in der Kunsttheorie des 18. Jahrhunderts," in Hans Robert Jauss, ed., *Die nicht mehr schönen Künste* (Munich, 1968), pp. 272–317, esp. pp. 290–92, 298–307.

38. *Pensées détachées,* p. 772.

39. Ibid., p. 826.

40. See n. 30. Also *Salons,* III, 165–66.

41. The phrase "verve brûlante" occurs in the *Essais,* p. 720; the phrase "chaleur d'âme" in *Salons,* III, 78, where it is granted to Doyen but not to Vien.

42. *Entretiens,* p. 152.

43. *Essais,* p. 718.

44. *Salons,* III, 143.

45. *Salons,* II, 144.

46. *Salons,* III, 148.

47. *Pensées détachées,* p. 787.

48. *Salons,* II, 112.

49. Ibid., 155. Grimm proceeds to explain how this was done:

On établit d'abord le fond du tableau par une décoration pareille. Ensuite chacun choisit un rôle parmi les personnages du tableau, et après en avoir pris les habits il cherche à en imiter l'attitude et l'expression. Lorsque toute la scène et tous les acteurs sont arrangés suivant l'ordonnance du peintre, et le lieu convenablement éclairé, on appelle les spectateurs qui disent leur avis sur la manière dont le tableau est exécuté. Je crois cet amusement très propre à former le goût, surtout de la jeunesse, et à lui apprendre à saisir les nuances les plus délicates de toutes sortes de caractères et de passions. (155–56)

First the background of the *tableau* is established by means of a similar sort of decoration. Then each person chooses a role from among the personages in the painting, and after having dressed himself like that personage, he attempts to imitate his attitude and expression. When the entire scene and all the actors have been arranged according to the painter's *ordonnance,* and everything has been appropriately lighted, the spectators are called upon to give their opinion of the way in which the *tableau* has been executed. I consider this entertainment excellent for forming taste, especially for young people, and for teaching them to grasp the most delicate nuances of all sorts of characters and passions.

See Appendix B for a brief discussion of the *tableaux vivants* scene in Goethe's *Die Wahlverwandtschaften.*

50. *Pensées détachées,* p. 760. Cf. his praise of Chardin's still-life compositions for being asymmetrical (*Salons,* III, 128), as well as his discussion of Loutherbourg's *Rendez-vous de la table* (Salon of 1765, No. 134; *Salons,* II, 167).

51. Further evidence of the close connection between asymmetry and drama is found in the Chevalier [Jean-George] Noverre's *Lettres sur la danse, et sur les ballets* (Stuttgart, 1760). The influence of the *Entretiens* and *Discours* is evident throughout the *Lettres* and indeed is acknowledged more than once. For Noverre as for Diderot, painting

provides models of truth and expressiveness; and for Noverre, too, symmetrical groupings are anathema. More exactly, they are to be avoided at all costs in "les Scènes d'action" (scenes of action), but may be tolerated in "les corps d'entrée, qui n'ont aucun caractère d'expression, & qui ne disant rien, sont faits uniquement pour donner le temps aux premiers danseurs de reprendre leur respiration" (the *corps d'entrée,* which have no expressive character and which, meaning nothing, are made only to give the first dancers time to catch their breath) (p. 8).

52. Lee, *Ut Pictura Poesis,* p. 29. The quotation elides portions of two sentences.

53. Jouin, ed., *Conférences,* p. 58. The discourse was delivered on 5 November 1667, and as usual discussion followed; the account of both in Jouin is by Félibien. They are analyzed by Lee, ibid., pp. 29–32, 61–66. Cf. also Du Bos's claim that "la Peinture se plaît à traiter des sujets où elle puisse introduire un grand nombre de personnages intéressés à l'action" (painting thrives on subjects into which can be introduced a large number of personages involved in the action) (*Réflexions critiques,* I, 102–03).

54. Le Brun, Testelin, De Piles, and other classical writers—for despite De Piles's upgrading of color, admiration for Rubens and Rembrandt, and other innovations he may be considered such—argue that whereas dramatic or epic poetry (or for that matter narrative prose) is suited to the representation of successive events, painting is limited to the representation of a single moment in an action. For the further development of this distinction in the writings of Shaftesbury, Richardson, and Harris in England, Du Bos, Caylus, and Diderot in France, and of course Lessing in Germany, see Folkierski, *Entre le classicisme et le romantisme,* pp. 171–89, 425–41, 529–57; Lombard, *L'Abbé Du Bos,* pp. 369–71; Lee, *Ut Pictura Poesis,* pp. 59–61, 65–66; Basil Muntaneo, "Le Problème de la peinture en poésie dans la critique française du XVIIIe siècle," *Actes du Ve congrès international de langues et littératures modernes,* pp. 325–38; Jean Seznec, *Essais sur Diderot et l'antiquité* (Oxford, 1957), ch. 4: "Un *Laocoon* français," pp. 58–78; Francis H. Dowley, "D'Angiviller's *Grands Hommes* and the Significant Moment," *Art Bulletin,* 39, No. 4 (1957), 262, 270–77; and Meyer, ed., *Lettre sur les sourds et muets,* pp. 24–25, 189–90.

55. Cf. the discussion that followed Le Brun's discourse on Poussin's *Israelites Gathering Manna* (Jouin, ed., *Conférences,* pp. 62–65) as well as the analyses of that discussion by Lee, ibid., pp. 61–66, and Jacques Thuillier, "Temps et tableau: la théorie des 'péripéties' dans la peinture française du XVIIe siècle," *Akten des 21. Internationalen Kongresses für Kunstgeschichte in Bonn 1964* (Berlin, 1967), III, 191–206.

56. "A Notion of the Historical Draught or Tablature of the Judgment of Hercules," in Anthony [Ashley Cooper, Third] Earl of Shaftesbury, *Second Characters, or The Language of Forms,* ed. Benjamin Rand (Cambridge, 1914), p. 38. Diderot's article, "Composition en peinture" (1753)—*Oeuvres complètes,* VI, 475–83—virtually paraphrases portions of Shaftesbury's brief treatise, which was originally written in French and published for the first time in the Amsterdam edition of the *Journal des Sçavans* in November 1712. (I owe to Dr. David Marshall the information that the treatise appeared in the Amsterdam but not the Paris edition of that journal.) The depth of Diderot's involvement with Shaftesbury's thought has long been recognized; recent studies include Paolo Casini, "Diderot e Shaftesbury," *Giornale Critico della Filosofia Italiana,* 3rd ser., 14 (April–June 1960), pp. 253–73; Dorothy B. Schlegel, "Diderot as the Transmitter of Shaftesbury's Romanticism," *Studies on Voltaire and the Eighteenth Century,* 27 (1963), 1457–78; Władisław Folkierski, "Comment Lord

Shaftesbury a-t-il conquis Diderot?," in *Studi in Onore di Carlo Pellegrini* (Turin, 1964), pp. 319–46; and Jacques Chouillet, *La Formation des idées esthétiques de Diderot,* pp. 33–57 et passim.

57. Du Bos, *Réflexions critiques,* I, 88–92, 108–09.

58. De Piles, "Conversations sur la peinture," in *Recueil de divers ouvrages sur la peinture et le coloris* (Paris, 1775), p. 156.

59. *Salons,* III, 311.

60. *Essais,* p. 711. Three *Pensées détachées* might also be quoted in this connection: "Peindre comme on parlait à Sparte" (To paint as the Spartans spoke) (p. 794); "En poésie dramatique et en peinture, le moins de personnages qu'il est possible" (In drama and in painting, as few personages as possible) (ibid.); and "La toile comme la salle à manger de Varron, jamais plus de neuf convives" (The canvas like Varro's dining room, never more than nine guests) (p. 795). Diderot's demand that the number of figures be kept to a minimum is consistent with strict classical doctrine as propounded originally by Alberti (Leon Battista Alberti, *On Painting,* trans. John R. Spencer [New Haven and London], 1966, pp. 75–76), and as advocated in the 1630s by Andrea Sacchi and his followers in their controversy with Pietro da Cortona (see Rudolf Wittkower, *Art and Architecture in Italy: 1600–1750,* 2nd rev. ed., Pelican History of Art [Baltimore and Harmondsworth, 1965], pp. 171–173).

61. *Salons,* II, 69. The sketch was one of those of scenes from the life of St. Gregory (Salon of 1765, No. 4).

62. *Pensées détachées,* p. 760.

63. *Essais,* p. 720.

64. Ibid.

65. "Conversations sur la peinture," p. 156. Cf. Jörg Garms, "Machine, Composition und Histoire in der Französischen Kritik um 1750," *Zeitschrift für Ästhetik und allgemeine kunstwissenschaft,* 16 (1971), 27–42.

66. *Pensées détachées,* p. 780.

67. *Corr. litt.,* IV, 205 (15 March 1760).

68. The first of the *Essais,* "Mes Pensées bizarres sur le dessin," should be read in its entirety. The sentences with which it opens are well known: "La nature ne fait rien d'incorrect. Toute forme, belle ou laide, a sa cause; et, de tous les êtres qui existent, il n'y en a pas un qui ne soit comme il doit être" (Nature makes nothing incorrect. Every form, beautiful or ugly, has its cause; and, among all the beings that exist, there is not one which is not as it should be) (p. 665). For Diderot's belief in the harmful effects of too much study of anatomy see the *Essais,* pp. 668–69, and the *Pensées détachées,* p. 815.

69. Herbert Dieckmann, *Cinq leçons sur Diderot* (Geneva, 1959), p. 118. The phrase "conspiration générale des mouvements" is quoted from the *Essais,* p. 670. Cf. Dieckmann's essay, "Die Wandlung des Nachahmungsbegriffes in der Französischen Asthetik des 18. Jahrhunderts," in Hans Robert Jauss, ed., *Nachahmung und Illusion* (Munich, 1969), pp. 28–59; and David Funt, "Diderot and the Esthetics of the Enlightenment," *Diderot Studies XI* (1968), pp. 107–36.

70. *Corr. litt.,* IV, 206; from the review of Watelet's *L'Art de peindre.*

71. Cf. *Salons,* III, 129–37, where the point is developed at length in connection with a group of landscapes by Vernet (see below, chapter three).

72. *Pensées détachées,* p. 800.

73. Ibid.

74. *Essais,* pp. 683–84.

75. Cf. the similar passage a few pages later:

Le difficile, c'est la dispensation juste de la lumière et des ombres, et sur chacun de ces plans, et sur chaque tranche infiniment petite des objets qui les occupent; ce sont les échos, les reflets de toutes ces lumières les unes sur les autres. Lorsque cet effet est produit (mais où et quand l'est-il?) l'oeil est arrêté, il se repose. Satisfait partout, il se repose partout; il s'avance, il s'enfonce, il est ramené sur sa trace. Tout est lié, tout tient. L'art et l'artiste sont oubliés. Ce n'est plus une toile, c'est la nature, c'est une portion de l'univers qu'on a devant soi. (ibid., pp. 686–87)

What is difficult is the correct distribution of light and shadow on each of these planes and on each infinitely small portion of the objects that occupy them; these are the echoes, the reflections of all these lights upon each other. When this effect is produced (but where and when is it?), the eye is halted, it comes to rest. Satisfied everywhere, it rests everywhere; it advances, plunges, is brought back on its track. Everything is linked, everything holds together. Art and artist are forgotten. It is no longer a canvas, it is nature, it is a portion of the universe that we have before us.

(For the further development of the ideas expressed in the last two sentences see below, chapters two and three.) Both quotations should be read in conjunction with the following from the *Pensées détachées:* "Pourquoi la nature n'est-elle jamais négligée? C'est que, quel que soit l'objet qu'elle présente à nos yeux, à quelque distance qu'il soit placé, sous quelque aspect qu'il soit aperçu, il est comme il doit être, le résultat des causes dont il a éprouvé les actions" (Why does nature never appear careless? It is because, whatever object it presents to our eyes, at whatever distance that object is placed, under whatever aspect it may be perceived, the object is as it should be, the result of causes that have acted upon it) (p. 824).

76. Fontaine, ed., *Vies d'artistes,* p. 160.

77. *Corr. litt.,* III, 317–18. Grimm goes on to deplore the cultural consequences of the imitation of original works of genius (e.g., the *Iliad* and *Odyssey,* decorative projects by Raphael and Annibale Carracci) that were never intended by their creators to provide models for epic poems or rules and theories for "grandes machines" in painting (318–20). And he concludes by noting the tendency of large-scale decorative projects to have recourse to allegory, "si froide en poésie, si obscure et si insupportable en peinture" (so cold in poetry, so obscure and so unbearable in painting) (320). See Appendix A for the whole of this crucial passage.

78. Cf. the announcement in the *Mercure de France* for December 1753 of the publication of engravings based on drawings by J.-B. Massé after Le Brun's decorations for the Grande Galerie at Versailles. There it is claimed that the engravings are more harmonious in effect than the original paintings, not because Le Brun neglected this aspect of his work,

mais outre que les couleurs de ses tableaux sont changées & obscurcies par les milliers de bougies alumées dans la galerie aux superbes fêtes qui y ont été données, il est incontestable que tout l'effet de ces belles compositions est comme éteint par l'éclat de la dorure, des richesses prodiguées qui les environnent, & que les ornemens même, tels que les trophées d'enfans en sculpture de relief, qui n'avoient été destinés qu'à accompagner & faire valoir ces grands morceaux, partageant inévitablement l'attention, produisent un effet tout contraire à celui qu'on s'étoit proposé.

Non seulement l'ouvrage de M. Massé n'a point contre elle cet inconvénient si fatal à M. le Brun, mais il a encore l'avantage d'avoir la totalité sous un seul point de vue, dans une seule estampe qui présente l'ensemble de la galerie. . . . (pp. 166–67)

but apart from the fact that the colors of his paintings are altered and obscured by the thousands of candles lit in the gallery for the superb festivities given there, it is undeniable that all the effect of these beautiful compositions is as if dimmed by the glitter of the gilding, by the lavish sumptuousness that surrounds them. Even the ornaments, such as the decorative groups of children sculpted in relief, that had been intended only to accompany and to set off those great works, inevitably divide one's attention and produce an effect contrary to the one originally proposed.

Not only does the work of M. Massé not suffer from the same fatal inconvenience as that of M. Le Brun, but it has the further advantage of capturing the totality from one point of view in a single engraving that presents the general effect of the gallery. . . .

One might say that Massé's engravings enabled Le Brun's decorations to be seen as (reproductions of) *tableaux*, a transformation that seemed to our anonymous author to present those works in a highly favorable light.

79. *Second Characters,* pp. 30–32.

80. Ibid., p. 32.

81. Cf. Caylus, "De la Composition," Fontaine, ed., *Vies d'artistes,* pp. 160–74, esp. pp. 162–65; and Charles-Nicolas Cochin, *Voyage d'Italie* (Paris, 1758), where it is said that Guido Reni's principal paintings "sont plus tableaux (s'il est permis de se servir de cette expression), & plus complets en tout qu'aucun de ceux des peintres qui ont existé avant & peut-être depuis lui" (are more fully *tableaux* [if one may use this expression], and more complete in all respects, than those of any painter who existed before and perhaps after him) (II, 187). There has been almost no recognition of the importance of the concept of the *tableau* in the thought and practice of French painters and critics of the eighteenth and nineteenth centuries. But see Michael Fried, "Manet's Sources: Aspects of His Art, 1859–65," *Artforum,* 7, No. 7 (1969), esp. nn. 11, 27, 46, 99, 114, 228; and Steven Z. Levine, *Monet and His Critics,* Diss., Harvard University, 1974 (New York, 1976), passim.

82. *Essais,* p. 711.

83. Ibid., p. 712. Among pre-Rococo writers Félibien placed allegory above history painting in his classic formulation of the doctrine of the hierarchy of genres (Lee, *Ut Pictura Poesis,* p. 19, n. 78); De Piles saw no objection to allegory provided it was intelligible, authorized, and necessary (*Cours de peinture par principes* [Amsterdam and Leipzig, 1766] pp. 56–57), and positively favored mixing allegory and history (p. 45); while Testelin too regarded the combination as acceptable (Jouin, ed., *Conférences,* p. 153). Du Bos's attitude was much more complex but may be summed up by saying that he cautioned against the invention of new allegorical subjects because of their inevitable obscurity (*Réflexions critiques,* I, 194); argued that in general wholly allegorical compositions tended to be both cold and unintelligible (204–5); tolerated the combination of allegory and history under certain conditions which he carefully defined (196–203, 207–10); but concluded by asserting that the true poetry of painters like Raphael, Poussin, Le Sueur, Le Brun, and Rubens consisted not in the invention of allegorical mysteries but rather in the ability to enrich their compositions "par tous les ornemens que la vraisemblance du sujet peut permettre, ainsi qu'à donner la vie à tous ces personnages par l'expression des passions" (with all the ornaments allowed by the verisimilitude of the subject, as well as to give life to all those personages via the expression of the passions) (220).

Among contemporaries, Diderot's views were closest to those of Grimm, who found allegory in painting "obscure et . . . insupportable" and argued that "rien ne dépose tant contre le génie de l'artiste que la ressource de l'allégorie" (nothing so

testifies to an artist's lack of genius as resorting to allegory) (*Corr. litt.*, III, 320; see Appendix A). Diderot however was not absolutely opposed to allegory in all circumstances, and reserved his strongest criticism for paintings that mixed allegorical and historical elements (see for example *Salons*, I, 108–09; III, 92, 288–90, 331; and *Essais*, pp. 715–16). La Font de Saint-Yenne and Laugier also opposed the use of allegory; while Caylus agreed that it tended to be obscure but argued that if an allegorical subject contained as it were *within itself* an action or actions it might succeed (*Tableaux tirés de l'Iliade, de l'Odyssée d'Homère et de l'Eneide de Virgile* [Paris, 1757], p. 2). For Diderot's views on allegory see Seznec, *Diderot et l'antiquité*, pp. 36–42; and two recent essays by Georges May, "Diderot et l'allégorie," *Studies on Voltaire and the Eighteenth Century*, 89 (1972), 1049–76; and "Observations on an Allegory: the Frontispiece of the *Encyclopédie*," *Diderot Studies XVI* (1973), pp. 159–74.

84. *Lettre sur les sourds et muets*, p. 53. Cf. Diderot's statement in the *Lettre* that when he went to the theater and stopped his ears in order to judge the efficacy of actors' gestures and expressions he chose a play that he *knew by heart* (p. 52), and his comparison between the beholder of a painting and a deaf person watching mutes converse on subjects *known to him* (ibid.).

85. *Oeuvres complètes*, VII, 194. The relevant passage reads: "[La peinture] n'est que d'un état instantané. Se propose-t-elle d'exprimer le mouvement le plus simple, elle devient obscure. Que dans un trophée on voie une Renommée les ailes déployées, tenant sa trompette d'une main, & de l'autre une couronne élevée au-dessus de la tête d'un héros, on ne sait si elle la donne, ou si elle l'enlève: c'est à l'histoire à lever l'équivoque" ([Painting] is only of a momentary state. When it attempts to express the simplest movement, it becomes obscure. If, in a decorative group, one sees a figure of Fame with wings spread, holding her trumpet in one hand and a crown above a hero's head in the other, one does not know whether she is bestowing it or taking it away. It is up to history [to the story] to remove the ambiguity) (193–94). But by far the most remarkable passage attesting to Diderot's unprecedented awareness of the *contextuality* of meaning was occasioned by two paintings by Greuze in the Salon of 1765, the first a portrait of Mme. Greuze (No. 114) and the second, for which she was also the model, a representation of a mother almost smothered in caresses by her children (No. 123):

Voici, mon ami [Grimm], de quoi montrer combien il reste d'équivoque dans le meilleur tableau. Vous voyez bien cette belle poissarde, avec son gros embonpoint, qui a la tête renversée en arrière, dont la couleur blême, le linge de tête étalé en désordre, l'expression mêlée de peine et de plaisir, montrent un paroxisme plus doux à éprouver qu'honnête à peindre? Eh bien! c'est l'esquisse, l'étude de la mère bien-aimée. Comment se fait-il qu'ici un caractère soit décent, et que là il cesse de l'être? Les accessoires, les circonstances, nous sont-elles nécessaires pour prononcer juste des physionomies? Sans ce secours, restent-elles indécises? Il faut bien qu'il en soit quelque chose. Cette bouche entr'ouverte, ces yeux nageans, cette attitude renversée, ce cou gonflé, ce mélange voluptueux de peine et de plaisir, font baisser les yeux et rougir toutes les honnêtes femmes dans cet endroit. Tout à côté, c'est la même attitude, les mêmes yeux, le même cou, le même mélange de passions, et aucune d'elles ne s'en aperçoit. (*Salons*, II, 151)

Here, my friend, is an example showing how much ambiguity remains in the best of paintings. Do you see the good-looking fishwife, with her excess weight, whose head is thrown back, whose pallor, untidy headdress, and expression of mingled pain and pleasure express a paroxysm sweeter to feel than honorable to paint? Well, this is the sketch, the study for the beloved mother. How can a character be decent here and stop being so there? Are accessories,

are circumstances necessary in order to read countenances accurately? Without this help, do they remain undecidable? Something like that must be the case. This partly open mouth, these vacant eyes, this thrown back posture, this swollen neck, this voluptuous mixture of pain and pleasure make all the honorable women here cast down their eyes and blush. Next to it, the same posture, the same eyes, the same neck, the same mixture of passions, and none of the women notices them.

For a general discussion of what he calls the priority of context over expression see E.H. Gombrich, "The Evidence of Images," in Charles Singleton, ed., *Interpretation: Theory and Practice* (Baltimore, 1969), pp. 68–103.

86. *Pensées détachées*, p. 765.

87. Thus Diderot in the *Lettre sur les aveugles* (1749): "Qu'est-ce que ce monde . . . ? Un composé sujet à des révolutions, qui toutes indiquent une tendance continuelle à la destruction; une succession rapide d'êtres qui s'entre-suivent, se poussent et disparaissent; une symétrie passagère; un ordre momentané" (What is this world . . . ? A compound of elements subject to revolutions, all of which betoken a constant tendency toward destruction; a rapid succession of beings who follow one another, jostle one another, and disappear; a fleeting symmetry; a momentary order) (Paul Vernière, ed., *Oeuvres philosophiques* [Paris, 1956], p. 123). (The word *symétrie* is meant as a synonym for *ordre* and is not to be taken literally.) The same vision of nature as a causal whole in perpetual flux is thematic in *De l'Interprétation de la nature, Le Rêve de D'Alembert,* and the Vernet section of the *Salon de 1767*. Two brief undated fragments published by Dieckmann might also be quoted in this connection: "Tout phenomene depend de l'etat actuel du tout" (Every phenomenon depends upon the present state of the whole); and "A chaque instant, on peut dire de l'univers que tout y est comme il est absolument necessaire qu'il y soit" (At every moment, one can say of the universe that everything in it is as it is absolutely necessary for it to be) (*Inventaire du fonds Vandeul et inédits de Diderot* [Geneva and Lille, 1951], p. 256). Cf. Lester G. Crocker, "Diderot and Eighteenth Century French Transformism," in *Forerunners of Darwin: 1745–1859,* Bentley Glass, Owsei Temkin, and William L. Straus, Jr., eds. (Baltimore, 1959), pp. 114–43; Charles Coulston Gillispie, *The Edge of Objectivity: An Essay in the History of Scientific Ideas* (Princeton, 1960), pp. 180–92; Dieckmann's discussion of *De l'Interprétation de la nature,* in *Cinq leçons sur Diderot,* pp. 53–58; and Aram Vartanian, "Diderot and the Phenomenology of the Dream," *Diderot Studies VIII* (1966), pp. 217–53.

88. Caylus, *Description d'un tableau représentant "Le Sacrifice d'Iphigénie" peint par M. Carle-Vanlo* (Paris, 1757), pp. 20–22. For information about the painting see Marie-Cathérine Sahut, *Carle Vanloo, premier peintre du roi (Nice, 1705–Paris, 1765)* (Nice, Clermont-Ferrand, Nancy, 1977), p. 78, Cat. No. 158.

89. Diderot's several formulations of the notion of the unity of time go back to Shaftesbury and in themselves do not mark a break with pre-Rococo thought. Thus he writes: "J'ai dit que l'artiste n'avait qu'un instant; mais cet instant peut subsister avec des traces de l'instant qui a précédé, et des annonces de celui qui suivra. On n'égorge pas encore Iphigénie; mais je vois approcher le victimaire avec le large bassin qui doit recevoir son sang, et cet accessoire me fait frémir" (I said that the artist had only an instant; but that instant can coexist with traces of the one that preceded it and with signs of the one that will follow. Iphigenia has not yet been slaughtered, but I see approaching the sacrificer bearing the large basin that will receive her blood, and this accessory makes me shudder) (*Pensées détachées,* p. 776). (See also "Composition en

peinture," *Oeuvres complètes,* VI, 476–78; and *Essais,* pp. 712, 714–15.) This has much in common with Shaftesbury's account of the operations of "repeal" and "anticipation" by means of which a painter may legitimately "call to mind the past" and "anticipate the future" of his subject ("A Notion of the Historical Draught or Tablature of the Judgment of Hercules," *Second Characters,* pp. 36–37). But when we return to the *Salons* and compare their discussions of individual pictures with Shaftesbury's analysis of the principal action in the "Hercules" or with the writings of the French Academicians, the conceptual and even more important the experiential gulf that separates Diderot from his classical predecessors becomes apparent. His sense of the multiplicity and specificity of successive phases of an action is far more acute than theirs; his insistence on the complete fidelity of all elements in the painting to the physical and psychological reality of the exact moment chosen goes far beyond their concern for *vraisemblance;* and his repeated assertions of the need for the painter to choose the most compelling moment of a given action are accompanied by a far more refined and demanding conception of the factors involved in that choice than is found in the writings of any previous theorist.

90. A vivid instance of this, in addition to the passages already quoted, occurs in Caylus's *Tableaux tirés de l'Iliade.* Caylus remarks that among modern epic poets Camoëns is more original than Tasso or Ariosto but adds: "Cependant son Poème présente plus d'Images que de Tableaux, c'est-à-dire, plus de Descriptions que d'Actions intéressantes" (However, his poem presents more images than *tableaux,* that is to say, more descriptions than interesting actions) (p. xiii). And in a note he expands on this distinction: "Le Tableau, pour parler exactement, est la représentation du moment d'une action. . . . L'Image, au contraire, n'a souvent point assez de corps pour être peinte dans les différens moments qu'elle présente, & n'est essentiellement qu'une Description: ce mot est souvent employé sans beaucoup de précision, de même que celui de Tableau. Ainsi le Tableau ne peint qu'un instant, & l'Image plusieurs instans successifs. Le Tableau, s'il m'est permis de le dire, tient au génie, & l'Image tient à l'esprit" (A *tableau,* accurately speaking, is the representation of a moment in an action. . . . An image, on the contrary, is often too insubstantial to be painted in the various moments that it presents, and is essentially nothing but a description. This word is often used without much precision, as is the word *tableau.* Thus a *tableau* paints only an instant, whereas an image paints several successive instants. A *tableau,* if I may say so, is a product of genius, whereas an image is a product of intellect) (ibid.). Here the presumed instantaneousness of painting becomes the basis for a literary distinction of some interest, which incidentally anticipates the more famous distinction in Lessing's *Laokoön.*

Two exceptions to the tendency of Diderot's contemporaries to define painting as essentially instantaneous should be noted. In his *Lettre sur l'exposition des ouvrages de peinture, sculpture, etc. de l'année 1747* (1747), the Abbé Le Blanc quotes at length from an earlier writer, the Abbé de Saint-Réal, to support his contention that there exists an implicit contradiction between the fixity and unchangingness of painting and the representation of bodies in motion, and that painters ought therefore to restrict themselves to the representation of nature "dans une sorte de repos, ou, si l'on me permet l'expression, dans une action lente" (in a sort of repose, or, if I am allowed the expression, in a slow action) (p. 149). Le Blanc's position would appear to have had much to commend it to those who valued absorption, inasmuch as the persuasive representation of absorptive states and activities necessarily involved creating the illu-

sion that those states and activities were sustained for a certain length of time (cf. my discussion of Chardin's genre paintings in chapter one). But his views were attacked vigorously by Baillet de Saint-Julien in the latter's *Lettre sur la peinture, sculpture, et architecture à M.——*(1748), pp. 71–75, and to the best of my knowledge were not restated by Le Blanc or any other French critic. The advent in the mid–1750s of the young Greuze, who from the outset managed to combine absorptive values and effects with the specification of a single moment in an action, would have helped at once to make the theoretical issue moot and to affirm the definition of painting as essentially instantaneous.

Less interesting is La Font de Saint-Yenne's assertion in his *Sentimens sur quelques ouvrages* of 1754 that the convention in early schools of painting of depicting multiple moments in an action or narrative was not without its advantages (pp. 118–19).

Finally, I find it suggestive that Du Bos, writing earlier in the century, associates the fact that paintings can be taken in at a glance with what he maintains is the greater perspicuousness of their faults as compared to those in epic or dramatic poems (*Réflexions critiques,* I, 288–90). If Du Bos is right, and at the very least his reasoning deserves to be taken seriously, it is not surprising that, starting around midcentury, a new concern with the instantaneousness of painting and the rise of art criticism in the modern, intensively evaluative form of the enterprise went hand in hand.

91. *Lettre sur les sourds et muets,* p. 64.

92. *Salons,* III, 180; Diderot's commentary on that painting is discussed in chapter three.

93. *Essais,* p. 728.

94. The concept of point of view is central not just to Diderot's vision of painting and drama but to his epistemology. As he writes in the important article, "Encyclopédie": "L'univers soit réel soit intelligible a une infinité de points de vue sous lesquels il peut être représenté, & le nombre des systèmes possibles de la connaissance humaine est aussi grand que celui de ces points de vue" (The universe, whether considered as real or as intelligible, has an infinity of points of view from which it can be represented, and the number of possible systems of human knowledge is as great as that of these points of view) (*Oeuvres complètes,* VII, 211). This suggests that for Diderot the concept of intelligibility entailed that of point of view; something could be said to be intelligible only from one or another of an infinity of points of view; and the claim to understand a given phenomenon involved accepting the responsibility not just for the explanation itself but for the point of view implicit in it from the first.

95. For example, Diderot writes of L'Epicié's *Descente de Guillaume-le-Conquérant en Angleterre* (Salon of 1765, No. 162): "Cette composition frappe, appelle d'abord, mais n'arrête pas" (This composition strikes, initially attracts, but does not arrest the beholder) (*Salons,* II, 182). In addition, chapters one and three quote various passages from Diderot's *Salons* that portray him arrested and transfixed by individual paintings. Cf. also Garrigues de Froment on the paintings by Carle Van Loo at the Salon of 1753: "En vain fait on des efforts pour s'arracher du lieu vers lequel presque tous ses Tableaux sont rassemblés; en vain veut-on finir le tour du Salon qu'on a déjà commencé; en vain est-on distrait & flatté par je ne sçai combien de morceaux tous dans leur genre fort au-dessus du médiocre: un charme plus puissant vous entraîne; le Connoisseur & l'Ignorant y cèdent avec un plaisir presque égal. M. Carle Vanloo les fixe" (In vain one strives to tear oneself away from the place where almost all these paintings are gathered; in vain one wishes to finish the tour of the Salon that one has

already begun; in vain one is distracted and delighted by I don't know how many works, all far above mediocrity in their genre. A more powerful charm draws one back. Both the connoisseur and the ignorant yield to it with almost equal pleasure. M. Carle Van Loo transfixes them) (*Sentimens d'un amateur sur l'exposition des tableaux du Louvre et la critique qui en a été faite* [Paris, 1753], p. 8). As Garrigues's remarks suggest, the institution of the Salon on a regular basis created a situation in which the power of individual paintings to attract, stop, and transfix the beholder was constantly at issue. For an early example of the critical use of the terms in question see De Piles's comparison between Raphael and Rembrandt in his *Cours de peinture par principes* (Paris, 1708), pp. 14–17, quoted and discussed by Svetlana Alpers in "Describe or Narrate? A Problem in Realistic Representation," *New Literary History*, 8 (1976 –77), 26–27. The comparison is adapted by Diderot (*Essais*, p. 733), a point noted by Gita May, "Diderot et Roger De Piles," *PMLA*, 85 (1970), 454.

96. *Pensées détachées*, p. 765.

97. *Entretiens*, p. 102.

98. *Discours*, p. 230.

99. Ibid., p. 231.

100. Ibid.

101. Ibid., p. 266.

102. Ibid., p. 268.

103. Ibid., pp. 268–69.

104. *Entretiens*, p. 88.

105. *Entretiens*, p. 81.

106. With regard to the difference between the two points of view, see the discussion in chapter one of the device of the half-open drawer containing playing cards in Chardin's *Card Castle*. Cf. also Diderot's praise in the *Lettre sur les sourds et muets* for the scene in which the sleepwalking Lady Macbeth, her eyes shut, goes through the motions of washing her hands (pp. 47–48). The perspective of the *Entretiens* and the *Discours* suggests that the expressive power of those gestures derived in part from the fact that they were made by a character who was ostensibly asleep and therefore unconscious of being beheld.

107. *Pensées détachées*, p. 792.

108. Ibid., p. 767.

109. *Salons*, II, 66.

110. *Salons*, III, 94. Cf. also Diderot's proposed subject of "le modèle honnête" (the virtuous model) (ibid., 109–10); and his criticism of the figure of Lycurgus in Cochin's drawing, *Lycurgue blessé dans une sédition* (Salon of 1761, No. 148; *Salons*, I, 138–39).

111. *Salons*, II, 95.

112. Ibid., 105. The two statements just quoted concern paintings by Lagrenée and Bachelier respectively (Salon of 1765, Nos. 28 and 39). For a recent discussion of these and other versions of the subject see Robert Rosenblum, "Caritas Romana after 1760: Some Romantic Lactations," in Thomas B. Hess and Linda Nochlin, eds., *Art News Annual XXXVIII: Woman as Sex Object* (New York, 1972), pp. 43–63.

113. *Pensées détachées*, p. 794.

114. See also the discussion of Pierre's *Jugement de Paris* (Salon of 1761, No. 14; *Salons*, I, 114–15), and the remarks by Grimm (*Salons*, II, 102).

115. *Salons*, III, 94.

116. Ibid., 112. The picture is Lagrenée's *Le Dauphin mourant, environné de sa famille* (Salon of 1767, No. 19).

117. *Salons,* I, 208.

118. *Discours,* p. 258.

119. *Essais,* pp. 678, 683.

120. Ibid., p. 722.

121. *Salons,* III, 52–64.

122. Ibid., 339.

123. *Salons,* IV, 106. (See above, n. 20.)

124. *Salons,* III, 335.

125. *Essais,* p. 714.

126. *Pensées détachées,* p. 749.

127. *Salons,* III, 338.

128. *Essais,* p. 702.

129. Ibid., p. 713.

130. Ibid.

131. There is one statement to this effect in the *Discours:* "De quel secours le peintre ne serait-il pas à l'acteur, et l'acteur au peintre? Ce serait un moyen de perfectionner deux talents importants. Mais je jette ces vues pour ma satisfaction particulière et la vôtre. Je ne pense pas que nous aimions jamais assez les spectacles pour en venir là" (How helpful would the painter not be for the actor, and the actor for the painter? It would be a means of improving two important talents. But I explore these ideas for my own satisfaction and yours. I do not think we will ever care enough about the theater to go that far) (p. 277).

132. See for example *Salons,* I, 64; II, 197; IV, 167, 359. By Diderot's time the word *théâtral* had in addition to its primary meaning of pertaining to the theater the pejorative one of a mode of action or expression which "convient guère qu'au théâtre" (is suitable only for the theater) (*Dictionnaire de l'Académie françoise* [Lyon, 1777], II, 545). Or in the stronger language of the *Dictionnaire de Trévoux* ([Paris, 1743], VI, 191): "Le plus grand vice d'un Poëme Dramatique, est de n'avoir que des passions *théâtrales,* qui ne sont point naturelles, qui ne se voient que sur un théâtre" (The gravest fault of a dramatic poem is to have only *theatrical* passions, passions that are not natural, that are seen only on stage). But it is only in Diderot's writings on drama and painting that the *maniéré* and the *théâtral* are in effect defined in terms of a positing of even a single beholder.

Probably the nearest approach to Diderot's use of those and related concepts is by Shaftesbury, who in this regard as in others anticipates crucial aspects of Diderot's thought. See for example his "Plastics," an unfinished treatise which Diderot could not have known (*Second Characters,* pp. 89–178, esp. pp. 110, 128–29, 151–52); and idem, "A Notion of the Historical Draught of Hercules," chapter three, paragraph seven, which includes the remarks:

Whoever should expect to see our figure of Virtue, in the exact mein [*sic*] of a fine talker, curious in her choice of action, and forming it according to the usual decorum, and regular movement of one of the fair ladies of our age, would certainly be far wide of the thought and genius of this piece. Such studied action and artificial gesture may be allowed to the actors and actresses of the stage. But the good painter must come a little nearer to truth, and take care that his action be not theatrical, or at second hand; but original, and drawn from nature herself. (ibid., p. 45)

(The paragraph in question does not appear in the French original, but seems to have been added by Shaftesbury when he translated his treatise for publication in England.)

Shaftesbury's distaste for the theatrical in painting must be seen in the larger context of his struggles against, or with, theatricality generally. Thus in his "Advice to an Author" he advocates the use of the dialogue form on the grounds that whereas the author who writes in his own person tends to fall into affectation owing to a desire to seduce the reader, in the dialogue "the author is annihilated, and the reader, being no way applied to, stands for nobody. The self-interesting parties both vanish at once. The scene presents itself as by chance and undesigned" (John M. Robertson, ed., *Characteristics of Men, Manners, Opinions, Times* [New York, 1964], p. 132). But the project of annihilating author and reader turns out to be vastly more difficult than these remarks suggest. The obsessive concern of Shaftesbury, Defoe, Diderot, and other eighteenth-century writers with the problem of theatricality, especially as it bore upon the status of authorship and the production, dissemination, and consumption of written texts, is the subject of an outstanding recent dissertation by Dr. David Marshall, formerly a graduate student in the Humanities Center at the Johns Hopkins University. My discussion in Appendix B of passages from Rousseau's *Lettre sur les spectacles* and Goethe's *Die Wahlverwandtschaften* also touches on that topic.

133. *Pensées détachées*, p. 824.

134. Ibid., p. 825. The concept of *naïveté*, like that of the *théâtral*, was used often by previous writers on painting. But Diderot's redefinition of it in terms of causality and necessity amounts almost to the creation of a new word, as he was well aware. "Pour dire ce que je sens, il faut que je fasse un mot, ou du moins que j'étende l'acception d'un mot déjà fait; c'est *naïf*" (In order to say what I feel, I must create a word, or at least I must extend the accepted meaning of an already existing word, i.e., naive) (p. 824).

135. *Essais*, p. 701.

136. *Essais*, p. 671. Diderot does not adhere to this usage throughout the *Salons*, however.

137. On drawing from the model, on the false graces of the dancing master, and on the Academic principle of contrast, respectively:

Toutes ces positions académiques, contraintes, apprêtées, arrangées; toutes ces actions froidement et gauchement exprimées par un pauvre diable, et toujours par le même pauvre diable, gagé pour venir trois fois la semaine se déshabiller et se faire mannequiner par un professeur, qu'ont-elles de commun avec les positions et les actions de la nature? . . . Rien, mon ami, rien. (*Essais*, p. 669)

Sachez donc ce que c'est que la grâce, ou cette rigoureuse et précise conformité des membres avec la nature de l'action. Surtout ne la prenez point pour celle de l'acteur ou du maître à danser. La grâce de l'action et celle de Marcel se contredisent exactement. (ibid., pp. 701–02)

Le contraste mal entendu est une des plus funestes causes du maniéré. Il n'y a de véritable contraste que celui qui naît du fond de l'action, ou de la diversité, soit des organes, soit de l'intérêt. (ibid., p. 672)

All those academic, constrained, affected, arranged postures, all those actions expressed coldly and awkwardly by a poor devil, and always the same poor devil, hired to come three times a week to undress and be posed by a teacher—what do they have in common with the positions and actions of nature? . . . Nothing, my friend, nothing.

Know then what grace is, that rigorous and precise conformity of the limbs to the nature of the action. Above all do not mistake it for that of the actor or dancing master. The grace of action and that of Marcel are directly opposed.

Contrast badly understood is one of the most fatal causes of the mannered. There is no authentic contrast except that which derives from the essence of the action or from the diversity of organs or interest.

For a useful discussion of the role of drawing from the model in Academic teaching see James Henry Rubin, "Academic Life-Drawing in Eighteenth-Century France: An Introduction," in the catalogue for the exhibition, *Eighteenth-Century French Life-Drawing* (Princeton, Art Museum, April–May 1977), pp. 15–42.

138. *Vies d'artistes,* p. 132.

139. "Sur l'harmonie et sur la couleur," ibid., p. 141.

140. *Tableaux tirés de l'Iliade,* p. xxxvi. The italics are Caylus's.

141. *Salons,* III, 193. Casanove's painting is *Un Cavalier espagnol vêtu à l'ancienne mode* (Salon of 1767, No. 69). Cf. Diderot's remarks on landscape (ibid., 176).

142. This is an appropriate place at which to acknowledge that I shall not be discussing Diderot's most famous piece of writing on the theater, the *Paradoxe sur le comédien* (largely composed 1773–1778), in the present study. However, it is worth remarking that the valorization in the *Paradoxe* of the "comédien qui jouera de réflexion, d'étude de la nature humaine, d'imitation constante d'après quelque modèle idéal, d'imagination, de mémoire" (actor whose performance will be based on reflection, on the study of human nature, on the constant imitation of some ideal model, on imagination, on memory) (*Oeuvres esthétiques,* p. 307) by no means contradicts the vision of drama expounded in the *Entretiens* and the *Discours.* Rather, it confirms that vision while at the same time augmenting it with the more acute recognition of the conventionality of the arts of imitation that we find at work throughout the later *Salons* (cf. this chapter, n. 20). "Réfléchissez un moment sur ce qu'on appelle au théâtre *être vrai,*" urges Diderot's spokesman in the dialogue that takes up most of the *Paradoxe.* "Est-ce y montrer les choses comme elles sont en nature? Aucunement. Le vrai en ce sens ne serait que le commun. Qu'est-ce donc que le vrai de la scène? C'est la conformité des actions, des discours, de la figure, de la voix, du mouvement, du geste, avec un modèle idéal imaginé par le poète, et souvent exagéré par le comédien" (Reflect for a moment upon what it means in the theater *to be true.* Is it to present things as they are in nature? Not at all. The true in this sense would be merely vulgar. What then is the truth of the stage? It is the conformity of the actions, speeches, physique, voice, movement, and gesture with an ideal model imagined by the poet and often exaggerated by the actor) (p. 317). The kind of exaggeration referred to here is manifestly a function of the nature of the dramatic medium; while the notion of a "modèle idéal" leads back to the introduction of the *Salon de 1767,* where it is explored at length (cf. the allusion to the *Salons* and in particular to that introduction [pp. 340–41]). In general the *Paradoxe* undertakes to clear up what may have come to seem an ambiguity in the *Entretiens* and the *Discours,* both of which counselled the actor to ignore the presence of an audience. Now there are two different approaches which might be held to issue from such a recommendation: either an actor can seek to lose himself in a working up of the very emotions that he is called upon to represent; or he can concentrate his forces in an attempt to put into practice the ideal of performance summarized in the first of the quotations given above. The whole point of the *Paradoxe* is to argue for the rightness of the latter approach. Finally, it should be noted that the *Paradoxe* amounts to a characteristically vigorous and unpredictable development of the notion, implicit from the first in the Diderotian concept of the dramatic *tableau,* of a radical separation between the point of view of the actor and

that of the beholder—a separation dramatized by Diderot in his presentation of the love scene from Molière's *Dépit amoureux* as played by a married couple who detest each other and who intersperse their lines with scathing remarks pitched too low for the audience to hear (pp. 324–26). Largely because of when it was written—that is, relatively late in Diderot's career—the *Paradoxe* remains a much less significant text for the historian of painting than the *Entretiens* and the *Discours*.

143. The desire to promote de-theatricalized modes of beholding is a principal theme of a famous text by an author whose relations with Diderot have been the object of intensive study, Jean-Jacques Rousseau's *Lettre sur les spectacles* (1758). Here for example is the climax of the often quoted passage toward the end of the *Lettre*, in which Rousseau advocates the institution of the sort of public festivals that he considers almost the sole *spectacles* befitting a republic:

Mais quels seront enfin les objets de ces Spectacles? Qu'y montrera-t-on? Rien, si l'on veut. Avec la liberté, partout où regne l'affluence, le bien-être y regne aussi. Plantez au milieu d'une place un piquet couronné de fleurs, rassemblez-y le peuple, et vous aurez une fête. Faites mieux encore: donnez les spectateurs en spectacle; rendez-les acteurs eux-mêmes; faites que chacun se voie et s'aime dans les autres, afin que tous en soient mieux unis. (M. Fuchs, ed., *Lettre à Mr. D'Alembert sur les spectacles* [Geneva and Lille, 1948], pp. 168–69)

But what then will be the objects of these spectacles? What will be shown in them? Nothing, if you like. With liberty, wherever abundance reigns, well-being reigns as well. Plant in the middle of a square a pole crowned with flowers, bring the people together there, and you will have a festival. Do better still, make the beholders the spectacle; make them actors themselves; make each of them see himself and love himself in the others so that they will all be more closely united.

The importance to Rousseau of the festival as a medium of "transparency" is emphasized by Jean Starobinski, *La Transparence et l'obstacle, suivi de sept essais sur Rousseau* (Paris, 1971), esp. pp. 116–21. Cf. also idem, "Jean-Jacques Rousseau et le péril de la réflexion," *L'Oeil vivant* (Paris, 1961), pp. 91–188. For further discussion of the *Lettre sur les spectacles* see Appendix B.

144. See Michael Fried, "Thomas Couture and the Theatricalization of Action in 19th-Century French Painting," *Artforum*, 8, No. 10 (1970), 42–46; idem, "The Beholder in Courbet: His Early Self-Portraits and Their Place in His Art," *Glyph 4: Johns Hopkins Textual Studies* (1978), 85–129; and idem, "Manet's Sources," esp. nn. 27, 46, 69, 91, 98, 99, 106, 114. The persistence in nineteenth-century art criticism of the concerns analyzed in this chapter is demonstrated by the following example. In an article on the painter Millet who had recently died, the critic Ernest Chesneau observes approvingly that in Millet's oeuvre nothing *poses*—not men, nor animals, nor trees, nor blades of grass ("Jean-François Millet," *Gazette des Beaux-Arts*, 2e pér., 11 [1875], 434). And this observation, which Chesneau says everyone will have made, leads to a discussion of Millet's working procedure:

Millet,—je le tiens de ceux qui l'ont suivi de plus près, et le caractère de son dessin confirme le fait d'une manière absolue,—Millet ne peignait ni ne dessinait d'après nature. Il observait patiemment, longuement, avec insistance et à maintes reprises, le phénomène immobile ou le phénomène d'action qu'il se proposait de reproduire. L'ensemble de la scène et la successivité des attitudes et des mouvements se gravaient ainsi dans sa mémoire, secourue au besoin par une note de crayon prise à la volée. Contrairement aux doctrines professées par les écoles de réalité, chaque geste posé est un geste faussé et figé. Les preuves abondent qui condamnent, dans toute oeuvre de maître, la théorie du travail d'après le modèle. (435)

Millet—I have it from those who have followed him most closely, and the character of his

drawing absolutely confirms the fact—Millet neither painted nor drew from nature. He patiently, slowly, earnestly,and repeatedly observed the motionless or active phenomenon that he intended to reproduce. Thus the ensemble of the scene and the succession of postures and movements engraved themselves upon his memory, with the help, when necessary, of a note quickly jotted down in pencil. Contrary to the doctrines professed by realist schools, every posed gesture is false and strained. There exists abundant proof, in all works by masters, to condemn the theory of working from the model.

Millet's mastery of "sujets où l'activité du travail rustique est montrée dans toute son énergie" (subjects in which the activity of rural work is shown in all its energy) (ibid.) is for Chesneau a case in point since by their very nature such subjects involve bodily positions that cannot be stopped or held. But Chesneau's argument goes beyond works that depict movement or physical activity of one sort or another to include those that do not: "Je prends même les motifs reposés: le *Vigneron,* la *Méridienne,* le *Jardin de paysan.* S'il se sait observé, croyez-vous que ce vigneron gardera cet affaissement de tout le corps, cette cambrure des malléoles internes si caractéristique, cette bouche béante, ce regard atone et vide? Point du tout. A défaut de ses vêtements que vous lui aurez fait conserver, il endimanchera ses membres, ses muscles et sa physionomie" (Take even the figures at rest: the *Vine-Grower,* the *Midday Rest,* the *Peasant Garden.* If this vine-grower knows he is observed, do you think he will retain this sagging of his whole body, the very characteristic curve of his inner ankles, this gaping mouth, this dull and vacant look? Not at all. Apart from his clothes, which you will have him keep wearing, he will give his limbs, his muscles, and his countenance their Sunday-best look) (ibid.). In other words, while recognizing that Millet studied long and hard the phenomena he intended to represent, Chesneau maintains that by working from memory and not from the model the artist succeeded in removing himself from the scene as actually depicted. More generally, Chesneau equates what he regards as the exemplary truthfulness to nature of Millet's art with the impression of not being observed or beheld which the figures, animals, and even the objects depicted in that art seem to him to convey. Cf. also Félix Fénéon's analysis of Degas' drawings of women in "Les Impressionistes en 1886," in Françoise Cachin, ed., *Audelà de l'impressionisme* (Paris, 1966), p. 59.

145. On the role of genre considerations in Manet's paintings of the first half of the 1860s see Fried, "Manet's Sources," n. 228.

CHAPTER THREE

Painting and Beholder

1. *Essais,* pp. 712–13. Cf. also Diderot's proposal of the subject of *"Joseph expliquant son songe à ses frères* rangés autour de lui, en l'écoutant en silence" (*Joseph explaining his dream to his brothers* grouped around him and listening to him in silence) as an exercise in composition (*Pensées détachées,* p. 788).

2. Jean Locquin, "La Lutte des critiques d'art contre les portraitistes au XVIIIe siècle," *Mélanges offerts à M. Henry Lemonnier, Archives de l'art français,* nouv. pér., 7 (1913), 309–19.

3. See for example Diderot, *Salons,* I, 26, 224–25; II, 75; III, 116, 168–69, 317.

4. Locquin, "La Lutte des critiques d'art," 315–16.

5. No. 4. The original is at present in the Ecole des Arts Décoratifs in Paris; I have reproduced the replica at Versailles.

6. *Corr. litt.,* III, 432 (15 October 1757). Grimm describes the painting as follows:

On y voit Carle Van Loo occupé à peindre sa fille; à côté de lui, un de ses fils avec un portefeuille sous son bras, attentif aux opérations de son père, comme un jeune homme qui veut apprendre; à côté de Mlle Van Loo, un de ses frères cadets qui lui fait une niche pour l'empêcher de se tenir comme il faut; derrière elle, Mme Van Loo sa mère, avec un papier de musique à la main. On ne peut présenter au public les traits de cette femme célèbre sans lui rappeler ses talents pour le chant et pour la musique. . . . Ce tableau est charmant. (ibid.)

One sees in it Carle Van Loo engaged in painting his daughter. Next to him, one of his sons with a portfolio under his arm, attentive to his father's operations, like a young man who wants to learn. Next to Mlle. Van Loo, one of her younger brothers who plays a trick on her to prevent her from holding herself correctly. Behind her, her mother, Mme. Van Loo, with a sheet of music in her hand. The figure of this famous lady cannot be presented to the public without recalling her talents for singing and music. . . . The painting is charming.

Cf. Grimm's remarks more than two years earlier: "Un caractère solitaire peut . . . être un fait historique, mais il ne peut pas être un objet du roman; de même qu'en peinture, il peut être un portrait, mais rarement ou jamais un tableau" (A solitary character can . . . be a historical fact, but cannot be the subject of a novel. Just as in painting such a character can be a portrait, but rarely or never a *tableau*) (III, 29 [15 May 1755]).

7. "Exposition des ouvrages de peinture, de sculpture, & de gravure," *L'Année Littéraire* (1757), Tome V, p. 342.

8. No. 8.

9. *Salons,* III, 67.

10. Ibid.

11. *Correspondance,* III, 73 (17 September 1760). Diderot's remarks are quoted and the drawing is discussed by Herbert Dieckmann, "Description de portrait," *Diderot Studies II* (1952), pp. 6–8. I am grateful to Professor Dieckmann for making available to me a photograph of the drawing.

12. Once again Shaftesbury turns out to have anticipated aspects of later critical thought. Shortly before he died, Shaftesbury commissioned from the Neapolitan painter Paolo de Matteis, for whom the original version of "A Notion of the Historical Draught of Hercules" had been written, a "historical" portrait of himself seated in his library at Naples and dictating the text of "A Notion . . ." to a secretary. His conception of the portrait was in all respects absorptive. Thus he called for the "Philosophe valetudinaire" to be shown "en action de repos s'appuyant la tête sur une main comme Rêveur" (invalid philosopher [to be shown] in a state of rest, supporting his head with his hand as if in reverie); and for the secretary, who was to be only partly visible, to be portrayed pen in hand while directing toward the philosopher "un regard extrêmement sérieux et attentif . . ." (an extremely serious and attentive gaze) (quoted by J. E. Sweetman, "Shaftesbury's Last Commission," *Journal of the Warburg and Courtauld Institutes,* 19, Nos. 1–2 [1956], 110–11). In a subsequent letter Shaftesbury specified that the philosopher be depicted in the process of emerging from a state of meditation; noted that the "action forte du Secrétaire attentif et en oeuvre" (the strong action of the attentive secretary at work) would underscore the meditative character of the philosopher's activity; and directed that the latter's extremely weakened physical condition—Shaftesbury had less than a month to live—be suggested by placing in his left hand a lowered and half-open book about to drop from his grasp (111–12). Neither Diderot nor any of his contemporaries could have known

these letters, which Sweetman was the first to publish.

13. Nos. 15 and 67 respectively.

14. *Salons*, III, 76.

15. Ibid., 74.

16. Ibid., 82.

17. Ibid., 189–90.

18. Cf. his praise of that figure, ibid., 183–84.

19. Ibid., 77–78.

20. No. 160.

21. *Salons*, III, 297.

22. No. 154. For the identification of this work with the painting in the Walker Art Gallery see the exhibition catalogue by Rüdiger Joppien, *Philippe-Jacques de Louther-bourg, RA 1740–1812* (London, Kenwood, The Iveagh Bequest, June–August 1973), n. pag., Cat. No. 2.

23. *Salons*, I, 225–26.

24. Ibid., 226.

25. No. 144. The entry in the official *livret* goes on to say: "On y voit un Berger qui suspend sa Balalaye pour écouter un jeune garçon qui joue d'un chalumeau fait d'écorce d'arbre. La Balalaye est une espéce de Guitarre longue qui n'a que deux cordes, dont les Paysans Russes s'accompagnent fort agréablement" (One sees in it a shepherd who stops playing his balalaika in order to listen to a young boy playing a pipe made of bark. The balalaika is a type of long guitar that has only two strings, on which Russian peasants accompany themselves very pleasantly) (*Salons*, II, 39). On Le Prince's Russian subjects see Louis Réau, "L'Exotisme russe dans l'oeuvre de J.-B. Le Prince," *Gazette des Beaux-Arts*, 5e pér., 3 (1921), 147–65.

26. *Salons*, II, 173.

27. Ibid.

28. The fiction of being in the picture recurs a few pages later in Diderot's commentary on Le Prince's *Baptême russe* (not in the *livret*). The commentary begins:

Nous y voilà. Ma foi, c'est une belle cérémonie. Cette grande cuve baptismale d'argent, fait un bel effet. La fonction de ces trois prêtres qui sont tous les trois à droite, debout, a de la dignité. Le premier embrasse le nouveau-né par-dessus les bras, et le plonge par les pieds dans la cuve; le second, tient le Rituel, en lit les prières sacramentelles. Il lit bien, comme un vieillard doit lire, en éloignant le livre de ses yeux. Le troisième, regarde attentivement sur le livre; et ce quatrième qui répand des parfums dans une poêle ardente placée vers la cuve baptismale, ne remarquez-vous pas comme il est bien, richement et noblement vêtu? Comme son action est naturelle et vraie? (ibid., 179)

There we are. Upon my word, this is a beautiful ceremony. This large silver baptismal font produces a beautiful effect. The function of the three priests, who are all standing at the right, has dignity. The first embraces the new-born child's arms and is immersing him feet first into the font. The second holds the ritual book and is reading the sacramental prayers. He reads well, as an old man should, holding the book away from his eyes. The third gazes attentively into the book. And the fourth, who is pouring out perfumes into an incense burner near the font, do you not see how richly and nobly he is dressed? How natural and true his action is?

Such a passage does not quite sustain the notion that what it describes is actually taking place; and about a half-page further on Diderot acknowledges that he has been describing not an actual scene but a painting, after which he no longer purports to be discussing anything else:

Je veux dire que j'oubliois que je vous parle d'un tableau; et ce jeune acolyte qui étend sa main pour recevoir les vaisseaux d'huile sainte qu'un autre lui présente sur un plat, convenez qu'il est posé de la manière la plus simple et pourtant la plus élégante, qu'il étend son bras avec facilité et avec grace. . . . (ibid., 180)

I mean that I forgot that I am speaking to you about a painting. And that young acolyte who extends his hand to receive the vessels of holy oil that another one is presenting to him on a tray, you must admit that he is posed in the simplest and yet the most elegant manner, that he extends his arm with ease and grace. . . .

For these reasons I consider this passage something less than a full example of Diderot's use of the fiction of physically entering a painting or group of paintings. On the other hand, the absorptive character of the actions of the priests in the *Baptême russe* is a point of connection between it and the *Pastorale russe,* and helps account for such use of the fiction as we find in the passage just quoted. (See below, n. 48, for another instance of a partial or qualified use of the fiction, once again involving paintings by Le Prince.)

29. *Salons,* III, 128–29.

30. In this connection see the introduction and notes on individual works by Philip Conisbee in the catalogue for the exhibition, *Claude-Joseph Vernet, 1714–1789* (London, Kenwood, Iveagh Bequest; Paris, Musée de la Marine; June 1976–January 1977).

31. *Salons,* III, 129.

32. Ibid., 162–67, 129. For the influence on the Vernet and Robert sections of the *Salon de 1767* of Edmund Burke's *A Philosophical Enquiry into the Origin of Our Ideas of the Sublime and Beautiful* see Gita May, "Diderot and Burke: A Study in Aesthetic Affinity," *PMLA,* 75 (1960), 527–39.

33. All the paintings by Vernet exhibited in the Salon of 1767 are listed simply as "Plusieurs Tableaux" under No. 39 in the *livret.* My association of specific works with Diderot's descriptions of various sites is based on Seznec and Adhémar, eds., *Salons,* III, 23–24.

34. Ibid., 131.

35. Ibid., 133.

36. Ibid., 134–35.

37. Ibid., 139.

38. Ibid., 139–40.

39. Ibid., 151–52.

40. Ibid., 159.

41. Two recent discussions of the Robert section of the *Salon de 1767* are Anne Betty Weinshenker, "Diderot's Use of the Ruin-Image," *Diderot Studies XVI* (1973), pp. 309–29; and Roland Mortier, *La Poétique des ruines en France: ses origines, ses variations de la Renaissance à Victor Hugo* (Geneva, 1974), pp. 92–97.

42. No. 106. On balance Diderot seems to have regarded that painting as "le plus beau de ceux qu'il a exposés" (the most beautiful of those he exhibited) (*Salons,* III, 230).

43. Ibid., 228. Cf. also Diderot's observations a propos a few paintings by De Machy in the Salon of 1761 (No. 77): "En général il faut peu de figures dans les temples, dans les ruines et les paysages, lieux dont il ne faut presque point rompre le silence; mais on exige que ces figures soient exquises. Ce sont communément des gens ou qui passent, ou qui méditent, ou qui errent, ou qui habitent, ou qui se reposent. Ils

doivent le plus souvent vous incliner à la rêverie et à la mélancolie" (In general there should be few figures in temples, in ruins, and in landscapes, places where almost always the silence should not be broken. But what figures there are must be exquisite. They are usually people who are passing through, or meditating, or wandering, or living there, or resting. Most often they must incline you toward reverie and melancholy) (*Salons*, I, 130).

44. No. 101.

45. *Salons*, III, 235–36.

46. A number of sketches and drawings were grouped together as No. 112.

47. *Salons*, III, 245. Even in this sketch, however, the figures seemed to Diderot not to match "la perfection du reste" (the perfection of the rest) (ibid.).

48. There is however one brief passage that does not fit this generalization. Toward the middle of the Vernet section Diderot remarks: "On avait exposé deux tableaux qui concouraient pour un prix proposé: c'était un *Saint Barthélemy* sous le couteau des bourreaux. Une paysanne âgée décida les juges incertains: *Celui-ci,* dit la bonne femme, *me fait grand plaisir; mais cet autre me fait grande peine.* Le premier la laissait hors de la toile; le second l'y fesait entrer. Nous aimons le plaisir en personne, et la douleur en peinture" (Two paintings competing for a prize had been exhibited: the subject was St. Bartholomew under the knife of his executioners. An old peasant woman decided the uncertain judges. "This one," the old woman said, "gives me great pleasure, but the other causes me great pain." The first left her outside the canvas; the second made her enter it. We like pleasure in person and grief in painting) (*Salons*, III, 144). I know of no other instance in the *Salons* where the fiction of entering the painting is associated with a work in a "higher" genre, and regard the passage as a momentary lapse on Diderot's part rather than as a significant extension of the usage I have been trying to chart.

49. Almost immediately before the start of the Robert section Diderot begins a discussion of paintings by Le Prince with the statement: "C'est une assez bonne méthode pour décrire les tableaux, surtout champêtres, que d'entrer sur le lieu de la scène par le côté droit ou par le côté gauche, et s'avançant sur la bordure d'en bas, de décrire les objets à mesure qu'ils se présentent. Je suis bien fâché de ne m'en être pas avisé plutôt" (A pretty good method for describing paintings, especially pastoral ones, is to enter the scene on the right- or the left-hand side, and, advancing along the bottom edge, to describe objects as they present themselves to us. I am truly sorry I did not recognize this earlier) (ibid., 206). But his attempts to apply this method in the pages that follow are repeatedly frustrated by his perception of various faults in the paintings. Thus he begins describing one canvas as if it were a real scene that he has entered but soon is compelled to observe: "Les objets y sont si peu finis, si peu terminés, qu'on n'entend rien au fond. Si Le Prince n'y prend garde, s'il continue à se négliger sur le dessin, la couleur et les détails, comme il ne tentera jamais aucun de ses sujets qui attachent par l'action, les expressions et les caractères, il ne sera plus rien, mais rien du tout; et le mal est plus avancé qu'il ne croit" (The objects in it are so unfinished, so indeterminate, that we really do not understand anything. If Le Prince is not careful, if he continues to neglect drawing, color, and details, inasmuch as he will never attempt any of the subjects that attract the beholder by their action, expressions, and characters, he will no longer be anything, anything at all. And the disease is more advanced than he thinks) (206–07). Another work discussed a few pages further on gives Diderot the opportunity to describe as if they were actually

there a figure group consisting of two peasants listening to a third play a mandolin. But the commentary goes on to reveal Diderot's inability to use the fiction of physically entering the painting as a nonjudgmental descriptive technique: "Je continue mon chemin, je quitte à regret le musicien, parce que j'aime la musique, et que celui-ci a un air d'enthousiasme qui attache. Il s'ouvre à ma droite une percée d'où mon oeil s'égare dans le lointain. Si j'allais plus loin, j'entrerais dans un bocage; mais je suis arrêté par une large mare d'eaux qui me font sortir de la toile" (I go on my way, I leave the musician reluctantly, because I like music and because this musician has an air of enthusiasm that captivates. On my right a space opens up, through which my eye wanders in the distance. If I went further, I would enter a grove; but I am stopped by a large pond that forces me out of the canvas) (211). It is only a short step from the latter passage to the demand that certain sorts of paintings not allow him to remain outside them. That step is taken in the section on Robert.

50. "In fact, in its calmer form . . . the aesthetics of the ruin can express a minor form of idyll: a new union of man and nature, through the intermediary of man's resignation to death. 'The charm of the ruin,' writes Georg Simmel, 'resides in the fact that it presents a work of men while giving the impression of being a work of nature. . . . The upward thrust, the erection of the building, was the result of the human will, while its present appearance results from the mechanical force of nature, whose power of decay draws things downwards. . . . Consequently the ruin gives an impression of peace, because in it the opposition between these two cosmic powers acts as the soothing image of a purely natural reality'" (Jean Starobinski, *The Invention of Liberty: 1700–1789,* trans. Bernard C. Swift [Geneva, 1964], p. 180).

51. I have borrowed the terms "existential reverie" and *repos délicieux* from an important essay by Roland Mortier, "A Propos du sentiment de l'existence chez Diderot et Rousseau: notes sur un article de l'*Encyclopédie,*" *Diderot Studies VI* (1964), pp. 183–95. Mortier analyzes a passage from the article "Délicieux," written by Diderot and published in the fourth volume of the *Encyclopédie* in October 1754, in order to show that the evocation in that passage of the condition of *repos délicieux* is analogous to Rousseau's account of the experience of reverie in his *Dialogues* and *Rêveries du promeneur solitaire.* The passage is as follows:

Le repos a aussi son *délice;* mais qu'est-ce qu'un repos *délicieux?* Celui-là seul en a connu le charme inexprimable, dont les organes étaient sensibles & délicats; qui avait reçu de la nature une âme tendre & un tempérament voluptueux; qui jouissait d'une santé parfaite; qui se trouvait à la fleur de son âge; qui n'avait l'esprit troublé d'aucun nuage, l'âme agitée d'aucune émotion trop vive; qui sortait d'une fatigue douce & légère, & qui éprouvait dans toutes les parties de son corps un plaisir si également répandu, qu'il ne se faisait distinguer dans aucun. Il ne lui restait dans ce moment d'enchantement & de faiblesse, ni mémoire du passé, ni désir de l'avenir, ni inquiétude sur le présent. Le temps avait cessé de couler pour lui, parce qu'il existait tout en lui-même; le sentiment de son bonheur ne s'affaiblissait qu'avec celui de son existence. Il passait par un mouvement imperceptible, au milieu de la défaillance de toutes ses facultés, il veillait encore assez, sinon pour penser à quelque chose de distinct, du moins pour sentir toute la douceur de son existence: mais il en jouissait d'une jouissance tout à fait passive, sans y être attaché, sans y réfléchir, sans s'en réjouir, sans s'en féliciter. Si l'on pouvait fixer par la pensée cette situation de pur sentiment, où toutes les facultés du corps & de l'âme sont vivantes sans être agissantes, & attacher à ce quiétisme *délicieux* l'idée d'immutabilité, on se formerait la notion du bonheur le plus grand & le plus pur que l'homme puisse imaginer. (*Oeuvres complètes,* VII, 9)

Repose also has its *deliciousness;* but what is a *delicious* repose? Only he has known its inexpressible charm whose organs were sensitive and delicate; who had received from nature a

tender soul and a voluptuous temperament; who enjoyed perfect health; who was in the prime of life; whose mind was untroubled by the slightest cloud, whose soul was not agitated by any overly strong emotion; who was coming out of a sweet and light weariness, and who felt in all the parts of his body a pleasure so evenly distributed that it was distinguishable in none. At that moment of enchantment and weakness, he no longer had any memory of the past, nor desire for the future, nor worry about the present. Time had ceased to flow for him, because he existed wholly in himself; the feeling of his happiness weakened only with that of his existence. He gradually passed from one state to another, amid the swooning of all his faculties, he was still awake enough, if not to think of something distinct, at least to feel all the sweetness of his existence. But he enjoyed it with a completely passive enjoyment, without being caught up in it, without thinking about it, without taking pride in it. If one could express in thought this situation of pure feeling, in which all the faculties of the body and the soul are alive without being active, and if one could associate with this *delicious* quietism the idea of immutability, one would construct a notion of the greatest and purest happiness that man can imagine.

It is as though the works we have been discussing seemed to Diderot to succeed precisely in joining to a "quiétisme *délicieux*" the idea of the immutability or unchangingness of the paintings themselves.

52. Thus I have argued in chapter two that, for Diderot, dramatic considerations applied even to Chardin's still lifes, and that the enormous distinction of Loutherbourg and Vernet as painters of landscapes with figures seemed to him to consist above all in their ability to create the dramatic illusion of the causal necessity of nature (e.g., through the medium of *clair-obscur*). The point is made even more explicit in Diderot's insistence in the course of the first *promenade* in the Vernet section of the *Salon de 1767* that the entire observable universe, which in this case turns out to be the creation of the artist Vernet, is in essence a causal system in perpetual flux (*Salons*, III, 132–37). And we have just seen that the treatment of figures engaged in absorptive activities played a considerable role in determining Diderot's response to the paintings by Loutherbourg, Le Prince, and Vernet that he most admired. In other words, no absolute distinction can be drawn between the two conceptions, both of which, I am now arguing, have a common end in view. (For more on the relations between those conceptions see my analysis of Diderot's commentary on Fragonard's *Corésus et Callirhoé*, coming up presently.) In this connection it may be noted that Loutherbourg in the 1770s and 1780s pursued a highly successful career as a stage designer in London. Perhaps more relevant to our discussion is his invention in 1781 of the Eidophusikon, a miniature theater without actors that foreshadowed in some respects the dioramas of the early nineteenth century. Among the scenes presented by Loutherbourg to the public were "Various Imitations of Natural Phenomena, represented by Moving Pictures" (quoted by Sybil Rosenfeld, "The *Eidophusikon* Illustrated," *Theatre Notebook*, 18, No. 2 [1963], 52–54).

53. On Rosa and Vernet see Philip Conisbee, "Salvator Rosa and Claude-Joseph Vernet," *Burlington Magazine*, 115 (1973), 789–94; and for a more general consideration of influences on Vernet's art see Conisbee's introduction, *Claude-Joseph Vernet*.

54. *Claude-Joseph Vernet*, Cat. No. 15 (London), Cat. No. 17 (Paris). On that painting see also Pierre Rosenberg, "La Donation Pereire," *La Revue du Louvre et des musées de France*, 25, No. 4 (1975), 260–63.

55. That double concern is amply documented in letters exchanged by Vernet and Marigny during those years. See Jules Guiffrey, "Correspondance de Joseph Vernet avec le Directeur des bâtiments sur la collection des Ports de France. . . .," *Nouvelles archives de l'art français*, 3e sér., IX (1893), pp. 1–99. Interestingly, Vernet's first

Ports seem to have been criticized for lacking a truly perspicuous mode of unity and in particular for dispersing the viewer's attention among the multitude of figures, operations, and objects the scrupulously exact representation of which was a principal aim of the commission. This emerges in Grimm's discussion of the Salon of 1755:

M. Vernet, si fameux ici pour son talent de peindre le paysage et les marines, a exposé quatre très-grands tableaux représentant: l'un *l'Intérieur du port de Marseille;* l'autre *l'Entrée du même port;* le troisième *le Port neuf ou l'Arsenal de Toulon;* le quatrième *la Madrague, ou la Pêche du thon.* Ces tableaux, d'un détail immense et d'une exécution prodigieuse, n'ont pas eu un très-grand succès. Les connaisseurs y ont trouvé peu d'entente de la lumière et de ses effets; ils ont trouvé trop de confusion dans le grand nombre de figures qui sont sur le devant de ses tableaux. L'art de grouper heureusement ne paraît pas trop familier à M. Vernet; il n'est pas aisé de faire des tableaux où il y ait beaucoup de mouvement sans unité d'action. Le grand secret du peintre consiste alors à rendre le chaos et la confusion sans confusion. Il me semble cependant qu'on a jugé M. Vernet trop sévèrement. On n'a pas réfléchi que, dans l'exécution de ses tableaux, il a été obligé de renoncer à son imagination pour ne peindre que ce qui est. Cet inconvénient est beaucoup plus grand qu'on ne pense d'abord. Le mérite de l'imagination de l'artiste et le travail de la composition pittoresque consistent, non à copier la nature telle qu'elle est en tel endroit, mais à rassembler plusieurs de ses effets et à en composer un tout heureux; voilà ce qui s'appelle imiter la nature. (*Corr. litt.*, III, 93)

M. Vernet, so famous here for his talent for painting landscapes and seascapes, has exhibited four very large paintings representing the *Interior of the Port of Marseilles,* the *Entrance to the Same Port,* the *New Port or the Arsenal of Toulon,* and *The Pen, or Tuna Fishing.* These paintings, with their immense quantity of detail and their prodigious execution, have not had great success. The connoisseurs have found them wanting as regards the harmony of the light and its effects; and they have found too much confusion in the multitude of figures who occupy the foregrounds. The art of grouping his figures successfully seems somewhat unfamiliar to M. Vernet; it is not easy to make paintings in which there is a lot of movement without unity of action. The great secret of the painter consists then in rendering chaos and confusion without confusion However, it seems to me that M. Vernet has been judged too severely. It has not been recognized that, in executing his paintings, he has been obliged to renounce his imagination in favor of painting things as they are. This is a greater inconvenience than might at first be thought. The merit of the artist's imagination and the work of pictorial composition consist, not in copying nature as it is here or there, but in bringing together several of its effects and in composing from the latter a successful whole. That is what is called imitating nature.

See also the brief remarks on Vernet's *Ports* in the same Salon by Baillet de Saint-Julien, *Lettre à un partisan du bon gout sur l'exposition des tableaux faite dans le grand sallon du Louvre le 28 aout 1755,* pp. 8–9.

56. No. 89. *Claude-Joseph Vernet,* Cat. No. 37 (London), Cat. No. 49 (Paris). The painting is dated 1762.

57. In the words of the anonymous reviewer of the Salon of 1763 for the *Mercure de France:* "Le spectateur distingue chaque partie de ces admirables compositions; il marche dans les chemins qui y sont tracés; il est prêt à aller à bord avec les Matelots; il parcourt les Atteliers, voit les différents manoeuvres, il converse avec les personnages dont les Figures ingénieusement grouppées, donnent de la vie & du mouvement à ces chefs d'oeuvre de l'Art" (The beholder distinguishes each part of these admirable compositions. He walks in the roads which are traced there; he is ready to go on board with the sailors; he visits the workshops, sees the different manoeuvres, and converses with the personages whose figures, ingeniously grouped, give life and movement to these masterpieces of the art) (quoted in *Claude-Joseph Vernet* [Paris], p. 88).

58. One further quotation is revealing in this connection. In a passage recounting his travels through the third site, Diderot tells how he and his companions sailed in a

boat across a body of water back to the chateau from which they had originally set out:

[N]ous voilà embarqués et vingt lorgnettes d'opéra braquées sur nous, et notre arrivée saluée par des cris de joie qui partaient de la terrasse et du sommet du château: nous y répondîmes, selon l'usage. Le ciel était serein, le vent soufflait du rivage vers le château, et nous fîmes le trajet en un clin d'oeil. Je vous raconte simplement la chose; dans un moment plus poétique j'aurais déchaîné les vents, soulevé les flots, montré la petite nacelle tantôt voisine des nues, tantôt précipitée au fond des abymes, vous auriez frémi pour l'instituteur, ses jeunes élèves et le vieux philosophe votre ami. J'aurais porté de la terrasse à vos oreilles les cris des femmes éplorées, vous auriez vu sur l'esplanade du château des mains levées vers le ciel, mais il n'y aurait pas eu un mot de vrai. Le fait est que nous n'éprouvâmes d'autre tempête que celle du premier livre de Virgile, que l'un des élèves de l'abbé nous récita par coeur; et telle fut la fin de notre première sortie ou promenade. (*Salons*, III, 138)

There we were embarked, with twenty opera-glasses trained on us, and our arrival greeted with cries of joy rising from the terrace and from the top of the chateau. We responded to them according to custom. The sky was serene, the wind was blowing off the water toward the chateau, and we completed the crossing in the wink of an eye. I am simply telling you what happened. In a more poetical moment, I would have unleashed the winds and incited the waves; I would have shown the small skiff now close to the clouds, now hurled down to the bottom of abysses. You would have shuddered for the schoolmaster, his young students, and your old friend the philosopher. I would have brought from the terrace to your ears the cries of weeping women, you would have seen on the esplanade of the chateau hands raised to the sky, but not one word of this would have been true. The fact is that we did not experience any tempest except that of the first book in Virgil, which one of the *abbé*'s students recited to us by heart. And that was the end of our first excursion or promenade.

As I read the passage, Diderot by his insistence that the voyage was accomplished "en un clin d'oeil" acknowledges the extent to which, as I have put it, solicitations such as that of the chateau across the water were subsumed within a unified and immediately apprehensible decorative scheme; that is, he acknowledges that the realms of the decorative and the imaginary were not wholly disjoined and uncommunicating but that his actual experience of the painting involved modulating ("voyaging") between the two. The reference to the storm in the *Aeneid* is a further complication. In an obvious sense, it alludes to another temporal process, that of reading or reciting; but it does so in terms that leave us uncertain whether the outcome of that process—the depiction of the storm—is to be understood as valorizing instantaneousness or duration or indeed some combination of the two.

59. In "Thomas Couture and the Theatricalization of Action in 19th-Century French Painting" (*Artforum*, 8, No. 10 [1970]), I argue that the major changes that David's art underwent between the 1780s and 1814 can be understood in these terms. For example, I recount how by the second half of the 1790s David came to see the composition of the *Horaces* itself as *théâtral*, and attempted in the *Sabines* to avoid this fault by suspending the action and reducing overt expression to a minimum. More generally, I claim that the evolution of David's art from the *Horaces* and other history paintings of the 1780s to the *Sabines* and the *Léonidas* reveals:

a drastic loss of conviction in action and expression as resources for ambitious painting, if not in fact a loss of confidence in the non-theatricality, which is to say the self-sufficiency, of action and expression as such. Only the most inward and spiritualized action, David seems to have come to feel, escaped being theatrical; only action that no longer engaged with the world, either physically or temporally, could express its meaning purely, self-sufficiently, other than as theater. If this is true, then David's history paintings record the expansion with a vengeance of the realm (the world?) of the theatrical. (41–42)

(See also chapter one, n. 138; and the discussion in Appendix C of David's *Homer* drawings of 1794.) In almost all David's late "Anacreonic" paintings, however, the presence of the beholder is frankly acknowledged and the *mise-en-scène* assumes a more or less blatantly theatrical character. This suggests that as early as 1809, the date of the *Sapho, Phaon, et l'Amour,* David, recognizing that it was becoming impossible for him to establish the fiction of the beholder's nonexistence, began to cast about for a subject matter and a mode of presentation that would allow him to embrace at least a version of the theatrical with open arms. The whole question of the significance of the "Anacreonic" paintings, which historians of David's art have continued to find deeply puzzling, should be reconsidered in this light.

60. Three authors who have insisted on this point are Sainte-Beuve, Locquin, and Folkierski, the last in "L'Etat présent des recherches sur les rapports entre les lettres et les arts figuratifs au XVIIIe siècle," in *Actes du Ve congrès international des langues et littératures modernes* (Florence, 1955), pp. 238–39. Much of the available evidence concerns Mme. Necker, whose relations with Diderot were particularly close in the 1770s. Thus Diderot in the *Paradoxe sur le comédien* mentions that his *Salons* have been read and admired by her and Suard (*Oeuvres esthétiques,* p. 340); in a letter of 6 September 1774 to Mme. Necker he alludes to her having been shown at least a few of the *Salons* (*Correspondance,* XIV, 77; cited by Locquin, *La Peinture d'histoire en France de 1747 à 1785* [Paris, 1912], p. 141, n. 2); and in a letter of roughly the same moment to Grimm, Mme. Necker writes: "Je suis enchantée de ses *Salons.* Je n'avois jamais vu dans les tableaux que des couleurs plates et inanimées. Son imagination leur a donné pour moi du relief et de la vie. C'est presque un nouveau sens que je dois à son génie" (I am enchanted by his *Salons.* I had never seen in painting anything but flat and lifeless colors. His imagination has given them depth and life for me. It is almost a new sense that I owe to his genius) (ibid., 94). Mme. Necker's remarks are quoted by Sainte-Beuve, who goes on to report a story which, whether or not literally true, demonstrates that as of the middle of the nineteenth century the notion that Diderot and David actually knew each other was still alive:

Diderot ne fut pas moins secourable et profitable aux artistes qu'au public. On m'a raconté que David, le grand chef d'école, sinon le grand peintre, ne parlait de Diderot qu'avec reconnaissance. Les débuts de David avaient été pénibles, il avait échoué jusqu'à deux et trois fois dans ses premières luttes. Diderot, qui hantait les ateliers, arrive dans celui de David: il voit un tableau que le peintre achevait; il l'admire, il l'explique, il y voit des pensées, des intentions grandioses. David l'écoute, et lui avoue qu'il n'a pas eu toutes ces belles idées. "Quoi! s'écrie Diderot, c'est à votre insu, c'est d'instinct que vous avez procédé ainsi; c'est encore mieux!" Et il motive son admiration de plus belle. Cette chaleur d'accueil, de la part d'un homme célèbre, rendit courage à David, et fut pour son talent un bienfait. ("Diderot," *Causeries du lundi,* 3e éd., III [Paris, n.d.], 309–10)

Diderot was no less helpful and profitable to the artists than to the public. I have been told that David, the great teacher if not the great painter, spoke of Diderot only with gratitude. David's beginnings had been laborious, he had failed up to two or three times in his first struggles. Diderot, who frequented studios, arrives at David's. He sees a painting that the painter was finishing. He admires it, he explains it, he sees grandiose thoughts and intentions in it. David listens to him and admits that he did not have all these beautiful ideas. "What!" Diderot exclaims, "you have done all that unknowingly, by instinct, that's even better!" And he justifies his admiration with renewed ardor. Such a warm reception from such a famous man restored David's courage and was beneficial to his talent.

Another piece of evidence for the circulation in the 1770s of one or more *Salons* may be cited. In an account of the Salon of 1773, Samuel Du Pont de Nemours

alludes to "la charmante idée de M. Diderot des pigeons de Vénus qui font leur nid dans le casque de Mars" (M. Diderot's charming idea of Venus's pigeons nesting in Mars's helmet) (Dr. Karl Obser with Gaston Brière and Maurice Tourneux, eds., *Lettres de Du Pont de Nemours à la Margrave Caroline-Louise de Bade sur les salons de 1773, 1777, 1779* [Paris, 1909], p. 17), a subject proposed by Diderot in his *Salon de 1767*. In addition, Du Pont in his commentary on the Salon of 1779 refers to a painting by La Grenée as having been "durement critiqué par M. Diderot" (severely criticized by M. Diderot) (ibid., p. 69), a remark that presumably reflects a conversation between the two men.

A striking instance of the use of Diderot's ideas on painting before the second half of the 1790s is André Chénier's article, "Sur la peinture d'histoire," in the *Journal de Paris* of 20 March 1792 (Gérard Walter, ed., *Oeuvres complètes* [Paris, 1958], pp. 284–88). Chénier makes the case for David's preeminence among his contemporaries in phrases and arguments that seem plainly to derive from Diderot. David and Chénier, later political enemies, were friends during the later 1780s, and it appears likely that Chénier's article provides valuable insight into the terms in which David himself thought about his art at that time. A further link between them was the Trudaine family, where Diderot had earlier visited and for whom David painted the *Mort de Socrate*, a thoroughly Diderotian work, as Seznec and others have remarked (see Seznec, *Essais sur Diderot et l'antiquité* [Oxford, 1957], pp. 15–20).

61. Between 1769 and 1775 David was a member of Sedaine's household. The playwright is said to have treated the young painter virtually as a son. In the words of Mme. de Vandeul (Diderot's daughter): "Il avait aimé David dans sa jeunesse avec une tendresse infinie, parce qu'il s'était créé lui-même la supériorité de son art. Il avait pressenti le talent de l'enfant, il était fier de ses succès. Son attachement pour lui était tel que beaucoup de gens le croyaient son fils, mais Mme Sedaine m'a assuré qu'il n'en était rien" (He had loved the young David with infinite tenderness because David had created for himself the superiority of his art. He had had a presentiment of the child's talent, he was proud of his successes. His affection for him was such that many people thought David was his son, but Mme. Sedaine assured me that it was not so) ("Notice historique sur Sedaine," *Corr. litt.,* XVI, 243). Sedaine's most famous play, *Le Philosophe sans le savoir* (1765), was written to avenge Diderot and the *philosophe* party generally against the slanders of Palissot (see Ira Owen Wade, "The Title of Sedaine's *Le Philosophe sans le savoir,*" *PMLA,* 43 [1928], 1031–32). That play is also widely understood as an attempt to put into practice Diderot's dramatic theories (ibid., 1029–32), and on the occasion of its first performances it was hailed by Diderot as a masterpiece (*Correspondance,* V, 210–12, 223–30). By the time David came to live with Sedaine, the playwright and the *philosophe* had for years been friends and mutual admirers. We know too that Diderot frequented Sedaine's Monday gatherings of friends and colleagues (see Mme. de Vandeul, "Notice historique sur Sedaine," 242). In short the young David would have had ample opportunity to meet Diderot socially and to become exposed to his ideas. In this connection the opening sentence of Diderot's commentary in his *Salon de 1781* on David's *Bélisaire,* a paraphrase of lines from *Bérénice*—"Tous les jours je le vois et crois toujours le voir pour la première fois" (Every day I see it [him] and think I see it [him] for the first time) (*Salons,* IV, 377)—may have special significance. The sentence is usually read as referring to David's painting; but it seems to me at least conceivable that it is meant to refer instead, or as well, to David himself, whose emergence in that Salon as

one of the leading painters of his generation must have given Diderot considerable satisfaction. It should also be noted that following the success of the *Bélisaire* in the Salon of 1781, David received *chez* Sedaine the visits of amateurs of painting, his own apartment being unsuitable for that purpose (Louis Hautecoeur, *Louis David* [Paris, 1954], p. 60).

62. One biographical fact about Fragonard deserves emphasis—his friendship and close artistic association with his almost exact contemporary, Hubert Robert. The two artists often drew in each other's company in Rome in the late 1750s and early 1760s, and both were patronized there and elsewhere in Italy by an enthusiastic collector and engraver, the Abbé de Saint-Non. It is therefore appropriate that Diderot's use of the fiction of physically entering the picture in connection with Robert's paintings of ruins is not without relevance to Fragonard's art. For details of the Fragonard-Robert-Saint-Non association see Georges Wildenstein, *The Paintings of Fragonard,* trans. C. W. Chilton and Mrs. A. L. Kitson (New York, 1960), pp. 7–9, 13. Cf. also Levey and Kalnein, *Art and Architecture of the Eighteenth Century in France* (Harmondsworth, 1972), pp. 178–84.

63. Alexandre Ananoff, *L'Oeuvre dessiné de Jean-Honoré Fragonard (1732–1806),* I (Paris, 1961), Cat. No. 61. Starobinski quotes Claudel on that drawing in *The Invention of Liberty,* p. 125.

64. Wildenstein, *The Paintings of Fragonard,* Cat. Nos. 202, 386, 387, 391.

65. Ibid., Cat. Nos. 272, 287, 390, 491, 496.

66. Ibid., Cat. No. 250. On the identification of the sitter as Diderot see Pierre Rosenberg and Isabelle Compin, "Quatre nouveaux Fragonard au Louvre (I)," *La Revue du Louvre et des musées de France,* 24, No. 3 (1974), 186–88. The best general discussion of the *portraits de fantaisie* to date is by Charles Sterling, *An Unknown Masterpiece by Fragonard* (Williamstown, Mass., Sterling and Francine Clark Art Institute, 1964). Sterling's short essay is chiefly concerned with Fragonard's *Portrait of a Man (The Warrior),* a painting not cited in Wildenstein's monograph on the painter. According to Sterling, there are fourteen *portraits de fantaisie* in all; the others, in addition to the presumed portrait of Diderot, are catalogued by Wildenstein under the numbers 239–47, 254, 256, and 342. "Excepting the female portraits whose attitudes are not impetuous," Sterling writes, "all the sitters appear to be possessed by an interior force which obliges them to turn their heads, cast a far-off look as if pursuing a thought or a dream: they are obeying the imperious command of their personal genius" (n. pag.).

67. Ibid., Cat. Nos. 85, 210, 211.

68. See the last two paragraphs of the essay on Fragonard in *L'Art du dix-huitième siècle.*

69. Ten such drawings originally belonging to Saint-Non are reproduced in the catalogue of the *Collection Pierre-Adrien Pâris* (Besançon, 1957), Cat. Nos. 32–41.

70. Ananoff, *L'Oeuvre dessiné,* II (Paris, 1963), Cat. No. 894; *Collection Pierre-Adrien Pâris,* Cat. No. 32.

71. Wildenstein, *The Paintings of Fragonard,* Cat. Nos. 447 and 448. The supreme landscape with figures of this period is of course the *Fête at Saint-Cloud* (ibid., Cat. No. 436). "It is no exaggeration," Levey writes, "to say that the gardens of the Villa d'Este haunt all Fragonard's later landscapes . . ." (*Art and Architecture,* p. 180).

72. Ibid., Cat. No. 306; also known as *The Declaration of Love, The Souvenirs,* and *The Love Letters.* For an account of Mme. du Barry's rejection of Fragonard's ensemble

in favor of paintings by Vien, see Franklin M. Biebel, "Fragonard and Madame du Barry," *Gazette des Beaux-Arts,* 6e pér., 56 (1960), 207–26. Biebel's contention that Mme. du Barry found Fragonard's canvases stylistically retardataire and that her choice of Vien represents a triumph for Neoclassic taste has won general acceptance. The most persuasive reconstruction of the ensemble in relation to its intended destination is by Donald Posner, "The True Path of Fragonard's 'Progress of Love'," *Burlington Magazine,* 114 (1972), 526–34. See also the discussion of the ensemble in *The Frick Collection: An Illustrated Catalogue* (New York, 1968), II, 94–120.

73. At any rate, there exists a considerable body of writing which, although not mentioning Fragonard by name, suggests that eighteenth-century audiences may have been inclined to view his art in those terms. For an interesting discussion of contemporary theories of imaginative expansion even of formally completed works of art and literature see Eric Rothstein, "'Ideal Presence' and the 'Non Finito' in Eighteenth-Century Aesthetics," *Eighteenth-Century Studies,* 9 (1976), 307–32. I might note that Rothstein regards as instances of such expansion Diderot's treatment *both* of Greuze's *Piété filiale* and of Loutherbourg's *Paysage avec figures et animaux* (318); this makes sense within the context of his rather general argument, but it fails to register the distinction crucial to mine between Diderot's dramatic and pastoral conceptions of painting. By the same token, the theories of imaginative expansion analyzed by Rothstein are drawn more or less equally from French and English sources, whereas the problematic of absorption and theatricality with which I am concerned appears to have been indigenous to France. The special significance of the sketch for eighteenth-century theorists of the non finito is discussed briefly by Rothstein on 326–27.

74. No. 176. Wildenstein, *The Paintings of Fragonard,* Cat. No. 225.

75. *Salons,* II, 188–98.

76. The subject appears to have been based on the libretto by Pierre-Charles Roy for *Callirhoé,* an opera (or "tragédie-lyrique"), first performed in 1712 and revived on various occasions thereafter. The ultimate source for the story is Pausanias, *Description of Greece,* bk. VII, ch. xxi.

77. *Salons,* II, 195.

78. There is an obvious affinity between Diderot's account of the projection of speaking colored images on a screen—an idea doubtless extrapolated from his acquaintance with magic lanterns—and the modern cinema. But I am thinking as well of the similarity between other aspects of his commentary on the *Corésus et Callirhoé*—e.g., his use of the fiction of dreaming, his description of his physical immobilization in the cave (a detail clearly derived from Plato), and his characterization of the projected images as *fantômes*—and the analysis by modern theorists of the cinema, notably Stanley Cavell, of the relation of the film audience to the object of its experience. See Cavell, *The World Viewed: Reflections on the Ontology of Film* (New York, 1971), esp. pp. 25–27, where the "helplessness" of the viewer is said to be "mechanically assured"; pp. 101–02, where movies are compared with and distinguished from dreams and fantasies; p. 155, where it is said of the experience of film that "as in Plato's Cave, reality is *behind* you"; and pp. 162–63, where it is claimed that "projected images are not shadows; rather, one might say, they are shades." The film-audience relation is also discussed in a long essay by Cavell, "More of *The World Viewed*," *The Georgia Review,* 28 (1974), 571–631. Cf. Francis Macdonald Cornford's remarks in his translation of *The Republic of Plato* (1941; rpt. New York, 1966): "A

modern Plato would compare his Cave to an underground cinema, where the audience watch the play of shadows thrown by the film passing before a light at their backs" (p. 228, n. 2).

79. *Salons,* II, 198.

80. It does this in part by emphasizing the intensely absorptive character of some of the *tableaux* which, we are told, led up to the climactic one (i.e., Fragonard's). Thus Diderot, after describing the temple in which the main action is to take place, goes on to report the arrival of a young acolyte dressed in white and with an "air triste" (sad air) followed by a priest: "Ce prêtre avoit les bras croisés sur la poitrine, la tête tout-à-fait penchée. Il paroissoit absorbé dans la douleur et la réflexion la plus profonde; il s'avançoit à pas lents. J'attendois qu'il relevât sa tête; il le fit en tournant les yeux vers le ciel et poussant l'exclamation la plus douloureuse, que j'accompagnai moi-même d'un cri, quand je reconnus ce prêtre" (This priest had his arms crossed on his chest, his head completely bent. He seemed absorbed in grief and in the deepest reflection; he walked with slow steps. I waited for him to raise his head; he did so, turning his eyes to the sky and uttering the most painful exclamation, which I myself accompanied with a cry when I recognized this priest) (ibid., 192). I see in Diderot's description of the priest's behavior—in his provision of an absorptive ontogeny for the climactic *tableau*—an acknowledgment of the extent to which the very expressiveness of Fragonard's painting seemed to him grounded in what I have called the primacy of absorption.

81. There is only one remotely comparable passage in the *Salons.* At the end of the Vernet section of the *Salon de 1767* Diderot recounts two highly emotional and dramatic dreams of shipwreck, which, although clearly based upon similar scenes by Vernet, are not presented as fictionalized versions of paintings (*Salons,* III, 162–65). Diderot's accounts of those dreams are part of a discussion of the intensity of sensation in dreaming, a discussion analyzed by Aram Vartanian. Summarizing Diderot's views, Vartanian writes: "The finality of sense-experience is ironically strongest when the senses are actually dormant. Thus the *naïveté* of the dream restores the cognitive conditions of an original materialism—of a primitive receptivity by which the mind accepts things *as they present themselves vividly to it,* overcoming through the immediacy of perception—by an act of visual faith—the overlucid subtleties of dualistic or subjectivistic metaphysics" ("Diderot and the Phenomenology of the Dream," *Diderot Studies VIII* [1966], pp. 250–51). In the terms developed in this book one might say that dreaming restores the cognitive conditions of a *pre*-theatricalized mode of perception.

I am further tempted to suggest that the medium of film may be thought of as routinely or mechanically capable of embracing the dramatic and pastoral conceptions of painting, that is, of providing an equivalent for the beholder's simultaneous exclusion from and presence within the scene of representation.

82. The painting is in the Devonshire Collection at Chatsworth. It was engraved in the seventeenth century by Gerard Scotin the Younger and again in the eighteenth century (I suspect from Scotin's engraving, which the later version reverses) by one Louis Bosse. I have chosen to reproduce the engraving by Bosse because its placing of Belisarius on the right facilitates comparison with David's *Bélisaire* of 1781; it is impossible to know which of the engravings Diderot had in mind. Already in the eighteenth century the attribution of the painting to Van Dyck had been called into question. "[Walpole] speaks of the Belisarius as a doubtful work, and in this opinion

the Writer fully coincides" (John Smith, *A Catalogue Raisonné of the Works of the Most Eminent Dutch, Flemish and French Painters*, III [London, 1831], 80–81, Cat. No. 265). Later authors such as Lionel Cust, *Anthony Van Dyck* (London, 1900), and Emil Shaeffer, *Van Dyck*, Klassiker der Kunst (Stuttgart and Leipzig, 1909), do not include the *Belisarius* among Van Dyck's authentic works. An exception to this widespread skepticism is Jules Guiffrey, *Antoine Van Dyck* (Paris, 1882), p. 146, Cat. No. 276. For the attribution to Borzone see Camillo Manzitti, "Influenze Caravaggesche a Genova e nuovi ritrovamenti su Luciano Borzone," *Paragone*, 12 (September 1971), 31–42, esp. 36–37. I am grateful to Professor Zirka Filipczak for her guidance through the secondary literature on Van Dyck.

83. Sources for the following very summary account of Belisarius's career and subsequent memorialization in literature and art include Procopius of Caesaria, *History of the Wars*, trans. H. B. Dewing, 6 vols. (New York, London, and Cambridge, Mass., 1914–1954); Edward Gibbon, *The Decline and Fall of the Roman Empire*, ed. J. B. Bury, IV (London, 1898); the article "Belisarius" in the eleventh and fifteenth editions of the *Encyclopaedia Britannica;* and Francis A. De Cato, "The Belisarius Theme in England and France, 1767–1802" (unpublished paper, the Johns Hopkins University, 1974).

84. For the *Bélisaire* controversy see John Renwick, "Reconstruction and Interpretation of the Genesis of the *Bélisaire* Affair, with an Unpublished Letter from Marmontel to Voltaire," *Studies on Voltaire and the Eighteenth Century*, 53 (1967), 171–222; idem, "Marmontel et 'Bélisaire': réflexions critiques sur les 'Mémoires'," in *Jean-François Marmontel (1723–1799): De l'"Encyclopédie" à la contre-révolution*, ed. J. Ehrard (Clermont-Ferrand, 1970), pp. 49–69; and idem, "Marmontel, Voltaire and the *Bélisaire* Affair," *Studies on Voltaire and the Eighteenth Century*, 121 (1974). Principally at issue in the controversy was Marmontel's fifteenth chapter, in which the author champions religious toleration and rejects the notion of a wrathful God in terms bound to provoke orthodox opinion.

85. Luigi Salerno, *L'Opera completa di Salvator Rosa* (Milan, 1975), Cat. No. 110. Today in the Sitwell Estate, Renishaw Hall, Stafford (Derbyshire), Rosa's *Belisarius* belonged in the 1760s to Lord Townshend, who made it the centerpiece of the "Belisarius Chamber" at Raynham Hall, Norfolk. In addition it was known through engravings by Robert Strange and Cristoforo dell'Acqua. Another painting by Rosa, this one in the Doria-Pamphili Gallery, was long regarded as a representation of Belisarius but is now known simply as *Landscape with Blind Philosopher* (ibid., Cat. No. 203).

86. *Correspondance*, IV, 57.

87. No. 153.

88. *Salons*, III, 286. In the course of demolishing Jollain's painting, Diderot shows his awareness of Rosa's version of the subject: "Quand je vois des Jollains tenter ces sujets après un Van Dyck, un Salvator Rosa, je voudrais bien savoir ce qui se passe dans leurs têtes; car enfin, refaire *Bélisaire* après ces hommes sublimes, c'est refaire *Iphigénie* après Racine, *Mahomet* après Voltaire" (When I see painters like Jollain attempt these subjects after Van Dyck or Salvator Rosa, I really wish I knew what is going on in their heads. For after all, to do *Belisarius* again after those sublime men is to write *Iphigénie* again after Racine, *Mahomet* after Voltaire) (ibid.).

89. See for example his criticism of Roslin's *Le Roi, après sa maladie & son retour de Metz, reçu à l'Hôtel-de-Ville de Paris* . . . (Salon of 1763, No. 70; *Salons*, I, 129); and

his praise of Greuze's *Piété filiale* in the same *Salon* (ibid., 234).

90. *Salons,* II, 157.

91. Jean-François Marmontel, *Mémoires,* ed. John Renwick (Clermont-Ferrand, 1972), I, 236–37. Marmontel's tale is this. Around 1765 (no exact date is given) he fell ill with what he describes as "une humeur visqueuse qui obstruoit l'organe de la respiration" (a viscous humor that obstructed the organ of respiration) (236); fully expecting to die, he resolved to occupy his last moments with an ambitious project; and he found the inspiration for that project before his eyes. In his words:

On m'avoit fait présent d'une estampe de Bélisaire, d'après le tableau de van Dyck; elle attiroit souvent mes regards, et je m'étonnois que les poëtes n'eussent rien tiré d'un sujet si moral, si intéressant. Il me prit envie de le traiter moi-même en prose; et, dès que cette idée se fut emparée de ma tête, mon mal fut suspendu comme par un charme soudain. O pouvoir merveilleux de l'imagination! Le plaisir d'inventer ma fable, le soin de l'arranger, de la développer, l'impression d'intérêt que faisoit sur moi-même le premier apperçu des situations et des scènes que je préméditois, tout cela me saisit et me détacha de moi-même, au point de me rendre croyable tout ce que l'on raconte des ravissemens extatiques. (237)

I had been given as a present an engraving of Belisarius after Van Dyck's painting. It often attracted my gaze, and I was astonished that poets had never made anything of a subject so moral, so interesting. I was seized with the desire to treat it myself in prose. And, as soon as this idea had taken hold of my mind, my illness was suspended as if by a sudden spell. Oh wonderful power of imagination! The pleasure of inventing my fable, the care necessary to arrange it, to develop it, the interest that I felt when first conceiving situations and scenes, all that seized me and detached me from myself to the point of leading me to believe all that is said of ecstatic raptures.

Presently Marmontel began to be treated by the Florentine physician Gatti and within a short while was cured. Marmontel goes on to say that he first read his novel aloud to Diderot, who was, he assures us, "très-content de la partie morale" (very pleased with the moral part) (ibid.). But Renwick in a note quotes from Diderot's *Correspondance:* "A propos on a prétendu que Marmontel a pris mon ton pour modèle de celui de son héros. Il me semble pourtant que je ne suis ni si froid, ni si commun, ni si monotone. Ah! mon ami, le beau sujet manqué! Comme je vous aurois fait fondre en larmes, si je m'en étois mêlé! Notre ami Marmontel disserte, disserte sans fin, et il ne sait ce que c'est que causer" (Incidentally, it has been claimed that Marmontel took my tone as a model for that of his hero. It seems to me, however, that I am neither so cold, nor so commonplace, nor so monotonous. Ah! My friend, what a beautiful subject botched! How I would have made you dissolve into tears had I had a hand in it! Our friend Marmontel holds forth long-windedly, endlessly, and he does not know what it is to talk) (*Mémoires,* II, 503). Cf. also Grimm in the *Corr. litt.* for 1 March 1767 (VII, 248–54), who says that the idea of writing *Bélisaire* was given to Marmontel by Diderot.

92. Jean-François Marmontel, *Oeuvres complètes* (Liège, 1777), III, 3.

93. Ibid., 5. Following this scene we are further told: "C'étoit sur l'ame de ce jeune homme [Tiberius] que l'extrême vertu, dans l'extrême malheur, avoit fait le plus d'impression. Non, dit-il, à l'un de ses amis, qui approchoit de l'Empereur, non, jamais ce tableau, jamais les paroles de ce vieillard ne s'effaceront de mon ame" (It was on this young man's soul that extreme virtue, in extreme misfortune, had made the strongest impression. "No," he said to one of his friends who was approaching the emperor, "no, never will this *tableau,* never will this old man's words fade from my soul") (7).

94. Ibid., 28.

95. Ibid., 29.

96. It is worth remarking that none of the four illustrations drawn by Gravelot for Marmontel's *Bélisaire* depicts any of the scenes just cited. (The illustrations were engraved by Le Vasseur, Massard, Le Veau, and Masquelier.) Nor does it seem to be the case that Gravelot's illustrations, whose character is not in the least absorptive, exerted an influence on the paintings by Vincent and David that I discuss in the remainder of this chapter.

97. No. 189. For a recent discussion of Vincent's canvas see the entry by J.-P. C. [Jean-Pierre Cuzin] in the exhibition catalogue, *French Painting 1774–1830: The Age of Revolution* (Paris, Grand Palais; Detroit, Institute of Arts; New York, Metropolitan Museum of Art; November 1974–September 1975), pp. 670–71, Cat. No. 199.

98. It is scarcely surprising that Vincent's *Bélisaire* struck contemporary critics as somewhat cold, especially when compared with Van Dyck's canonical treatment of the subject. In the opinion of the critic for *L'Année Littéraire:*

Son Belisaire recevant l'aumone a beaucoup de merite du coté de l'execution, sur tout pour la precision des contours qui sont de la plus grande verite; mais la composition en parait bien froide lors qu'on se rappelle ce meme sujet par Vandick et Salvator rose. Le general des armées d'un empereur privé de la vue et aprés une longue prison reduit a mendier sa vie, est un evenement si extraordinaire, si attendrissant que je m'etonne qu'il n'ait point echauffé la verve du jeune artiste. (*Deloynes Collection,* XLIX, 795–96)

His Belisarius receiving alms is full of merit as regards execution, especially for the precision of the contours which are extremely true. But its composition appears rather cold when one recalls the same subject treated by Van Dyck and Salvator Rosa. The general of an emperor's army, deprived of sight and reduced to begging for his living after a long imprisonment, is an event so extraordinary, so moving, that I am surprised that it failed to arouse the young artist's verve.

And the critic for the *Mercure de France* observes:

C'était sans doute une entreprise difficile de nous representer, après Vandick, Belisaire reduit a la mendicité. nous avouerons cependant avec plaisir que le Belisaire de M. Vincent a plus de noblesse, il est mieux drapé et on apperçoit encore sous la draperie qui le couvre, une marque de son ancien etat. d'un autre coté aussi, le soldat que Vandick a representé debout, les mains croisées et reflechissant sur le sort de son ancien general, au quel il vient de donner une obole, forme un contraste plus frapant, plus sublime dans son tableau, que l'officier que M. Vincent a representé dans le sien et dont l'attitude n'a rien de bien caracterisé. (*Deloynes Collection,* X, 1102)

It was no doubt a difficult task to represent for us, after Van Dyck, Belisarius reduced to begging. However, we will gladly admit that M. Vincent's Belisarius has more nobility, his clothing is better draped, and one can still see, under the robes covering him, a sign of his former condition. On the other hand, the soldier whom Van Dyck represented standing with hands crossed and pondering the fate of his former general to whom he has just given an obol makes a more striking, more sublime contrast in his painting than the officer whom M. Vincent has represented in his and whose posture is not well characterized.

(Both passages are handwritten transcriptions of the original publications, hence their peculiar orthography.)

Recently Vincent's *Bélisaire* has been described by Jean-Pierre Cuzin as "this still and taciturn painting, where the emphasis is on the intensity of the gaze that the five figures turn on the face of the blind man" (*French Painting 1774–1830,* p. 671); and Carol Duncan has put forward a psycho-political reading of the painting that attempts

to account for the observation that the figure of Belisarius "asserts his presence *against* those who confront him" ("Neutralizing 'The Age of Revolution'," *Artforum*, 14, No. 4 [1975], 49). See also the letter by Robert Rosenblum in reply to Duncan's article in *Artforum*, 14, No. 7 (1976), 8–9.

99. One index of Vincent's concern in the *Bélisaire* with the representation of absorption is what seems clearly to have been his conscious decision to base its composition on that of Caravaggio's *Incredulity of St. Thomas*. The latter is one of the most concentratedly absorptive works involving more than a single figure in all of painting; together with several other canvases of the mid- and late 1590s, it marks a new phase not only in Caravaggio's development—until then he mainly depicted figures who appear acutely conscious of being beheld—but also in the evolving relationship between absorption and realism which within a matter of decades would come to a head in the art of Rembrandt and Vermeer (see chapter one, n. 88). The original of the *St. Thomas* is today in Potsdam, but it remained in the Galleria Giustiniani until 1816, and in any case seventeenth-century copies abound—a fact that testifies to the extreme popularity of Caravaggio's absorptive mode in that century. For a brief discussion of the *St. Thomas* see Walter Friedlaender, *Caravaggio Studies* (1955; rpt. Princeton, 1974), pp. 161–63, Plate 22; for a list of copies after it see Alfred Moir, *Caravaggio and His Copyists*. College Art Association Monographs, 31 (New York, 1976), pp. 88–90.

100. No. 311. For a recent discussion of David's *Bélisaire* and related works see the entry by A.S. [Antoine Schnapper] in *French Painting 1774–1830*, pp. 364–65, Cat. No. 30. Cf. also Hautecoeur, *Louis David*, pp. 55–61.

101. This is one of the distinguishing characteristics of David's history paintings of the 1780s. In my article, "Thomas Couture and the Theatricalization of Action," I analyze the temporal structure of David's *Horaces, Sabines,* and *Léonidas* (41–42).

102. Historians have tended to stress the Quattrocento character of the handling of space in the *Horaces,* the painting of the 1780s that has received by far the most extensive analysis in the modern literature (cf. Hautecoeur, *Louis David*, pp. 84–85; Robert Rosenblum, *Transformations in Late Eighteenth Century Art* [Princeton, 1967], p. 72; Hugh Honour, *Neo-Classicism* [Harmondsworth and Baltimore, 1968], pp. 36–37). But the *Bélisaire,* the *Socrate,* and the *Brutus* are all in different ways spatially more complex than the *Horaces,* and as far as they are concerned sixteenth- and seventeenth-century parallels seem to me more appropriate. The figure style of the *Bélisaire* is also obviously indebted to Raphael and Poussin.

103. Hautecoeur, *Louis David,* p. 56.

104. See E.H. Gombrich, "The 'What' and the 'How': Perspective Representation and the Phenomenal World," in *Logic and Art: Essays in Honor of Nelson Goodman,* ed. Richard Rudner and Israel Scheffler (Indianapolis and New York, 1972), pp. 129–49.

105. See Etienne-Jean Delécluze, *Louis David, son école et son temps* (Paris, 1855), pp. 222–23. Delécluze, a former student of David's, also relates how the master asked his help in making a perspective rendering of the *plan topographique* that David intended to use as a basis for the composition of the *Léonidas* (p. 223).

106. My discussion of these points has profited greatly from an exchange of views with Professor Samuel Y. Edgerton, Jr., whose *The Renaissance Rediscovery of Linear Perspective* (New York, 1975) I had already found indispensable. It is only fair to say that Professor Edgerton remains unpersuaded by my reading of David's *Bélisaire,* in

particular by my suggestion that the function of the perspective structure is to position the beholder in front of the figure of the soldier.

107. For a recent discussion of Peyron's *Bélisaire* see the entry by P.R. [Pierre Rosenberg] in *French Painting 1774–1830*, pp. 563–64, Cat. No. 139. The painting was executed in Rome for the Cardinal de Bernis.

108. The *Mort de Socrate*, with its deep tunnel depicted almost head-on at the left, is perhaps David's most daring exploitation of the conventions in question. In thinking about the *Socrate*, it should be borne in mind that because that painting is much smaller than David's other masterpieces of the 1780s, there could be no question of controlling where the beholder actually stands (he will stand in front of the painting as a whole). But this seems to have made it all the more imperative that the beholder's gaze be conducted away from Socrates, the effect of the tunnel seen in perspective with three exquisite and poignant figures climbing the stairs at the far end being precisely that.

109. The implications of that imaginary rotation and essentializing are still being worked out in the stupendous *Marat assassiné* (1793), in which the wooden block in the right foreground engraved "A MARAT / DAVID / L'AN DEUX" is a direct descendant of the masonry block in the *Bélisaire*. The wooden block and its inscription in the *Marat* might also be compared with Chardin's treatment of the half-open drawer with playing cards in *The Card Castle*, analyzed in chapter one; and in general the *Marat* bears an intimate relation to the entire range of issues discussed in this book.

110. *Salons*, IV, 377.

111. Ibid.

112. No. 104. The replica is dated 1784. Cf. the references cited in n. 100.

113. David may also have been responding to various criticisms that had been levelled against the original when it was exhibited at the Salon of 1781. It is striking, though, that the features of the original most criticized by contemporary writers—e.g., the action of the soldier and the position of the young guide's legs—survive more or less intact (the former less than the latter) in the replica.

114. See Appendix C for an analysis of David's *Homer* drawings of 1794, which at once look back to the *Bélisaire* and foreshadow the retreat from outward action and expression that takes place in the *Sabines* and the *Léonidas*.

APPENDIX B
Two Related Texts:
The *Lettre sur les spectacles* and
Die Wahlverwandtschaften

1. Jean-Jacques Rousseau, *Lettre à Mr. D'Alembert sur les spectacles*, ed. M. Fuchs (Geneva and Lille, 1948), p. 114, n. 1 (continued from p. 113).

2. Ibid., pp. 171–73. My translation of this passage follows closely that in Jean-Jacques Rousseau, *Politics and the Arts: Letter to D'Alembert on the Theater*, trans. Allan Bloom (Ithaca, 1968). Bloom, however, renders "toute personne mariée" as "all married *women*" (p. 129, my italics), a translation which, although not obviously mistaken, does away with certain implications of the original phrase. The same can be said, of course, about my sexually neutral version of the phrase.

3. Ibid., pp. 3–4.

4. Ibid., p. 165.

5. Ibid., p. 81, n. 1.

6. Ibid., p. 123.

7. Ibid., p. 124.

8. Ibid., p. 162, n. 2.

9. See for example Roland Mortier, *Diderot en Allemagne (1750–1850)* (Paris, 1954), pp. 305–18.

10. On Ter Borch's painting see the exhibition catalogue, *Gerard Ter Borch* (Munster, Landesmuseum, May–June 1974), pp. 126–27, Cat. No. 32.

11. Johann Wolfgang von Goethe, *Elective Affinities,* trans. James Anthony Froude and R. Dillon Boylan (New York, 1962), pp. 166–67. By a historical irony that both Goethe and Diderot would have appreciated, the painting is today understood to represent a scene in a bordello; see *Gerard Ter Borch,* p. 126.

APPENDIX C
David's *Homer* Drawings of 1794

1. Louvre, Cabinet des Dessins, Inv. 26079. See the exhibition catalogue by Arlette Sérullaz, *Dessins français de 1750 à 1825 dans les collections du Musée du Louvre. Le Néo-Classicisme* (Paris, Musée du Louvre; June–October 1972), Cat. No. 53. Is it absolutely certain, however, that Homer is depicted sleeping? Might we not be meant to see him as absorbed in meditation?

2. Louvre, Cabinet des Dessins, Inv. RF 789. See Sérullaz, *Dessins français de 1750 à 1825,* Cat. No. 52.

3. For the text of the letter see Daniel and Guy Wildenstein, *Documents complémentaires au catalogue de l'oeuvre de Louis David* (Paris, 1973), p. 116. Dated 8 November (18 Brumaire), the letter includes the remarks: "Je m'ennuie actuellement, parce que mon sujet d'Homère est totalement composé. Je brûle de le mettre sur la toile, parce que je sens intérieurement qu'il fera un pas de plus à l'art. Cette idée m'enflamme, et l'on me retient dans les fers. On m'empêche de retourner à mon atelier dont, hélas, je n'aurais jamais dû sortir" (I am frustrated now, because my Homer subject is totally composed. I am burning to put it on canvas, because I feel inside me that it will mark a step forward in the art. This idea has me on fire, and they are keeping me in chains. They are preventing me from returning to my studio, which, alas, I should never have left).

4. See chapter three, n. 59.

5. Louis Hautecoeur, *Louis David* (Paris, 1954), p. 56. The *Homer* drawings suggest that David was by then familiar with the engravings of Flaxman, whose illustrations to the *Odyssey* and the *Iliad* were first published in 1793.

6. Cf. Jon Whiteley, "Homer Abandoned: A French Neo-Classical Theme," in Francis Haskell, Anthony Levi, and Robert Shackleton, eds., *The Artist and the Writer in France: Essays in Honour of Jean Seznec* (Oxford, 1974), pp. 40–51. A different but analogous sort of mingling and interfusing of characteristics takes place in a landscape painted by David around this time, the breathtaking *Jardin du Luxembourg.* Although the latter has always been regarded as a more or less exact representation of the view from the artist's prison window, the figures gathered within the fenced-in portion of the garden are in fact dressed in ancient costume. They also appear to be absorbed in intellectual activity, which is to say that the *Jardin du Luxembourg* too bears a close relation to the principal argument of this book.

7. The subject of the *Homère récitant* in particular may be compared with the concluding lines of *L'Aveugle,* or with one of Chénier's so-called *quadri* (notes for paintings or poems) which reads in its entirety: "Homère chantant dans un village et des hommes et des femmes et des enfants lui donnant des fruits et d'autres hommes et d'autres femmes accourant pour l'entendre" (Homer singing in a village with men and women and children giving him fruits and other men and other women hurrying to hear him) (André Chénier, *Oeuvres complètes,* ed. Gérard Walter [Paris, 1958], p. 603).

8. One's sense that the beholder is *present but concealed* is reinforced by David's use of a perspective structure which, being both de-centered and skewed relative to the plane of the sheet, "places" the beholder toward the right of the composition — directly in front of the young women — and at the same time makes that location anything but obvious. The obscurity in which the beholder's position is thereby cloaked is compounded rather than dissipated by David's counter-assertion of classical parallelism to the picture-plane via the handling of light and shade.

Index

Italic page numbers indicate the location of illustrations

DESIGNER	Eric Jungerman
COMPOSITOR	Wilsted & Taylor Publishing Services
PRINTER	Malloy Lithographing
BINDER	Malloy Lithographing
TEXT	VIP Garamond
DISPLAY	Ludlow Garamond Light
CLOTH	Joanna Arrestox B 44000
PAPER	55 lb. P & S Offset Regular

[249]